COMPANIONS OF FATE: BOOK 1

A PERILOUS
ROAD

A.C. SMITH

atmosphere press

ACKNOWLEDGEMENTS

We all have an escape from the rigors of our reality, whether it be from the mundane or the chaotic. For years I have been an avid reader, especially fiction, and I enjoy the quiet solitude that writing affords me. But it is only now that I am coming to understand just how many people it takes to publish a book. Many have given of themselves to my success: their time, their attention, their effort, their opinion, their encouragement, and most of all, their belief in me. I am truly humbled.

First and foremost, I thank my lovely wife Dianna for her faith in me, and for the many hours of companionship she sacrificed to my selfish pursuit. She is my childhood sweetheart, my lifelong partner and my soul mate, and I could not succeed without her undying love and support.

For assistance in character and plot development, I thank Dianna Smith, Sharon Ward, Mike Smith, Doug Easter and Brent Rupp. For assistance with technology, media, marketing and web services, I thank Paul Smith, Sharon Ward and Cain Humphrey. I thank my friend and fellow author Dennis Keith Kieren Jr. who possibly more than anyone else, tirelessly encouraged me to publish.

And I sincerely thank the staff at Atmosphere Press who patiently supported me and collaborated to bring this project to fruition. You are amazing at your jobs, and truly care about the author and their vision.

And to a couple of English teachers from my school days who pushed me to learn when I was convinced I would absolutely never, under any circumstances, ever get any use out of knowing their favorite subject. To Pat Royce and Willis Poole, a heartfelt thanks.

I proudly dedicate this book to my family: Dianna, Wyatt and Kassidy, and my beautiful granddaughters, Gemma and Holland.

And to all those, past and present, who've given yourselves to military service in defense of your nation, I dedicate this book to you. Thank you for your sacrifice. God bless you and your family.

PROLOGUE

She pulled the hood of her cloak tighter. What began as a re-freshing midday shower had become the torrent that now beat against her face incessantly. It wasn't late yet, but with the storm, darkness had set in. She was cold and tired, and soaked. And she longed for the soft, warm bed she'd left behind when she rode out of Arcana yesterday. Her brief stay with *the Elder* had been pleasant, yet the thing she'd most hoped to get from her visit had not come to fruition. He'd welcomed her to stay until the approaching weather passed, but she declined. She had to get to the twin cities. She rode on, her mare's hooves sloshing in the mud. She was already in a miserable state, and riding through the night could put her there by tomorrow's sunset.

The Queen's Highway was a network of well-maintained gravel roads linking all the regions of this vast domain, but right now her spirited horse trudged through a vexing quag-mire. The forest hugged both sides of the road here, and ap-proaching a bend, she saw a glow up ahead. With a slight tug on the reins, her horse promptly stopped. She pulled back her hood and sat still, listening through the cacophony of rain-drops, scanning the road and surrounding trees for any sign of danger. Nothing. But her keen elvin instincts told her to be-ware. Finally, she dismounted and led her horse into the trees. Finding a sturdy branch to lash the reins to, she left it and carefully continued on toward the glow, drawing her sword as she went.

Nearing the road again she paused, mouth open, aghast at the horrible sight before her. A group of travelers had been attacked. Several wagons were ablaze—some overturned—their contents strewn about. Dead bodies littered the roadway: men, women, even children. The horses were gone, save a lone dead animal in front of each wagon. *Highwaymen, and not long ago,* she thought with her anger welling up. *Curse your wretched souls!* She'd seen it before. They would hide and shoot arrows into a horse in each team to stop the wagons and then attack. After they finished with the people, they'd take the remaining horses and a wagon or two to carry away their spoils. *Rotten cowards!*

Searching for survivors, she counted twenty-seven dead. Six wagons were ransacked, and tracks indicated another had been taken away. As she was leaving, walking past an overturned wagon still ablaze, she suddenly stopped, listening. *There . . . it's a baby.* She spun toward the wagon, quickly dropping to her knees to look beneath it. She'd already checked but saw nothing through the dim glow and choking smoke. This time she could see a baby lying in the mud beneath the wooden seat. The entire weight of the wagon seemed to be pressing down, and it cried softly, coughing, fighting to breathe.

She knew what she must do, and she knew the risk of doing it. She quickly scanned all around to make sure she was alone. Then, working frantically, she used her hands to rake away the mud beneath the wagon's sideboard. Once she cleared a space, she wiggled through the mud, squeezing beneath it. Inside the cavernous wooden shell, she crawled, coughing and squinting as she went. The warmth from the flames felt good on her wet, chilled body, but the smoke choked her and burned her eyes without mercy. Working quickly, she raked away the mud around the baby and pulled it from beneath the seat. She was amazed the muddy road had yielded under the wagon's weight else the child would have been crushed.

She emerged after pushing the mud-caked suckling through

ahead of her. Then, crawling away from the smoke, she held it while she knelt and coughed to clear her burning lungs. Breathing in fresh air, she smiled at the baby who now cried vigorously. *An infant girl about three seasons of age*, she thought. They were both covered in mud that dissolved beneath the raindrops pelting them. She laughed as she held her tightly, thankful her stubborn determination had kept her out on this wretched night.

Distracted by the moment, she didn't realize they were no longer alone. She brought a foot beneath her as she took up her sword and wiped it against her filthy clothing. Then as she stood, she sensed a presence behind her and spun around with the girl child cradled and her sword in hand. She gasped when she saw men on horseback lined up across the road just forty feet away. She instinctively crouched, her eyes darting side to side looking for an escape. They were dressed in dark clothing and wore capes with deep hoods. A dozen strong, they were all armed with blades and most carried crossbows. She thought diving behind the wagon might buy her enough time to sprint for the cover of the forest. *Oh, your chances are nil you fool. . . . All right, hang on little one*, she thought with a fleeting glance down at the crying infant.

Just then one of them raised his crossbow and fired. Her reaction was swift and automatic. She'd trained for this. Time seemed to slow as her body responded without conscious thought, and she brought her sword up. Even with the rain and only a dim glow from nearby waning fires, her eyes locked onto the bolt in flight as her sword crossed its path, deflecting it with a mud-muffled clang. As some of the riders straightened in their saddles, she heard the sounds of two more shots. Again, without thought, her body simply reacted. She crouched with her weight on one leg and the other extended, swiftly moving her blade to deflect one bolt while letting the other fly past harmlessly.

That's it. Go! She stood and turned to flee, but was startled by a shout.

"Hold!" a deep, throaty voice resounded ominously.

She first thought the command was meant for her, but then saw the riders lower their weapons. She paused as the row split, and they coaxed their mounts to the sides. Then a man approached from the darkness, riding a black warhorse, its wet hide glistening. He wore a black cloak over black armor, and a black helm concealing his face, but she could feel his eyes boring into her as his impressive animal slowly plodded through the mud. Finally, he reined it to a stop barely an arm's length away.

She'd controlled her fear till now, her actions merely a conditioned response to the threat. But she found herself unable to move as he silently, eerily sat there, his breath escaping his helm in rhythm with that from the flared nostrils of his mount. Squinting in the rain, she managed to rip her eyes away from the narrow slit of his helm to survey his cohorts. They silently held their positions on mounts that shifted their weight restlessly.

Returning her eyes to the leader, she swallowed hard to quell the fear that now gripped her. She knew who this must be. *The Shadow Knight . . . all right, if it is to be,* she thought, tightening her embrace on the baby girl, thankful it had finally quieted. Defiantly, she raised her sword, trying to clear her mind so she could summon its destructive, magical power. She was ready to fight, ready to die, if that was to be her fate this night.

Suddenly, inexplicably, the knight pulled back on his reins, slowly turning his huge horse away. She stared in disbelief as he nonchalantly turned it around with his back to her and coaxed it away. Without a word he slowly rode between the split ranks of his henchmen and into the darkness. As if on cue, they reined their mounts around two by two into the widening gap and followed him, disappearing into the stormy night.

She stood there briefly, collecting herself, wondering if they'd return. Then she turned and fled into the forest, taking an indi-

rect path back to her horse. She'd planned to find a safe place to get warm and dry and care for the infant, but now that had changed. After wrapping the baby in a spare blanket from her saddlebag, she led her horse through the forest, returning to the road well beyond the scene of the ambush. When she was confident the Shadow had not followed, she mounted and set out for the twin cities. There would be no rest this night. The morning would find her exhausted beyond measure, but far away from this place and the Shadow Knight.

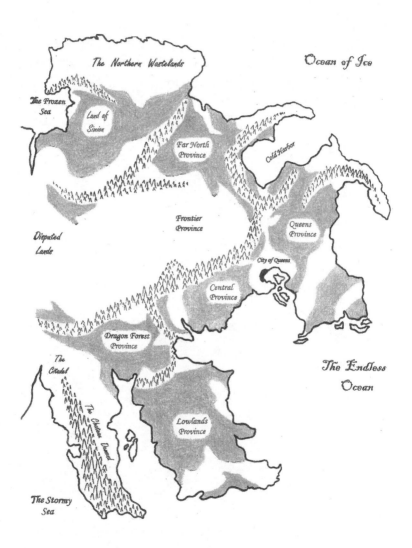

CAST OF CHARACTERS

/// \\\

Faelintari (fā'lin'tär'ē): elf, age - 79, born and raised in a small elvin village near Port Estes, she is a Blademaster who descends from a long bloodline of great fighters.

Draigistar (drāg'is'tär): elf, age - 79, born and raised in a small elvin village near Port Estes, he is a wizard with spell-casting ability far beyond his years.

Gustin VanHolt: age - 35, born and raised in Lake City, Lowlands Province, he is a former cavalry officer in the Queen's Royal Army.

Erin: age - 24, birthplace unknown, raised in the North Woods, she was orphaned at the age of 12 and grew to maturity secluded from society.

Hollis McNeill: age - late 50s, wealthy merchant in Port Estes, father to son Jonas and daughter Celeste.

Hunter: age - 34, a quiet, aloof swordsman with a mysterious past, hired by Hollis as a bodyguard.

Edmond White (*the Shadow Knight*): age - 36 but looks much older, former paladin of the royal court of the Citadel, banished from his homeland.

Hanlin: age - 40s, birthplace unknown, second in command to Edmond White in the Shadow organization.

Lance Deiter: age - early 50s, crew foreman and close personal friend of Hollis McNeill.

Celeste McNeill: age - 27, born in Port Estes, Hollis's daughter and sister to Jonas.

Janae: age - 30s, birthplace and past unknown, teamster for Hollis and friend to Celeste.

Flynn: age - 24, from the disputed lands, occasionally scouts for Hollis McNeill.

CHAPTER ✝ 1

Briefly they looked at each other in disbelief, then gave a resigning laugh. They'd been so careful to stay clean and dry as they made their way across town in the dismal weather. It was late winter, and as they navigated the busy streets of Port Estes, a wet snow was falling for the third straight day.

One of six provincial capitals in the Eastern Kingdom, Port Estes was the northernmost shipping port that stayed open year-round. With vast amounts of harvested timber and fur pelts the main exports, it was a bustling, rambunctious town, a small city with big city amenities necessitated by its remoteness.

The bitter cold of winter had recently given way to warmer weather, and the melting snow had turned the streets into a quagmire of huge puddles and wagon ruts. Avoiding splashes from passing riders and wagons, they'd turned onto a boardwalk passing between two prominent boarding houses to the next street over. Hastily walking along, they commented on the large crowds filling the dining halls on either side. They had on occasion dined there themselves. Probably the two finest establishments in the city, they were lavish and opulent with fine rooms and fine food, at very fine prices.

Suddenly a door opened revealing the sounds of a bustling kitchen, and when they turned to look, they were both drenched in dirty dish-water. There in the doorway stood the culprit, a young girl barely in her teens, wearing a dirty apron and holding an empty bucket. She winced. "Sorry, didn't see

you," she said, then abruptly closed the door.

What was done was done. They couldn't worry about their appearance now. It was more important they not be late for their meeting with Hollis McNeill. He was, after all, the wealthiest and most respected merchant in the entire north shore region.

Faelintari and Draigistar were lifelong friends, having grown up together in a small elvin village just three day's ride from here. Their two companions, Erin and Gustin, would join them at the Cold Harbor Inn to meet Hollis. They'd gone ahead so Gustin could deliver a message to the local garrison commander. Ever since the war began, Fort Estes had been the kingdom's busiest army post.

Two and a half years ago the barbarian tribes of the northern wastelands invaded the Far North Province. Their forces struck without warning in early winter, catching the army unprepared. They razed farms and villages, killing the men and abducting women and children for slaves. All crops and livestock that could be used were taken, and everything else burned. With travel slow and difficult in the heavy winter snow, it was the following spring before the army could respond in force.

The last forty years had seen enormous growth in the Eastern Kingdom. It was a prosperous time, and national pride and loyalty had never been higher than under the rule of the current queen. The thirty-year construction of the Queen's Highway was nearly complete, linking the cities and towns to the capital, the City of Queens. Settlers had spread out to stake their claim on a new life. And as the Eastern Kingdom laid claim to the lush valleys and meadows of the northern forestlands, the tribelanders who resisted being governed moved ever further north, out onto the frozen tundra. Raids on crops and livestock had become commonplace. But depleted food sources after several harsh winters had brought them to the verge of starvation. The result was a swift invasion by fearless warriors desperate and determined to reclaim the land and

resources that had once been theirs.

Some of the Far North Province was still under the invader's control. By last winter they'd advanced south as far as Port Estes, laying siege to it briefly. It had taken the army nearly two years to turn the tide and begin driving the invaders back north. Still, more bloodshed lay ahead, and the army was seriously depleted. All reserve troops had been sent north, and the Queen had authorized military conscription. Anyone seen in the north shore region these days looking like a fighter was potentially subject to a forced enlistment.

The four had learned that accepting an occasional assignment from the garrison commander was, at least for now, a way to avoid full-time service. Both Gustin and Faelintari—Fae to her few close friends—had served in the army and did not wish to return to military life. They'd been here in Port Estes for over a year now and had developed a reputation and demand for their services. They'd worked as bodyguards for the wealthy, gathered intelligence, protected supply trains and couriers for the army, and undertaken sensitive assignments for employers who did not publicly discuss the details.

Last night at dinner, they received an invitation from an acquaintance, Simon, *the Book*, as he was known for his meticulous record keeping of his employer, Hollis McNeill. Simon was a thin, bespectacled man who could at any moment account for every last gold tallin of Hollis's fortune. He extended Hollis's request that they join them for lunch today.

When the elves reached the end of the boardwalk alley, they saw Erin and Gustin approaching and hurried to meet them. Erin saw them coming. Her bright blue eyes were always darting about, always alert. She was as shy as she was beautiful. In her early twenties and taller than average with a muscular build, she had broad shoulders that accentuated her well-defined feminine features. With skin tanned from living outdoors, and long blonde hair she wore in a braid down to her slender waist, she stood out in a crowd, though that was of no concern

to her. She loved the tranquility of the woods and hated being in the city. *Strangers are not to be trusted*, was her philosophy. *They always want something.*

Her parents had lived away from civilization, raising her in the natural world. So as a child, she'd had little contact with others. They taught her to survive, to track prey, to find food and natural cures, to read the weather, and most of all, to trust her instincts. She was the first-born. Then five years later a younger brother died within days of his birth, and there'd been no other siblings.

When she was twelve, she witnessed the violent death of her parents and fled into the forest where she remained, growing up in seclusion. She was welcomed into the elvin village where her father had traded. They fed and clothed her and taught her their ways. She quickly learned how to defend herself with her hands, her sword, and her bow, and how to read the forest for signs of danger. She never stayed long but returned often, until the day they told her a group of riders had been there asking about her. To protect her, the village elders had denied any knowledge of the orphaned girl.

Who could be after me? she wondered. They'd protected her. So, to protect them, she bid them a tearful goodbye and left, never to return. She went back to the site of her burned-out childhood home only once. There were no remains of her parents or of her former once-innocent life. She fell to her knees and wept, aching for vengeance. She would never forget those men, the leader, the one who'd done those horrible things to her mother, the scar on his face, his lifeless eyes. She knew someday, somewhere, she'd be riding down a road, or walking through a town, or standing in a shop, and she would see him. She'd know it was him, and she wouldn't hesitate. She would kill him.

She'd learned elvin ways in her time with the villagers, including their belief that justice and vengeance were almost never the same thing. But for those men, in her heart it was

the same. She'd sworn to never stop looking for them. And someday she'd exact her vengeance and her parent's justice with the same cut of her sword. She'd give her life to kill any of them, but especially him, the scarred one. And if she swung from a gallows for her deed, then so be it. At least her parents could rest in peace.

After years of little contact with other people, she emerged from the forest a fully grown woman, soon discovering she was naive to the ways of the *civilized* world. There'd been no one in her life she considered a friend until she met Fae about five years ago. That changed everything for her. Now she enjoyed life. She had friendship. She had purpose. She belonged. Life was good.

"What happened to you two?" she asked her elvin friends.

"You wouldn't believe us," Draigistar replied.

"Stop at the bathhouse?" Gustin added with a teasing grin.

Fae glared at him, feigning anger. "Can we just go?"

The four had grown close in the time they'd adventured together. They trusted each other in their work, and in their personal lives when time allowed for relaxation. Even the aloof Erin often exposed bits of her persona that no stranger would ever see. And for Gustin and Fae, it had evolved beyond friendship.

They entered the Cold Harbor Inn to find a small midday crowd. It was a typical inn, a tavern with hot meals served and a handful of adequate sleeping rooms upstairs. The main room was long and narrow, with a score of various-sized tables that could seat, at most, a hundred people. It was well lit by lanterns hanging along the walls. And near the back wall stood a bar in one corner and a stairway up to the second floor in the other. They'd been in here before, among the rowdy midnight crowd. With just a few people in here now, they quickly spotted Simon when he stood up from a large, round table near the center of the room and motioned them over. As they approached, the other man stood and extended a hand.

"Hello, I'm Hollis McNeill. Pleasure to meet you."

They each shook the wealthy merchant's hand, introducing themselves before taking a seat.

"You two have an accident?" he asked, sitting back down.

"Matter of fact, we were attacked in an alley," Draigistar said straight-faced.

Hollis chuckled. "Well, looks like you survived to fight another day."

How humiliating, Fae thought, rolling her eyes.

They knew who Hollis was, recognizing him on sight, but had never been introduced. He seemed personable, even jovial. A brief silence ensued as he sized them up. He was a large man, six feet tall, with broad shoulders and a barrel chest. He was obviously accustomed to hard work, even with a hint of excess girth typical of a man his age. Finally, he spoke.

"Well, I'm sure you're all curious why I invited you here. Let us order food and drink, and then we'll get started. Order anything you like; it's on me."

After a server had been summoned and left, he began.

"I've heard of you people. And Simon here, who knows just about everyone in town, speaks very highly of you. I'm in need of someone I can trust to escort me and some of my people on a journey to the south. I plan to expand my freighting enterprise in the twin cities while my son Jonas remains here in Port Estes to manage things in this region. It will be a permanent move for me. My business is already established, and I believe there's good opportunity to expand from there into the Frontier Province. I plan to leave in a few days and travel south by wagon to the City of Queens, and then on to the twin cities by sea."

After a pause to study their reactions, he continued. "Now I must tell you I'd prefer this not be made public knowledge whether you accept the job or not. Please discuss it while we eat. And if you're interested, I'll be glad to give you more details."

During the meal, they disclosed some of the work they'd

done, satisfying Hollis's curiosity. They'd arrived in Port Estes early last winter when the tribelanders controlled the north shore region and had, in fact, helped defend the city during a week-long siege. Since then, they'd found plenty of adventure while enjoying the economic boom that often accompanies a military campaign. But they'd grown weary of the cold, snowy weather, and with the threat of military conscription looming, the reputation they'd earned had become a liability. Eventually they agreed they were interested in his offer.

"Ah, good news," he said. "Now let us work out the details."

They talked well into the afternoon, with Erin remaining mostly silent. She was excited about the travel but not the destination. She recalled stories Draigistar told her about life in the city. *And this is the capital city*, she thought. She'd never been there and couldn't imagine so many people in one place.

Hollis told them he planned to travel south with a column of eight to ten of his large freight wagons. He would provide the teamsters, outriders, and scouts. In good weather, the trip could be made in a week, but in late winter, it could take longer. Loaded with trade goods, they'd move slowly and be vulnerable to attack from thieves and bandits, or worse, *the Shadow*.

The Shadow appeared in the Eastern Kingdom ten years ago, just a band of highwaymen along the southern coast of the Lowlands Province. But soon, they organized, recruited new members, and formed an extensive network of spies and sympathizers, including peasants, merchants, landlords, tax collectors, and even local sheriffs and soldiers. Now it seemed the Shadow had eyes throughout the kingdom. They always seemed to know which supply trains carried valuable cargo and which ones didn't, which couriers to stop and which ones to let pass.

Their leader was a man who called himself *the Shadow Knight*. Violent and brutal, he was known for being as merciless to his followers as he was to his victims. No one seemed to know his identity, though he was rumored to be a banished

knight from another kingdom. Now, the Shadow lurked along the Queen's Highway and lesser roads, ambushing, robbing, abducting and killing travelers at will. Their numbers were thought to be into the hundreds, and they'd proven to be elusive to the army detachments charged with hunting them down.

During this journey, the primary duty of *the Four* as Hollis had taken to calling them, would be the protection of him and his daughter, who would accompany him. Given their reputation, he'd grant them freedom in their tactics. And he assured them of his people's cooperation. They were pleased with the wages offered; he was indeed a generous man.

Fae and Gustin sat where they could watch the other patrons come and go, and noticed when a man walked in who was quite obviously different. Though unintentional, he stood out. Well over six feet tall with broad shoulders, he wore black leather pants and boots, and a royal blue tunic beneath a chain mail vest. In one hand, he carried a worn backpack and a buckler. And in the other, he carried a large sword nearly five feet long. Sheathed on his belt was a horseman's flail. The weapons, shield, and armor were well-crafted and ornate.

Making his way past, he glanced their way. Gustin gave no reaction, but Fae smiled, holding his eye contact briefly. He went up to the bar and spoke to the keeper before laying his pack and shield on the floor and leaning his sword against the bar next to him. He discretely sized up the other patrons while he waited for his food and drink, and then stood alone, eating his meal.

Fae remembered what Hollis had said about Simon knowing everyone, so she leaned close. "Simon, who is that?"

"They call him Hunter, although I doubt that's his real name. He's a bounty hunter, tracks down criminals and army deserters. I spoke to him once, but I haven't seen him since last winter. Who knows where he's been or what he's been up to. You know bounty hunters, unsavory rogues."

His disapproval was obvious, and after adjusting his posture, he continued. "Some say he's from another kingdom, but

I doubt that. Always works alone, I'm told. It's even said he's pursued criminals into the disputed lands, captured and returned them for his bounty long after being given up for dead. How crazy is that? No one travels alone in the disputed lands, at least no one in their right mind."

Fae glanced at Gustin, and he gave her a fleeting grin.

Just then, a group of soldiers walked in, seven including an officer. As they sauntered over to a large table and sat down, the officer gave them a second look. It wasn't long before they were drinking and laughing, getting loud.

Aggravated, Fae watched them, assuming they were off duty. They heckled a young couple sitting near the front door until the two finally settled up and left. Then there came a few loud comments about the tall stranger with the big sword at the bar. Not a glance came from the one called Hunter. Fae was amused. Being a Blademaster, she could recognize a dangerous opponent. *How easily this man could dispense with seven drunken soldiers*, she thought.

Eventually, the officer stood up and headed their way, blatantly staring at the front of Erin's low-cut leather vest when he approached. After brief eye contact, she looked away in embarrassment and adjusted her posture.

Offended, Fae started to stand, but Hollis quickly reached out and placed a fatherly hand on her forearm.

"What can we do for you, Lieutenant?"

"Hello, Mr. McNeill. Good to see you out today, sir."

"What is it you want? Perhaps you were planning to apologize to this young lady for your lapse in etiquette. Yes?"

Even though they'd just met the jovial merchant, they could tell he was angry.

"Well, uh, yes of course. I do apologize, my lady," he stammered, looking at Erin.

She gave no response.

"Good day, Lieutenant." Hollis's tone was unmistakable.

"With respect, sir, I was wondering who these people are

and if they work for you? I'm sure you're aware of the recent conscription order."

"Matter of fact, we just finalized a contract of employment," Hollis replied. "And by the way, what is your name and authority here?"

The officer straightened. "My name is Lieutenant Bruger, sir. And my authority is my rank and service. I've been instructed to conscript on sight anyone I deem fit to serve the kingdom in the war up north. I'm afraid you four will have to come with me to the fort for enlistment proceedings."

Suddenly, his soldiers stood and began spreading out around the tables.

Fae and Gustin both responded by standing and placing a hand on their sword. "We're not going anywhere with you," he said.

"Now hold on, Lieutenant," Hollis interrupted. "As I understand the order, those working in a capacity that serves the interests of the kingdom are exempt from conscription. These people have worked for your commander, and now they're working for me, protecting my supply trains that transport goods for the army."

Continuing to eye Gustin, the lieutenant replied. "Well, sir, whether or not your claim of exemption is valid will be a decision for the commander."

Erin could no longer control the anxiety that had been smothering her since they sat down. She suddenly stood, knocking her chair over behind her as she drew her scimitar. It was a beautifully crafted weapon with a broad blade that looked huge and menacing in her hand.

"I'll not be joining your stupid army!" she told the officer as her fiery eyes locked onto his. Her unexpected actions surprised everyone.

Now Draigistar stood, drawing a dagger. Being a mage, it was the only bladed weapon he normally carried. But imperceptibly, his free arm drew close to his side with his hand

turned palm forward and fingers splayed. He was prepared.

Some of the lieutenant's soldiers responded by drawing their swords. The escalating show of force caused the few remaining patrons of the late afternoon crowd to scramble from harm's way. The scuffle of chair legs and footfalls on the wooden floor exploded briefly. Then dead silence filled the room.

"Well," the officer said with a widening grin. "You do have some fight in you. That's just what we're looking for."

Now Hollis stood, discretely raising his hand to a sheathed dagger concealed beneath his vest. "All right, everyone just calm down. Let's not let this get out of hand, Lieutenant. No one needs to regret what happens here today. I'll have Simon ride out to the fort tomorrow and explain the situation to your commander. . . ."

By now, all the lieutenant's soldiers had drawn their weapons and formed a loose half-circle behind him.

"You'll get the chance to seek your exemption, Mr. McNeill. But for now, these four will have to surrender their weapons and come with us. Don't get yourselves into trouble here," the officer warned.

"We already told you we're not going," Fae said, casually drawing her sword.

"That's right, Lieutenant," Hollis continued. "You and your men have been drinking. And frankly, both your actions and your authority are in question here."

"Don't be foolish, Mr. McNeill. Are you willing to get hurt defending these ruffians you hardly know? We are seven trained soldiers. You are only five—six, if you count the bookkeeper."

Several of his men laughed at the insult.

"Seven," someone said from behind Erin.

Startled, she turned and made eye contact with the big stranger.

He gave her a fleeting smile as he pressed between her and Draigistar to step up next to Gustin with his sword in hand.

The smile evaporated from the lieutenant's face. "Look, I

have, we have no quarrel with you. You're not involved in this. We're just doing our job here."

"Does your job include insulting young ladies and newly-weds? Getting drunk in the middle of the day? You should take your men, Lieutenant, and leave, lest I have a quarrel with you."

Fae was impressed by the sight of Gustin and Hunter standing shoulder to shoulder. She admired Gustin for the exceptional fighter he was. And for the exceptional man he was, the man she'd trusted her life to, the man she'd welcomed into her arms and into her bed. He never said much. But what he didn't say spoke volumes about who he was. She told herself she didn't love him. *He was human; their worlds were just too different. Her own people would disapprove. She was now twice his age and would outlive him by centuries if a natural death was to be her fate. Heartbreaking as it was, they could never be more than lovers.* At least, that's what she told herself.

After a brief, defiant stare, the lieutenant's eyes faltered. Knowing he was no match for the seasoned fighters standing before him, he silently took a step back, then turned and walked to the door with his soldiers following.

"Well, I'm certainly glad that's over," Hollis said. "Thank you, stranger. Join us for a drink?"

"Thank you indeed," Gustin added, extending a hand. They briefly sized each other up before Hunter reached out and shook his hand.

"We could've handled that, you know," Gustin said with a grin.

Hunter chuckled. "Yes, I know."

Men, Fae thought with a subtle smile. *Always posturing.*

Hunter shook each one's hand as they introduced themselves. Then, after retrieving his belongings from the bar, he quietly took a seat between Gustin and Draigistar. While the inn's atmosphere returned to normal, they ordered more drinks.

"I'm Hollis McNeill," the merchant said. "So, uh, Simon here tells us your name is Hunter."

Hunter studied Simon's face, clearly trying to recall a past meeting.

Simon squirmed, nervous from the scrutiny.

At last, he looked at Hollis with minimal expression. "Yes, that's right."

Hollis nodded. "So, may I ask what brings you to Port Estes? Don't recall seeing you in town before."

"Well, I've only been here a few days. Just passing through. I've been up north since last winter. Now I'm headed south to the capital."

That prompted some mutual glances among the others.

"Were you tracking outlaws up north?" Gustin asked.

Hunter looked at him with a surprised expression.

"Simon said you're a bounty hunter, so I, uh, just assumed," Gustin trailed off.

Again, Hunter glanced at Simon who nervously repositioned.

"No," he said, looking back at Gustin. "Some friends and I were fighting the tribelanders, defending settlers and their farms and villages in the countryside. Now that the army's pushing the invaders back north, they're keeping to the roads to give chase, so those who live far from the towns haven't seen much help. We taught them to rebuild their houses together inside fortifications so they could be defended."

"You called them your friends. Were you part of a regiment?" Fae asked.

"No. I'm not in the army."

"Hunter, you said you were traveling south," Hollis said. "As luck would have it, so are we. I own a freighting business, and I'm moving some of my operation to the twin cities. I've just struck a deal with these four to escort me and my people. Don't suppose you'd be interested?"

Hunter studied Hollis for a moment, then glanced around the table.

"Well, sir, thank you for the invitation, but I'm afraid I must decline. No offense, but I really do prefer to travel alone."

Hollis nodded. "I understand. I'm sure you have your reasons, but I'd be happy to pay you. The trip south could be dangerous just now given the recent activity of the Shadow. There's safety in numbers. If you change your mind, let me know. We won't leave for a few days."

Fae had been watching Hunter and noticed when mention of the Shadow piqued his interest.

"Hunter, is there anything about the Shadow you could share with us?" she asked.

He knew why she asked, and he wished he'd controlled his emotions better. "Dealing with the Shadow is always dangerous," he replied. "They're well organized and ruthless. No doubt the army's commitment in the north has kept it from protecting the rest of the kingdom as it should. . . ." He looked at Hollis. "You're right. Perhaps I could travel with you. I'll give it some thought."

"You didn't really answer me," Fae reminded him.

They held each other's gaze, studying, somehow looking for a tactical advantage like two pugilists squaring off. Then he glanced around the table at the others.

"Look, I know we just met, and trust takes time. But just as you don't know me, I don't know you. . . . While I appreciate the offer, I won't consider joining you unless you all agree it's what you want." After looking at each of them briefly, he returned his attention to Fae.

"Faelintari, you're right; I didn't answer you. I have a personal interest in the Shadow that doesn't concern anyone else."

She held his gaze briefly before conceding a smile. "All right, Hunter. And please, call me Fae."

"I understand the bounty for Shadow recently increased," Draigistar said. "The leader's worth a thousand gold tallins now."

"Just think, Hunter. You could travel with us for safety, and if we're attacked, you stand to pick up a handsome bounty," Hollis said.

"I don't care about collecting bounty for Shadow," he replied flatly.

"Your interest is in the Shadow Knight," Fae said, still studying him.

"No, Fae. My interest is in the man who is the Shadow Knight."

"You know him?"

"Yes."

More surprised glances were exchanged around the table.

"Who is he?" Erin finally asked.

"His name is Edmond White. . . . We were once friends."

Again, they looked at each other, astonished.

"Forgive my curiosity, Hunter, but what happened?" Fae asked.

Hunter hesitated. "He, uh . . . he changed."

"He's of the Whites who rule the Citadel?" Hollis asked.

"Yes."

"So, the stories are true," Simon said. "He is a banished knight."

Hunter grinned fleetingly. "Well, it's a bit more complicated than that, but yes."

No one quite knew what to say. Their minds raced. Questions abounded.

Who is this stranger that fate has delivered into our circle? Fae wondered.

The evening crowd was filtering in, and they were all spent.

Finally, Gustin spoke. "Hunter, I know my friends well enough to speak for them on this. We'd like to have you along with us if you're willing."

For a man like Hunter, the invitation meant more coming from Gustin than from anyone else. He looked at him, then at each of the others, lingering with Fae. Once he felt affirmed by all, he nodded.

"Very well. I will accompany you," he said, looking at Hollis. "When do we leave?"

"Three or four days," the merchant replied with a satisfied smile. "If you need anything, just stop by my emporium, the North Shore Trading Company. I'll be at the warehouse or the mercantile. When we're ready, Simon will find you. We'll plan

to meet here again to finalize details and then leave the next day. . . ." With that, he scooted his chair back and stood up. "You take care of the chit, and I'll see you tomorrow."

Simon simply nodded.

"Well, thank you, my young friends," he said as he put on his coat, then turned and walked out the front door.

The next day Hunter rented a room at the lodge where the four were staying. The other three were amazed at how much the two big men were alike. The night before meeting Hollis again, simple food and drink turned into a riotous celebration, revealing a side of the moody loner they hadn't seen. They all agreed they'd made a new friend—at least for one adventure.

CHAPTER ✝ 2

The day arrived to meet with Hollis again, bringing a brilliant sunrise in a cloudless sky. The muddy streets were drying out, with wagon ruts crusting into hard, narrow ridges just right for turning an ankle. Port Estes seemed poised for an early spring.

The North Shore Lodge stood on a hill near the waters of Cold Harbor and its busy docks. A beautiful two-story stone and log structure with a dozen rooms to let, it was where the four had stayed all winter, and Hunter had just taken a room.

Draigistar was the first of the four to make it downstairs. Last night was festive, but he'd never been one for indulging in spirits. Knowledge and adventure were his life. As a child, he was inquisitive, even for an elf. He'd spend countless hours exploring the nearby forest or sitting in the cellar reading books on ancient civilizations and magic.

It was thirty-four years ago when he and Fae struck out together from their village in search of adventure. They were nearly the same age, with her just a month older. It was something she wasn't afraid to remind him of, for by elvin tradition, the older was considered the wiser and, therefore, in authority. They traveled to the City of Queens, where he found a bustling world that electrified his senses. He loved the city the moment he arrived, immediately taking to the crowded environment. He found a place to let and ended up living there for eighteen years while apprenticing with a master wizard.

Fae grew restless. She was destined to be a great fighter,

and to do that she had to train with the best. So, the two child-hood friends said goodbye, and she was off to the twin cities, Altus and Athum. Together, their population rivaled the City of Queens. And Athum was the only place in the Eastern King-dom where the sport of arena fighting was legal. Gladiators, free and enslaved, came from throughout the known world to train and fight there.

Draigistar traveled to the twin cities often, eventually mov-ing there. He joined expeditions into the disputed lands, un-earthing ancient artifacts at Old War Ruin. He traveled to the Chateau Demond high in the Mountains of Ice where he spent two years searching for the mythical elvin city of Lohawna. He'd accomplished much in his life, and he was still very young for an elf. He was already a good mage, but dreamed of becom-ing the greatest wizard of all. He not only possessed magical powers well beyond his years, but was deceivingly strong and agile. He prided himself in staying fit, and could be lethal in a fight with or without spells.

He'd managed to keep in touch with Fae for a while, but eventually lost track. Then about three years ago in Fort Kotter, he ran into her and her new friend, Erin. Soon after setting off together, they found Gustin who proved to be a good fit for their group.

Not long after Draigistar sat down, Erin joined him. They ate together and joked about their wild celebration last night.

"I wonder where they are?" he asked.

"Well, I knocked on Hunter's door, but he didn't answer."

"Hunter? He's the one with the big sword?" the waiter asked, overhearing them as he walked by. "I saw him walk out the front door an hour ago, miss."

"Thank you," she said.

He nodded and went on.

"Wonder what's up with that?" she asked.

"Ah, who knows?" After chewing a bite, he continued. "You know, I like Hunter, but he sure is secretive. Like that big sword

he carries. It's so full of magic it makes my skin tingle when he's close to me with it."

"Really?"

"Uh huh. Strange thing though, I'm not sure he knows how to use it."

"Is it bad magic?"

"No. That I'm sure of."

"How do you suppose he got a sword like that?"

"Well, I've given that some thought too, and honestly, I think he was a paladin."

"Um, you mean a knight?"

"Oh, more than a knight, Erin, a holy knight, a champion with a cause."

She looked worried. "You think he was banished like the Shadow Knight?"

"No," he answered quickly. "Hunter still hasn't said how he knows this Sir Edmond White. But if the rumors are true, then he's being consumed by evil. That makes sense, given his horrific deeds. But that's not Hunter. No, I think he gave up knighthood, maybe to pursue Edmond. And it's obvious he's from the same region as Edmond White. In fact, I think I know where he's from, but that's not the point. Whatever else he fills his time with, be sure of one thing. He's in the hunt for the Shadow Knight. And when he finds him, one of them will die. . . ."

The effect was not lost on her. She gazed down at the table, absorbing what he'd said as she chewed. Then she gave him a concerned look. "You think having him along is a mistake? Are we asking for trouble?"

He considered her question, then smiled. "Oh, I doubt he can get us into any more trouble than we can find on our own."

They laughed before continuing to eat.

"So, what's up with the other two?" he asked between bites.

"Well, Fae's not in her room."

"Surprise."

Laughing again, their eyes met, lingering briefly before she looked away. It made him think how lonely she must be. She'd never shown any serious interest in a partner, and he thought she was, in fact, still chaste. *Shame*, he thought. He, too, had devoted precious little time to romance. But, he was a man, and he wasn't blind.

The next time their eyes met, she surprised him, holding his gaze until he looked away. As he chewed another bite, his mind wandered back to last summer when the four traveled to the Frontier Province. They'd been hired by some wealthy landowners to put a stop to some poaching.

They were camped out in a stand of tall grass surrounding a pond. At dusk Fae and Gustin decided to go swimming, which led to other things. As the sun fell below the horizon, a full moon shone brilliantly in the cloudless sky. He and Erin quietly sat together, talking, listening to the sounds of splashing and laughter from the water's edge.

Eventually, they agreed to join their friends, and to his amazement, she overcame her inhibitions, doffing her clothes to swim. He was filled with desire as he stood naked in the cool water, watching her undress with the light of the campfire and the moon glistening off her nude, voluptuous body.

Later, when Fae and Gustin ran off into the tall grass, naked and giggling, his hopes were high. They talked and laughed, swimming ever closer, lightly brushing against each other until they were standing in neck-deep water, embracing, sharing a passionate kiss. It was then he sensed her excitement turning to smothering anxiety, and knew an emotional battle raged inside her.

Torn between desire and chivalry, he loosened his embrace and their lips parted. She looked down and slowly backed away until they no longer touched. He was gracious as she softly cried and apologized for leaving him unsatisfied. Not wanting the incident to destroy their friendship, he gently assured her he understood. Together they retreated to the shore and

dressed with little conversation. Ultimately, she retired to her bedroll, embarrassed. And he took first watch, allowing his friends to sleep through the night. The next morning, she discretely thanked him, and it had never been mentioned again.

She was less self-conscious these days, accustomed to the unavoidable breaches of personal privacy when friends live and work together. *Perhaps the memory of that night is special to her too,* he thought as he heard footfalls on the stairs.

"Well, look who finally decided to get up," he said jokingly.

"Good morning, you two," Fae replied.

Gustin followed, still rubbing the sleep from his eyes.

After eating, they split up and left the lodge in pairs to spend the morning on some last-minute needs. There was talk of Hunter's absence, but they assumed he was off on a similar task of his own.

<p style="text-align:center">/// \\\</p>

Hunter dressed, grabbed his pack, and left before the others awoke. He took an untouched loaf of bread from a serving bowl on a vacated table as he walked out the front door without speaking to anyone. With a water skin slung by his side, he had a meal he could eat as he walked across town.

Once certain he wasn't being followed, he began a systematic approach to the Cold Harbor Inn. He circled, first at two blocks distant, then at one, observing other people out on the chilly morning. He studied faces, clothing, actions, and any glances returned his way. He passed through alleys, even lingered in front of a barn and livery stable with its doors open.

Satisfied the inn wasn't being watched, he turned into the alley behind the row of businesses across the street from it. When he came to a narrow stairway leading up to a side entrance on the second floor, he swiftly bounded up every other step, unsheathing his dagger as he went. When he reached the landing, he slid the blade into the crack between the door and

its frame, prying it open. When he stepped inside, he glanced back at the alley, taking note of the footprints he'd left in the thin frost on the wooden steps. Unavoidable, but he knew the warmth of the morning sun would soon obscure them.

The building belonged to an elderly couple who lived in a little cottage three blocks away and ran the bakery downstairs. He knew because he'd followed them home the night before last after visiting their store. He'd gone in late in the day and struck up a conversation as he purchased some baked goods. He learned the top floor was vacant, so he went back well after dark to look around. It turned out to be perfect. With four windows across the front and two along the side where he entered, he would have an unobstructed view of the inn where they were to meet, without exposing himself to unwanted scrutiny. The stairs came up from a narrow half-alley that ran from the main alley behind the bakery to the street directly in front of the Cold Harbor Inn.

The second floor was one big, mostly empty room with an interior stairway leading down to a wide door locked from the other side. Only a few crates and small barrels sat piled near the top of the stairs, undoubtedly carried up by the strapping youth that worked for them.

Hunter had visited with him too. He was fifteen, from Northport, and now the provider for his family. His father had been killed by the tribelanders, so he'd fled with his mother and four younger siblings to Port Estes. He worked at a livery in the mornings and the bakery in the afternoons. Hunter liked him. His size and strength were beyond his years, and he didn't complain about hard work. When he shook his hand as he was leaving, he slipped ten gold tallins into his palm, five weeks' pay for the young man. At first, he refused, but Hunter assured him he meant no insult. He was just fulfilling the role he'd been born to, that of a knight. Finally, the young man smiled and thanked him.

Hunter was royalty—in his former life. His family was pow-

erful and wealthy. When he rode away that gray, drizzly day, he forfeited his claim to that power and wealth, but not to the empathy he felt for those less fortunate. Speaking with that young man was the first time in years he'd referred to himself as a knight. He'd sworn long ago to never speak of it, but it had served its purpose. He'd given a widow the means of providing for her cold, starving children. And more than that, he'd sewn the seed of benevolence in the heart of a brave young man who'd been forced to grow up before his time. He'd given him hope without taking his pride.

Hunter slowly walked past all the windows and the door, shifting his weight with each step, memorizing the areas of solid flooring that remained silent under his weight. The owners would arrive soon to begin their day's work, and he didn't want to be discovered. He'd considered simply asking permission to be here, but he knew it would've caused the nice old couple undue alarm. Once satisfied with his paths of egress and to the windows, he picked up a crate and placed it on the floor near the window that gave him the best view. Then he sat down where he could watch without being seen.

Now we wait. The other day when Hollis walked out of the inn by himself, it struck Hunter as brazen, even reckless. But then it occurred to him that Hollis didn't realize the target his immense wealth made him to the Shadow. So, he decided to see who might be interested in him leaving town. He knew his effort may be wasted, but he wanted to cover his back and his friends'. *They're an interesting bunch*, he thought, *solid, honest, capable, and fun, even the mage.* He liked the four—Hollis as well. And he trusted them. Perhaps after fighting the tribelanders, he just wanted to believe he could still make new friends who might live longer than a few days.

Tribelanders. Most called them barbarians or savages. Those who fought beside him never understood why he claimed not to hate the tribelanders. They'd committed unspeakable acts. But they were not savages, just desperate men fighting

for the survival of their kind. Fighting for food and shelter so they'd no longer have to watch their young starve and their women freeze to death in the unforgiving cold and snow of winter.

Cold and snow. He loved the cold. He loved the snow. He loved the way his lungs burned in the thin air as he stood on the snow-covered mountain peak looking down at his home nestled in the lush alpine valley below. That's when he felt most alive. . . . Stop! You're not there; that's not your home anymore.

He realized he could hear footsteps and voices downstairs. The old couple had arrived to begin their day. He looked down at the tattered white scarf in his hand, the scarf he always carried. Her scarf. He didn't remember taking it out. He held it up and smelled it. The scent of her perfume had faded, obscured like the vision of her beautiful face in his memory. Solemnly he put it away and stood to begin his watch.

Many people passed by. Port Estes was a busy shipping port, a provincial capital, and an army town in wartime. And it was waking from its winter slumber. Time passed slowly, with no one piquing his interest. Then two men stepped out of the shop next to the Cold Harbor Inn. *But no one went in*, he thought. It was a seller of tobacco, herbs, and leather goods, and it had been closed all morning. These men did not look like live-in proprietors, given their manner of dress. Both carried weapons. He knew if they'd been watching the street since daylight, they may well have seen him arrive.

The two talked briefly, facing each other, watching the street in both directions.

Now they were looking at the bakery. *Must've seen me*, he thought. Then they split up, and one walked toward the bakery while the other sat down on a bench in front of the tobacco shop. Hunter quietly slipped over to the corner window to see his approach. *Why is only one coming over?* He stepped to the window overlooking the alley, and there, just a few feet beneath him, stood a man holding a horse by its reins. *How could I not*

have heard someone get that close? He was glad the morning sun had melted the frost on the stairs, taking his footprints with it.

The man was slight of build, wearing brown pants and boots with a matching brown hat and vest over a bright red shirt. Hunter glanced back out the front window to make sure the other one remained seated. When the man crossing the street reached the alley, the one waiting removed their hat. Hunter was surprised. *That's a woman.* As the two stood talking, too softly for him to hear what was being said, he again looked to see the other man still sitting on the bench. *Perhaps they don't know I'm here.*

He looked back down at the couple just in time to see a man come around the corner from the main alley. He rode a black horse and was dressed in black with a gray cape. Hunter bristled. He'd been this close to Edmond only one other time in the last ten years. *Could it really be you? Could I be this lucky?* He assessed his chance of throwing open the door with sword in hand and then jumping over the rail and striking the fatal blow on his way down. He figured he'd at least break a leg when he landed, leaving himself open to attack from the other two. Then it occurred to him that even Edmond would not be so brazen as to ride through a provincial capital in broad daylight. Slowly he relaxed and studied the man just ten feet below him. *No, that's not Edmond. . . .*

Just then, the woman swiftly mounted her horse and backed it into the main alley before turning and riding out of sight. The two men remained, so Hunter took hold of the doorknob and slowly turned it. *Did the hinges squeak when I came in? I don't remember.* He gradually pulled it open just a finger's width. Now he was able to watch through the window with his ear to the barely opened door. It was sketchy, but he surmised they were waiting for someone.

"Well, let me know as soon as you find out," the rider said. "I'll get word to him."

Then there was something from the other man, a question, maybe.

"No. We'll wait a few days and watch," the rider answered. "We don't want any surprises." Then, as he abruptly reined his horse back, he glanced up.

With a fleeting glimpse of his face, Hunter instinctively drew back from the window. After a calming breath, he looked back out to see the man riding away.

Realizing how long it had been since he checked the street, he looked back out the front window to see the other man still seated, now watching Hollis and Simon approach. Just as they stepped inside, Fae and Gustin rounded the corner at the other end of the block. Walking past the man on the bench, Fae glanced back to catch him sizing her up. He quickly looked away, and Hunter smiled. Then, holding the door for her, Gustin too studied the man.

Hunter was pleased to see his new friends were careful. He saw the one who'd come over to the alley now walking back across the street and knew it was time to go. He opened the door and set the lock to latch, then stepped out onto the landing with his back to the street. Closing it, he quickly made his way down the stairs to the main alley and turned right, running almost to the street before slowing to a walk. Then he turned right again and walked over to the street he'd been watching. As he stood on the boardwalk in front of the corner store, he glanced up at the sound of horses and saw two women ride past. The one nearest him he'd just seen in the alley. He didn't get a good look, but the other one seemed familiar too. *It's the hair.* Suddenly they reined up in front of the Cold Harbor Inn, dismounted, and went inside.

Erin and Draigistar were just coming up the boardwalk, so he headed across the street to join them.

Erin saw him coming. "Hi, stranger," she said as he fell in next to her.

"Morning, Erin . . . mage."

Draigistar glanced his way, expressionless.

"Oh, you two, really?" she said, making them both smile.

Reaching for the door, Hunter discretely sized up the two men now standing in the street, talking. The one facing them nodded to his partner, and both men looked in their direction before quickly turning away.

"After you, my lady," he said.

"Thank you, kind sir," she replied, stepping past. Draigistar followed, and then Hunter stepped in, closing the door. The inn was crowded.

"Looks like a little sunshine's good for business," Draigistar said.

"Indeed," Hunter replied.

"There they are," Erin said, looking past Hunter.

He turned and started that way, only to pause when he saw who was at the table. He'd not expected to see the striking young woman from the alley sitting there.

"Hello," Hollis said with a summoning wave.

Gustin stood as Fae smiled and waved. "Come on over," she said.

Both women who'd walked in together were seated next to Hollis, along with a man Hunter didn't know. And when they looked up at the trio of late arrivers, he instantly recognized the one with long, flowing auburn hair and emerald-green eyes. She gave him a warm smile and then looked away.

It's you, he thought as a surge of excitement coursed through him.

"Hunter!"

He shook to his senses. "Uh, forgive me, Fae," he said, approaching the table.

"You all right?" Gustin asked.

"Ye—yes," he managed unconvincingly as he sat down.

Gustin gave him a worried look and took his seat.

Hollis made the introductions after food and drink were ordered.

"All right, folks, let's get to it. To my left, everyone knows my assistant, Simon. Then we have the lovely Faelintari, deadly in skills and looks."

She smiled at his compliment while the others chuckled.

"Next, we have the two runts of the party, Gustin and Hunter."

More brief laughter.

Then he swept a hand in her direction. "And this shy young lady is Erin."

She smiled and looked down.

"Next, we have Draigistar, the expedition's mage. And next to him is my dear friend and foreman, Lance Deiter."

Lance nodded, glancing around the table as Hollis continued.

"And last but not least, the two most beautiful teamsters in the entire kingdom, Janae, and my lovely daughter, Celeste. Oh, and by the way, gentlemen, hands off; she's spoken for."

"Oh, Father, am not," she protested as everyone laughed.

"Well, you can't blame me for trying, dear," he said with a grin.

The mere sound of her voice consumed Hunter's thoughts. *I remember the first time I saw you . . . first time I heard you speak*, he thought, sitting there blissfully lost in the past.

He was standing in the North Shore Trade Emporium looking at leather goods. He'd already laid back some items at the counter and had just decided on a particular set of new saddle bags. As he turned to go pay and leave, he suddenly heard a voice from the past, the most beautiful voice he'd ever heard. He knew it couldn't be her, but he turned and looked anyway. No. It wasn't . . . but what an incredibly beautiful woman. He was unable to turn his eyes away.

She was working there in the mercantile, dressed in well-worn clothing, a smudge of dirt on her face. She wore a braided leather tie to keep her long, flowing hair out of her eyes. Even from a distance he was smitten by her piercing, bright green eyes. She was beautiful . . . and that voice. When she spoke to

her customer, it was like music to his ears. He wanted to find a reason to go speak to her, but he didn't have the courage.

Finally, after discretely following her and her customer, watching her, listening to her, he realized the absurdity of his adolescent behavior and decided to leave. While paying, he asked the clerk who she was.

The young man gave him a knowing smile. "You're not the first to ask me that," he replied. "That's Celeste McNeill, the owner's daughter. And no, she's not married."

Hunter smiled, thanked him, and picked up his things to leave. He paused briefly as he walked to the front door so that she was just coming around a tall shelf with her customer in tow and bumped into him. Their eyes met for an instant as they exchanged apologies and smiles. Then she continued on. He watched over his shoulder as he stepped outside. She never looked back.

That was more than a year ago, and he hadn't been able to forget her since. He couldn't recall a single day without thinking of her. After a hard day of fighting, watching his friends fall at his feet in the bloodstained snow and gasp their final breath, he'd spend the night lying somewhere in a snow cave or under a pine tree, cold and lonely. He'd seen her beautiful face many times over the past year in his mind and listened to her speak, listened to that beautiful voice.

"Huh." He gasped, wincing in pain as his breath left him. *What the? Someone kicked me.* He saw Fae just scooting back up in her seat, giving him a disgusted look. Then he realized others around the table had noticed.

"What's wrong with you?" Gustin whispered.

"Sorry."

"Show some manners," Fae said, causing the others to laugh.

He glanced at Celeste and was surprised to catch her looking at him. She held his gaze briefly before looking away, making him wonder if she remembered their previous encounter. And if not, would he ever get the chance to tell her about it?

He'd been to the mercantile since returning to Port Estes, but she hadn't been there. It was pure luck that he stopped in here the day he met Hollis and the four. And while he appeared to consider his offer of employment long and hard, truth was he welcomed the chance to work for him. Even if she wasn't traveling with her father, he stood to win her favor by protecting him on a perilous journey. He still had unfinished business with Edmond White, but for now, that would have to wait. He couldn't miss this opportunity. And if his suspicion about Janae was true, he figured he'd likely be seeing Edmond soon anyway.

As the meal and conversation progressed into the afternoon, it became obvious why Hollis was a successful businessman. He took charge from the outset, assigning everyone's duties. Lance would be in charge of the wagons, the drivers, and the escorts. Hollis had hired two scouts who'd both worked for him previously.

"And now for our new friends," he continued. "As agreed, you four will provide personal protection for the group, but specifically for Celeste and me."

"We won't fail you," Gustin replied.

"I know. And we will cooperate at all times. Is that understood, young lady?" he asked, eyeing his daughter.

"Ah, yes, Father," she replied indignantly.

"Good. Hunter here will help you remember."

What? Hunter couldn't believe it. *Thank you!*

"Father! I'm a grown woman! I don't need a sitter!" she protested, leveling her gaze on Hunter.

"Not a sitter, my dear, a bodyguard," he countered. "Hunter, I want you to personally watch over her unless you're needed for some other duty."

"Yes sir, you can count on me," he replied. *Indeed, I will watch over her.*

After Hollis finished laying out the plan and conceding a few suggested changes, he leaned back with a satisfied look

while everyone conversed.

Hunter noticed Erin chatting up a storm with Celeste and Janae. *That's good.*

Janae asked Lance to trade places with Erin so they could sit together, and Fae traded seats with Draigistar, leaving the four men seated together at one side of the table while the women slid their chairs together in a tight circle across from them.

Hollis and Simon stepped away to speak privately, so they engaged Lance in conversation. It was clear why Hollis trusted him. He was an intelligent, competent leader who'd been with him from the beginning. The three men listened as Lance shared their history together.

"Twenty-eight years ago, Hollis moved his wife and young son up here from the City of Queens to expand his freighting business. He'd been shipping goods up here for a couple of years with four wagons and a leased ship and crew.

"I was barely in my twenties and ambitious. And I could ride, handle, and train horses better than anyone else in town, so we hit it off. Shortly after I started, he purchased more wagons and teams and named me his chief wagon master over two older hands. Well, they quit over it. But Hollis said neither of them had shown him the loyalty that I had. And that's what he needed in the man who'd manage his business when he was away.

"He's treated me well over the years, and the business has never stopped growing. He later purchased that ship he'd leased, along with another one, and has since had four more built. He owns a hundred wagons now and several hundred horses. He employs a master wainwright in Athum who builds them for us, everything from light freighters to the heavy bircks, even the covered kaishons."

"Just how big is his freighting business?" Draigistar asked.

Lance smiled. "Well, besides the North Shore Trading Company here in Port Estes, he owns the Coastal Trading Company in Altus and the Frontier Trading Company in Frontier City.

And he still operates his original warehouse in the capital. He's not only the wealthiest man I know, he's the best man I know: fair, honest, generous. I watched him raise his kids alone after his wife took ill and died. Somehow, through the grief, he managed to maintain his business, and his sanity. I truly owe him for the life my family and I have today. I'll do whatever it takes to protect him and his daughter," he said with a determined look. "And once they're settled in," he added with a smile, "I'll be returning home to a comfortable retirement. . . ."

Finally, Hollis announced he must leave and go bid farewell to a few more old friends. "I'll see you all in the morning," he said. "Lance, you'll see Celeste and Janae safely back to the shop?"

"Of course."

"Father, I—"

"Don't father me, young lady," he interrupted. "You've already said your goodbyes. Now I want to know you're safe."

She remained silent with a pouting expression.

They all agreed to report to the warehouse at dawn. So, with a peck on his daughter's cheek, Hollis stepped out into the chilly afternoon with Simon in tow.

The others stayed awhile as the inn began bustling with hungry customers arriving for dinner. Outside, people hurried along the streets, eager to finish up their day's business and get home.

The four women still huddled on one side of the table while the men sat discussing the trip and sharing adventurous tales. Occasionally, laughter erupted from the women's circle, along with glances their way.

Hunter kept watching Celeste. And each time he'd become lost in the sound of her voice, or the dimples in her cheeks when she laughed, or the way she tilted her head to toss her flowing hair from her eyes, she would suddenly glance his way and catch him looking. She'd briefly hold his gaze with a satisfied grin and then look away.

Finally, they all agreed it was time to call it a day.

When they walked outside, Hunter quickly spotted one of the two men from that morning. The one who'd spoken with Janae in the alley now sat on a bench in front of the old couple's bakery.

"Hey," he said to Gustin, subtly motioning him over.

"What is it?" he asked when they came face to face.

"As we talk, look over my right shoulder at the man sitting in front of the bakery across the street."

Gustin leaned slightly. "Ah, yes, he's looking right at me."

"More likely at someone else over here."

Gustin looked at him without expression. "Dying to hear about it."

"And you will my friend, later."

"What's up, you two?" a familiar voice asked from behind Gustin. As he turned around, they saw Fae and Celeste standing on the edge of the boardwalk. The others had gathered a few steps away, and when Gustin turned to walk with Fae, Hunter stepped up to face Celeste.

"Hey."

"Hey," she replied with a fleeting smile. "Hunter, is something wrong?"

"No."

She gave him a suspicious look. "Hunter, my father told you to watch me, not patronize me. Now we're apparently going to be spending a lot of time together. And I can tell you it will be a very long trip if you intend to treat me like a child. I won't accept that."

He was impressed. He admired a woman who would speak her mind freely.

"Celeste, I didn't mean to insult you. I apologize. I'm just concerned about the dangers of this trip, about everyone's safety, your safety."

"But Hunter, you don't even know me," she said with a bluntness that stung.

He thought about her rebuff. *She's right; I don't know her.*

"Celeste, do you really believe you must know someone to care about them?"

She looked away briefly, then slowly returned her eyes to meet his. "Now, I must apologize. I was rude. I do appreciate you putting yourself at risk for my father and me. But you know I'm not happy about this special treatment. I can pull my weight. I can ride a horse and drive a wagon as well as anyone else here. I can use my sword and take care of myself. And I want to make certain you understand I value my independence as a woman. And my privacy," she added in a stern tone.

After studying her, he responded without expression. "Celeste, I promise I will respect you and your privacy above all else, except your safety. And know this. I will do what your father has entrusted me to do. I will protect you, whatever it takes. Not to impress you. And not because he's paying me; he's not."

He wanted to turn and walk away. Their first conversation hadn't gone well. He was angry with himself and hurt at her. *Perhaps Hollis forcing me on her was not a good idea. She is an independent woman . . . stubborn, outspoken, beautiful. She's perfect.*

"Look, it's been a long day," he continued in a softer tone. "Tomorrow will be even longer. Perhaps we should take our leave and go get some rest."

She nodded. "Yes, you're right," she said, stepping off the boardwalk. Loosening her horse's reins from the rail, she put her foot in a stirrup and slowly pulled herself up. Settling into the saddle she smiled, knowing she'd given him ample time to assess the way she filled out her leather pants.

Then Lance and Janae stepped into the street, and Janae mounted up.

"Where's your horse, Lance?" Draigistar asked.

"Oh, I didn't come with the ladies," he replied. "My horse is in the stable around the corner. I walked through the alley and

came in the back this morning."

Hunter remembered the stable. *That's why I didn't see him walk in.*

Lance turned to face them with the two women flanking him. "Well, I guess we'll see you in the morning."

"We'll be there," Gustin replied as he gave him a firm handshake.

Goodbyes were exchanged, and after bidding farewell to the others, Celeste returned her eyes to Hunter's, giving him a look that betrayed her excitement. Then the women reined their horses around and slowly headed down the street with Lance walking between them.

Hunter continued to watch her after they'd turned away. *Come on, you know you want to*, he thought. *Come on.*

Halfway to the corner, Celeste subtly tilted her head, and he smiled. She quickly turned her head, tossing her long hair to the side as she looked back at him. Their eyes locked briefly, and they exchanged a smile before she turned away again.

Gotcha.

CHAPTER ✝ 3

Standing in front of the Cold Harbor Inn watching Celeste ride out of sight, Hunter found himself anticipating his future for the first time in years.

"Heading back to the lodge?" Draigistar asked as they gathered.

"I'm ready," Gustin said.

"I have something to take care of first," Hunter said. "And I have a favor to ask. Mage, you smoke a pipe, don't you?"

He looked surprised. "Occasionally."

"I need you to check out that shop. Buy yourself some tobacco and get me five cloth-lined leather pouches big enough to slide a hand into. I'll pay you tonight."

"And what are we looking for?" Gustin asked.

"Two men came out of that smoke shop before you got here this morning. You saw the one, Gustin. Strange thing though, that shop was closed all morning. Just see if anything looks suspicious."

"Hunter, what's going on?" Fae asked.

"I'll tell you all about it tonight at the lodge; I promise."

"That's where you went this morning?" Gustin asked. "To watch and see who was interested in our meeting?"

"Uh huh."

"Why didn't you say something? I'd have come with," Gustin continued.

Hunter smiled. "Well, I thought it might be a waste of time. And I, uh, knew you'd be busy well into the night."

Fae's mouth fell open. "What?"

Draigistar laughed heartily as Erin giggled, placing her hand over her mouth.

"Just what do you mean by that?" Fae asked, placing her hands on her hips.

"Come on, Fae. I saw the way you two looked at each other last night."

She glared at him till Gustin slipped an arm around her waist, drawing her to him.

"You're mean," she told Hunter, finally conceding a smile.

"You know, Hunter, speaking of the way two people look at each other, you seemed to have a little trouble today," Erin said. "I thought you'd fall out of your chair when Hollis told you to watch over Celeste."

The other three laughed as he looked at her.

She boldly stared back and continued. "And then, out here just now, pretending not to stare at her butt when she mounted her horse."

Their laughter rose to a crescendo.

"All right, you got me," he said with a smile as he threw his arm around her and pulled her close.

"So where are *you* going, Hunter?" Draigistar asked once the laughter faded.

"I need to go see a merchant two streets over, a gem dealer."

"You see? He's already buying a ring," Erin added, and they laughed anew.

He shook his head in embarrassment, his arm still resting on her shoulder.

"Don't you have somewhere to go?" he asked her.

"Yes, with you. You'll need a woman's opinion before you make your purchase."

He discretely glanced up at Fae, and she gave him a nod.

"All right," he conceded. "I suppose you can tag along."

"Be careful," Fae said.

"We will," he replied, sliding his arm off Erin's shoulder as

they turned and headed down the street together.

"Coming, Fae?" Gustin asked, turning toward the tobacco shop.

"You two go ahead. I'll be along."

"All right." He said, following Draigistar in.

She stood on the boardwalk, watching Hunter and Erin disappear around the corner. This man, who just days ago was a stranger, had earned their trust and friendship. Now Erin was emerging from her lonely, inhibited world, and Fae knew she'd be better for it. As she savored her young friend's triumph, she thought of the choices she'd made in her own life: her joy, her sorrows, her regrets.

She came from a long bloodline of great fighters. Her father was a sentinel, and his father before him. Each elvin village was protected by trained fighters called guardianals, who were led by a sentinel. Fae was firstborn, followed by two younger sisters. And by the time the fourth, a son, was born, her father had spent years proudly teaching his number-one child his craft. He was amazed at her natural ability with a sword; it seemed to become part of her when she drew it. Exhibiting the raw skills of a fighter far beyond his own, her speed and agility surpassed anything he'd ever seen. But unfortunately, his legacy could never be hers. Elvin tradition allowed women fighters to become guardianals, but not sentinels.

As she matured, she grew restless and bored with life in her small village. So, in the summer of her thirty-fifth year, her father took her on a journey to the Land of Simion. He was a legend, the greatest elvin ranger who ever lived. He was up in years, retired to his stronghold on the Mirsham Plateau with more than a hundred loyal followers, mostly young rangers and fighters. They'd sworn allegiance to Simion and patrolled his land, keeping order and protecting the villages.

The plateau was an enormous white stone edifice jutting up several hundred feet from a lush grassy steppe. At its center was a warm, spring-fed lake that never froze over despite

the harsh winter weather of the region. On a forested island in the middle of the lake was Simion's stronghold, a large, wooden-walled structure like a frontier fort with two main gates, six watch towers, and battlements. A village of sturdy lodge pole structures surrounded the stronghold. And within the walls stood his two-story lodge with broad balconies and an enclosed tower rising forty feet above the roof for a commanding view of the island, lake, and plateau beyond.

Fae and her father went there to attend the rendezvous. Every summer, the plateau became home to hundreds of adventurers: rangers, fighters, even bards and a few druids. All were welcome, as long as they behaved themselves. The festivities lasted through summer, the most popular events being the archery and combat sparring tournaments. To Fae, the enchanting beauty of the plateau was surreal. She had the time of her life but sensed her father was preparing to set her free. She'd heard stories of the large cities to the south and longed to see them for herself. They stayed through most of the summer, with her showing off her skills in the sparring tournaments. She was one of only a dozen women fighters present. And with her long, flowing hair and bright, amber-colored eyes, her good looks and remarkable skills drew the attention of everyone there.

Simion had watched her sparring matches with interest, but at one match, she noticed him and a friend observing her intently. The man was elvin, up in years, yet still younger than Simion. When she was finished, she saw her father sitting with them, so she approached.

"Fae, I want you to meet someone," her father said. "This is Telfari."

It's him, she thought, tentatively reaching out.

Telfari was the revered legend to fighters that Simion was to rangers. He was *the Blademaster*. He'd developed the legendary fighting style combining swift, defensive sword work with battle magic. And like Simion, he too had a stronghold,

and a training academy for aspiring Blademasters.

"Uh, hello sir," she managed.

He smiled and gently took her hand in his. "Hello, Faelin-tari. It's a pleasure to meet you. I've been watching you, and I must say I'm impressed."

She felt weak as she glanced at her father, realizing the significance of the introduction. *My God, is that what this trip was for?* To win Telfari's favor was beyond her wildest dreams. She suddenly found herself frightened at the thought of not returning home. *Perhaps I'm not ready to leave.*

"Thank you, sir," she replied at last. "Please, it's Fae."

"I was just telling your father I enjoyed watching you two in the pair's matches," he continued. "You're both very good, and you work well together. . . . Fae, what would you say if I told you I have a place for you in my school? I would like to train you."

She wasn't prepared to make such an important decision. She was frightened and confused. "Father," she said, looking at him. *Help Me. Please!*

"It's your decision, Fae," he replied. "Whatever you decide, I'll support you. Just follow your heart."

Simion looked on in silence as she composed herself.

"I uh . . . I'm sorry, sir, I can't," she said, barely above a whisper.

He slowly smiled. "Good for you, Fae. It was a test for which there was no wrong answer. I hope to train you someday, but your father can still teach you much. And you will know when you're ready. You have as much potential as any pupil I've ever had, perhaps as much as any young fighter I've ever seen. When the time comes, just travel to the town of Arcana and ask for the Elder. Tell him I'm expecting you. He will show you the way." Then he gently kissed the back of her hand and released it. "Good luck, Fae. I look forward to our next meeting."

"Thank you, sir," she replied, withdrawing her trembling hand.

The next morning Telfari was gone, and Fae and her father left a few days later to return home. Finally, at forty-five, still young for elves, she and Draigistar left home. They traveled to the City of Queens where she roomed with him before moving on to the twin cities. She sparred in the arenas of Athum for two years, studying fighting styles from faraway kingdoms like Ormond, Edin, and Myndora.

Then she spent an eventful five years in the Queen's Royal Army, serving as a palace guard in the Queen's residence, and as a marine aboard a naval ship patrolling the coast for pirates. And finally, she served with a regiment patrolling the Dragon Forest Province, where she came to loathe highwaymen and their evil deeds.

After finishing her enlistment, she decided it was time to complete the training her father had started when she was a child. She rode to Arcana and found the Elder. It had been twenty years since she'd seen Telfari, but when she walked into the Elder's shop, he looked up and smiled.

"You must be Faelintari," he said. And just as Telfari had said, he led her to his stronghold in the forests of the Lowlands Province.

Telfari was glad to see her, but the training was hard, and he was demanding. Her first two years she was sequestered from the other students. And worst of all, he forbad her to touch her sword. He had her tumbling, balancing on poles and tightropes, climbing trees and running through the forest. He told her she must master self-control before she could begin training with her sword. She had a mentor for the magic she would need as a Blademaster. And she looked forward to what she called *the magic days*, giving her body a break from the hard physical training.

Telfari quickly learned of her short temper and, at times, provoked her, pushing her until she told herself she hated him. Then one rainy day when she was resting in her room, feeling tired and sore and lonely, mustering the courage to tell him

she was quitting, there was a knock on her door.

When she didn't answer, Telfari opened it and peered in. "Fae?"

"What!" she replied without turning from the window.

He walked over and knelt where she sat on her bed. "It is time."

She looked at him, perplexed.

"Pack your things. You're moving in with the other advanced students."

As tears came to her eyes, he smiled.

"Fae, I promised you'd be a great fighter, and you will be. Perhaps even one day, the best I've ever trained. I pushed you because I had to. And now the worst is over. We still have to work on your magic, and your temper. But come with me now and meet your new training mates. Then I want you to take tomorrow off and rest. After that, we begin training with the sword."

She threw her arms around him as she let go of her emotions, and he returned the hug, taking her back to her childhood.

After that, she enjoyed learning from him the way she had from her father. With her unmatched reflexes, coordination, and balance, he taught her to do things she'd never imagined. From a squat, she could jump over a wall her own height, tuck and roll in mid-air, and land on her feet with sword drawn. She could face arrows fired from a long bow at twenty paces and avoid or deflect them with the blade of her short sword. She perfected his unique fighting style.

"Wear down your opponent, Fae," he told her.

She learned to step in and quickly draw back, causing her opponent to strike wildly. She studied all types of armor to learn their weaknesses. And she learned to defend herself without weapons or magic, landing punches and kicks to vital areas and using her opponent's size and momentum against them.

Their relationship evolved until the man she'd once told

herself she hated was a man she came to love like a father. She gave him sixteen more years, an average apprenticeship for an elf. Then one day, he summoned her to the assembly hall and a surprise celebration. The Elder was there. And in a ceremony before all, Telfari presented her with her new sword, made by his resident weaponsmith and enchanted by the Elder. It was a beautiful short sword imbued with the magic she'd been taught to use.

"Fae, this is yours," he said, placing it in her trembling hands. "There is no other sword like it. It was made for you. Your training is complete."

"Thank you," she said, hugging him with tear-filled eyes. She was beset with a storm of emotion, realizing he was setting her free.

"You've been ready to leave for a while now. I just wasn't in a hurry to see you go. Please forgive a selfish old man."

She smiled. "It's all right. I wasn't in a hurry to leave. So tell me, am I your best student?"

He studied her briefly. "The truth?"

"Uh huh, I can take it."

"Yes. There was only one other. And you're at least as good as he was."

She grinned and hugged him. "I love you like a father, Telfari. I'll miss you."

"And I shall miss you, my dear. Now go. Spread your wings. You are destined for greatness."

After leaving Telfari, she began hearing stories about the Shadow Knight, and she thought back to the day of her graduation ceremony.

While dining that evening, the Elder shared a vision with her. He told her there was a force of great evil consuming the land, and one day her destiny would lead her into conflict with it. The details were unclear. He only knew she would face a great struggle unlike anything else she'd endured. And he didn't know how it would end.

She stopped in Arcana to see him again, but he was still unable to summon the vision clearly. He told her to go see the blind sage, Isaiah, in Altus.

"He is a seer, Fae," the Elder said. "He can help you."

On her way there in a rainstorm, she ran into the Shadow and narrowly escaped. When she arrived in the twin cities, she learned that Isaiah had gone to Simion's rendezvous on the Mirsham Plateau. On the long journey north, in Frontier City, she met Erin. The two quickly became friends and traveled on to the plateau together. She gave up when Dreyfus, the commander of his forces, told her that Simion and Isaiah had left on a yearlong trek into the disputed lands.

"What's a blind man doing out in the disputed lands?" she asked, frustrated.

He smiled at her remark. "I'm sorry, Fae. It's just something the two old friends do every few years. No one knows where they go or what they do. And Simion may well escort Isaiah home before returning here. You know you and your friend are welcome to stay as long as you like. It's beautiful here in winter."

They accepted his offer, staying the winter and then another whole year.

Traveling back to Altus, they ran into Draigistar in Fort Kotter and joined him on a treasure hunt near Old War Ruin. That's where they found Gustin lying face down on a sand dune with an arrow in his back. He was near death. And after nursing him back to health, he joined them.

That had been almost three years ago, and none of them had ever voiced any regrets. There'd never been a need for a leader. They all just seemed to know which offers to accept and which ones to pass on. With life's distractions, she'd never taken the time to find Isaiah. And now those words the Elder had spoken years ago came back to her vividly. She had to wonder. Should she have attacked the Shadow Knight on that muddy road? She would surely have died that stormy night. But how many others might be alive today for her sacrifice?

She heard the door of the shop open behind her and glanced over to see Gustin looking her way. Gustin VanHolt, her friend, her companion, her lover. She could feel herself falling in love with him and worried about how it would affect their relationship and what it might do to the four of them.

"Thought you were coming in," he said. "You all right?"

"Yeah," she said with a smile. "I was just uh, reflecting. Find anything?"

"Nothing to worry about," Draigistar said. "Shall we call it a day?"

"Sounds good," she said as they turned and headed down the boardwalk with her walking between them.

<p style="text-align:center;">/// \\\</p>

As they walked across town, Erin told Hunter that Janae had moved here a year ago from the twin cities and met Celeste one day last summer. They quickly began a friendship that led to Hollis offering her a job.

"How come you're asking me about Janae? Don't you want to know about Celeste?" she asked as they stepped up onto the boardwalk and paused.

"Sure, after we're finished here. Come on, it's getting late," he said, stepping into the gem dealer's shop.

"Well, hello, my young friend," a kindly old man said from behind the counter. "I was worried you wouldn't make it back in before you left town. Then, you're standing in front of my store with a beautiful young wildflower. So, I say to myself, he is young and has better things to do than talk to an old man. I think perhaps you two are lovers, no?"

Erin blushed and looked away.

"No sir," Hunter said with a chuckle. "Just friends."

"Ah yes, I was young once. And I, too, had friends like that, until I got married." They all laughed, and then Hunter pulled out a leather pouch and carefully poured its contents onto the

counter. There were seven gold nuggets, and about twenty shiny, silvery-black stones.

Erin softly gasped at the sight. "Oh my, those are beautiful. What are they?"

He looked at her. "Don't know what they're called, but they're in the frozen ground up north. And he likes to make jewelry with them. Go ahead; take a look."

She leaned in and picked up one of the shiny black stones. It wasn't the biggest, but was smooth with a brilliant sheen and shaped like a teardrop. She held it up toward the front windows to catch the final rays of the setting sun with it.

"Beautiful," she said, carefully laying it back on the counter.

Hunter smiled.

The old man inspected them. "Well, with the gold dust and the other stones you brought in yesterday, I can give you fourteen hundred gold tallins for the lot."

"What?" Erin asked, her eyes wide.

He looked at her and smiled before responding to the dealer. "Tell you what. I can accept that, without this one," he said, picking up the stone she fancied.

The old man scowled, then sighed. "You press a hard deal, my young friend. But you are in love and not in your right mind, so, all right."

They laughed as he placed them on a tray and sat them under the counter.

"And now your payment, as we agreed?"

"You have the pearls?" Hunter asked.

"Aye."

"Well then, let's see the shipment."

"Get the door for me," he said, disappearing through a curtain into his workshop.

Hunter locked the front door and returned to the counter as the old man came out carrying three flat, wooden boxes with hinged lids. He sat them on the counter and unlocked all three. As he opened the lids, both men watched Erin's reaction.

"Huh. Oh my," she whispered as her eyes lit up.

The men exchanged a smile as she studied the pieces of finely crafted jewelry.

"Well, what do you think, young lady?" the old man asked.

"They're so beautiful," she said, looking up at him and Hunter.

There were necklaces, earrings, bracelets, a tiara, some medallions and rings. Most were gold; some were silver or copper. Nearly all were adorned with gems.

"Tell me, Erin, which do you think is the most beautiful?" Hunter asked.

She examined them for a moment without speaking and then pointed to a braided copper necklace set with an array of faceted sapphires and black pearls. When the old man smiled and nodded to Hunter, he picked it up by the ends and stepped behind her. Realizing his intent, she lifted her braid so he could lay it across her neck and fasten it. The old man took out a mirror from beneath the counter, and when she saw herself, she began to tear up.

Hunter smiled and looked at the old man. "How much?"

"Two hundred gold tallins for that one."

"She'll take it."

Her mouth fell open. "Hunter, what are you doing? I can't afford this."

"Yes, you can, Erin. I want to do this for you."

"No," she said, a tear rolling down her cheek.

"Please, Erin, a gift from a friend."

"Hunter, that's crazy."

"Gold means nothing to me; my friends do. Please, let me do this."

She finally conceded. "All right, thank you."

"My pleasure," he replied before looking at the old man. "With the price of the necklace, that leaves twelve hundred you owe me. I'd like to leave two hundred of it here with you."

The old man raised an eyebrow. "Oh? What for?"

"Do you know the couple who own the North Shore Bakery?"

"Yes, of course. But why?"

"Well, they have a young man working for them."

"Yes, yes, I know. He asked me for work too. In fact, they recommended him. But I'm not sure I need to hire someone."

Hunter smiled. "That's perfect. If you'll hire him, I'll pay his wages."

"What? I don't understand."

"It's a long story, but I want to help this young man take care of his family. I'll leave the two hundred gold tallins here with you, and you pay him four tallins a week to help out. That's a year's pay. If his mother decides to move them away, you can give the boy the rest of his wages."

"All right," he said with a shrug. "You trust me to give the boy his gold?"

"Of course. You're trusting me with much more," he said, waving his hand over the open wooden boxes.

He smiled. "Guess you have me there."

"If you have some parchment, I'd like to write something for him."

"Sure," he said, handing him a piece along with ink and quill.

Hunter began writing while the old man closed and locked the wooden boxes. "Tell him, if they decide to try a warmer climate, I have a friend in Altus who can help out," Hunter said. "A man named Rufus DeLong owns the Twin Cities Trading Company. He can put him to work, teach him the freighting business." He noticed Erin leaning closer as he wrote, watching his hand move, intrigued by the strokes of the quill. When she glanced up and caught him looking at her, she smiled shyly, and it occurred to him why she was so fascinated.

"There. If you'll give that to him and manage his pay, I'd appreciate it," he said, handing him the parchment.

"Aye," the old man said.

"And as for the remainder, I'll take a hundred in gold tallins and the rest in the gems we agreed on yesterday."

"Very well," he said, turning to go get his payment.

"Hunter, who's this boy you spoke of?" Erin asked when they were alone.

"He's a fifteen-year-old who lost his father last year and has a mother and four siblings to take care of. A brave, hard-working lad who deserves a helping hand."

The gem dealer returned with Hunter's gold and two cloth pouches.

Hunter carefully poured them onto the counter.

"Oh, those are beautiful," she said, pointing at the black pearls.

He stirred through them, picking out the best one and placing it in his pocket with the black stone he'd put there earlier. "Looks good," he said, pouring the rest back into the pouches and stowing them in his pack.

"Well, Godspeed," the old man said, handing him the key.

"Thanks," he replied, putting the gold and the boxes in his pack. "When I get to the City of Queens, I'll deliver these to your brother."

"Very well."

They left, and as they walked across town, he reached into his pocket. "Here," he said, holding out his clenched hand.

When she looked at him and reached out, he dropped the shiny black stone and black pearl into her hand. "That's the rest of your gift."

"No," she protested. "You already gave me too much."

"Erin, I have many of those, as you saw. I want you to have them."

"Well, thank you," she said, reluctantly placing them in a pocket.

They walked on in silence until he noticed her reaching up and touching the stones set in her necklace.

"Erin, forgive me for asking, but do you have a dress?"

She looked up at him and smiled. "Yeah. Think I should wear it tonight?"

"Uh huh. And perhaps let your hair down."

They exchanged a smile as they continued walking.

His next question was difficult, but he had to know. "Erin, can you read?"

She didn't respond, and they continued walking in awkward silence. Finally, when they stopped to wait on a passing wagon, she looked over at him.

"I can read and write some, but not good like you," she said, looking away. "The others have been teaching me."

"Erin, please understand I'm not judging you. I would never do that. I uh, just wanted you to know if you ever want my help learning, I'd be glad to."

She gave him a silent nod and they resumed walking.

"You know, I was blessed with a privileged childhood," he continued, hoping to ease the tension. "Difficult and demanding, mind you, but I never wanted for anything. I was also blessed with a loving grandmother who made sure I learned to appreciate how good I had it. And as children do, my brother and I would sometimes forget and have to be reminded."

"What happened?"

"Well, judgment was swift," he replied with a smile. "If we were close enough at the time of the offense, she'd apply correction through the back of her hand with all the love and tenderness of a hot branding iron."

She giggled.

"And if we were fast enough—and stupid enough—to escape her immediate wrath, she knew we'd be back at mealtime. And she always had a willow switch lying around."

"Ouch," she said as they both laughed. "Sounds like you were close to your grandmother. Are you still?"

He looked away briefly. "She died six years ago."

"Oh, I'm sorry. Were you with her?"

Another pause. "No, Erin. I haven't been home in years."

As they walked on, she recalled her conversation with Draigistar. "Is it because of the Shadow Knight?" she asked. "Did

you leave home to find him?"

"No," he replied, still looking ahead. "I left home because . . . because there was no future for me there. And, because I was angry with my parents. . . ."

After a long silence, she reached out and touched his arm as she slowed to a stop.

When he stopped and turned to face her, she looked at him through wet eyes.

"I can't believe what I just heard," she said. "What a selfish thing to do."

He was speechless.

"Hunter, I lost my parents when I was twelve. And not a day goes by that I don't miss them. There's nothing I wouldn't give to have—" Her voice broke and she briefly looked away. "To have them back," she finished, looking back up at him with tears rolling down her cheeks. "And you ran away from yours like a spoiled, pouting child who didn't get his way?"

He was embarrassed, racked with guilt for hurting her.

"Hunter, haven't you ever wondered what it did to your family when you left?"

"Erin, if you knew why I left, I think you'd agree it was the only thing for me to do. But I'll admit, the way things turned out, I shouldn't have stayed away so long. It's been years. I guess I'm just afraid of facing them after all this time . . . afraid I'll find I'm not really missed anymore."

"Trust me, Hunter, they'll never stop missing you, or caring about you. I don't know why you left, but you should go home. You'll never be whole again until you do." She paused briefly to wipe away tears.

"Ever since I've been on my own, I've had this strange notion I needed to go home," she continued. "Maybe it's just a silly little girl's dream. But in my heart, I believe that somewhere I have family, a place I belong, a place to call home. I don't know where that is. But I know I'm not going to stop searching or believing that I'll find it someday. You know where your home

is, and your family. You don't know what I'd give to be in your place. Don't take them for granted. Even if you don't stay, go home. Face them. Make it right so you can put it behind you and get on with your life."

He felt ashamed. "Erin, I'm sorry I hurt you."

"Oh, just disappointed me," she replied as she turned and continued walking.

When they entered the lodge, the dining hall was busy. Draigistar and Gustin were sitting at a round table near the bottom of the wide stairway that led up to the sleeping rooms on the second floor.

"Bout time," Gustin said. "We're hungry."

"Is Fae upstairs?" she asked, ignoring his complaint.

"Yeah. Primping, I'm sure."

"I'll be back," she said before bounding up the stairs.

Hunter sat down, and they settled into small talk after catching up on the day's events. A few moments later, he noticed people staring and looked up to see Fae and Erin standing at the top of the stairs, each in a velvet dress with a wide-cut neckline extending to the curve of their shoulders. Fae wore crimson, and Erin's was royal blue. When they started down the stairs, Hunter smiled and stood, prompting the other two to look. Erin's eyes locked onto Hunter's, while Fae exchanged a lustful gaze with Gustin. Hunter was amazed by Erin's beauty. She'd unbraided her hair, letting it hang down past her waist, and the blue dress and sapphire set in her necklace accentuated her bright blue eyes.

"Somebody wake me up," Draigistar said.

"Well, if it's a dream, thanks for sharing," Gustin replied.

Draigistar and Gustin had rarely seen Fae in a dress and had never seen Erin like that. Though petite compared to Erin, Fae was equally curvaceous, and by now, the dining room had fallen silent. When they approached the table, Hunter slid back a chair.

"Thank you," Erin said, taking a seat.

Fae sauntered up to Gustin, and they embraced and kissed.

"Looks like another sleepless night," Draigistar said.

"If I'm lucky," Gustin replied.

Once food and drinks were ordered, they fell into quiet conversation, and Erin reveled in the compliments she received.

Fae leaned close. "Thank you, Hunter," she said softly. "I can't tell you what tonight means to her."

"Oh, I think I have an idea," he replied with a smile.

Fae received her share of compliments too. And when they'd finished, they went up to Hunter's room, where he told them about his morning. Hearing his report, they reluctantly agreed that Janae was likely in with the Shadow. They suspected her chance encounter with Celeste was planned and meant to get her close to Hollis through a feigned friendship with his daughter.

"But she seemed so sincere," Erin countered.

"I agree," Hunter said. "I watched her today, her glances round the room, her reaction when the front door would open. I believe what began as a ruse has grown into a genuine friendship, and I hope she won't be able to betray them when the time comes."

"So, you think they plan to attack us on the road and kill Hollis?" Draigistar asked.

"No, just think about it," Gustin interrupted. "They could've killed him anytime the way he roams the streets of this town without bodyguards. I think they more likely plan to kidnap him for ransom."

"Makes sense," Hunter agreed.

"What do we really know about his son?" Draigistar asked.

"Nothing," Gustin said. "I hope we get to meet him tomorrow."

"Don't forget Simon isn't making the trip," Erin said. "Who'd know more about Hollis's fortune: how much he's got, where it's kept, how to get it."

"Good thinking," Fae added, "lots of possibilities."

"Well, at least we know who to watch when we leave town," Gustin said. "I guess the thing to decide is do we tell Hollis and Celeste?"

"I've thought about that all day," Hunter said. "And I think for now we should keep it to ourselves. I'm just not sure either of them could act normal around Janae if they knew. They might not even believe us. And we don't want to tip her off. She may not be the only Shadow traveling with us. And right now, we've got the advantage."

"Indeed," Gustin affirmed.

"Well, it's getting late, and the morning will be here before we know it," Hunter said. "But before we break up, I want to show you something." He opened his pack and took out the three wooden boxes, placing them on the table. Then he unlocked and opened them up.

Erin smiled when she saw their reaction.

He explained he'd been hired to deliver the jewelry to the gem dealer's brother and business partner in the City of Queens.

"Mage, this is why I had you pick up the leather pouches," he said. "Just let me know what I owe you. Anyway, if you're agreeable, I'd like to split these up and have each of us carry some. I figure I have a better chance of getting them there that way. I'm to be paid a hundred gold tallins when I deliver them, and I'll gladly split it with you."

"Sure, I'm in," Draigistar said.

"Me too," Gustin added.

"Well, it's not like it will make the trip any more dangerous," Fae observed.

"I agree," Erin said. "I'm in."

"Hey, you're already wearing your share," Draigistar said.

"Am not," she replied as the others laughed. "This is a gift from a gentleman," she said, tilting her head back in feigned arrogance.

Fae chortled. "I don't see any gentlemen."

"Me neither," Gustin agreed, causing the others to smile.

"So, what will you do with the boxes?" Draigistar asked.

"Well, I thought I'd deliver them as well," Hunter replied. "Why, do you have a use for them?"

"For one. We'll call it even for the pouches."

"Done," Hunter said, as he noticed Erin yawning. "Tell you what. I'll put these in the pouches and get them to you in the morning. I think now we should get some rest?"

Gustin promptly stood. "I agree."

"I said rest," Hunter reminded as the others chuckled.

"Oh, I'll get to that," he said, grinning at Fae.

She stood, and after bidding the others goodnight, they left.

Then Draigistar retired, and Hunter walked Erin to her room. When they reached her door, she unlocked and cautiously opened it, glancing around before stepping inside. *Good girl,* he thought, *being careful.*

"What a day," he said when she turned in the doorway to face him.

"Yes, Hunter. Thank you again for the necklace and the jewels. And I'm sorry for the way I spoke to you earlier."

He smiled. "I needed to hear it. . . . Well, goodnight. See you in the morning."

"Goodnight, Hunter."

"Lock your door," he whispered as he turned down the hall.

"I will," she whispered back with a grin.

Stepping away, he heard the door close and lock behind him. *Good girl.*

/// \\\

When Fae and Gustin left Hunter's room, they went straight to hers. It wasn't that late yet, and they had plans. When they reached her door, she took out her key and unlocked it, and when she pushed it open, Gustin's tunic flew past her, settling onto the floor. She smiled and turned around to see him standing there bare-chested with a wide grin. As she ran her

hands over his muscular chest, he slid his hands up her back, pulling her close. Then hooking his thumbs in the wide neckline of her dress, he suddenly pulled it down off her shoulders, exposing her breasts.

"Huh! Gustin!" she said with a giggle as she recoiled, instinctively raising her hands to cover herself. "We're in the hallway, you fiend," she said in a loud whisper.

He reached down and scooped her up in his arms as he stepped into her room. Then he suddenly turned to head back down the hall. "Wait, there's something else I need to tell Hunter."

"No!" she squealed.

He laughed and spun around, stepping back into her room just as the door across the hall opened. He turned, exposing her bare back as she tucked her face into his chest. Standing in the doorway was a middle-aged man holding an open book in one hand. After taking in the sight of Fae's bare flesh, he looked at Gustin. "What's this?"

"Uh, sorry, sir," Gustin replied. "We, uh, got a little carried away. It's our wedding night."

Fae was too embarrassed to rebut his lie, but clinched her hand into his chest hair.

"Oh, well, uh, I see," the man said with a knowing smile. "Very well then, carry on," he added with an endorsing nod before closing his door.

Gustin shoved her door shut with a foot as he spun around toward the bed.

"Ouch!" he exclaimed when she grinned up at him. She let go of his chest hair and slapped his face just as he pitched her onto the bed. Like a falling cat, she twisted her body, landing on her hands and knees on the bed, still looking at him.

"You *liar*," she said, feigning disgust.

He stood there briefly, returning her coquettish grin while he rubbed his chest. Then he kicked off his boots and began doffing his pants. She watched him disrobe as she kicked off her shoes and stood up on the edge of the bed, still bare above

the waist. Moving in close, he reached up and slid her bunched dress down over her hips, letting it fall around her feet as he nuzzled her cleavage.

Their naked bodies came together in a frenzy of desire. They made passionate love, taking and giving pleasure insatiably until at last, exhausted and fulfilled, they fell asleep in each other's arms.

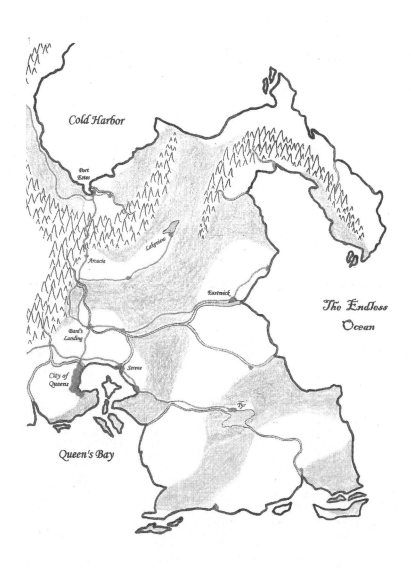

Cold Harbor

Port
Estes

Lakeview

Arcacia

Eastwick

The Endless
Ocean

Bard's
Landing

City of
Queens

Serene

Fyr

Queen's Bay

CHAPTER ᛏ 4

As the eastern sky unveiled its predawn hues, the large warehouse of the North Shore Trading Company was already abuzz with activity. When the friends arrived, they saw two hitched wagons sitting outside the open main doors and several others lined up inside. There were teamsters working, hitching teams, securing loads, and checking covers and ropes. They dismounted and walked inside, garnering a few curious looks from the workers. The inside of the cavernous building was lit up by fires in clay pots spaced across the dirt floor at a safe distance from anything combustible.

"Impressive operation," Fae said.

The others quickly agreed.

"Hello," came a voice from above them. They turned to see Lance standing on a catwalk that spanned across the front wall above the large main doors, connecting to a second-floor balcony where a stairway led down to the dirt floor. He held an open ledger, and Janae stood close by, holding up a lantern so he could read it.

They returned the greeting as he closed the book and headed down the stairs.

"Good to see you," he added when they reached the bottom.

"Trouble?" Gustin asked.

"Oh no, just running a little behind."

Just then, a door opened, and Simon stepped out of a room followed by Hollis, Celeste, and a man they didn't know.

"Morning," Hollis said. "Missing one?"

They glanced around and saw Hunter was gone.

"There he is," Erin said just as he disappeared between two of the heavy bircks near the back wall.

"Sorry, he's not yet fully domesticated," Draigistar said.

Hollis chuckled. "Well, we should be ready to leave soon."

"Anything we can do to help?" Fae asked.

"No," he answered. "Feel free to have a look around. My people know you're joining us. Some you'll find more outgoing than others. After we get down the road a ways, I'll give proper introductions. Oh, by the way, this is my son, Jonas," he added with a gesture.

Each of the four exchanged a handshake and greeting with him. Then while the workers finished up, they meandered, observing and commenting on their single-minded efficiency.

/// \\\

Hunter walked among the huge wagons, watching the teamsters, looking over the cargo, and admiring the draft horses. He was struck by the size and durable construction of Hollis's heavy freighters. *Only drafts could pull these things when they're fully loaded,* he thought, *especially over the mountains.* As he slowly walked beside a birck, reading some crate labels, he neared the front and noticed a subtle movement above him. Looking up at the seat, he saw a pair of emerald-green eyes peering at him from over the wooden backrest. Startled, he took a step back before he realized it was Celeste.

"Oh, it's you," he said, embarrassed.

She giggled as she rose from her prone position and scooted over to sit on the end of the seat. "Gotcha," she said with a grin. "Not quite awake yet?"

"Sure. I knew you were there."

"You *liar,*" she responded, emphasizing the word. They gazed at each other in a brief silence until she spoke with a feigned serious expression. "I don't know, Hunter; maybe you're

not the person to protect me. It was easy to sneak up on you."

"Perhaps you had someone else in mind?"

"Oh, I already told you I can take care of myself. I'm a big girl; don't need anyone to hold my hand."

"I hope that turns out to be true."

"Why? Don't you want a chance to prove your mettle? Rescue me from grave danger?" she asked as her smile returned.

"No."

"So, tell me then, of what use are you if I don't need you to defend me?" she asked as she swung her legs, kicking the side of the wagon with her heels like a nervous child would.

"Oh, I'm far more useful than merely being your protector. I can cook your meals or tend to your horse. I can keep you from getting bored on such a long journey with engaging conversation. Why I can even tuck you in at night and tell you a bedtime story," he said with a mischievous grin.

"Ha! Like that would ever happen," she said, feigning arrogance.

Suddenly he reached out and grabbed her by the ankles, pulling her off the seat.

"Ohhh!" she let out a yell as she fell feet first. He closed his hands firmly around her midriff on the way down, gently setting her feet on the dirt floor.

"Shhhh!" he said after they briefly broke into quiet laughter.

Standing face to face with his hands on her waist and hers on his shoulders, she reached up and playfully slapped him. "Don't shush me, you brigand," she said before they resumed their laughter.

"Come on," he said, and they turned to walk back to the others.

/// \\\

With Lance's stern oversight, the drivers soon had their wagons lined up in the street, ready to go. Now gathered where

their horses were tied, the friends had a chance to talk with Jonas and his father. They were impressed with the young man and warned him to guard his own safety.

"I will be careful," he said. "Please take care of my father . . . and my baby sister," he added when Celeste walked up and gave him a hug.

They assured him they'd look after them both. As they mounted, Jonas stepped between the two big men's horses and spoke just loud enough for them to hear.

"Please watch my sister," he said. "She and Janae are close, and well, Janae can be impulsive. I don't want her to get Celeste into trouble."

"That's good to know," Gustin replied.

"We'll take good care of them," Hunter added, extending his hand.

Jonas gave them both a solid handshake and wished them a safe journey. Then Hollis gave his grown son a hug before mounting up. Gustin and Hunter noticed Lance talking to an attractive woman. He'd told them he was married with two grown children, so they assumed she must be his wife. Sizing her up, they exchanged a subtle smile.

"And just what are you two looking at?" Fae asked from behind them.

When they turned in their saddles, they saw the four women eyeing them from atop their mounts.

"Busted," Draigistar said with a chuckle as he reined his horse around.

The morning sun broke the horizon as the column rolled down the main street of Port Estes and headed south on its long journey to the City of Queens. After leaving town, Lance set the pace of the wagons with nearly a hundred feet between them, a reasonable distance for open terrain on a clear day. He pushed them hard through the morning. Then, near midday when the scouts came in, he signaled for a break.

Hollis gathered his people and introduced them to the five

newcomers before they spread out among the wagons to eat a quick, cold meal. Gustin, Draigistar, and Hunter sat down on some felled trees on the far side of the road while Fae stayed near the lead wagon with Hollis and Lance. To Hunter's disappointment, Celeste, Janae, and Erin sat down in the road by the front wagon. Although the surrounding trees and meadows were still dressed in snow, the gravel road had dried out in the last few days. Soon the three young women were joined by Derek and Krysta, siblings who'd known Hollis their whole lives and had worked for him the last three years. As he ate in silence, Hunter watched the group chatting and laughing heartily.

"Sounds like a party," Draigistar said, "and you weren't invited. Don't fly into a jealous rage and turn a wagon over."

Gustin chuckled at his goading.

Stoically, Hunter finished chewing. "Don't start with me, mage. Or when we leave here, you'll find yourself flailing, stuffed headfirst inside that hollow tree stump behind you."

Gustin laughed heartily at the mental image.

"Ha ha," Draigistar said mockingly before continuing to eat.

A long silence befell them while they finished their meal. Each seemed lost in thought until Draigistar spoke again.

"So, how long you think we'll travel in this snow?"

"Oh, two days at most, wouldn't you say?" Gustin said.

"Yes," Hunter agreed. "Once we get over Howling Pass and down into the meadowlands, we'll leave it behind."

Winter storms picked up moisture over the Cold Sea and dumped enormous amounts of snow from the shores of Cold Harbor up the northern slope. The group was just starting their climb toward the spine of the Howling Mountains, a range that looped around the Cold Sea. Tall, heavily forested, and mostly uninhabited, they were named for the numerous packs of wolves that roamed the steep, jagged terrain. Timber wolves were abundant. And even an occasional pair of much larger frost wolves could be encountered.

They didn't live in packs, but rather as a mated pair, raising only a single pup every year. When either died, its mate typically didn't survive the next winter.

After eating, the group mounted and set out again, not having encountered a single person since leaving Port Estes. Lance and Hollis rode out front with the two scouts for a while until the hirelings set out ahead at a cantor, angling off the road to either side through the snow-laden slopes.

"Wonder how good they are," Gustin said, looking over at Hunter and Fae.

"Don't know," Hunter answered. "But I wouldn't mind getting in the rotation."

"Count me in," Gustin added.

"You mean I'm not invited?" Fae asked.

"*No*," they both replied together, before all three laughed.

"Is it because I'm a girl?"

"No, Fae," Hunter answered. "We need you to look after things here."

"Yeah, sure. You boys just don't want to share the fun."

They rode in silence for a while until Hunter spoke without taking his eyes off the road. "Fae, you know why you're the one I'd trust to look after things if we're both gone? Stand beside me in a fight? Cover my back?"

She looked at him intently, studying him until he looked her way.

"Because I know what you're capable of," he continued. "You're not the first Blademaster I've met. I recognized Telfari's work in your weapon and in you, the way you carry yourself, confident, poised. I know you're a superb fighter. I knew it the moment our eyes met that day at the inn," he added before returning his eyes to the road.

As they rode on, she silently took in what he'd said. He was obviously comfortable in his position with the four. She liked that. She liked him. And she trusted him. He was so much like Gustin. She was attracted to him, as she knew he was to her.

But I can't be attracted to him, she thought. *I'm taken.* She looked over at Gustin, but he didn't notice. He was intently scanning the road ahead and into the trees, keeping watch over everyone. She did love him. And that meant she no longer had the freedom to choose others. Her unexpected attraction to Hunter made her realize she could no longer deny being in love with Gustin.

"Hunter, thanks for the compliment," she said.

He just smiled and nodded.

"So how is it you know Telfari?"

"Oh, I don't really," he replied. "I mostly just know his reputation through other Blademasters I've met over the years. I only met him once, about fifteen years ago, at a jousting tournament. He and a group from his academy put on an impressive exhibition."

Her heart raced as she relived that event. "Fifteen years ago, in the kingdom of the Citadel. I remember. It was the most beautiful country estate I've ever seen."

He smiled, glancing over at her. "Yes, the estate of Lady Fiona Graben, near the town of Westin. And you were one of Telfari's students. You wore a crimson-colored tunic with no armor, and demonstrated how you could avoid arrows fired at you from twenty paces."

She looked at him in astonishment as Gustin, now too, looked his way.

"Hunter, have you known that since we met?" she asked.

"No, Fae. Honestly, no. It just now came to me when you said you were there."

She glanced at Gustin, who was now listening intently while he watched the road ahead. Then she turned back toward Hunter. "I'm sorry, but in the few days we were there, I met so many people."

"Of course, Fae. No offense taken."

She tried to recall meeting him. "We met knights from so many kingdoms. I'd never seen such beautiful armor and

barding. Now it all makes sense. You were one of the knights. You're a knight, aren't you?" she asked. "Tell me it's not true."

He grinned. "All right, it's not true."

Gustin laughed.

"Oh, that's not what I meant, you jackass!" she said. "Hunter, please tell me," she pleaded in a softer tone. "I really want to know."

After a long silence, he looked over at her with a serious expression. "It's not important, Fae," he said, abruptly reining his horse to a stop.

"What the—what are you doing?" she said, pulling back on her reins.

Gustin grabbed her horse's bridle. "Come on, let him be."

"Gustin!" she exclaimed, glancing at him briefly. Then she turned in her saddle as Gustin led her horse on. "This is not over! You get up here and talk to me!" she yelled, not caring who heard.

Hunter simply smiled and waved.

"Oooh!" she growled before giving Gustin an ear full.

"Turning on the charm, I see," Draigistar said when he rode past with Celeste and Erin next to him.

"What did you do?" Erin asked, looking back at him.

"Just a little misunderstanding," he replied, falling in behind them. For a while they rode, the three of them chatting, occasionally glancing back at Hunter until he moved up next to Celeste.

"Were you just looking at my butt?" she asked.

Erin giggled.

"More like admiring it. . . . Your father did tell me to keep an eye on you."

"You're a pig," she said, causing all of them to laugh. Riding on, they traded teasing glances, their anxious minds racing, desire welling up inside.

The afternoon passed uneventfully, with the column moving at a steady pace, members shifting positions and conversing,

and scouts checking in at regular intervals. Finally, they began to climb into the mountains, and the occasional copse of trees became forest closing in on both sides of the now-winding road. Lance ordered the distance between each wagon closed to one length so they could be watched and protected. Late day took on a chill when an ominous cloudbank approached from behind, so when a suitable clearing came into view, Lance decided they would stop and camp for the night.

The friends joined Hollis and Celeste, and watched the drivers expertly place their wagons on a level patch of ground where the snow had melted away. The first two wagons were stopped parallel to each other about fifty feet apart. Their crews unhitched the teams while the driver of the third wagon pulled in across their tracks, stopping just behind them. Then Krysta pulled in from the opposing direction in the fourth wagon and, with reins and verbal commands, backed it up to meet the tailboard of the third. By this time, the teams were led clear of the first two wagons. The next two put in place were the kaishons, built lighter than the bircks, with canvas tops stretched over wooden frames. They were backed up in front of the first two and unhitched, while the last two were backed in ahead of them. In just moments, all eight wagons were in place.

"This is our standard camp formation," Hollis explained while they sat atop their mounts. "Of course, it depends on the number of wagons, but in this case, we have three wagons lined up on two sides. The front wagons will remain hitched through the night with fresh horses. The two backed in opposing serve to close off the end of our campsite. They'll have fresh horses hitched up as well. This gives us a large area enclosed on three sides with half our wagons hitched with fresh teams. The horses can be kept inside or outside the wagon perimeter to suit the situation. Then fresh teams will be hitched to the other four wagons in the morning."

"Impressive," Fae said. "Your plan?"

"No. I thought I had a good method till Lance showed me this. Now we have a more tenable camp set up in half the time."

"The army could learn from this display," Gustin added.

Once the wagons were in place, everyone set about their assigned duties to make camp for the night. Soon the fresh horses were hitched to the wagons and hobbled, and there was a fire burning in a pit with cooks preparing the evening meal.

While Gustin and Hunter tended their horses, they commented on the impressive work ethic of Hollis and his people. Gustin had two identical gray warhorses, and Hunter owned a pair of black ones. Both men were expert horsemen and took pride in the quality and care of their magnificent animals.

"Now, this is the way to travel," Gustin said as they worked back-to-back.

"I'd think you were used to this," Hunter replied as he removed his saddle.

"Oh? How so?"

"Well, I mean with you being a former army officer, I'd have thought you'd be used to the good life."

Gustin silently studied him until Hunter glanced back over his shoulder.

"Did Erin tell you that? No. Fae did, right?"

Hunter smiled and shook his head. "No. I just knew, my friend, just as I knew she was a Blademaster. You carry yourself like a soldier."

They worked on in silence for a while until Gustin spoke again. "Yeah, I was in the army for ten years."

"Ah, a captain then?"

"Yes."

"Feel free to tell me to mind my own business, but I'm curious. You must've had a good career. Did you leave to be with Fae and the others?"

"No," he answered after a thoughtful pause. "I'd already resigned my commission. I met them when they saved my life out in the disputed lands. That was nearly three years ago, and

we've been together since."

"Well, you're good together. Not just you and Fae, but all four of you."

"Thanks."

They fell silent again until Gustin finished and looked over. "Fae was right, wasn't she? About you being a knight, I mean."

Hunter still had his back to him, but he saw him pause. "Yes. I was raised from birth to be a knight. But don't tell her I admitted that," he said with a glance over his shoulder.

They exchanged a smile.

"Don't worry. Your secret's safe with me," he said, slapping him on the shoulder.

"Oh, isn't that sweet," Erin said as she approached with Celeste and Janae, each leading their horses.

"You two aren't going to hug, are you?" Celeste asked Hunter with a teasing grin.

"No. I was saving the hug for you."

"Yeah, well, keep on dreaming," she said, turning away to remove her saddle while the others laughed at her playful insult.

While she stood with her back to him, he bent over and scooped up the last handful of snow that clung to a nearby tuft of grass. Then carefully slipping a finger into the back of her collar, he pulled it away from her neck and dropped the snow inside.

"Huh!" She gasped loudly from the intense cold as it slid down her bare back. She spun to look at him. "You didn't!"

The others laughed heartily.

"Bet you're wishing you'd accepted that hug," he said, turning to leave.

"Oh, you're a dead man, Hunter! This means war!" she yelled, turning heads throughout the camp.

Hunter glanced back at her with a satisfied grin as he walked away.

Fae had just led her horse up. "Doesn't he make you just want to kill him?"

"Yes, he does," she replied, shaking the snow from inside her clothing.

Hunter stopped by the fire where others were gathering.

"Picking on my poor, helpless daughter?" Hollis asked, approaching him.

"Oh, just teaching her the virtue of tolerance, sir."

Hollis laughed. "Well, I wish you luck. I've tried to get the best of her since the day she was born, and I've not succeeded yet."

They stood silently for a moment, soaking up the warmth of the fire.

"You know, Hunter, her wild spirit has gone unvanquished for too long," the merchant continued. "With each day, she seems less inclined to give me grandchildren."

Hunter raised an eyebrow and glanced over at Hollis, then looked around to see that no one else was paying attention.

Hollis just stared into the fire. "Hunter, I've watched the two of you together," he finally said, "the way you look at each other. I'm not the dotard my sweet daughter takes me for. You fancy her, yes?" he asked, looking squarely at him without expression.

While Hunter admired his directness, it made him uncomfortable, fearing others might overhear their conversation regarding the personal matter. "Yes, sir, I do. But—"

"Good for you, son," Hollis cut him off with a grin.

"Sir, I assure you my feelings will not affect my ability to protect her."

"Ha. Nonsense," he replied with a dismissive wave. "It is, in fact, those feelings I'm counting on to give you an edge if her safety is threatened."

Hunter looked at him in silence, not knowing how to respond.

"Son, I don't doubt your ability to protect my daughter. If I did, I wouldn't have assigned you to protect her. Believe me, that's not what this is about. You're a man of integrity and

compassion who knows how to treat a lady with respect. And, you have an advantage others have not. She is equally taken with you. Trust me; I know her better than any man. Don't underestimate her. She will try you. Just be relentless in your pursuit. . . . Now let's eat."

While some patrolled the camp's perimeter, most gathered to eat and enjoy quiet conversation by the fire. The women sat together, talking and laughing, and eventually Fae came over and knelt down in front of Gustin.

"Hey," she said with a smile.

"What's up?"

"I know we agreed to take turns with our own watch."

"But?"

"But Celeste invited all us girls to sleep in her wagon to-night."

"Oh, that's all we need," Draigistar said sarcastically.

"Yeah, no one will get any sleep," Gustin added.

"Come on, I'll make it up to you," she countered with a flirty smile.

Just then, a gust of cold, north wind blew through the camp, bringing with it a barrage of tiny snowflakes.

"Well, looks like weather is moving in," he said as they stood up facing each other. "All right, you girls get a good night's sleep. We'll watch things."

"Thank you," she said as they exchanged a kiss. "I owe you."

"Yes, you do."

Lance assigned a night watch while the rest of his hands finished setting camp and filling their stomachs. Afterward, he and Hollis retired to one of the kaishons while the women settled into the other.

Once the women were safely in, Gustin, Draigistar, and Hunter sat by the fire, visiting until the others who weren't on watch had gone to their tents. The tiny specks of snow had turned into big flakes by the time Gustin and Draigistar turned in and Hunter began first watch. There were four of Hollis's

people on patrol around the camp, and he studied their routine. He was impressed with the military-like approach to their sentry duties. He and the four had reasoned the Shadow would surely be watching their every move, but there was little chance of an attack until they were further from Port Estes. As expected, his watch was uneventful, and after waking Gustin, he brushed away the fresh snow and laid out his bedroll under the wagon where the women slept. The rest of the night passed without occurrence, and the camp awoke to a landscape blanketed in white.

While the predawn eastern sky turned orange, the camp was astir. Food was prepared while tents and bedrolls were picked up and stowed. Hunter was an early riser and awoke to find Draigistar stoking the campfire and visiting with the two cooks. Hollis and Lance appeared soon after.

"Morning," Hollis said as he approached spryly.

Draigistar and Hunter both responded.

"I must say I hesitated to move south. I will miss these invigorating mornings."

"Invigorating? Some might call this morning cold," Draigistar replied.

"Ha! Nonsense!" Hollis rebutted. "Surely you must agree with me, Hunter."

"Yes, sir, I love this weather."

"Good man," Hollis said with a satisfied grin.

"Oh, come now," Draigistar said. "Surely, kissing up is beneath you."

Hollis roared with laughter while Hunter gazed at him through narrowed eyes.

"I like you, wizard," Hollis said. "You make me laugh."

When Gustin joined them, he and Hunter asked Hollis about sharing some of the scouting duties. He was reluctant, worried about leaving the main group unprotected. But he relented, permitting them to scout, but only one at a time.

Travel was precarious in the fresh snow, and Lance kept

the wagons close together as they settled into a slow, steady pace. Gustin and Fae rode together at the front of the column, followed by Erin and Draigistar.

Behind them were Hunter and Celeste. She'd hardly spoken while breaking camp, so he wondered if she was upset. And knowing she had him worried, she was playing it.

"Gustin, thank you for last night," Fae said, looking over at him while their horses climbed up the steep, winding mountain road.

He smiled. "You girls have fun? I expected to hear a lot more laughter."

She smiled. "We were all tired. We lay awake and talked awhile, serious conversation. You know, woman stuff."

"Good. It'll give you an idea what to expect from Janae when the time comes."

They rode on in silence for a while till she spoke again.

"Gustin, it's hard to see her for the spy we're all convinced she is. I believe her friendship with Celeste is real, even if it did start as a ruse. I think she's a victim of circumstance who regrets the position she's in."

He gave her a concerned look before returning his eyes to the snow-slicked road. "You realize that's good for us," he said. "Hunter said it. Perhaps when the time comes, her friendship with Celeste will bring her over to our side. It could mean the difference between life and death for her. I'd rather see her have to admit her part to Celeste and Hollis than be killed along with other Shadow, especially by any of us."

She studied him for a moment. "Could you kill her?"

He looked over at her. "If she were posing a real threat to me or anyone I care about, yes," he said, letting his expression drive home his sincerity. "And so could you in that case. But we're not going to let it come to that."

"No. We're not."

They fell silent and rode on, each taking in the splendor of the snow-laden forest around them, invigorated by the crisp

chill of the morning.

Finally, he spoke again. "Fae, remember what we talked about yesterday?"

"Yeah."

"Well, we talked to Hollis, and he agreed. I'm going to ride on ahead today and scout the road over the pass."

She looked at him. "Be back tonight?"

"Should be. But don't fret if I'm out till tomorrow," he said, sensing her worry.

They rode on for another silent moment until he suddenly reined his horse to a stop on the steep road. When she reined hers around and stopped next to his, he pulled her to him, and they exchanged a kiss.

"When our contract with Hollis is finished, perhaps we should spend some time alone."

"Uh huh," she replied softly. "You be careful."

He nodded. "I must go," he said, glancing back to see the others had slowed to respect their privacy. He released her so they could separate.

"Goodbye, lover. You come back to me."

"I will," he replied, spurring his horse to start up the road.

She reined her sleek, black mare around and watched him ride out of sight around the bend in the road while the others advanced and reined up next to her.

"You all right?" Draigistar asked.

She looked over at him. "Uh huh."

"Look out ahead!" the driver of the lead wagon yelled. "Make way!"

They spurred their horses forward and settled into a pace to stay out in front of the column. The rest of the day passed uneventfully as they climbed higher into the mountains, closer to the pass that would deliver them to the southern slope and a more moderate climate. The scouts reported to Lance at intervals, and he decided they'd forego a stop for lunch so they could reach the pass by nightfall. The melting snow caused the

draft horses to struggle with footing, and progress was slow and tense. But just before sunset, the wagons pulled off the road into the familiar clearing at Howling Pass.

CHAPTER ✝ 5

When Gustin rode on ahead, he quickly outdistanced the others and found himself alone with his thoughts. He soon spotted Flynn, one of Lance's scouts, sitting on a rocky outcropping up the slope from the road. He gave a cursory wave, so Gustin returned the gesture and quickened his pace before the young scout decided to join him. He was in no mood to talk. He was thinking of Fae. She'd told him after their first night together that she could never let herself fall in love with him. She reasoned it would complicate their relationship and the friendship the four of them shared. It hurt, but he accepted it. He'd loved her since they'd met. And he knew she loved him, even if she wouldn't admit it.

He rode on through the morning without sighting anyone else. When he came to a clearing on the left side of the road, he stopped to rest his horse. The road leveled here, and the clearing sloped down, ending abruptly at a cliff. He dismounted in the road and led his horse over to the cliff, the wet snow packing noisily under boot and hoof. The morning sun had begun the melting process, even though the breeze rising over the cliff carried a biting chill. He stood there looking at the breathtaking vista. In the distance, he could see Port Estes nestled on the shore of Cold Harbor. And beyond that, beyond the white of the snow-covered land's end, a brilliant blue stretched as far as he could see. On the horizon, he could just make out small specks of white, broken fragments of the northern pack ice.

It had been a cold winter, and he was not sorry to see it coming to an end. He could tolerate any weather, but preferred a warmer climate.

He'd stood on this spot before and had never failed to be awestruck by the landscape before him, or the empowering feeling of freedom that filled him when he surveyed the pristine beauty. He discretely scanned the road and trees behind him as he bent down and scooped up a handful of wet snow. Then he bit off a chunk before tossing the rest down into the tops of the pine trees below. As he stood there letting the snow melt in his mouth to quench his thirst, he allowed his mind to wander, reflecting on the events in his life that had led him here.

He was the third son of General Winston VanHolt, a well-respected officer in the Queen's Royal Army. To his father's dismay, neither of his older brothers pursued a military career. But the regimented life of a soldier suited Gustin well. Growing up in the provincial capital of Lake City, he'd enjoyed a good relationship with his mother and siblings, but had never been close to his father. He viewed him as an overly demanding authoritarian who foolishly placed more value on his service to the Queen than to his own family. He was seldom home. And when he was, he felt it his duty to whip the household into shape as if his family were a regiment of young, undisciplined troops.

When Gustin came of age, he struck out on his own for a while before securing an appointment to the academy. He impatiently spent the required two years there before receiving his commission. His duty posts included Fort Grigg, Fort Estes, Fort Kotter, and even a brief billet at the army garrison in Lake City. After a short stint as a lieutenant, he was promoted to the rank of captain in record time and assigned to the expeditionary army stationed in Frontier City. The Eastern Kingdom was growing, so the army's mission there was to explore and map the region west of the Frontier Province. Gustin found his calling. He'd already earned a reputation as an excellent scout and

cartographer, having ventured far into the untamed land to map the region and make first contact with tribes and villages. In time, he came to be considered the foremost expert on the subject. He would spend the remainder of his career working on the western fringes of the kingdom, exploring ever deeper into the vast region known as the disputed lands.

His future in the military looked bright. Even his father benefited from his outstanding performance, being promoted to Commandant of the Queen's Royal Military Academy, second in rank only to the Adjutant General. Gustin was virtually guaranteed an early promotion to the rank of commander. But that would change with one ill-fated mission. He was sent to the West to negotiate for water rights with the elders of a small village deep in the disputed lands. A perfect location for river crossings and watering livestock, Gustin knew there were no better places for more than a week's travel in either direction. The mission was led by a pompous commander who'd just transferred in with his own retinue of soldiers. He was insanely jealous of Gustin's status with the senior army staff. And Gustin loathed him. He thought him a pathetically inept officer, lazy and dishonest. The only things he did well were lie and take credit for the work of others.

After days of frustrating negotiations with no agreement struck, the impatient commander implied the use of military force was an option. Enraged, Gustin intervened, reminding him that while he commanded the expedition, it was Gustin alone who'd been authorized to negotiate for the Queen's interests. Disgruntled, the elders suspended the talks to consider the matter privately. During the respite, animosity between Gustin and the commander boiled over, resulting in fiercely heated arguments in front of the troops. Finally, he ordered Gustin to leave and go scout the river for another crossing. Under protest, Gustin left, staying away four days before returning to discover the entire village had been slaughtered. A hundred and forty-one people were dead. And the commander

and his men were gone. Bodies lay strewn among the ashes, bloated and decaying in the intense summer heat. The attack had obviously taken place soon after his departure. Men, women, children, no one had been spared. The elders had been tortured and hanged. Gustin was shocked by the unprovoked brutality. He'd been to the village many times and had come to know the people, so the heart-wrenching task of gathering and burning the bodies was nearly unbearable. He put the murdered villagers to rest, and returned to Frontier City where he was arrested upon his arrival at camp.

He stood accused of ordering the massacre of the village to cover up his failed negotiations. Finally, the commander had beaten him. An investigation was conducted, and he was taken to Fort Kotter to face an army tribunal. At the trial, the commander testified it was he who'd gone out to scout the river and had returned too late to prevent the massacre. His story was supported by the loyal soldiers of his platoon, save four who'd gone missing. The platoon sergeant claimed two of his men had been killed by villagers during the attack, and two had deserted rather than follow Gustin's orders.

That lie gave Gustin his chance to avoid the gallows. There was a lone survivor of the four missing soldiers. And out of respect for Gustin, he'd come back to tell his story at the trial. He testified that he and three others had refused to follow the commander's order to kill the villagers. And after the massacre, the commander swore they would regret their betrayal. Their weapons were confiscated, and on the way back to Frontier City, they were constantly harassed and finally attacked. Two were killed outright while he and another escaped in the night. The third man was wounded as they fled and later died.

His testimony refuting the commander and the other soldiers was pivotal. The tribunal issued an 'Acquittal by Reason of Conflicting Evidence'. In short, they found Gustin neither guilty nor innocent. And without official vindication, he knew his military career was over. He returned to active duty, knowing

the stigma of the incident would prevent any future promotions. He was bitter. The generals who'd shouted his accolades when he was making them look good had scattered like rats from a sinking ship.

The one person who'd stood beside him throughout the ordeal was his father, despite pressure from the army to *'distance himself from the whole affair'*. He never even asked Gustin if he'd committed the crimes he stood accused of. *I guess he knows me better than I know him,* Gustin thought the day he walked into his cell in Frontier City and sat down across the table from him.

"Good to see you, son; looks like you're in a spot," he'd said as Gustin looked at him in disbelief. "Now, let's see what we can do to get you out of it."

For most of his life, Gustin thought he and his father didn't know each other. He expected General Winston VanHolt would be the last person to come to his aid. He felt ashamed for the ill feelings he'd borne against him for so long. After the trial, his father retired from the army and returned to his home in Lake City. His last official act as Commandant was to secure an appointment for the brave young soldier who'd come to Gustin's defense. The young man had been criticized by many—even threatened. And Gustin knew he had a long road ahead if he remained in the army, a road far more easily traveled as an officer.

There was other fallout. No one else faced any charges, but the platoon was broken up, and its members were reassigned. The commander was ordered back to the City of Queens. It was obvious the whole matter was to be forgotten.

Gustin had sworn to kill him. But the transformation in his relationship with his father had quelled his desire for vengeance. He no longer cared about that, or his army career. He wanted no part of such an insane bureaucracy, so he resigned. After ten years he was out and was amazed at how liberating it felt. Being a soldier had once been his reason for living. Now

it felt more like an old friend he'd lost to bitter conflict in a failed relationship. He returned to Lake City briefly, but knew he couldn't stay. He needed to be on the move, to be alone, to take time to rid himself of the feelings of betrayal and the terrible images that haunted him.

He headed back out into the disputed lands. He was inexorably drawn to the vast, untainted land and its simple people. He spent a year alone, exploring the unknown regions to the west. He ventured into the isolated kingdom of Rendova where he found mountains that rumbled and belched fire and smoke, and exotic wildlife unlike anything he'd ever seen. He continued on across the Great Salt Plain and through the Land of Dead Giants until he came to a vast river. From stories he'd heard, he knew on the other side lay the kingdoms of Andalar and Myndora. With few provisions and no way across the wide, turbulent river, he decided it was time to head for home.

On his way back to the Eastern Kingdom, he was ambushed by a band of robbers. During a midnight skirmish, he managed to scare off their horses before mounting to make his escape. He took an arrow in the back as he rode away. A lucky shot fired in desperation, but it hit its mark. By morning, miles away from his attackers, he was too weak to stay in the saddle and passed out, falling to the ground. When he awoke, he saw Fae smiling down at him and realized he'd been rescued by three strangers.

Three strangers . . . strangers who've become the best friends I've ever had, he thought with a smile as he consciously drew his thoughts back to the present. He decided he'd rested his horse long enough. As he turned to check the rigging on his mount, he discretely searched the trees up the slope but saw nothing amiss. Walking his horse back to the road, he mounted and coaxed it on at a gallop toward the mountain pass. After riding for a few moments, he slowed his horse to a brisk walk. He'd left the clearing in a hurry to panic anyone who might be watching and perhaps force them into a careless

mistake trying to keep up.

The sun was high overhead when he reached the pass. He approached carefully, scanning the trees on both sides of the road. In sight of the summit was a clearing large enough for the column to make camp, and he was confident they'd reach it by nightfall. He'd been watching all morning for tracks of horses or men, but had found none. He figured the pass had been watched since before his party left Port Estes, so whoever was there would be dug in, well-provisioned, and hard to find. He stopped and dismounted, slowly walking his horse around the clearing while he scanned the forest. Then he walked up the road to the summit. Nothing seemed out of place, yet his well-refined survival instinct told him he was being watched. *I know you're up there*, he thought, discretely glancing back up the slope. He'd contemplated his strategy all morning. And now, as he stood looking at the lush green valleys and meadows to the south, he knew what he must do. Foregoing a meal, he took a long drink from a water skin, then mounted and spurred his horse to a gallop down the road southward.

Just as he'd anticipated while the wet snow fell on their campsite last night, the late-winter storm dissipated before crossing over the mountains. The road before him was mostly dry. He wanted to find out if he was being followed before he returned to the pass, so after riding awhile, he left the road where the rocky terrain would make it hard to follow his tracks. He dismounted and led his horse over to a stand of conifers for concealment, where he watched the road, growing evermore concerned about the waning daylight. Then finally, he heard the faint sound of approaching horses on the road. He watched as three riders slowly passed by going south, two men and a woman, all dressed in dark clothing and well-armed. They spoke little as they scanned the road in an obvious tracking posture.

Once they'd passed, he quietly led his horse away from the road, then mounted and headed back to the pass. He knew

they would eventually figure out they'd lost his trail and begin backtracking. *Hopefully by then the sun will be too low for them to pick up my trail*, he thought as he pushed his horse hard through the patchy forest that covered the steep slope. After covering most of the distance back up the mountain on horseback, he dismounted and continued on foot through the thickening forest and rocky outcroppings. As he carefully worked his way back to within sight of the road, he looked for a place to leave his horse. He wanted to find whoever was watching the pass before his friends arrived, and it was getting hard to maneuver on the steep terrain. Finally, with scant daylight remaining, he found a ravine concealed by a thick copse of trees and left his horse there for the night. With the abundance of wolves, he decided not to hobble it. *Better it run off than be killed*, he thought, continuing on afoot.

By dusk, he sat in concealment on the mountain with a good view of the pass. Lance and one of his scouts had appeared in the clearing just moments ago, and now the drivers were pulling their wagons into formation to make camp. He knew that with all eyes focused on the column, it was the best time to move in. The sun was below the western horizon and the mountains at his back ravenously swallowed up the last bit of daylight, so he silently moved through the forest until he found what he was looking for. *There you are.* Dug in behind a large fallen tree two hundred feet up the slope from the clearing were two men carefully concealed, watching the group. He'd seen no sign of others in hiding, so he slowly inched forward through the patchy snow until he was just thirty feet away. Then he carefully concealed himself and settled in for a long, cold, sleepless night.

The column had made steady progress, and the pass was a welcome sight. A more somber mood now prevailed among the

group. They all sensed the danger was increasing with every mile they traveled further away from Port Estes.

Once their horses were tended to for the night, Fae and Erin sat by the fire with Celeste, eating their evening meal.

"Fae, he said he might not make it back tonight," Erin said.

She smiled halfheartedly. "I know he can take care of himself. I just worry."

Erin exchanged a grin with Celeste.

"Oh, come on, you two," Fae protested.

"Why don't you just admit you love him?" Celeste countered. "I mean, the way you two said goodbye this morning."

"What? It was just a kiss. I'll bet you and Hunter have kissed."

"No. We haven't," she said with a serious expression. "Not that I wouldn't," she added as her smile returned, causing them to chuckle.

Hunter and Draigistar ate by the main fire with Hollis and Lance in a solemn atmosphere. There was little conversation, save the unavoidable subject of securing the camp for the night. Everyone planned to eat and turn in quickly, anticipating a long, hard day tomorrow. Lance always required a night watch on the road, and this night he added more teamsters to the rotation. Before turning in, he ordered them to light several small fires around the perimeter of the camp beyond the wagons and allow the main fire to burn down. He wanted just enough light for his people to maneuver in the camp if they were attacked without being easy targets for the enemy. And he wanted to discourage incursions into camp by the curious wolves that had already started gathering in response to intruders in their domain.

Hunter and Celeste managed only a few private moments together before turning in. Though neither dared speak of it, they both sensed their growing mutual attraction and secretly fantasized about the day they might indulge their desires. For now, they shared an unspoken agreement that it must remain in check until a more suitable time.

/// \\\

Gustin quietly lay in concealment, watching his friends in camp bed down while he listened to the occasional whispers exchanged by his two oblivious foes just mere feet away. It had taken him a while to get settled in, quietly pushing away the snow, rocks, and sticks that prevented him from getting comfortable enough to focus on his task. He listened to the call of wolves in the distance as those in camp gathered and ate a warm meal, with the scent of cooked food permeating the woods for miles around. He found himself enviously thinking about a hot meal and a warm, soft bed until he realized the carnivores were drawing closer to investigate. He was glad he'd left his horse unhobbled.

The night was clear, so the cold darkness settled over the mountain pass. It slowly wore on, and in the predawn hours he found himself fighting to stay alert. The whispers between the two men near him had ceased; they'd obviously fallen asleep. In the faint glow of the distant watchfires below, he could see their breath as it rose from their hiding place. His back ached. And despite his warm clothing, his hands and feet were numb from the freezing night air. He remained convinced that spending the night watching the watchers could help him determine the strength and plans of their enemy and, just as important, who in their group might be a spy. He thought of how easy it had been to pull an all-night watch ten years ago when he was still young. *I feel old tonight*, he mused as his mind drifted back to other events in his life. In his exhausted state, he failed to realize he'd just taken the first step in yielding to the greatest enemy of someone on night watch. Sleep.

He'd been riding at an easy pace, sparing his pack horse. It limped all morning after slipping on the moss-covered rocks in the creek where he'd camped last night. He wouldn't push him for a day or two. He wasn't in a hurry anyway. He was awestruck by the breathtaking sights around him. The wide,

unkempt road he traveled on meandered through the most incredible forest he'd ever seen. The huge, red trees were as big as a house at their base and towered hundreds of feet into the sky, casting a nearly complete shadow across the unique landscape.

Suddenly he turned to look back at the sound of heavy breathing. He thought his pack horse had taken ill, but it seemed fine. Guess I'm hearing things, he thought as he gently coaxed his mount on down the road. He continued taking in the unbelievable sights around him. So, this is the Land of Dead Giants, he thought. Magnificent.

He whirled around in his saddle at the sound of heavy breathing again and a chill coursed through him. Once again, nothing. This time his pack horse wasn't there. What the . . . what's going on? he wondered as he sat there looking back over his shoulder at the empty road behind him. This isn't right. This isn't how it was. He looked to the front, then back again when something brushed his neck. Still, nothing.

When he began emerging from his dream, he knew something was terribly wrong. His instincts told him he was in grave danger. As his mind cleared, he struggled to maintain his composure and make sense of his situation. To his horror, he realized the incessant breathing noise invading his peaceful dream was the sound of wolves nuzzling him. Listening to the sniffing and guttural growls, he fought to control his fear and the overwhelming urge to jump up and run. He'd fallen asleep with his large hunting knife in his hand and one of his swords lying on the ground within reach. Still, he knew he stood little chance of surviving a fight with a wolf pack. He slowly turned his head to look toward the other two men in hiding. Shadows moved around him, illuminated by the moonlight on the snow, and the fetid odor of wolf's breath filled his nostrils. He knew one had taken a dominant position over him as the rumbling, throaty growls intensified with his slightest movement.

In the darkness, he could see several wolves milling around the fallen tree where the other two were hiding. Suddenly he

heard a voice. Now he could see one of them scrambling to his feet. The wolves attacked. Amid terrified screams of pain and fear that erupted in the night, the pack went to work on their prey. Gustin's heart was pounding as his fear mounted. Finally, the wolf that loomed over him broke from its stance and charged into the mayhem.

He didn't hesitate. He quickly came to his knees and grabbed his sword as he looked behind him. Then he glanced down the slope at the campsite to see sentries scrambling. He desperately wanted to run, but he wasn't sure his cold, numb legs would respond. Just then, one of the wolves turned and charged him. He was ready. The calm he'd learned to master before going into battle was with him once again. He stood with sword raised and waited for the wolf to lunge before sidestepping and slashing his blade into its chest. It fell to the ground with a whimper, convulsing. Another one charged him, and he knew the decision to fight or run had been made. He was amazed to see one of the other two men struggle to his feet and attempt to run up the slope. There were several wolves attacking the man still on the ground, but Gustin had his own trouble.

Two were now headed for him, one behind the other. As they approached, he sheathed his knife and drew his second long sword. Then they split to flank him. Both wolves kept their distance, and he knew he must dispense with them before the rest joined in, or he wouldn't stand a chance. It struck him that he felt no animosity. To him, these were merely wild animals fighting to survive. And to them, he was merely food.

He feigned a lunge at one. And when it backed away, he turned to slash at the other one he knew would instinctively charge him from behind. His tactic worked. He brought the blade down hard across the back of the wolf's neck, nearly severing its head. Then he slipped on a patch of snow. He knew the stumble was unrecoverable, so he rolled away to regain his footing. The other wolf was on him. When he came up on one knee, it took him by the forearm. Its teeth tore through

his sleeve and sunk deep into his flesh, the intense pain making him lose his grip on his sword. As the animal violently whipped its head and pulled back to tear flesh and keep him off balance, he desperately slashed at it with his other sword. He struck a glancing blow into its forelegs, causing it to release him and yelp as it stumbled away.

Then he heard the growl of another charging wolf. Still on his knees and vulnerable, he looked up to see it was already in mid-air, bearing down on him. He responded the only way he could, falling back and raising his sword. The tip of the blade met the wolf's chest, impaling it as it slammed into him, knocking them both to the ground. He was out of breath as he pushed the mortally wounded animal off him and scrambled to his feet in time to see the last two wolves break off their attack on the other man and run into the night. Then he realized the screams had stopped, leaving only silence. He grabbed the sword he'd dropped and spun around to face the one that had bitten him, but it, too, had fled. As his head cleared, he knelt and grabbed the hilt of the sword embedded in the now-dead wolf and pulled it free.

Looking down the slope at the camp, he saw his comrades moving about inside the barrier of wagons. He couldn't spot anyone specifically, but he knew they couldn't possibly have seen what just happened this far away in the darkness. *So much for their night's sleep*, he thought, considering his options. He decided it would be best not to enter the camp, even though his friends would be worried. Fae would be worried. He didn't want to tip his hand to Janae or anyone else in the group who may be Shadow. He knew what he must do. His arm was sore but not bleeding badly, so he gathered his gear and stepped over to where the other two men had dug in. Even in the darkness it was repulsive. The man was obviously dead, and he knew the surviving wolves would eventually return to claim their kill. *For some of them, life would go on*. He could now hear voices emanating from the camp below as he took

one last look around at the dead wolves littering the snowy forest. His nostrils drew in the stench of fresh blood and death that rose with the steam from the warm carcasses. *Damn! That's the first time I've ever fallen asleep on watch. Guess I really am getting old.*

Without looking them over, he grabbed two sets of saddlebags and a small crossbow that lay near the dead man and started up the slope in pursuit of the other one. Since spotting them last night, he'd contemplated how to handle the two men. He'd decided to take them in the morning after Hollis and the others broke camp. He planned to interrogate them, but now his only chance to get any information was to find the one who'd fled.

It was impossible to track him in the darkness, so he climbed for a while and then stopped to listen for sounds of someone ahead. The eastern horizon hinted at the coming of dawn, but there wasn't enough light yet to do him any good. He continued on, alternately climbing and stopping to listen. Eventually, he heard the distinct sound of a man stumbling through the low-hanging limbs of the thick pine forest. *He's changed directions.* Following, he quickened his pace until he sighted his quarry in the dim, predawn light. He was still stumbling, moving erratically as he looked around in a frantic state of fear. The cries of wolves could once again be heard, unnerving Gustin as well. Suddenly, the man slid down into a ravine and stopped, looking around before cursing. As Gustin quietly crept closer, he could see two horses lying on the ground. One lay motionless, while the other still writhed in pain with the last of its waning strength. *Wolves.* As the man bent over, apparently looking for something, Gustin sheathed his sword, drew his knife, and leapt off the rocky ledge behind him.

Startled, he spun and lost his balance, falling down.

Gustin dropped his loot and grabbed him, laying the knife to his throat.

"Oh please! Don't hurt me!" he pleaded.

"Shut up!" Gustin growled. He quickly searched him, finding only a sheathed dagger and a few coins. He had several bite wounds and some cuts and scrapes. His clothes were shredded and bloodstained. Gustin tossed the dagger away and started to speak when he suddenly paused, pulling him closer in the dim light.

"Why you're just a kid."

"Am not!" he replied defiantly.

"How old are you?"

"Seventeen."

"What are you doing? The Shadow? You have your whole life ahead of you."

"What do you know about my life?"

Gustin looked into his fear-filled eyes and then straightened up, effortlessly pulling him to his feet. "All right, I don't have time to mess with you. I need some information, and you're going to give it to me."

"You can kiss my—"

Gustin gave him an openhanded slap across his face, knocking him back to the ground. He rolled over onto his knees and elbows, groaning.

"You stay there," Gustin ordered as he pulled one of his swords and brought it down across the neck of the stricken horse, severing its windpipe. It convulsed and kicked before expelling its final, gurgling breath as it closed its eyes and went still.

"You don't let a dying animal suffer," he said. "If you idiots hadn't hobbled them, they'd have had a chance with the wolves." While the young man fought to regain his composure, Gustin scanned the woods around them. Seeing no signs of danger, he sheathed his sword and grabbed the kid's long hair, lifting his head up as he placed his knife to his throat.

"Oh no! No! Don't hurt me!" he exclaimed as he began to weep. "I almost died tonight! Come on, I'm bleeding! I'm hurt bad!"

"I know. I was there," Gustin said calmly. "Enough about your problems. Now listen to me kid, I'm going to ask you some questions and you're going to tell me what I want to know. If you don't want to be staked out for the wolves, you'll cooperate. Understand me?" he asked, pressing the blade to his skin.

"Ye—yes sir."

"What's your name?"

"Daemus."

"How many of you were assigned to watch the pass?"

"Uh, just me and one other."

"Don't lie to me!" he replied as he yanked on his hair. "What about the three who followed me down the mountain yesterday?"

"That was you?"

"Yes. Now tell me about them."

"They followed you over the mountain, ordered to trail the outriders until—"

"Until what?"

"Uh, until they were ordered to take them out," he replied hesitantly.

Gustin pondered his words before continuing. "When were you due for relief?"

"At midday. But if the wagons came through before then, we were to follow."

"Was your relief coming from Port Estes?" Gustin sensed his hesitation and slid his knife just enough to break the skin.

"Ahhh!"

"Think hard before you answer. Your life depends on it," he calmly reminded him, keeping pressure on the blade.

"All right, all right. No. From the south."

Gustin thought for a moment, keeping the knife in place. "Very well. What else? When your relief arrived, what then?"

"We were supposed to go back to camp."

"Where?" he demanded, pressing the knife again. "Think."

He hesitated, aware that divulging the location would bring

him a horrible death if the Shadow found out. "Two days ride south," he said quietly, "near the river."

"Is the Shadow Knight there?"

"Uh, I'm not sure. I've seen him there. But we report to someone else."

"Who?"

"Our group leader. Then they report to the knight's second in command. I don't know his name. He's tall, with an ugly scar on his face."

A chill suddenly coursed through Gustin. He thought of a long-ago conversation when Fae had confided in him about Erin's childhood. *No time for that now.*

"So, are my friends being followed?"

"Uh, yes, I think so. But they don't tell us what the other groups are doing."

After a tense silence, Gustin responded. "All right, kid, I believe you. Now tell me how many of the Shadow are traveling with the wagons, and don't lie to me."

"Uh, just two."

"Now that I don't believe!" he growled, grabbing his wounded, bloody shoulder and rolling him over on his back.

Daemus cried out in pain.

Gustin had no evidence to refute his claim but decided to bluff. "I grow weary of repeating myself," he said, leaning down face to face as he returned the knife to his throat. "How many besides the woman?"

"You—you know about her?"

"Ha, yes," he replied with a smile of satisfaction.

Daemus tried to compose himself. "I, uh, I swear, I only know of two besides her."

While his response alarmed Gustin, it didn't surprise him. He paused to collect his thoughts before continuing. "All right, we'll get to their names, but first, how do they make contact?"

"They use drops along the road. We were supposed to check it after you broke camp this morning."

"They'd leave you a note?"

"Uh huh, if they had anything to pass on."

"Where?"

"There's a hollow tree stump at the edge of the clearing you're camped in."

Gustin slowly stood up, moving the knife away from his throat. As he looked down through the steam from his own breath at Daemus, shivering in bloody ragged clothes, he became fully aware of his own weakened condition. His wounded arm was throbbing. His whole body ached. He was cold, tired, and hungry. He was spent.

"Mister, I told you what you wanted to know. Now please let me go."

Gustin smiled fleetingly. "So you can run back to warn your friends? No kid, you're coming with me to identify your spies in my camp. Come on, get up."

As he took a step back to give him room to stand, Daemus slowly rolled over to his knees, bringing a foot under him. Then he suddenly thrust a fist up into Gustin's groin with all his remaining strength.

"Ohhh!" Gustin let out a deep, throaty moan as his breath left him from the intense pain that racked his body. When he bent over to grab himself, Daemus lunged, driving his shoulder into his chest, causing him to stagger back and fall to the ground. Gustin was dazed, fighting to breathe, but he knew he must counter the attack. Despite the pain, he'd managed to keep hold of his knife and slashed wildly at Daemus, only to see he was not advancing. He was on his feet, struggling to run away.

Gustin was relieved he hadn't pressed the attack. *He can't get far in his condition*, he thought. He ached, and he fought the urge to vomit that inevitably followed a blow to that region. Finally, he struggled to his feet, grabbed his loot, and gave chase. His ears rang from the painful blow, so he couldn't rely on sound. But the coming dawn shed ample light through the trees for him to find the young man who'd just bested

him. After running for what seemed like days, he spotted him ahead and sprinted. Daemus saw him closing in and tried to find greater speed in his tired, wounded body.

As Gustin drew within clear sight, Daemus suddenly changed directions and ducked under some low-hanging limbs on a huge pine tree.

Ahhh!"

Gustin heard him cry out from beyond the tree. *Now what?* Once again, he dropped his things and pulled his sword, slowing his pace to plow his way through the barrier of tree limbs. He broke through to find himself looking over a sheer cliff. His momentum had brought him to the crumbling edge, and he reacted, pulling frantically on the limb he still clung to. As he regained his balance and reeled back from the edge, he saw Daemus rolling down the steep slope, caroming off boulders. He finally came to rest in a contorted position with his motionless body wrapped around the base of a tree. Gustin feared he was dead. As he knelt there looking over the edge, chest heaving and heart pounding, he was shaken to realize how close he'd just come to sharing the young man's fate.

Crazy kid. He's got to be two or three hundred feet down there. Considering the terrain and his condition, Gustin figured it would take him half a day to climb down there and back up. He wasn't sure how far he'd come from the pass. And in his exhausted state, he only had a vague idea of which way to go to find his horse. But he knew he couldn't do anything for Daemus. *Sorry, kid.* Filled with sadness and a tinge of guilt, he reluctantly turned away from the cliff and crawled back under the limbs of the big tree. Reclaiming his things, he set out to find the ravine where he'd left his horse. He had to get back to Howling Pass and to his friends.

CHAPTER ✝ 6

After a long day ascending the north face of the mountains, the clearing at Howling Pass was a welcome sight. They'd arrived with just enough daylight to make camp. Now with horses tended to and dinner served, the night watch was assigned, and everyone else settled in. The clear mountain air lent well to a breathtaking celestial show of falling stars and ribbons of rainbow-colored lights flowing lazily on the northern horizon. The night also brought cold. Winter was not yet ready to relinquish its hold on this beautiful landscape.

Among the four, Fae had taken first watch, knowing she'd have trouble falling asleep with Gustin still out. Once she finally felt tired enough to sleep, Erin and Draigistar both enjoyed an uneventful watch. Now Hunter was up. After Draigistar woke him, they sat and talked for a while before the mage retired. Though he'd feigned indifference, Hunter enjoyed visiting with him. In fact, he liked the good-humored mage as much as he liked the other three.

Growing up, being groomed for knighthood, he'd been trained to cast the spells of a paladin, spells of healing and personal defense. Nothing as powerful as what he knew Draigistar was capable of. He'd given up that life and the privileges that went with it, including his imbuement of magic. He still had his magical sword, but even his ability to summon forth its powers had waned over the years. It seemed the longer he was away from his home, his faith, and his birthright, the more ordinary he became. He was no longer a holy knight.

He was just another fighter. At times he viewed himself as a failure, and he knew he had to come to terms with the person he was now. *At last, I have a reason*, he thought, looking over at the kaishon where Celeste lay sleeping.

For a while he busied himself studying the hirelings Lance had assigned to night watch. He was impressed. Teamsters by profession, they did a good job of protecting themselves. They remained alert and unpredictable, changing the frequency and patterns of their patrols around camp. They stayed in sight of each other but kept their distance, seldom spoke, and didn't use names. *Someone has taught them well*, he thought.

Suddenly he was startled by the horrifying sound of a man screaming. Instinctively kneeling behind one of the wagons, he peered up the slope into the darkness as he heard the unmistakable sounds of a wolf pack in the frenzy of an attack. He looked around to see the others on night watch taking refuge behind wagons as well.

The women were sound asleep in one of the kaishons when the awful sound pierced the still night. Fae and Celeste instantly sat up, exchanging glances by dim candlelight, neither sure of what they heard. Erin was dreaming when the terrible sound erupted, causing her to sit upright from her pallet with her own deafening scream. Her action shook Janae awake and startled the other two.

"Everybody up!" Fae shouted, grabbing her boots and sword. "Erin, are you all right?"

"Uh huh," she replied, rubbing her eyes.

"You stay by Celeste," she said before leaping through the opening in the back of the canvas cover and disappearing into the night. While Celeste and Janae hurried to dress, Erin scrambled past them, still clothing herself. Despite her extreme shyness, she preferred to sleep in a state of undress. The three women exited the wagon together, into the frigid, night air. By now, everyone in the camp was awake and scrambling.

Lance emerged from the other kaishon and ran to where

Hunter and Fae were crouched. "What's going on?"

"There's a wolf pack up on the mountain attacking some-one," Hunter replied, just as the frantic screams stopped. They exchanged looks while the attack continued briefly. Then they heard a loud yelp, followed by silence.

"Sounds like one just got killed," Fae said.

"Yeah," Hunter agreed.

"No sign of any Shadow?" Lance asked.

"No," Hunter said, glad to see the hirelings spreading out to cover all sides of the camp. Hollis and Draigistar approached them, accompanied by the women.

"We need to get up there," Fae said, looking at Hunter.

He knew her sense of urgency. Earlier, he'd suggested Gust-in might well stay out all night. He told her if it was him, he'd take a position to watch the camp and try to capture a Shadow for interrogation. She agreed. But now as she knelt across from him, he saw in her expression a frantic state of vulnera-bility he would not have thought possible in her. *I wonder if he knows how much he's loved*, he thought of Gustin.

He looked over at Hollis. "Fae and I should go have a look."

"Hunter, we don't know this isn't a ruse to draw us out, split us up for an attack," he said, shaking his head. "No. Until we're sure, I want you here with Celeste."

"I'll go," Draigistar said.

"Good," Fae said. "Let's go."

"Just wait," Lance said, raising a hand to stay them. "Janae, get Derek, and you two go with them," he told her.

"Yes sir," she replied before darting off to find him.

"They're our best shots with a crossbow," he said, looking at Fae.

She exchanged a glance with Hunter before nodding to Lance.

Hunter could now see her anxiety melting away, yielding to the cold calm that filled a seasoned fighter before battle. "You ready?" he asked.

She responded with a nod and a fleeting grin, acknowledg-

ing his concern.

Draigistar stepped over the tongue of the wagon and spoke softly as he raised his hands in front of him in a prayerful posture.

"*Vaneeshoma-taa*," he said, gently clapping his hands three times before spreading his arms wide in a sweeping motion. Three fist-sized orbs appeared a few feet in front of him, levitating at knee level, each one emanating a blue glow that lit up the ground around them.

Fae joined him and turned to Janae and Derek who fell in behind. "You stay forty feet behind us on the flanks. And don't shoot us."

"Got it," Janae said, exchanging a glance with Derek.

Draigistar used subtle hand gestures to move the orbs out ahead of them, weaving them through the trees and boulders. Once they were at a distance, he gave another soft utterance, and their glow intensified. "All right, let's go."

Together they started making their way up the mountainside with Derek and Janae keeping the formation she'd ordered.

Hunter looked over when Erin stood and climbed up onto the seat of the wagon. Impressed by the muscles flexing in her bare arms and shoulders as she deftly moved, he watched her raise her bow, ready to protect her friends. Then his attention was drawn away when he heard Lance speak.

"It'll soon be light enough to travel. I'm going to get them hitching the wagons."

"Good plan," Hollis replied.

After giving them a glance, Hunter looked at Celeste. She knelt beside him with a hand resting on his shoulder. He was taken with her appearance, her sleepy expression, her bed-ruffled hair. As he looked at her, savoring her beauty, she suddenly turned to meet his gaze. They silently searched each other's expressions by the light of the watchfires till he knew he could no longer stand to be distracted and returned his attention to the elves.

Fae and Draigistar climbed the steep slope while he swept

the forest ahead with the lights to expose anyone waiting to ambush them, and to scare off any straggling wolves. Eventually, the light of the orbs began to reveal the carnage. They saw the carcasses of several dead wolves lying about. And when they closed in on a dugout behind a fallen tree, they found a sight so repulsive it nearly caused Fae to retch.

"Oh, my—" she managed as she turned away to regain control of her stomach.

Before them lay the dead body of a man who'd taken the brunt of the attack. The stench of blood and bowel rose with the steam, attacking their senses. Draigistar knelt and surveyed the sight after glancing down the slope to make sure Derek and Janae held their positions.

"Interesting," he said at last.

Fae looked at him without speaking.

"There were two of them, been here for some time. The snow's been pushed away. Look how the ground is worn down and the lack of frost over there," he said, pointing near the deceased. "Looks like they killed this wolf with that sword and perhaps wounded another one or two before the other man escaped. . . . I'll say this, their attack was efficient. Just look at the injuries: hands, throat, stomach, genitals. They went for the vital areas just like they would with any other prey."

"I'll take your word for it," she said, turning away and walking toward the other dead wolves. "What about these over here?" she asked when he stepped up beside her.

"Someone else was here," he said after a quick scan.

"Yes," she agreed, pointing at a burrowed-out place on the ground where the snow had been cleared. He moved an orb closer as she knelt down on the spot and felt the warmth of the ground with her palm. He patiently waited for her to collect herself; he knew her thoughts were racing. Finally, she picked up a handful of pine needles and held them to her nose, taking in the scent.

"Gustin," she said as she slowly stood, looking at him.

"Yes. He's the only one who could take down this many wolves and walk away. Well, and you, of course," he added with a fleeting smile.

She smiled back, knowing he was trying to calm her fears. Then she began studying the footprints on the ground. "Look, it appears he dropped those wolves over there and then came over here, maybe to help," she said as she followed the boot prints through the patchy snow. She passed the corpse and continued tracking the impressions that were clearly bigger than the other set leading up the slope.

He moved the orbs closer. "Fae . . . Fae, stop!" he said, raising his voice.

She stopped and turned around, meeting his gaze.

"You know we can't go looking for him. He's my friend too, but we're obligated to Hollis and the others."

She wore a look of desperation. "I know," she replied with resignation.

His heart was breaking for his lifelong friend. "Surely you noticed the blood on the ground is near the smaller tracks," he continued. "None is present where Gustin walked. He's all right, Fae. He's going to come back to you."

Without speaking, she sniffled and gave him a nod.

He looked back down the slope to see Derek and Janae approaching.

"Come on," he said quietly as he turned. She fell in beside him, and they headed back, meeting the others near the dugout, and when the orbs shed light on the mauled corpse, Janae gasped. Draigistar studied her reaction for any indication she recognized the dead man, but he saw none.

"Looks like two were dug in up here, and the wolves attacked them," Fae said.

"Where's the other one?" Derek asked.

"Got away," she replied, "ran up the slope." She turned and pointed behind her, noticing that blue orb was now absent.

"Are we going after him?" Janae asked.

"No," the mage quickly answered. "We'll go back to camp. They'll be getting ready to pull out by now. They can use our help."

Fae saw the two remaining orbs had moved down the slope, away from where Gustin had killed the other wolves. They returned and shared what they'd found with Hollis and the others, omitting any mention of Gustin being up on the mountain.

Several hirelings asked about the gruesome details of the attack and whether anyone would stay behind to bury the body. Hollis agreed the right thing to do was bury him, despite the fact he'd obviously been spying on them. But he wasn't willing to endanger anyone by leaving them behind for the task. By the time the wagons were hitched and everyone had eaten, it was light enough to travel.

"All right, people, mount up!" Lance shouted. "Let's move out!"

When they headed down the mountain, Fae made a point of riding with Hunter and Erin so she could fill them in.

/// \\\

Gustin walked through the forest after leaving the cliff where Daemus had fallen to his death. The decision not to climb down and confirm what he already knew weighed on him. True, Daemus was a criminal. And he'd bruised more than Gustin's pride with a well-placed blow. *But they likely recruited him from a hopeless life of poverty,* he thought. As regretful as it was, he couldn't worry about that now. He had to get back to his friends. He was injured. His arm still throbbed from the wolf's bite. His back ached. And he'd twisted an ankle in his desperate struggle to avoid falling off the cliff. On top of that, he could run into the three riders who'd followed him down the mountain yesterday.

Finally, he found his horse, unharmed, still tied to a tree

in the ravine where he'd left it. He hastily made his way back toward the pass, walking, leading his mount to avoid riding into an ambush on the forested mountainside. Once in sight of the road, he took sanctuary in a copse of trees. He sat down cross-legged with a water skin and some dried meat from his saddlebag to watch the road as he enjoyed his first meal in a day.

While he ate, he assessed his injury. Carefully pulling up his sleeve, he found four large puncture wounds in two distinct rows of teeth marks that nearly encircled his forearm. The lesser teeth had left behind mostly superficial damage; the skin was ripped in places with dried blood clotted over it. But the large fore teeth had sunk deeply in from the top and bottom of the animal's jaw. After dropping his sword, he'd tried to keep his fist clenched and arm muscles taut so the bones wouldn't break as the wolf violently whipped its head. Now as he held up his bruised, swollen arm, making a fist through excruciating pain, he was amazed the bones hadn't been crushed. *Erin will have some herbs to prevent infection*, he thought, pulling his sleeve back down. He knew it would be a few days before the swelling and soreness went away and he regained full use.

Next, he quietly rummaged through the saddlebags he assumed belonged to Daemus and his partner. The contents were mostly unremarkable. He found a wool blanket, a sling and two pouches of smooth stones wrapped up in a small pelt, and a small sack of grain. He also found a dagger, and fifteen bolts that fit the crossbow he'd picked up. What piqued his interest was a small wooden box about the size of a book. He gently shook it and could tell it contained small, hard items. After unlatching the lid, he carefully opened it. The inside was lined with blue velvet and divided into six compartments, four of them occupied. There was a pair of finely finished wooden dice, a single silver earring fashioned in the shape of a horse in a running stride, two small pearls, and a gold ring with a

shiny black stone set in it.

He removed the ring for a closer look. It was an ornately engraved signet ring with etchings in a language he couldn't read, but he didn't need to. He knew where it was from. The black stone in the main set bore the symbol of two tiny, crossed scimitars inlaid in gold. He recognized it as the royal symbol of the kingdom of Rendova. In his year-long solitary journey to the West, he'd spent time in that amazing land. His thoughts drifted while he watched the road through a small break in the cover of trees. He sat there rolling the ring around the tip of his finger as he pondered two low-level followers of the Shadow Knight, mere lackeys, possessing such an item. *They must be holding out*, he thought. *Surely those two idiots weren't capable of claiming such a prize on their own.*

Finally, he decided he dare not spend any more time on the matter. He was exhausted. And he knew the longer he sat there, the more likely he was to fall asleep. He returned the ring to the box, closed and latched the lid, and slid it inside his vest. Then he put the dagger, sling and stones, and the bolts in the better set of saddlebags and tied them shut. Leaving the rest, he slowly stood up. His tired, injured body revolted as he struggled to his feet. He'd sat on the cold ground long enough for his limbs to stiffen. It hurt to even walk, so he lashed the saddlebags to his horse and stood for a moment with his back arched, moving his arms around in an effort to stretch his aching muscles.

At last, he mounted his horse and rode out onto the road, quickly spotting the tracks of the column and confirming what he already knew. They had pulled out at first light, heading down the mountain. There were no other tracks present, and it worried him not to know where his three followers from yesterday were. After brief consideration he turned and spurred his horse back up the mountain.

When he reached the pass, he carefully scanned the woods on both sides as he rode into the clearing his friends had camped

in. He could see the convergence of wagon tracks where they'd pulled out, but there was no evidence anyone else had been there. He dismounted and walked around the vacant campsite, leading his horse. He found a hollow tree stump and looked inside but found nothing. Disappointed, he continued on until he approached another and suddenly paused, breaking a smile. There it was, an obscure carving in the bare wood where the bark was missing, a small bell-shaped figure with two horizontal cuts near the top. He'd seen it before and had heard it was the silhouette of a hooded person with two peering eyes—the symbol of the Shadow.

He anxiously walked over and checked it. Inside lay a small leather pouch tied shut at the top. He took it out and untied it while glancing down the road in both directions to make sure he was still alone. Tugging at the lace, he realized he was giddy as a child anticipating a gift. He pulled out a small, folded piece of parchment and wondered what it might yield or who it might incriminate. He opened it up to see it had been written on with a sharpened piece of chalk. He knew the technique well. He'd penned many maps during his army career, and chalk used on damp parchment or animal hide resisted smudging once it dried. He carefully checked his surroundings once more and then began to read.

Things going as planned

Gold in three or four wagons

Will stay in touch

Best to wait a few days

New bodyguards a problem

Beware — they have a wizard

He took a moment to ponder what he'd just read. It didn't surprise him to hear of gold in the wagons, given Hollis's immense wealth. It was the last line that sent a chill coursing through him. *Draigistar. I have to get back*, he thought. He knew he could easily catch up with the wagons before nightfall. But he still worried about riding into an ambush. He folded up the note and returned it to the leather pouch. Stuffing it into a pocket, he led his horse back over to the road and took one last look around.

He started to raise a foot to a stirrup but froze, thinking he heard a noise to the south. He stood motionless and listened until he was sure. *Yes, horses, coming up the road.* He quickly chose a hiding place on the opposite side of the road from the clearing. *If they're coming to check the drop, they'll have their backs to me.* He intentionally led his horse through the myriad of other tracks as he made for the stand of trees on the down slope side of the road. Once behind them, he was surprised to find one of the larger trees had been stripped of its lower limbs to make a hiding place for someone to watch the road from. *Perfect.* He positioned himself in the trees where he could see the road without being exposed. His concern was the morning sun at his back. It could cast a silhouette if he moved, but it would be to his advantage if he had to fight.

He watched three riders come into sight, a woman and two men, the three who'd tracked him yesterday. *No surprise.* Since they hadn't found his horse in the ravine and waited to ambush him there, he figured they'd be somewhere on the road. He watched them ride up and dismount not far from where he'd stood only a moment ago. It was the woman who captured his attention. She had dark skin and foreign features. She slung a bow and wore a scimitar, an unusual blade, especially for a woman, heavy and cumbersome. She was tall like Erin, sleek, well-toned. Erin stood nearly six feet tall, with a large, rock-solid, muscular frame. This woman matched her

height but was leaner and considerably older. She carried herself with the poise and confidence typical of an experienced fighter.

He suspected he knew where she was from, and when he heard her speak, he was sure of it. Her dialect was unmistakable. *Rendovan.* He'd learned their culture and knew of elite women fighters who were revered for their prowess in battle. Some were even royal bodyguards. As he stood in the forest yesterday watching them ride past, he'd noticed her unusual appearance, but she was further away. And at the time he was more concerned with eluding than identifying.

Now he had to wonder if she was connected to the ring he'd found in the saddlebags. He could only hear bits of their conversation, but it was obvious she was in charge. *Perhaps she's the group leader Daemus spoke of.* They kept looking up through the trees while they conversed, and eventually they walked over to the drop. They didn't seem surprised to find it empty, and he recalled Daemus saying it would only be used if their spy wanted to make contact. Suddenly she pointed up the slope and spoke loudly to one of the lackeys. He was clearly unhappy, but he obeyed, heading up the mountain toward the dugout. *All right, now it'll get interesting.*

The woman and the other man milled about, talking and constantly looking both directions on the roadway. Gustin noticed her glancing over her shoulder in his direction.

His senses told him she was alerted to something but not overly concerned. The third time she looked across the road, he saw her wrinkle her nose. A chill shot through him when he realized she smelled something that alarmed her. Since the morning breeze rose over the mountains and he was below them, he deduced she could smell him. *Great, here we go,* he thought as he readied himself with a firm grip on one of his swords.

"Hey!"

Gustin suddenly heard a yell, causing his two would-be

opponents to whirl and look up the slope to see their comrade stumbling down the snowy incline.

"They're dead!" he yelled as he drew closer. "They're dead!"

"What are you babbling about, fool?" she replied.

"They're de—" He suddenly stopped, bent over, and retched.

Amazingly, she seemed to forget about what she'd just been doing.

Gustin couldn't believe it. *She was onto me and didn't follow her instinct.*

She ordered the other man to watch the horses and started up the slope. Gustin watched in amazement as her lean, muscular frame effortlessly bounded up the mountainside. She cursed the sick man as she passed and told him to follow.

Not wanting to get in a fight with these three, Gustin considered his options and decided the best thing would be to take their horses and leave them afoot. To that end he carefully mounted his horse. Peering through the foliage from his saddle, he watched the woman reach the dugout and kneel down. *All right,* he decided, suddenly spurring forward. The silent morning was shattered when he came crashing out of the trees behind the lone Shadow who stood by the horses.

The man's eyes widened when he turned and saw Gustin, sword drawn, charging at him from across the road. Panicked, he spun and found a stirrup, pulling himself up into the saddle. He frantically yanked on the reins in an effort to flee, but it was too late. Gustin was on him, plowing the chest of his well-trained warhorse into his mount as it turned broadside. When the horse responded, rearing up on its hind legs to keep its balance, it unseated the rider, sending him to the ground. Gustin watched him fall and strike his head on a nearby tree stump, knocking himself unconscious.

That was easy enough, he thought, reaching out to take the reins of the horse before it could bolt away. Moving toward the other two horses that now nervously backed away from the commotion, he glanced up the slope to see the woman

stand and pull her sword. He sheathed his weapon and made a sweeping grab, snagging the reins of one. The other reared and bolted down the road southward, dropping the woman's quiver and bow that was slung from her saddle. *No matter; I'll catch up with that one.*

"You!" he heard the woman yell. He looked up at her while he worked to position both confiscated horses on his injured side to free his good hand for swordplay. He expected to see her running down through the trees at him, but instead she was methodically walking his way with sword in hand.

"If you take those horses, you're a dead man!" she growled at him, her face distorted in anger.

"Ha, I've been nearer death than now and lived to tell of it," he replied in a contemptuously calm voice. It occurred to him that her pride wouldn't let her run after him, so she planned to manipulate him into accepting a challenge to stay and fight. *Women, always playing us,* he mused.

"I knew I should've checked those trees. I could smell you, swine!" she spat at him with a crazed look while she continued walking down the slope.

"I was disappointed you'd make such a blunder," he calmly replied. "But it's for the best. You'd be dead right now if you hadn't."

By now, she'd covered half the distance between them while her lackey was working his way down through the trees in an effort to flank Gustin.

"Go back to Rendova, *woman.*"

He saw her expression change as she stopped moving on him. It was obvious she'd recognized his insult. And it was equally clear she was surprised he knew where she was from.

"Don't let our paths cross again," Gustin continued in a deadly calm voice. "Or the next time, I'll take more than just your horse," he added before spurring his mount and heading down the road at a gallop.

She responded swiftly. Her tactic had failed, and she could

no longer afford to feign a nonchalant approach. She broke into a run and leapt off the rocky slope onto the road behind him without breaking stride.

That is a dangerous woman, he thought, witnessing her display of agility with a glance over his shoulder.

After a few steps of an all-out sprint, she knew she couldn't catch him, so she gradually slowed to a stop, raising her arms in the air with clenched fists and her great sword held high.

"Ahhhhh!" she let out a deafening war cry as her lackey appeared on the road beside her.

Gustin gave her a taunting wave and rode on.

CHAPTER ☦ 7

At first light, the column pulled away from Howling Pass and began descending the southern slope into the meadowlands. This side of the mountain range was protected from the fierce winter storms that pummeled the north shore region, so the gravel road was mostly dry. The advantage of draft horses became clear in the mountains. Their massive strength let them climb steadily with heavy wagons and descend more safely holding back the enormous weight bearing down on them.

Near midday, one of the scouts reported to Lance that there were two northbound wagons approaching with a military escort. Moments later, the small entourage came into sight, and Lance signaled his wagons over to the side of the road so the others could pass by. It was common etiquette among teamsters to yield to wagons ascending a grade. As the northbound strangers approached, the leader of the group ordered his wagons to stop so the two parties could engage in conversation while the horses rested. Two families were moving to Port Estes, and their escort, a twelve-member platoon of soldiers, was returning to the fort after a week-long patrol. They exchanged pleasantries while they enjoyed a hurried meal together.

Resuming travel down the mountain, Erin and Draigistar rode point while Fae, Hunter, and Celeste followed. Hunter and Celeste made playful conversation and tried to include Fae, but she politely avoided small talk. Her thoughts were of Gustin; he'd been gone too long, and after the attack last night, she was worried. Suddenly she noticed Erin rein up and stop her

horse, looking down at the ground around her. Then Draigistar stopped and began pointing at the ground.

"What's that about?" Hunter asked, noticing their actions.

Fae glanced over at him. "Tracks, I'd say."

They quickened their pace.

"What's up?" he asked, reining to a stop when they reached them.

"Tracks," Draigistar replied as Erin dismounted and knelt.

Hunter scanned the trees on both sides of the road for any signs of an ambush.

"It's all right," Erin said without looking up. "We're alone."

He smiled, impressed with her savvy.

Fae dismounted and knelt beside her just as Lance arrived and signaled the wagons to stop. Descending from the pass, the hard-packed gravel had given way to the dirt road surface beneath, revealing discernible tracks to a trained eye.

Erin explained as she pointed out features in the jumble of tracks. "There were two people walking up the road from the south when three others confronted them here," she said. "They came from over there in those trees, two on foot, one on horseback," she added, gesturing in that direction. She glanced up briefly before continuing. "They must've had swords drawn. There's no sign of a scuffle, but they all left the road together over here," she said as she stood and walked toward the forest.

The others exchanged glances.

"It was an ambush," she said with her back still to them. "They didn't come back to the road. . . ." She turned to face them. "You see it, don't you? Fae? Hunter?"

Lance and Hollis looked on in silence.

"Yes, I do," Hunter said. "Impressive, young lady."

She nodded in appreciation.

"Well, we need to go see if we can find them," Draigistar said.

"Probably a pair of travelers now in need of burial," Lance added.

"Could this be an ambush?" Hollis wondered aloud.

"No, don't think so," Fae answered. "It was far too subtle. We could easily have passed right over those tracks."

"Agreed," Hunter said. "Erin and I should follow them," he added, looking at her.

"Uh, Hunter, I'm not sure Erin should—"

"It's all right, Fae," she interrupted. "I'll go."

"Well," Hollis said with a sigh. "You're right. We need to do the decent thing here. Fae, you and the mage stay with Celeste while they go."

"Yes, of course."

"Want company?" Lance asked Hunter.

He briefly considered his offer. "Thanks, but not this time."

Lance silently nodded.

Hunter looked over at Celeste who'd already locked her eyes on him.

"You be careful," she said.

He smiled and gently stroked her cheek. "I will."

Hollis looked on, unashamed at his daughter openly expressing herself. He liked Hunter, as he did the other four. And he trusted them completely.

"Ready?" Hunter asked Erin, nudging his horse forward.

"Uh huh." She turned and led her horse into the forest with him riding behind.

He looked back when Erin stepped into the trees. "We won't be gone long, whether we find them or not."

"We'll be here," Lance replied.

He followed her into the trees, observing her as she focused on her task. He was glad it wasn't him performing the tediously back-breaking work of tracking as he'd done so many times in pursuit of criminals. *She tracks like a seasoned ranger*, he thought, watching her silently move, fully aware of her surroundings. They didn't go far before she stepped into a small clearing and paused, her eyes fixed on a ghastly sight. From his vantage point atop his mount, he caught a glimpse

through the trees of what they'd expected to find. She slowly walked closer as he dismounted and stepped up next to her.

"You all right?"

She nodded. "Uh huh."

Before them were the lifeless bodies of two men. They'd been bound and beaten. They were both covered in dried, matted blood and had numerous puncture wounds on their torsos. Hunter ignored the stench and stepped closer, kneeling to examine them. He reached out and ripped open the shirt of one of the victims, exposing the skin and the wounds.

"Erin, would you hand me that water skin hanging on my saddle, please?"

Without a word, she retrieved it for him.

"Thanks," he said as he took it and poured the water over the chest and stomach of the victim. Then he ripped off some of the dead man's colorful garment and used it to scrub away the dried blood. "Look at this," he said. "There are more than a dozen non-lethal stab wounds here."

"From a dagger?"

"I think not. They're oddly shaped. And this, the fatal wound, look at the size of that hole. Looks like a single large blade." He rolled him over, exposing his back and an exit wound.

"He's been run through," Erin said.

"Yes," he agreed, rolling him back over.

"The other one's the same. They were tortured," she said, briefly looking away.

"Erin?"

She swallowed hard. "I'm all right," she said softly, looking at him.

"This was no simple robbery," he said, looking back down. "They either tortured these men for pleasure or interrogated them for information."

"You're right, Hunter," she said as she freed her scimitar from its scabbard. She leaned forward and laid the widest point of the blade across the large, fatal wound. It matched. They

looked at each other as she moved the sword and laid the point-ed tip of it on the victim's skin near one of the smaller wounds. Again, an apparent match.

"These aren't dagger wounds," she added. "They were made with the tip of the same sword that killed him."

Hunter sighed and slowly stood. "Well, it appears someone shares your fondness of unusual blades."

"Yeah . . . Hunter, did you notice anything strange about these tracks?" she asked, gesturing to the numerous footprints near the bodies.

Realizing he was on the spot, he repositioned to use the angle of the sun and knelt down, hoping to buy some time be-fore having to admit he wasn't seeing what she wanted him to see. Then it occurred to him. It was right there in plain sight.

"There, the same two sets of tracks made by the robbers out on the road. One had hard-soled boots like mine. The oth-er had soft boots like yours. There's no apparent third set of tracks from the rider until you realize these in front of the vic-tims are slightly different. Soft boots, but different." He looked up, pleased with himself.

"And?"

He looked back down to hide his disappointment, again studying the footprints. Then there it was, so obvious he'd missed it before. "These tracks from the rider, they're the same size as the others but not as deep. A woman," he said, looking up at her.

"I'd say so. Look closely at those," she said, pointing at the shallow tracks nearest them. "You see, women put more weight on the inside of their feet when they walk, and men put more weight on the outside."

She stepped up and made her own footprint next to one of those in question. They briefly compared Erin's print with the other one. Same size, only Erin's was slightly wider. But they both had a deeper impression on the inside. They held each other's gaze for a moment, considering the implications.

"I know it's hard to believe, but from these footprints and the knee impressions of the victims, I think a woman questioned these men while the others forced them to kneel. She stabbed them with the tip of her sword before finally killing them. Maybe she got angry, or bored. I don't know, but I do think she's the leader. And after they killed these men, you can see they mounted their horses and headed off in that direction," she said, pointing away.

Hunter slowly stood. "Well, I agree with your conclusion. Erin, I learned from some of the best trackers anywhere, and I must say I'm impressed. Good work."

"Thanks. . . . Hunter, is that for making music?" she asked, pointing.

"Yes. These men were bards. They've been dead since yesterday, so I'm sure they're the ones that army lieutenant told us they saw on the road. They probably lived up north and were on their way home from the bard's fest."

"What's that?"

"Oh, every winter, there's a big festival at Bard's Landing. That's one of the towns we'll pass through on our way to the City of Queens. Anyway, bards from all over the kingdom go there. There's singing, dancing, juggling, acrobatics, you name it. If someone can be entertained by it, somewhere there's a bard that'll do it. It's like the winter fighting tournaments in the arenas of Athum, or the ranger's rendezvous at Simion's stronghold."

"Oh, you know the place?" Erin asked excitedly. "Have you been there?"

"The Mirsham Plateau? Yes. I've met Simion, been to his rendezvous. Even wintered there, five years ago, I believe it was."

"Me and Fae stayed there three winters ago," she said. "It's the most beautiful place I've ever seen."

"It is magnificent. . . . Well, there's nothing we can do for these men now except bury them. Let's get back and report."

"All right."

/// \\\

After leaving the pass, Gustin rode hard down the mountain. Eventually he found the horse that had run away, quietly grazing on some newly emerged grass in a meadow near the road. He stopped long enough to inventory all three mounts, ultimately discarding everything but one pair of saddlebags, a blanket, a dagger, and a leather scroll case. The case contained two blank pieces of parchment and a letter he couldn't read, written in Rendovan. There was also a map of a coastline with two darkened areas he assumed were forests surrounding a cove with an anchor drawn in it. On the shoreline of the cove was the symbol of the Shadow. *It's an anchorage near a Shadow encampment*, he thought. *But where is it?*

He knew he must go. So, after stashing the unwanted items in a stand of trees away from the road, he mounted up and again headed down the mountain. As he rode, he thought about the contents of the woman's saddlebags, or rather, the lack of contents. The scroll case would've been hers by virtue of being the leader. And he would assume the Rendovan ring had been hers. Perhaps she'd traded it for something, but he found nothing of particular value in her things.

His thoughts returned to the present when he rounded a bend and saw some mounted soldiers and wagons coming toward him on the road. He slowed his horse to a walk and approached them. In a brief conversation with the leader of the family and the army lieutenant, they told him they'd taken a meal with Hollis and the others not long ago. Anxious to continue on, he patiently answered their questions about the weather and road conditions ahead. When the lieutenant asked him about the three extra horses, he told him he'd found them without riders up in the mountains, and with no way of knowing who their rightful owner was, he'd claimed them for his employer, Hollis McNeill. He hoped using the name of such an influential man would dissuade the young lieutenant from

confiscating them for the army. It worked.

Finally, he bid them farewell and rode on, pushing his mount in anticipation of reaching the others. He didn't ride far before he saw in the distance the tail of Hollis's column stopped in the road. When the rear wagon's escort spotted Gustin, he slowed his tired mount to a canter. Once he knew the alarm was sounded, he gave them a friendly wave and yelled out. "Rider coming in!"

The escort who'd started toward him reined up. "Hello there," he said as he turned his mount and fell in beside him. "Lots of folks been worried bout you."

"Yeah, I'm sure. Had to stay out longer than I planned," he replied. "Anything happen while I was gone?"

"Oh yeah, plenty of excitement," he said as they reached the rear wagon. "I'm guessing you'll be busy explaining yourself," he added, pointing ahead.

Gustin saw Fae approaching on horseback. "Take care of these horses for me?" he asked while he untied the reins and handed them over.

"Sure," he replied, taking them and riding on.

The lovers drew closer, holding each other's gaze. Gustin simply raised a hand in response to the greetings as he rode past more of Hollis's people. His thoughts were consumed with the woman he loved as they silently reined up next to each other on their opposing mounts. He could see the relief on her face and began to smile.

"Hey, lover," she said at last, breaking a smile of her own. "You look terrible."

"I feel terrible," he replied. "Don't remember ever being this tired."

"You hurt?" she asked, pointing to the torn, blood-stained sleeve.

"Oh, just a little disagreement with a wolf pack last night."

"Yeah, I heard; we all did. You scared me."

"So, you were worried?"

"Yeah, a little."

"Guess you missed me too."

"Yeah, a little."

Finally, she inched her horse closer and reached for him. He leaned out to meet her, and their lips came together in a passionate kiss while they hugged.

"Fae, I told you I'd come back to you," he said as he straightened up, lifting her from her saddle and sitting her across his lap while she continued hugging him. He kissed her temple through her thick, flowing hair, then took the reins from her hand and eased his horse forward with hers in tow. She curled up tightly with her face against his chest while he slowly rode on to find his other friends. He simply nodded to the welcoming wagon crews when he rode past.

"Fae, why are you stopped here?" he finally asked.

She looked up at him and brushed away her hair. "Erin found tracks; looked like an ambush. She and Hunter went to have a look."

He thought about it. "Well, I've never seen her misread tracks. It's probably the same three that followed me yesterday."

"Shadow?"

"Uh huh. That's where I got the extra horses. Fae, does everyone know I was up on the mountain last night?"

"No. Just the four of us and Hunter. Why?"

"Well, let's leave it that way for now. We'll all need to get together tonight, privately. . . . Listen, I really need some rest to think straight but promise you'll keep an eye on Draigistar."

"All right. Why?"

"I think he's in danger because they know he's a mage."

"I'll watch him," she said with a nod. "You need to let me look at that arm."

"I know. Later, in private. I don't want the others knowing it's from the wolves."

She silently nodded.

"Well, hello stranger. You gave us quite a scare," Hollis said

when Gustin reined up next to him and the others.

Fae took her horse's reins and slid off his lap, landing silently on the ground.

"Yeah, it's good to be back," he replied before dismounting slowly.

"Gustin!" Erin exclaimed gleefully, heading for him.

"These two just returned from a patrol of their own," Lance said, nodding toward Erin and Hunter.

"Bad news, I'm afraid," Hollis added. "A couple of traveling bards were killed."

"That's no good," Gustin replied before exchanging a hug with Erin.

"You hurt?" she asked, looking down at his arm.

"Just a little mishap, I'll explain later. Can I help with the burial detail?"

"No, you can't," Hunter replied, stepping up. "I'm sure you're long overdue for a good rest. Besides, Hollis just agreed to let me take a couple of his people and bury those men while the rest of you go on. We'll catch up before nightfall."

"We're going on to a place I know," Lance said. "There's a level clearing with a stream near the road. We'll camp early and rest up, then hit it hard and make it to the hot springs tomorrow night."

"Sounds great," Gustin replied. "I know those springs. Right now, I'd sure enjoy a long soak."

"I'll bet you would," Hollis said.

"Hunter and Janae will take two of our strongest backs for grave digging," Lance said. "Once they get those men sent off properly, they'll join us."

"Well, I guess I'll take it easy then," Gustin said. While Lance got his people ready to move, Gustin spoke briefly with the other four, promising a full report later. Soon the wagons pulled out, heading down the mountain. During the short trip to their campsite, Hollis and his daughter rode with Gustin and Fae, and he pressed him to explain his injury. He relented, telling them about his patrol: of being on the mountain,

of watching the camp, and ultimately of the wolf attack. He didn't mention Daemus.

It was late afternoon when they arrived at the empty clearing, and the crew quickly set up camp. The only other travelers they saw were some fur traders headed north over the mountains. As expected, Hunter and the others arrived before dark, in time to enjoy a well-prepared meal. Lance, always concerned with security, continued his increased night watch and warned his people to take advantage of what might well be their last good night's sleep for some time.

At last, the five friends managed to sequester themselves by the campfire.

"Hunter, did Celeste turn in?" Fae asked. "Didn't I just see you two together?"

He stood, gazing into the fire. "Yes. But I told her we needed to talk, alone."

"What? You sent her to bed like a punished child? You'll pay for that tomorrow," Draigistar said, causing the others to chuckle.

Hunter cracked a fleeting grin. "Thank you for that much-unwanted advice, mage. Would you like to live to see tomorrow?" he replied, causing more laughs.

"Draigistar living through the night is one of the things we need to discuss," Gustin said. He was spent, and his entire body ached. And he desperately wanted to sleep now that his arm felt better from Erin's treatment. He had no idea what she'd put on his wounds, but it made the pain go away. That was all he cared about. The others leaned in close, and he shared the details of his patrol. He showed them the letter he found in the hollow tree, the box with the ring and other items, and the letter and map in the scroll case. He described his run-in with the Shadow at the pass, and what he learned from Daemus. He even told them of nearly falling to his death over the cliff's edge when he gave chase.

"Well, don't beat yourself up about falling asleep on watch,"

Hunter said. "It happened to me once too, and it nearly got me killed."

Gustin simply nodded.

"So, I was right about those tracks," Erin boasted. "They were made by a woman. And she killed those bards."

"Yes. I've no doubt of that," Gustin said. "She's obviously the leader. And she's as crazy as anyone I've ever met."

"Did you happen to catch her name?" Draigistar asked.

"Sorry, no."

"Sounds like she'll have to be dealt with," Erin said. "I'll take care of it."

"Erin," Gustin said, surprised.

"What? After what she did, she needs to be put down. . . . So do you think Janae wrote this letter?" she asked.

"I don't know," Gustin replied with a sigh. "I honestly never saw anyone approach the hollow tree where I found it."

"Sounds like it could've been just about anyone on night watch," Draigistar said.

"When I was on watch, I saw someone returning from the darkness at that end of camp," Hunter said. "Didn't give it much thought. I assumed he just went to answer nature's call."

"Know who it was?" Gustin asked.

Hunter thought briefly before shaking his head. "No. The watch fires were dim, and I couldn't see him well. Sorry, should've paid more attention."

"No harm," he replied.

"Do you really think there's gold in these wagons?" Erin asked.

They all exchanged glances.

"Oh, probably," Gustin said. "You've seen the deep tracks they're leaving. And Hollis is a rich man."

"What about the map?" Draigistar asked, holding it up. "That coastline look familiar to anyone?"

"Well, I don't recognize it, but I did notice something interesting," Hunter said. "It looks like the camp can only be reached

by sea. There are no roads or trails marked. Perhaps the forest around the cove is impassable."

"When we get to the City of Queens, I think I can help with the map and the letter," Draigistar said. "You're right, Gustin, it's written in Rendovan. I'm just not sure what it says," he added, handing them back to him. "I'll go see my old master. He'll let me use his archives for research."

"Sounds good," Gustin said through a big yawn. "Well, there's really nothing more we can do tonight, and we all need some sleep."

"We'll have to keep an eye on Draigistar," Erin said.

"That mean you're going to spend the night with me?" he asked.

She looked at him, her mouth agape.

"You'll pay for that, mage," Hunter said.

"You're a pig," Erin told him, and the others laughed.

"Draigistar, I do think perhaps you should start dressing inconspicuously," Fae said. "You know, looking less like a mage."

"Very well."

"Hunter, any progress with Janae?" Gustin asked.

"I think so. She was repulsed by what she saw today. And I made sure she knew it was the Shadow who tortured and killed those men. I'm hopeful she'll come around."

"That's good," he said. "Well, I'm turning in."

"Yes, go get some rest," Hunter said. "I'll watch tonight."

"Hunter, the rest of us can take a turn while he sleeps," Fae said. "You don't—"

"Fae, go to bed," he interrupted.

"You heard him," Gustin said as he stood and offered her his hand.

She looked up at him before glancing back at Hunter.

"Go," he repeated with a dismissing wave.

She smiled and took Gustin's hand. "Thank you."

Hunter nodded and they excused themselves.

The other three agreed to split the night watch. Hunter

would take first watch, with Erin relieving him, and Draigistar would rise early to watch until dawn. With that, they turned in, leaving him alone. Here on the southern slope, this night was noticeably warmer than last. It was bittersweet for him. He was going to miss winter, the snow, and the cold. But he'd done his part to defend the kingdom he now called home. It was time to finish his business with an old friend.

As he stared into the waning flames, he let his mind wander. He thought about him and Andrew growing up together, the adventures they'd shared with Edmond, and how inseparable they'd been. He thought of their accomplishments together as young knights. Eventually, his mind drifted to a tragic night when their young, ambitious dreams were shattered, a night that changed the course of their lives forever.

He'd hoped to see Celeste one more time when he passed through Port Estes on his way to find Edmond. But he never dreamed fate would bring their lives together. He'd already spent more time with her and learned more about her than he'd ever hoped for, and their journey had just begun. She stirred feelings in him he'd not had since being with Stephanie. And that frightened him. He was torn about whether to pursue her or simply fulfill his commitment to her father and then disappear. At times he thought the best thing he could do for her was to ride away and never look back. But he knew he wouldn't be able to stay away. Truth was, he never wanted to leave her side again.

Regardless of how things turned out with her, he took it as a sign. He had to find Edmond and put an end to his reign of terror. *Sir Edmond White, the Shadow Knight*, he mused. *Ha, you're no more a knight than I am . . . less, in fact, you crazy, wicked bastard. I should've hunted you down long ago.*

"Hunter."

He was startled by a voice invading his thoughts, and looked up to see Erin standing beside him.

"I, uh, I'm sorry," she said softly. "You looked like you were

deep in thought."

"Sorry, Erin. Not much of a night watch, I'm afraid," he replied, embarrassed.

"It's all right. That's what the others are for."

"Why are you up? Couldn't sleep?"

She grinned. "It's time for my watch to begin. You were really out of it."

"I, uh, I guess I was," he said, shaking his head.

"Can I ask about that?" she said, pointing to the tattered white scarf in his hand.

He glanced down briefly before tucking it back into his pocket. "Oh, it was given to me years ago."

"By someone special, yes?" she replied, kneeling to stoke the fire.

"Yes, but that was a lifetime ago. . . ." He looked around to make sure they were alone. "Erin, remember when I offered to help you with your reading?"

"Uh huh," she replied tentatively.

"Well, I just happen to have some free time," he said with a smile.

She smiled back. "You're tired; are you sure?"

"It would be my honor."

"Wait right here," she said excitedly, springing to her feet. "I have a book in my things." After retrieving it, they sat together with their backs to the fire so they could see the pages, and she quietly read. She was like a child with a new gift, relishing his attention. The time passed until she realized he was struggling to stay awake, so she closed the book.

"Thank you, Hunter, but that's enough," she said. "You need to sleep now."

"You're right. I'll be no good tomorrow if I don't," he said as they both stood.

"Goodnight, Erin."

"Goodnight," she replied, and they exchanged a brief hug. Then he turned away.

The rest of the night passed quietly while she stood watch till morning. When the camp began to stir, Draigistar awoke having missed his watch, and hurried to find her.

"It's all right. Hunter stayed up and watched me read," she proudly announced.

"Oh, I see," he said with a knowing smile.

When the sun broke the horizon, the column was already on the move. And by midday, they'd passed through the foothills, stopping in the small village of Arcacia. With less than a hundred residents, it was hardly more than a cluster of houses with a few stables and corrals built around a communal well. It had a blacksmith, a trading post that served hot meals and spirits to travelers, and an animal trainer considered to be one of the best in the entire kingdom.

Lance was pleased with their progress as they sat packed into the cramped dining room of the trading post.

"Father, us girls were wondering if we'll have some time to enjoy the hot springs when we camp tonight?" Celeste asked.

Hollis raised an eyebrow, studying his daughter briefly. "Well, dear, I hate to disappoint, but Lance and I agreed that since we're making good time, there's no reason not to push on past the hot springs and camp further south tonight."

She looked down at the table. "Oh," she replied, her disappointment obvious.

The others at the table were drawn into the conversation, so when Hollis smiled, they realized he was playing a joke on his daughter.

Finally, he laughed robustly. "Got you," he said. "You should've seen the look on your beautiful face."

"Oh, Father, how could you?"

"Sorry, dear, I couldn't resist," he said, pulling her close while the others laughed.

She pushed him away and gently slapped his broad chest, feigning anger.

He chuckled. "Of course we'll have time. For my beautiful, spoiled daughter, anything. . . . So, what did you have in mind?"

When she looked down again, he glanced at the others with a mischievous grin.

"Well, we just thought it would be nice to take a long swim in the hot water. You know, to relax a bit," she said, looking back up at him sheepishly.

"Ah, yes. The hot springs are the perfect place for a little skinny-dipping."

"Uh, Father!" she replied in embarrassment while the others laughed.

"What? You think I've forgotten what it was like to be your age? I should tell you young lady, before you were here, your mother and I swam naked in those springs."

"Oh no!" She ducked her head and buried her face in her hands while the others roared with laughter. "I really didn't need to know that," she said with her face still covered.

Hollis was relishing the rare occasion of having his sassy daughter on the run. "In fact, I'll tell you something else, child. When you were very young, she and I often joked that you were conceived in those springs," he proudly announced.

"Oh my God!" she yelled into her cupped hands as the laughter around the table rose to a deafening crescendo. "All right, forget it. I changed my mind. I don't want to swim there ever again," she said, shaking her head with her face still covered.

Hollis grinned with satisfaction as the others around the dining room looked on.

"That's all right, sweet. No trouble at all, anything for my precious girl."

She silently shook her head as he pulled her close with a crushing hug. She lowered her hands but continued looking down as she drew her knees up and turned sideways on the bench they shared. Laying her legs across his, she put her head

on his broad chest with her eyes closed as the laughter died and the conversation took a new direction.

At last, it was time to move on. The horses were rested, and everyone had eaten a hot meal. The group slowly made their way outside just as a company of soldiers rode into the village and began dismounting. Being among the last in the group, Gustin and Fae walked out onto the porch in time to see an officer dismounting from a white horse. When he turned around, Gustin froze.

Fae stood beside him and, sensing his sudden reaction, looked up at him.

"Ha, well, would you look at this. Isn't it a small world we share?" the officer said as he and Gustin gazed at each other.

"Now, why am I not surprised they made you a general?" Gustin said. "I guess the war really has taken its toll on the army." Stepping off the porch, he reached back, gently pressing his open hand to Fae's midriff, signaling her to stay.

She felt slighted but understood. She knew who this man must be.

"Oh, not just a general," the officer boasted. "You're speaking to the new second-in-command of the combined northern armies. I'm even making my case to be appointed a Provincial Governor."

"Well, that's typical. Now that the war is nearly won, you show up to claim the glory," Gustin said while the soldiers looked on in disbelief that anyone would dare address their commanding officer that way. "As for being governor, I'm sure you'll make a better politician than you do a soldier."

Ignoring Gustin's insult, he countered with his own.

"Well, it appears you're enjoying a state of prosperity these days. Although I must say, you could use a haircut and a bath. A very long bath," he said as his soldiers laughed.

Without response, Gustin slowly continued toward him and Fae's anxiety grew.

"Lieutenant, please forgive my manners," the arrogant officer continued. "Let me introduce you to the former, and infamous, Captain VanHolt. He was once considered by some—not me—to be a brilliant young officer, poised to follow in his legendary father's footsteps and be a general himself someday. But he did something very, very bad," he said, clearly trying to provoke.

Gustin held his tongue, refusing to give him the satisfaction of a response. At last, he stopped, standing face to face, looking down on him, expressionless.

The obnoxious general continued undeterred. "Oh, by the way, you'll be delighted to know that sniveling fool who lied to save you from the hangman's noose, the one your father rewarded with an appointment, has finally been commissioned. But that's all right. I personally saw to it he got his due. He's wasting away in that hellhole, the Frontier Province. He'll spend the rest of his miserable days roaming those Godforsaken disputed lands you seem to love so much."

Gustin still didn't respond, and by now, a deathly silence had fallen on the entire crowd. Hollis and Celeste had stepped out onto the porch just when the confrontation began and now glanced at Fae. She was focused on the dialogue, wondering how much more verbal abuse Gustin would take before erupting. He'd told her the story, and she knew he loathed the man. She was proud of his tolerance. She knew he could easily pull his sword and kill the fool where he stood before anyone could react. She also knew it would mean certain death in response from his soldiers. She was prepared to leap into the uproar with sword in hand. She would give her life protecting the man she loved.

Finally, Gustin spoke. "I see some things never change. Just as before, you're a brave man with a hundred more behind you. Tell me, do they know what an incompetent, pathetic, lying coward you are?"

The tide was now turned. Instantly, the general's anger

surfaced. His cheek twitched, and he visibly shook as Gustin continued in front of the soldiers who'd gathered around.

"Do they know that when they look to their leader in the heat of battle, you'll be gone, hiding somewhere like a frightened child? That is, of course, unless you're fighting defenseless old men or women and children. You're a pompous fool, a disgrace to that uniform, and an insult to the soldiers who follow you."

It was more than the general could take. He clenched his fists, exploding in rage.

"Why, you insolent wretch! I'll not have you address me like that! I'll have you strung up here and now!" he shouted as a trail of spittle ran down his chin and his neck veins bulged. "Why I—I. . . ." Suddenly, he froze, expressionless.

Gustin saw his gaze falter when he halted his rampage but didn't understand why. *What the hell is wrong with this idiot*, he wondered. Then he realized he was looking over his shoulder, so he took a step back and glanced that way.

Hunter had been following the others outside and stopped in the doorway when he saw the confrontation begin. Now he'd stepped out on the porch into the sunlight behind Fae and Celeste. It was clearly him the general was fixated on. And Hunter stared at him with an expression that would unsettle the bravest man.

Gustin returned his gaze to the general and watched him regain his composure.

"Captain, I realize that, given our history, we've both allowed our emotions to get the best of us. . . . That said, I'm going to let this matter pass and bid you and yours a good day," the general said as he stepped back, holding his hand out. The soldier standing behind him slowly realized his intent and placed the reins in his hand. Then he turned and mounted his horse while his troops stood there dumbfounded.

"Men, I've decided we'll move on and billet closer to the mountains tonight," he announced. "Lieutenant, if you please."

He glanced at Hunter, who still stood motionless, eyeing him. Then he looked down at Gustin, his contempt still obvious. Finally, without another word, he turned his horse and coaxed it away.

"Company, mount up!" the lieutenant shouted as a wave of subdued grumbling arose from the ranks of the soldiers.

Gustin stood in silence and watched the general head down the road with his troops scurrying to catch up.

Curious glances were exchanged among Hollis's hirelings until Lance stepped off the porch. "All right, people, we've had our meal, and our entertainment. Now it's time to earn our wages. Get ready to move out!"

As they scattered to comply with his order, Fae stepped off the porch to go to Gustin, and their two friends joined them.

"Gustin, what just happened?" Draigistar asked.

"Yeah, I thought we were headed for a fight," Erin said excitedly.

Gustin looked at Fae. "I guess you never told them."

"No, of course not," she replied. "You said it was private."

"Well, it's complicated," he told the other two. "But he's the reason I left the army. When we have more time, I'll explain. Anyway, doesn't matter now. That part of my life is over."

"Bet you're having more fun with us anyway," Erin said, grinning.

He chuckled. "Yes, I am."

"So, what was the deal with Hunter?" Fae asked.

"KSS," Draigistar replied.

"What's that?" Erin asked with a curious look.

"Kingdom Security Services. I heard about it a few years ago when I lived in the City of Queens. They answer directly to the Minister of Kingdom Affairs. It's made up of military officers and others with, how should I say it, special abilities or influence. There are even women agents. They basically just keep a watchful eye on the kingdom and its people so unrest

and subversion can't grow unchecked, like the Shadow, for example. Funny thing, though, its existence has never even been officially acknowledged."

"Well, obviously, they know each other," Gustin said. "I'm sure he'll fill us in. You heard Lance; let's get to it," he added, reaching out toward Fae. She stepped close so he could put his arm around her waist, and they walked to their horses.

Draigistar and Erin walked on ahead with her still talking excitedly.

"I'm proud of you," Fae said.

Gustin looked at her. "Why's that?"

"Well, you held your steam and didn't kill anyone," she said with a grin.

He chuckled briefly as they walked on. "It was difficult, Fae. But as much as he deserves to die, it won't be by my hand. I have too much to lose," he said, raising his hand from her waist to run his fingers through her long hair. "I refuse to carry it around with me. I couldn't save those villagers. And I don't care what others believe; I know what really happened that day. . . . You know it's ironic. In his effort to destroy me, he actually did me a favor. My life is far better now than I ever imagined it would be," he said as they reached their horses and stopped face to face. For a moment they gazed at each other, smiling, then embraced and kissed before mounting up.

/// \\\

As the crowd dispersed, Hunter walked with Hollis and Celeste to their mounts.

"Well, young man, I've been trying to make sense of the general's sudden response to your appearance," Hollis said. "Since you say you've not served in the military, there can be only one explanation. You're with Kingdom Security Services," he added, still looking forward as they walked.

Hunter noticed Celeste glance his way.

"Yes, sir," he confirmed. "I, uh, know many people take a dim view of the kingdom being watched covertly in the name of security. They feel it's an invasion of their privacy and an insult to their loyalty. I understand if this changes things between us."

Hollis suddenly stopped and turned to face him. "Hunter, am I being investigated by the KSS?" he asked, looking at him squarely.

His daughter grew anxious but remained silent.

"No, sir, not that I know of," he quickly answered, looking him in the eye.

"And it was purely by chance that you walked into the inn that day we met?"

"Yes, sir."

Hollis studied him briefly and then smiled. "I believe you, son. Therefore, it changes nothing," he said with a dismissing wave as he turned and resumed walking.

"I assumed, at the least, you'd be upset I hadn't told you."

"Ha. Nonsense, I'm not offended. After all, that's not the sort of thing you go around sharing with everyone you meet now, is it? Defeats the purpose, yes?"

Hunter cracked a smile. "Yes, sir."

"Truth is, I'm proud of you. They don't recruit just anyone for the service. I know. They tried to get me four years ago, but I turned them down."

"Father, you never told me that," Celeste said, looking at him with surprise.

"That's because it didn't concern you, child," he answered with a glance. "I told you; I turned them down. I'm a merchant, not a soldier or a spy."

She looked at her father and then at Hunter.

"Well, it's good to know you're connected," Hollis continued. "Trouble is the others will figure it out too. And I'm sure you would've preferred to avoid that."

"Yes, sir."

When they reached their mounts, Hollis led his away to go speak with Lance.

Now alone, Hunter turned to Celeste, not sure what to expect. When their eyes met, she stepped up to him.

"So, I learned something new about my protector," she said with a smile of admiration.

"Uh huh," he responded, brushing a stray lock of hair from her forehead.

Her expression turned serious as she placed her hands on his chest and leaned into him. "I want to learn more about you, Hunter. I want to know everything."

He gently slid a hand around her waist and drew her close. "And I want the same of you, Celeste." Sensing the time for their first kiss was finally at hand, they ached with desire as their lips slowly moved closer.

"Hey, you two!" Erin called out. "It's time to go!"

They looked up to see her and the others ready to ride. So, reluctantly, they exchanged a smile and released each other to go mount up.

CHAPTER ☥ 8

Leaving Arcacia, they pushed on to the hot springs, passing a few more travelers along the way. They arrived in time to set up camp before the sun disappeared over the foothills, and after dinner, those without assigned duties headed up to the springs for a relaxing dip.

The hot springs had more than a dozen shallow pools of hot, bubbling water in an outcropping of huge rocks that jutted up defiantly from the forested hillside. The gigantic rocks formed natural bowl-shaped pools perpetually fed by hot water bubbling up through the cracks. It gently flowed over the rim of each pool, cascading down over the rocks to the lower ones. From the last pool, the water flowed on lazily to join a stream fed by runoff from melting snow on the mountain peaks to the west.

The constant mixing of hot and cold water in the stream shrouded the valley in a fog that lay over the landscape like a huge blanket. Summer was the only season without it. From the first cool weather of autumn to the last chilly nights of spring, a morning fog could be expected. Sometimes it was so thick travelers had to wait till midday to push on. Seductively inviting, the springs were a welcome stopover for all who knew about them. They were nestled in the picturesque foothills a half mile west of the main road. And with no homesteads nearby, they were a popular respite for weary travelers, or lovers in search of a romantic hideaway.

After some of Hollis's hirelings had gone up to the springs,

he sat by the fire finishing his meal. "Aren't you going for a swim, child?" he asked, looking over at his daughter.

Gustin chuckled, and Hunter nearly choked on a bite of food he'd just taken.

"Oh, shut up, you two," she said, raising a leg and playfully kicking Hunter before he could scoot out of range.

Hollis laughed heartily. "So how bout that swim?"

"Oh, I suppose, if you'll show me which pools are safe."

"You'll just have to take your chances, dear," he replied with a chuckle.

"Well, I'm not going to miss it," Gustin said as he stood, extending a hand to Fae.

She took his hand and stood, giving Hunter a glance as they walked away.

The evening progressed without incident while nearly everyone in the party took a turn relaxing in the springs. The women staked their claim on one of the large pools while Gustin and Fae moved higher up the hillside to find some privacy. Strategically placed torches lit up the rocks and the water cascading over them, creating an enchanting scene.

"That a good idea?" Hollis asked. "You can see it for miles."

"No matter," Hunter replied. "We've been watched since we left Port Estes."

"I suspected as much. . . . Hunter, there are things you and the others aren't telling me. I assume you have good reason."

After a brief silence, "yes, sir."

"Then you don't deny it."

"No, sir. I won't lie to you."

Celeste now listened intently as Hollis gazed into the fire.

"I have a spy in my camp," the merchant finally said.

Hunter remained silent, wondering if he was fishing or if he really knew.

"I presume you have a plan to deal with it."

"Yes, sir. We're working on it."

Hollis slowly shook his head. "I'm not going to ask who it

is. I'm guessing that's why you haven't told me."

"That's part of it."

"And you're sure of this?"

He sighed. "Yes sir."

"You know who it is?" Celeste asked, looking at him.

He simply nodded, his expression gently warning her to let it drop.

Hollis stood, then turned to face Hunter as he, too, stood. They studied each other before Hollis spoke again. "Son, I'm trusting you and your friends with the most important thing in my life," he said, looking down at his daughter.

"Yes, sir, I know. And we're ready. Now that we're over the mountains, too far from home to make a run for it, they'll begin making their presence known."

"The Shadow? You believe an attack is imminent?"

"Yes, sir."

"And what of the Shadow Knight?"

Hunter drew in a deep breath and slowly let it out. "He's here; I know it," he said, looking out into the darkness.

Celeste shivered, chilled by his words.

Hollis sighed and looked down at his daughter. "Well, young lady, you go enjoy your swim. Make it a nice long one. Because after that, I don't want you away from Hunter's side unless you're by mine."

"Yes, Father," she replied, realizing for the first time the seriousness of the situation they were now in.

As some of the swimmers made their way back to camp, Hunter escorted Celeste up to the pools, where they found Draigistar and Derek keeping vigil over the pool of bathing women. They'd already relaxed in another pool and now dutifully sat with their backs to the ladies, making small talk.

"You know, we could do what Fae and Gustin did and go find a pool of our own," she said softly as she leaned in close.

"I don't want to know what Fae and Gustin are doing," he replied with a smile, glancing up the hillside into the darkness.

"You sure?" she said with a teasing grin. "Might be fun."

His smile faded as he reached out and gently pulled her close. "I'd like nothing more; you know that. But I can't, for many reasons."

"I know," she replied. "Hunter, I'm scared, for all of us, but mostly for you. You're going to face him, aren't you?"

He studied her face by the light of the nearby torches. *All the things I wish I could say to you,* he thought as he ached to be alone with her, to know her. There remained no doubt he must free himself of Edmond and get on with his life.

"Yes, I am," he replied. "It'll be all right. Now go relax and have fun with the others. I'm right here."

"Join me later?"

He raised an eyebrow and grinned. "We'll see."

Suddenly Janae emerged next to her, giggling and dripping wet. "Hey, come on," she said, standing there nude in front of the men. "The water is—"

"Ah, Janae! What are you doing?" Celeste interrupted, looking down at her nakedness. "Get back in the water!" she exclaimed, clearly offended by her brazen act of immodesty.

"Sorry," she said, raising her arms across her bare breasts as she turned and retreated back into the pool.

"Well, now. And I thought it would be just another boring night watch," Draigistar said, causing Derek to chuckle.

"You stop!" Celeste admonished, pointing her finger at him. "She doesn't need your encouragement."

Hunter grinned, both at his remark and at her swift rebuke.

Draigistar cowered and placed his hand over his mouth, clearly mocking her.

She smiled and gave him a dismissive wave.

"Like I said, you go enjoy your swim," Hunter said, still smiling. "I think I'll sit down here and see if the mage can make me laugh again."

"Sorry about that," she said, embarrassed.

He simply nodded before turning around so she could disrobe.

"Draigistar, you look the other way," she said sternly.

"Oh, all right."

The women relaxed in the hot water while the three men sat and visited. Others passed by, returning to camp from smaller, secluded pools higher up the rocky hillside. Finally, Fae and Gustin appeared.

"Hey, come on in," Erin invited Fae with a gesture.

"No thanks," she replied as she went over and knelt by the pool where the women were gathered.

Gustin took a seat on a boulder near the other men.

"Well, did she kiss it and make it all better?" Draigistar asked him, in a clear reference to Fae and his injuries.

"As a matter of fact, she did," he replied with a satisfied grin.

Hunter chuckled. "I knew if I sat here long enough, you'd make me laugh again, mage. I just didn't know at whose expense it would be."

Just then, Fae returned. "Hey boys," she said.

They all looked at each other and burst into laughter.

"What?" she asked, perplexed by their amusement.

"I'm sorry," Gustin managed. "It's just something Draigistar said."

"Oh, that's no surprise. I'm sure he's being a jackass."

They continued to laugh, and when she realized her arrival had set them off, her smile faded. "Are you laughing at me?" she asked Gustin.

He tried to respond but couldn't stop laughing.

"Hey! Answer me! Are you?"

"No. Uh, well, yeah," he managed through his laughter.

"You bastard," she said, stepping forward. She was far too swift for him to avoid as she raised her foot and planted it squarely in his chest, sending him backward off his perch onto the ground. The others roared with laughter at the sight of his feet resting on the boulder where he'd just been seated.

She turned and headed toward camp while he picked himself up, still laughing. She marched away with her anger seething,

obviously the butt of a joke. Then, through tear-filled eyes, a particular rock caught her attention. She stopped and picked it up, then turned and threw it at him.

"You pig!" she yelled just as it struck him in the side with a thud. He recoiled and grabbed his ribs in pain while the others looked on in disbelief, then laughed with renewed vigor. When she got back to camp, she picked up her bedroll and pack and went to find her own place to sleep.

The laughter faded, and eventually, the women announced they were ready to return to camp. Dutifully, the men stood and took a position with their backs to the pool so they could emerge to dry and clothe themselves.

"Gustin, you messed up," Erin said, drying off. "What were you thinking?"

"Erin, I didn't mean to hurt her," he said with a glance as he held out her clothing.

"Well, I didn't hear what was said, but she was hurt by it. You don't know how she worried about you while you were gone."

He looked away in silence, ashamed of his immature behavior.

"She loves you, so she'll come round. I just wouldn't try to force it tonight if I were you," she added, adjusting her clothing against her damp skin.

Once everyone was dressed, Hunter told Celeste he was staying behind.

She looked at him, concerned. "Why?"

"I need to be alone with my thoughts. And a nice soak will help me prepare."

"Prepare? To face him?"

"It's all right, Celeste. I asked Gustin to see you back to camp. I'll be in later."

She smiled fleetingly. "I think he has his own problems to worry about."

He smiled as he thought of the incident. "We all helped get

him into trouble. I'll talk to Fae tomorrow."

"You sure that's a good idea?"

"Yeah. Now go on back with the others and get some sleep."

She silently gazed at him before leaning in and kissing his cheek. "All right."

Gustin stepped closer. "Evening chill's setting in, bringing the fog with it," he said, nodding toward the camp.

They could see the fog settling over camp, illuminated by the fire.

"You go on now," Hunter said, smiling at her.

She silently nodded before joining the group as they headed down the hill.

After watching them make it safely back to camp, he disrobed and stepped into the pool of hot water. The heat attacked his senses. He wondered how the women tolerated the discomfort with such apparent ease, but eventually, his tired body acclimated, and he settled in up to his neck. The soothing warmth enveloped him, and he relaxed in its embrace while he listened to the sound of the water gently cascading over the rocks on the hillside above him.

While he soaked, he thought of Edmond. He tried to imagine what it would be like: when and where it would happen, what they would say to each other, and most of all, how it would end. He knew one of them would die. He couldn't count the number of opponents he'd faced over the years. And each time, he'd been victorious, despite carrying scars away from some of those battles. He wasn't afraid of Edmond. They'd trained together since childhood. He knew he was better with his sword. But he also knew Edmond's threat went beyond what any steel weapon could do. He was possessed. Hunter was there; he saw what happened to him that terrible night in Tuskin.

Suddenly his senses piqued, and he was ripped from his reflective state. He sat motionless, carefully listening for the slightest noise while his eyes scanned the darkness. There was

a single burning torch lying on the far side of the pool. *There.* Suddenly its light betrayed a subtle movement. *Edmond*, he thought as a chill coursed through him. He'd imagined more dignified circumstances when they met, but no matter. He was ready. He reached up and grasped his sword that lay on the rocks nearby.

"All right, come forward, into the light!" he said in a loud voice. Silence was the only response. After considering his options, he stood and stepped up onto the edge of the pool and into the bushes. Now, standing naked in the chilly darkness of night, he bent over and picked up some rocks. He began tossing them into the air, so they'd randomly fall in the surrounding bushes, their sound confusing whoever lurked about. Just as he was about to move in the direction where he'd seen the figure, he heard a feminine voice.

"Hunter. It's me, Janae," she said, stepping into the light of the torch. The only weapon she wore was her short sword, and he hadn't seen or heard a sign of anyone else. *Oh, well, she showed me hers*, he thought, stepping out.

"Why are you here, Janae?" he asked, walking around the edge of the pool. Her mouth fell open in reaction to the sight of his wet, nude, muscular body when he approached. She was clearly flustered, looking down at his manhood before turning away, embarrassed.

"Uh, I, uh, I'm sorry, Hunter. I didn't mean to disturb you. I was just hoping we could talk," she said tentatively.

Good. This is my chance, he thought. He'd been looking and listening into the darkness while she stammered. Now convinced they were alone, he leaned his sword against a big rock and took up his clothing.

"Sure. Go ahead while I get dressed," he replied in an intentionally calm voice.

There was silence behind him as he put on his tunic. Then reaching for his pants, he again turned to face her. "Janae?" he said, waiting for eye contact before he raised a leg to step into

them. She was clearly unsettled, and that's what he wanted. Finally, she collected herself with a deep breath and spoke, eyes still fixed on his fleeting nakedness.

"Hunter, I, uh, wanted to apologize for my behavior earlier."

He looked at her when he sat down on the rock to put his boots on. "No need; I wasn't offended. Celeste is the one you should apologize to."

"I already did, while we were soaking. She was upset, but she forgave me."

"You mean a lot to her, Janae. And I think she means a lot to you. . . . Am I right?" he asked as he stood and sheathed his sword. "Are you her friend?" he asked, approaching her.

"Yes, of course," she replied with a confused look.

"Janae, friends don't betray each other . . . and you have a terrible secret."

Blindsided, she nervously crossed her arms in front of her and looked away.

He allowed the silence to continue, watching her, forcing her to respond.

"You know about me, don't you?" she finally asked, looking back up at him.

"Yes."

She closed her eyes, and a tear trickled down her cheek.

Again, he patiently waited through her silence.

"So now what?" she finally asked with a sniffle, looking away again.

"Janae, look at me."

She slowly looked up at him.

"Let me help you stop this madness. I don't know how you got mixed up with them. But I know you're better than that. We can help, but you have to come clean."

"We? Oh God, please tell me Celeste doesn't know."

"No. She doesn't, yet. But you're going to tell her."

"I can't tell her the truth. She'll hate me forever," she said as she began to softly cry. "Besides, you don't know what you're

saying. You don't just leave the Shadow. They'll never let me go. He'll never let me go," she added, looking back down.

When he raised a hand to touch her cheek, she briefly recoiled in fear.

"You said *he* would never let you go. Do you speak of the Shadow Knight?"

"Ha, no," she answered, shaking her head. "His second."

"And his name? . . . Janae?"

"Hanlin," she finally said.

"Was he the man on horseback you spoke to in the alley that day in Port Estes?"

Her mouth fell open as she looked up at him in disbelief. "You've known about me since the day we met?"

"Yes. Was that him?"

She silently shook her head in confirmation.

"You're his woman?"

She looked offended but then calmed herself. "Yeah. Look, he cares about me. He treats me all right, most of the time, long as I do what I'm told, please him when he wants it," she said softly, looking away as if for the first time realizing the kind of man she'd just described.

"Janae, you know what he is. He doesn't care about you. He's using you. I saw the way you reacted when I raised my hand. It's obvious he beats you. Is that the kind of man you want to be with? The kind of man you want to give yourself to?"

Still looking away, she slowly shook her head as if trying to resist his reasoning.

"Janae, Hollis loves you like a daughter. And you're the sister Celeste never had. Your life could be so good with them."

"All that's gone now," she said as she sniffled and wiped away tears. "I have nowhere to go but back to him. He'd find me anyway. He told me I'd never be with anyone else."

His heart ached for her. "Janae, he beats you. He forces himself on you when it suits him. He's robbed you of your dignity. You deserve so much better."

She shook her head again before looking up at him. "No, Hunter. You don't know where he found me," she said as her voice broke.

"Oh, I see. So, he has you convinced you somehow deserve the degrading things he does to you. Oh, Janae," he said, placing a hand on her shoulder. "Please let us help you. We can take you away from him, but you have to want to go."

She began crying harder. "But he'll kill me!" She broke down and sobbed, leaning into him.

He held her, letting her cry, until at last she regained her composure.

"Hunter," she said softly, her cheek now pressed to his chest.

"Yes."

She leaned back to look up, and when their eyes met, he knew he'd won her over. "All right, I'll do it," she said. "I'll talk to Celeste and Hollis."

He smiled. "Good. You've done a brave thing deciding to fight for a better life," he said, wiping away her tears. "Tomorrow, I'll arrange for you to have some time alone with them. There's a fog setting in tonight, so we won't be leaving early."

"I might talk to Celeste tonight, if it seems right, before I lose my nerve."

"All right, but Janae, I have to ask you this. Do you know of any other Shadow in our camp?" He carefully studied her response.

"No," she said without hesitation or falter in her gaze.

Good. You passed that test.

"Listen to me. When Gustin questioned the one who escaped the wolf pack, he said there were two in our party besides you."

She shook her head as she spoke. "Hunter, I swear to you I don't know of anyone else," she pleaded, desperate for him to believe her.

He gently placed his hands on her cheeks. "I believe you. Just understand we still must keep this between us. For your safety we don't want everyone knowing about it."

"I understand," she said with a slight nod. "Hunter, does anyone but you and the four know about me?"

"No. And I'm hoping that Hollis, Celeste, and Lance are the only other ones to find out. Is it possible that other Shadow went to work for Hollis to keep an eye on you?"

She thought about it. "I suppose so. I can point out the ones who started after me."

"Well, besides talking to Hollis and Celeste, you'll need to level with me about the Shadow's plans. I need details."

"I'll cooperate, Hunter. I'll tell you everything I know, I swear."

He could see the relief on her face from the heavy burden now lifted. "All right, it's getting late. Why don't you go on back to camp, and I'll be in later. We shouldn't be seen together just now."

"Right," she said. "Hunter, thanks for giving me a chance to square things, for caring, and for believing in me."

He smiled. "I know you'll do what's right."

She wiped her eyes and nodded, then silently turned and headed back to camp.

He waited a few moments and then quietly made his way down the hillside through the forest surrounding the camp. He wanted to enter from a different direction so anyone watching wouldn't be suspicious of Janae. Approaching the center of camp, he saw Erin and Draigistar sitting on one side of the fire pit with Gustin seated across from them. Lance stood near the fire, and they were all quietly talking. He grinned when Erin suddenly glanced over her shoulder at him before the others knew he was coming.

"Have a nice swim?" she asked when he sat down.

"Uh huh. Much better than I'd hoped," he said as he winked at her, knowing she would've seen Janae enter the camp. Her expression was subtle but unmistakable. She understood him. While the others continued talking, she raised a hand to cover her emerging smile, her eyes still locked on his. When he

returned the smile and nodded, she drew her knees up and laid her forehead on them with her arms wrapped around her legs. It appeared she was just tired, but he imagined her silently shedding a tear of joy at his news. He'd felt the same way when Janae broke down in his arms, and he knew their patience had most likely saved her life.

Soon Lance bid them good night and retired, leaving just the four of them by the fire. Rarely did one of the hirelings wander within earshot, and those who hadn't turned in were on patrol or huddled around a fire at the other end of camp.

"Erin, are you all right?" Gustin asked.

She looked up and nodded. "I think so," she said, glancing at Hunter. "Did you mean what I think you meant?"

"Uh huh."

She smiled and let out a squeal of elation as she cupped her hands over her face.

"Janae?" Gustin asked.

"Yes," Hunter replied. "She came to me when I was up in the springs."

"Oh. Did she, uh . . . see you? I mean," she stammered, embarrassed.

He chuckled. "Yes, Erin, she saw me naked."

"Erin," Draigistar admonished. "You should be ashamed."

She just looked away with a wide grin.

"So, she came 'round?" Gustin asked, smiling at the mage's tease.

"Yes. She agreed to tell Hollis tomorrow, and she's going to tell Celeste tonight."

"That is so good to hear," Erin said.

"Uh huh. . . . Say, where'd Fae get off to?"

"She's sleeping over there under the wagon," Erin said, nodding toward one of the bircks. "I talked to her. I think you three would do well to keep your distance."

Gustin looked down when she gave him a disapproving glance.

"Erin, we didn't mean to hurt her feelings," Hunter said.

"I know. She'll be all right in the morning. She loves you all enough to forgive. Don't know why," she said, rolling her eyes.

Hunter laughed quietly.

"So, Hunter, what's the deal with you and the general?" Draigistar asked.

He searched their expressions while carefully choosing his words. "Well, I don't know if you've heard of it, but I occasionally work for an organization—"

"Kingdom Security Services," Draigistar interrupted.

Hunter gazed at him, then smiled as he glanced at the other two. "Well, apparently you have," he continued. "The KSS was conceived by the former Minister of Kingdom Affairs and sanctioned by the Queen to help him keep a watchful eye on the kingdom and its citizens. There are several hundred agents, I'm told, but in such a vast kingdom, that's not a lot. They, uh . . . we, come from all walks of life and work throughout the kingdom and even abroad. There's a structured chain of command for those agents paid by the kingdom's coffers. I'm a contract agent, which is just a fancy way of saying I work for them when it suits me. I was approached about four years ago after I broke up a scuffle between two men outside a brothel in Altus."

"And just what were you doing there?" Erin asked him with a narrow-eyed look.

"Yes, by all means, let's hear every detail," Draigistar added with a grin.

Erin snatched up a small rock from the ground and threw it at him. "You hush. He was just about to explain himself, weren't you?"

He smiled and continued. "It turned out my intervention saved the Queen's married nephew from a scandalous public disclosure."

Erin raised a hand to her mouth. "He had a paramour?"

Hunter chuckled. "Yes, more than one, in fact. And a propen-

sity for, uh . . . how should I say it, satisfying them together."

Erin's mouth fell open. "Oh my."

The men chuckled.

"Anyway, about two years ago, I was in the City of Queens when they finally convinced me to get involved," Hunter continued. "I told them I was planning to go north and help out in the war, but they thought I would be especially well suited for a particular assignment since I had no ties to the military. They wanted me to investigate an army officer, a Commander Corwin Mallory, who was being considered for promotion to the rank of general. Now that in itself wasn't unusual but—"

"Well, I'll be," Gustin interrupted. "Hunter, how could you conduct an investigation without knowing my connection to him?" he asked with suspicion.

Hunter expected his reaction. "Just let me explain. I agreed and began the investigation, working with the Adjutant General's liaison. I spoke with old acquaintances and former commanding officers—you know, the usual stuff—and discovered some troubling details. All the officers on the list were right there in the capital. Only two enlisted men were in the pool of names, both of which were gone fighting in the north, well out of reach.

"I wondered how he'd managed to avoid a field assignment, so I requested to see his complete service record, several times, in fact, before they finally produced it. Turned out he'd spent two years as a captain assigned to the garrison in Southport. That's a small shipping port on the southern coast of the Lowlands Province."

"Yes, I know," Gustin said. "I grew up in Lake City. Go on."

The other two were now intently listening as well.

"Well, the senior officer there, a Commander Briggs, had given him two negative service reports, including a letter of reprimand for conduct unbecoming. Problem was, the letter itself was missing, so I was never able to find out why. But I did find out that Briggs requested the captain and his entire

platoon be reassigned. His record stated that he was promoted to commander and sent to, and I quote, 'the western region' of the kingdom . . . quite cryptic for a duty assignment. Anyway, he was there a short time before being transferred to the capital."

"But what did the record say about his time there?" Gustin asked.

"That's just it, Gustin. It was the most ambiguous part of his entire service record. It simply stated he spent time exploring the disputed lands and—"

"Exploring!" Gustin erupted. "That damn fool couldn't find his way home lest someone point him in the right direction!"

Draigistar was amused but thought better of goading him on.

"Gustin, calm down," Erin said. "You're scaring me."

"Oh, I'm all right. That rotten. . . ." He trailed off as he shook his head in disgust.

"I'm not sure we should continue," Hunter said.

"Yes, Hunter. I want to know what it says about me," he insisted.

Hunter looked down into the fire for a moment before continuing.

"It doesn't . . . it doesn't mention you by name."

"What?" he said in disbelief.

"You see, that's why I didn't know who you were before today. His record stated that during an expedition he led into the disputed lands, his first officer instigated a mutiny and led the platoon in killing twenty friendly locals while he was away scouting."

"No," Gustin softly said in disbelief, his eyes now far away as he stared into the campfire. A long, uncomfortable silence settled over them.

"A hundred and forty-one," he finally said, looking up at Hunter. "Not twenty, a hundred and forty-one innocent people. I know. For two years, I saw them every night in my sleep.

Sometimes I still do. . . . My God, it's like they never existed," he added, shaking his head.

Hunter could see the pain in his eyes from the horrible memories, and he empathized. He'd collected enough of his own through the years. "You see, Gustin, I'd heard of the massacre at Kwantah. But until today, I had no way of knowing it involved you."

"Surely you can't believe what was in that report."

"Of course not; I know you better than that. And I know what he is. As for my connection with him, I suspected my assignment was a mere formality, and the army's decision had already been made. Turns out I was right. He's clearly riding on someone's coattail. I recommended against his promotion and disclosed some embarrassing details to support my reasoning. Left him with some uncomfortable questions to answer, but of course, I was rebutted by a couple of pompous old windbag generals who campaigned for him. . . . Then later, he made the mistake of accosting me in the hallowed halls of the Royal Army Staff Headquarters."

"Um, Hunter, I'm sorry; what does that mean?" Erin asked.

"He picked a fight with him," Draigistar said.

"Oh," she said, wide-eyed. "What happened?"

Hunter smiled. "He woke up in the infirmary with a broken jaw."

They chuckled, and even Gustin smiled at the news.

"You didn't get in trouble?" she asked.

"No. Plenty of witnesses saw him start it. If it's any consolation, I'm sure he hates me as much as he does you," he said, looking at Gustin.

He nodded and slowly stood. "Do people like him ever get their due?"

"Yes. Just not in this life," Hunter replied as he stood and extended an open hand to his friend.

Gustin smiled and shook it.

"Well, it's been an exciting day," Draigistar said. "I'm turning in."

"Good plan," Gustin agreed. "How're we going to split up night watch?"

"I'll start it," Erin said. "You all get some sleep. Hunter, you were up most of last night."

"Yeah, and I slept all night," Gustin said. "Erin, you wake me when you're tired, and I'll take the rest of it."

"All right."

"How's your arm?" Hunter asked.

"Oh, it's good," he replied, holding up his hand and making a fist. "Still sore, but I can use a sword if I have to. Well, goodnight," he said as he headed off to his bedroll. Draigistar did the same, leaving Erin and Hunter alone by the fire.

They quietly visited while Lance's night watch woke their relief and turned in.

"The fog's really setting in," she said.

"Yeah, part of camping near the springs."

"Hunter, you think they'll attack us soon?"

He studied her. Despite her youth and worldly innocence, she had a seasoned fighter's wisdom and confidence. He knew she'd faced death in her adventures with the other three and could handle the truth.

"Yes, Erin. I think they'll start wearing us down, depriving us of sleep, picking us off if they can. Then eventually, when they've got us jumping at every little noise in the dark, they'll attack."

"That's pretty much what Gustin said," she replied, looking down into the fire.

"Want some company on watch tonight?"

"No," she said, shaking her head. "You get some sleep. I'm not afraid of the dark."

He smiled. "All right. Wake me if you need anything. I trust your instincts."

"Thanks. That means a lot."

He stood up.

And when she stood to face him, she froze. "Hear that?"

He listened briefly. "Voices," he whispered.

"Yes," she agreed, pointing to the kaishons. They both looked around to see the night watch was still in place before heading toward the wagons. Then they saw Fae sit up on her pallet and look around. When her eyes met Hunter's in the dim light of the campfires, he placed a finger to his lips and pointed at Celeste's wagon. She was instantly on her feet, sword in hand, moving to join them. They could hear a heated conversation between Celeste and Janae when they drew close to the wagon. It was clear they were trying to keep their argument private.

"What do you mean you're sorry? You keep saying that," Celeste said. "I trusted you. My father trusted you."

"I know, Celeste," Janae replied through her crying. "Please understand, I was only supposed to report things about your father's business. I—I just got in too deep. I had to do what they told me to. Celeste, please, I never meant to—"

"Oh, just shut up," Celeste cut her off. "How could you?"

It was obvious they were both crying now, and Hunter's heart ached, listening to their friendship being torn apart.

"Celeste, please forgive me," they heard Janae say. "I deceived you when we met, and I'm sorry. But I swear our friendship is real. That's why I—"

"Real?" Celeste cut her off again. She was becoming less concerned about waking others. "It isn't real. How can you say that? You lied to me all this time. The personal things I shared with you," she said as her voice cracked.

"I never told anyone, I swear."

"Oh, just get out!" she replied as their crying escalated. "Go! And don't speak to me anymore, you liar!"

"Celeste, please, I'm so—"

"Just go!" she yelled.

They exchanged a panicked look and quickly moved to the front of the wagon before Janae exited. As they huddled, Erin suddenly dropped to a knee and grabbed Hunter's hand, pulling him down. When he knelt, she pointed to the other

side of the wagon, and he could see one of the night watchmen just resuming his patrol. Fae joined them in a crouch, and they watched Janae climb out of the wagon and walk off toward the far side of the camp, still crying. They could hear Celeste crying inside the wagon as they stood and quietly moved behind one of the big freighters where they could talk.

"We blew it," Hunter said. "We forgot to watch for anyone else listening in."

"It's all right," Fae said. "I know who it was. I'll keep an eye on him."

"Well, tomorrow should be interesting," Erin said.

"I didn't see anyone else waking to their argument," Hunter said. "But like all news, it'll spread like wildfire through the camp."

"Now I'm worried about Janae," Fae said.

"Yeah, if that kid told Gustin the truth, she's not the only Shadow in camp," Erin said. "When he finds out she confessed, he'll try to get word out."

"Or take care of her himself," Fae added looking over at Hunter. "Listen, you need some rest. Go try to sleep; you'll need it. Erin and I will finish the watch."

"We've got to keep an eye on Janae," he said.

"We will. Now go; rest while you can. Later we'll talk to her."

"All right," he conceded with a sigh.

"Hunter, do you need to check on Celeste?" Erin asked.

"No," he replied quickly. "She'll know I sent Janae. And she already knew I was aware of a spy in the camp. She heard her father ask me about it. No, I'm sure I'm the last person she wants to see right now."

"Hunter, I'm sorry," Fae said. "We all agreed it was best not to tell her or Hollis."

"I know. I just don't think that'll matter to her. . . . Anyway, I'll deal with it tomorrow. Goodnight, ladies," he said before turning away.

"Goodnight, Hunter," Erin replied.

He silently gave her a wave without looking back as he walked away.

"Oh, what have we done, Fae?" she asked after Hunter had gone.

"Don't worry. I'll fix it. I'll talk to Celeste in the morning after she's had a chance to cry herself out and sleep on it. I'm not going to see them torn apart because Hunter did what was best for her and her father. I will make her understand."

CHAPTER ✝ 9

Once the argument ended, Fae realized she was wide awake. She figured she'd slept enough to get through the coming day and was glad Hunter had gone to rest. *He's taking too much on himself*, she thought. *He's just like Gustin.* She admired them both for it. The difference was she loved Gustin. She'd fallen asleep angry with him—with all of them—for laughing at her. Now, as she silently patrolled the camp, she thought about it and realized they weren't laughing at her per se. It was simply their way of dealing with the knowledge that she'd just given herself to someone, and the timing of her arrival had set them off. *Immature . . . no matter how big they get, they're still boys inside*, she mused. She was over being mad at Gustin, but she'd make him grovel. While patrolling, she looked for Janae, but to no avail. Finally, she saw one of the scouts standing night watch.

"Flynn, have you seen Janae?" she quietly asked, approaching him.

"No. Uh, pardon me for asking, but did she argue with Celeste?"

Now her interest was piqued. She and her friends were confident he was loyal to Hollis, but she wondered what prompted his question.

"Why do you ask?" she replied with a surprised look intended to mislead.

"Well, earlier Carlo came by the tents where most of the others are sleeping and said he overheard them arguing and

Celeste threw her out."

"Oh? Who'd he tell?"

"Derek and Krysta. They were sitting up talking, and he told her, I guess, since she's friends with them. Strange thing happened after that. When Carlo went back to his watch, I saw Zandor sit up and look around. He didn't see me standing by the wagon. Anyway, when Derek and Krysta went to their tents, he got up and headed toward the horses in a hurry."

Fae's instincts told her she'd just found one of the spies. She and the others had become suspicious of Zandor, Hollis's other hired scout. Now, worried about Janae, she decided to confide in Flynn.

"Yes, Flynn, they did argue," she confirmed. "Listen, I'm worried about her. We know there's a spy in our camp."

"Shadow?"

"Yes," she replied, carefully reading his expression.

His response was unexpected. Briefly, a distant look befell him as if he was trying to recall something. "That would explain the way he's been acting. What can I do?"

"You can find Janae; she's in danger."

"On it," he said before turning and disappearing into the foggy darkness.

She headed back to center camp. It was time to wake Gustin. He'd get a pass on the groveling, for now. When they had made camp, the four staked their claim on a large, flat patch of ground encircled by a ring of waist-high boulders. It was near the center of camp, yet far enough away from the main fire so they could turn in early with minimal distractions. And best, it was tenable if they were attacked.

She wouldn't wake Draigistar yet. She wanted him rested so he could fully utilize his magic. In all their travels together, Erin and Gustin had yet to witness the full might of his magical powers. She alone knew what her lifelong friend was capable of. He would often spend an entire night reading scrolls he'd collected, most of them written in ancient or foreign tongues.

He was her oldest and dearest friend, and she admired him greatly for his inaxhaustible drive to learn. She didn't even know how many languages he could read or speak, but she knew what it took to master a single spell, and he was always working on new ones.

She found Gustin asleep and knelt down beside him.

"Gustin," she whispered, gently placing a hand on his shoulder. He was normally a light sleeper. "Gustin," she whispered louder. She felt his body tense, and he opened his eyes, quickly turning his head to look up.

"Fae? Oh Fae, I'm sorry for—"

"Shhh." She placed her hand over his mouth. "That's not why I'm here. We'll talk about that later," she said coldly. "Listen, wake up, and clear your head. There's trouble."

When she took her hand away and stood up, he threw off his blanket and came to his knees, grabbing his tunic. While he clothed and armed himself, she stepped over the rocks and stood with her back to him, facing the waning campfire.

"Fill me in," he said, stepping up next to her.

She quickly explained, telling him of the argument and of Janae missing. She was telling him what Flynn had said about Zandor slipping out when Erin appeared.

"I've looked everywhere; Janae's gone," she said. "I found some tracks leading off toward the stream but dared not follow alone."

"A wise decision," Gustin said. "This fog's really set in since dark."

"I've got a bad feeling about tonight," Erin said. "We've got to go find her."

"You know we can't do that," Fae replied. "We're responsible for everyone else."

Just then, the darkness shrouding the camp lit up. They heard a faint sizzling sound that grew louder as their eyes were drawn to a bright light.

"Look out!" Gustin yelled, grabbing them and falling to the

ground. A bright orange flaming ball flew past them, striking the ground before bouncing up into one of the heavy freight wagons with a loud crash. It rocked the birck violently, igniting its wood before falling to the ground, still burning.

"It's started," Gustin said, hearing frantic yells from those around camp who'd been shaken from their slumber.

"A fireball," Draigistar announced, having been jarred awake. "They have a wizard up on the hillside."

Then another one approached, lighting up the camp. The thick fog that covered them magnified the illumination of the burning object, briefly turning night into day. The second flaming sphere struck the front of another birck and caromed into the team of hobbled draft horses still hitched to it, knocking one off its feet. The remaining horses in the team panicked and began struggling to break free of their restraints. The two lead horses broke their hobbles and tried to run, dragging the injured horse and its still-restrained mate along with the damaged, burning wagon.

Now pandemonium spread throughout the camp. They could see others running, searching for cover.

"Fae, you and Erin go check on Hunter and Celeste," Gustin said. "I'll see about Hollis and Lance."

"Got it," she replied as they turned and sprinted away.

"Bring them back here!" Draigistar shouted. "It's the safest place!"

Hunter awoke and emerged from his bedroll beneath Celeste's wagon.

"Celeste!" he called out as he yanked open the heavy cover.

She turned to face him, startled. Even in the dim light of a single candle, her expression was unmistakable. She wasn't happy to see him. "What's going on?"

"We're under attack. I need you to come with me, now."

She slung her leather vest on over her nightshirt, and grabbed the rest of her clothes and her sword just as the second fireball struck the wagon behind hers. She scrambled toward him, and he caught her when she threw an arm around

his neck. Then he turned and started to run.

"Put me down!" she protested as Fae and Erin approached. He slowed just enough to set her bare feet on the ground.

"Come on!" Erin yelled with a summoning wave.

Running for safety, Hunter didn't give a thought to the brief, sharp pain that coursed through his right hip and down his leg.

By the time they reached the safety of center camp, Gustin was at the other kaishon with Lance and Hollis. They knelt together just as an arrow stuck in the side of the wagon above Lance's head, causing him to recoil.

"It's started," he said.

"Yes," Gustin replied. "Let's get to the cover of the big rocks."

"You go with him, boss," Lance said. "I'm going to check on our people."

"All right, be careful."

"Come on," Gustin said.

Hollis jumped to his feet with a younger man's agility, and they ran through the flying arrows to join the others.

"Father!" Celeste yelled when she saw him coming through the fog. Hunter placed a firm hand on her shoulder to prevent her from standing and took a narrow-eyed glance in response. Just then, an arrow sliced through the night air past her head, scintillating off a nearby boulder. She crouched, and Hollis knelt over her as a shield.

By now, most of the others in camp had taken refuge under the wagons, and a torrent of bolts and arrows seemed to come from all directions.

"Everyone stay inside the rocks!" Draigistar yelled. "*Kineesh-timoss*," he said as he came to his feet, raising both hands over his head with palms up and thumbs together. He lowered his arms as he turned in place, and a faint blue, glowing sphere enveloped them. To everyone huddled inside the circle of boulders, it looked as if they were inside a giant half-round bubble thirty feet across that extended to the ground all around them.

Now when arrows struck the protective shield, they bounced off, causing subtle blue fingers of light to course over its surface like tiny bolts of lightning.

"That's amazing," Celeste said.

"Now we can make a plan," Draigistar replied simply.

"Impressive, mage. Can anything get through that?" Hunter asked with a grimace that puzzled Fae.

"We'll be safe," he replied confidently.

"Hunter, are you all right?" Fae asked.

He didn't acknowledge her as he pulled his hand up from behind him to see it glistening with blood.

"Hunter!" Fae exclaimed.

"You're hurt!" Celeste said as both women moved toward him.

"Oh, I'll be all right. I took a glancing shot from a crossbow when I sat you down by the wagon."

"Where?" Fae asked. "Oh, Hunter, you've been shot in the butt," she said. "How embarrassing."

Just then, a third fireball lit up camp, approaching from the same direction. It struck the ground near the fire pit, careening into a line of horses tied to a freighter. Two of them went down from the impact as others ripped at their tether to break free, their inherent fear of fire driving them to a maddened frenzy.

Soon after, a fourth pierced the night, heading toward the center of camp. It slammed into the shield Draigistar had conjured, causing intense blue streaks to race over its surface. The fireball disintegrated into a plume of sparks that drifted down, sizzling when they contacted the blue sphere before sliding harmlessly to the ground.

"All right, somebody's got to go up there and put a stop to that," Gustin said.

"Can we leave this?" Hollis asked.

Draigistar was kneeling, rummaging through his pack. "Sure," he calmly replied. He picked up a rock and tossed it past Hollis. It hit the shield and continued on through, leaving a wave

of subtle blue light rings emitting from the point of impact like ripples on a pond. Everyone looked at each other in amazement.

"Hey, it's stopped," Fae said.

Hunter lay on his side, pants partially down, with Erin and Celeste examining his wound. He noticed Draigistar stand up, peering through the fog toward the hillside with his hands cupped around his face.

"*Shonee-shoah*," the mage quietly uttered. "*Shoah, shoah.*"

"What are you doing, mage? You look ridiculous with those feathers," he said just as Erin yanked the bolt from his backside. "Ahhh! What the, you didn't have to—"

"Don't yell at me," she cut him off. "And don't be a baby; it wasn't in that deep," she added, slapping his butt.

Draigistar didn't respond. Holding feathers between his fingers, he continued to focus on his task.

"Owl feathers, for a spell," Fae told Hunter. "Any luck?" she asked the mage.

He nodded slightly. "Erin, how far would you say it is from here to the first big pool where you ladies bathed?" he asked without looking her way.

She stepped up beside him, not bothering to look into the fog. "About two hundred feet I'd say, and twenty feet up the hillside," she said, readying her bow. "Within range."

"Four men stand together," he said, raising a hand high in a sweeping motion, causing the shield to disappear.

"What? Why'd you—?"

"Shhhh!" Draigistar interrupted Hollis. "I need quiet."

Now the others watched intently as Erin nocked an arrow and waited.

Slowly, without looking, he reached out and touched the shaft of her arrow.

"*Klaneesto-wintha*," he whispered. Then releasing it, he slowly raised his hand with a finger pointing. "There. . . ."

She stepped behind him and drew back her bow, carefully

lining up her extended left arm with his right arm, using his finger for a sight. As the muscles in her shoulders and arms strained against the force of her taut bow, she slowly let out a breath and released it. *Thunggg.* It was gone, racing into the night.

Draigistar curled his hand into a tight fist. "*Dumoshhh!*" he said forcefully as his body went rigid and he thrust his fist forward. Everyone was startled by his sudden outburst, so contrary to his normal soft-spoken demeanor. They looked on as he returned his free hand to the side of his face, showing no further emotion.

"You got him, Erin. Well done," he said, lowering his hands as he turned to face them. "The others fled."

"The wizard?" she asked.

"I hope that was him."

"That was the most bizarre thing I've ever seen," Hollis said.

Just then, one of the hirelings who'd taken refuge with them pointed. "Hey! Here comes Lance!"

When he approached with Derek and Tobias, everyone began standing up.

"We've taken casualties," he told Hollis. "We lost some people, some horses and wagons. I can't find everyone. We need to round them up and see who's missing."

"Hey, it's Flynn," Erin said, pointing as he emerged from the fog.

"Any sign?" Fae asked him when he stepped between the rocks to join them.

"No. Janae's gone. Zandor's gone. I found tracks, that's all," he said before turning to Lance. "Roth and Milo are dead. Kraven and Randol are both hurt. Those are the ones I know of."

"Damn," Lance said as Hollis shook his head.

"Janae's gone?" Celeste asked.

"Yes," Fae said, watching her close her eyes and raise a hand to her mouth.

"I'm sorry, dear," Hollis said, reaching out to take her in

his arms. Leaning into her father, she looked up at Hunter through wet eyes. He carefully studied her expression in the dim light of the nearby torches. The anger he'd seen before was now a look of confused desperation.

"All right, let's get busy, people. Daylight's coming," Lance said as he began assigning duties. They quickly split up to assess the damage.

Hunter stayed with Hollis and Celeste while the others went to work.

Fae pulled him aside and filled him in on what happened while he slept.

"Hunter, it's time they both know the truth," she said of Hollis and his daughter.

"I know," he said with a sigh. "Fae, as soon as we get the camp back together, I'm going to find her."

"Hunter, calm down. As soon as we can, we will, but right now, you're needed here with them."

"I know."

The eastern horizon began to lighten, making their recovery easier. The attack lasted only moments, but it dealt a serious blow. There were two dead, five injured, and two missing. Two horses were killed, and several others were injured so badly that they had to be put down. The first wagon struck was a total loss, burned in place. Another was pulled away from camp when its panicked team bolted. Both wagon and team were unaccounted for.

After the others dispersed, Hunter knelt with a water skin, washing dried blood off his hands. When Hollis took a seat on a boulder facing him, Celeste knelt behind her father to discretely finish clothing herself for the day. After dressing, she stepped over the large rock and sat down cross-legged near them both.

"Hunter, why didn't you tell me?" she asked when their eyes met. "Why didn't you tell my father?" Her tone was accusatory, her expression exuding her feelings of betrayal.

He'd contemplated how to handle the questions he knew would come when they learned the truth about Janae.

"Celeste, the others and I decided before leaving Port Estes that it would be best to wait about telling you. Frankly we weren't sure either of you could act normal if you knew," he said, looking at them.

"You knew before we left?" Hollis asked in amazement.

"Yes, sir."

"I just can't believe it," he replied, shaking his head as he looked down. "How could I have been so naive?"

"Both of you, please try to understand something. As I've gotten to know you, I've studied the relationship between you three. I know both of you care about her. And I know she cares about you."

"But she lied to us," Celeste said.

"Yes, I know. . . . Last night when I confronted her, I got to know more about her and her past. She's been involved with them for a while now. And like most, she was recruited from a loathsome existence. Celeste, put yourself in her place for a moment. She's been beaten and violated. She's been degraded and threatened with a horrible death if she ever tried to leave them. Her situation was hopeless until I offered her help getting out if she came clean. She's been living with the burden of a terrible secret ever since you met her. She did a brave thing coming to you."

She returned his gaze without faltering, even as tears streamed down her cheeks.

"I can't say you should forgive her," he continued. "I changed the course of my life with an unforgiving heart, only to realize the price was far too great. No, that decision is yours alone. But as you deal with your own pain, try to imagine hers. She's alone in this world. And I think you'd agree we've all made mistakes and hurt those who care about us. Maybe she deserves another chance."

"Hunter, what if Janae's absence is related to this attack?" Hollis asked.

He studied the merchant. "You mean, did she deal us the final betrayal? No. After last night I don't believe that. I'm sorry for what you're both facing right now, but she didn't do this. She's run off to hide, or been abducted. But either way, she's facing a fate far worse than death if we don't find her. I know she's hurt you both, but she doesn't deserve what they'll do to her."

"No, she doesn't," he agreed, shaking his head. "Right now, getting her back here safe is my first concern," he added as Celeste covered her face with her hands and softly wept, horrified by the images Hunter's words evoked.

Lance had Tobias form a burial detail for their fallen while Gustin, Fae, and Draigistar searched the hillside near the springs to confirm Erin's kill. When they approached the large pool at the base of the hill, Fae discovered a body sprawled on a large rock. The dead man was lying supine with a massive wound to his midsection.

"What did you do?" Gustin asked, picking up two broken, bloody halves of what looked like Erin's arrow, only much bigger. "This looks like a ballista shot."

"My spell enlarged the arrow in flight," he said, looking down at the corpse.

"Not the wizard," Fae said.

"No," Draigistar agreed, "just one of the lackeys."

While Hunter put down one of his horses that was gravely injured by a fireball, Erin and Flynn led a party away from the camp to find the missing wagon and search for any sign of Janae. They followed the tracks nearly halfway back to the main road before finding the wagon ransacked. Its contents were strewn about with crates busted open and pilfered. The team of horses lay dead, still hitched. They'd all suffered wounds from arrows and bladed weapons. And the tracks of several men and horses led away from the scene toward the stream.

Now the five friends stood at center camp with Hollis and his daughter.

"We have to go find Janae," Celeste said frantically. "I know it's my fault she left; I want to go help find her."

"Absolutely not, young lady. I won't hear of it," her father countered. "We'll find her. But you're not leaving this camp."

"All right, just slow down," Gustin said. "Some will need to stay here and guard the camp. Hunter and I can go find her."

"No," Hollis replied. "I want at least one of you here in case of another attack."

"I'll go," Fae interrupted. "Gustin, Hunter should be the one to go find her. We'll take Erin with us."

He knew she spoke the truth. "Just be careful," he said after they stepped away from the others. She leaned into him when they stopped with his arms closing around her.

"I will," she replied before they kissed, parting when Hunter and Erin approached.

"You ready?" Hunter asked.

"Uh huh."

"I'll show you where I found Janae's tracks," Erin said.

"Good. We'll start there."

The two big men exchanged looks.

"You need not say it," Hunter said. "I won't let anything happen."

Gustin nodded before his eyes returned to Fae's as she stepped away with her hand still in his. When their fingertips parted, she turned and walked away, flanked by the other two. He silently watched until the morning fog swallowed them up. Then he thought of Erin's words from last night. *You don't know what she went through while you were gone, worrying about you.* Turning to go help break camp, he realized that now he would know.

/// \\\

The three walked for a while in relative silence until Erin slowed and began looking down at the ground. Even with the sun now

up, visibility was still poor. The fog around camp had begun to lift, but the closer they came to the stream the thicker it was.

"There," she said in a loud whisper, pointing as they knelt together and studied the tracks. "Before the attack, I found tracks like these just outside camp. I'm sure these belong to Janae. It's uh, just something I do," she said shyly. "I loved to learn tracking as a child. I look at people's footprints," she said with a shrug. "I could follow all of you together and know who made which tracks."

Hunter and Fae exchanged a fleeting smile. "These other prints here, the larger, deeper ones, they were there too?" he asked.

"Yes," she replied. "I don't know Zandor's tracks. I stayed away from him; he's creepy. But I don't think he forced Janae to leave. I think he followed her."

"Yes," Hunter agreed. "It doesn't appear these tracks were made by someone under duress. And she wasn't running like she was being pursued."

"No," Erin said. "I'd say after leaving Celeste's wagon, she probably found a place alone and just sat down and cried."

"That's when Zandor overheard Carlo tell Krysta and decided it was time to get out of camp," Fae said.

"Yeah. He may have been looking for Janae, or he may have just happened upon her," Erin said with a confirming glance.

Hunter looked at Erin with a puzzled expression. "Just sat down and cried?"

His confusion made them smile, and Fae squeezed his hand. "It's a woman thing."

He shook his head. "Well, let's go find her," he said, standing up.

They stood, huddled together, briefly deciding on their strategy. It was crucial from this point on that they move silently, so they devised a few hand signals and formed a skirmish line with the women on the flanks and Hunter following Janae's tracks. Now barely in sight at thirty feet apart, they

methodically moved toward the stream. Soon they reached it and found signs of activity along the bank. There were numerous prints of boots and shod hooves. They stood listening until Hunter gave the signal to converge.

"What happened here?" Fae asked in a whisper. "There are tracks everywhere."

"I made four different horses, one of them big," Erin replied. "And several men moving along the bank. They must've found Janae."

"Maybe not," Hunter said. "About fifty feet back when I stopped—"

"Yes, what was that about?" Fae asked.

"From the tracks, it looked like Janae discovered she was being followed. She stopped and turned, perhaps to listen, then quickened her pace. Look, I'm not ready to give up yet. I'm going to find her," he whispered passionately. "I know she's scared, but she's also smart. So, until I find some evidence otherwise, I'm going to assume she did what I'd have done in her situation. Once to the stream, I'd have entered and moved quietly until I outdistanced my pursuers or found a good place to hide."

"Yeah, but which way did she go?" Fae asked.

"Downstream," Erin quickly replied.

"Yes," he said, looking at her. "Why?"

She looked at him thoughtfully.

"You're right, Erin," he added. "Instinctively, you know it, but why? The best way to track someone is to—"

"Put yourself in their situation," she finished.

"Yes, and in their state of mind. So why?"

"Because . . . well, when she realized she was in danger, she wanted to return to the safety of camp."

"But?"

"But she knew she might not make it past whoever was behind her. And even if she did, she thought she wasn't welcome there anymore. So, she just ran."

"Yes," Hunter replied with a confirming nod. "I believe she went downstream and evaded Zandor. She may not have even known who was following her, but eventually he gave up and went for help to return and search for her. That's why all the tracks."

"All right, let's go," Fae said impatiently.

With swords drawn, Hunter and Fae forded the forty-foot-wide stream that ran waist-deep on him. Once on the other side, they silently made their way along the bank. Erin could barely see them through the fog, but she paced them with her bow at the ready. The stream paralleled the road that meandered through the small valley from the Queen's Highway up to the hot springs. Hunter figured they'd gone about halfway to the main road when he suddenly stopped them.

"Look," he whispered to Fae.

When she stepped closer, he pointed down at the tracks of a large horse. They'd followed the tracks of two mounted riders downstream from where all the other footprints had broken off and led into the forest. Here, it was apparent that one horse had turned into the forest while the other much larger one had turned toward the stream and stood for a while, shifting its weight. Perhaps the rider had spent time listening for sounds through the fog before reigning the horse around and heading into the trees.

"Follow me," he said quietly. They stepped back across the stream on boulders until they all stood together once again.

"Anything over here?" he asked Erin.

"No. The footprints played out."

"Well, what now?" Fae asked.

"I still think she evaded them," he said. "We've seen no sign of a struggle, or of anyone being led or dragged from the water's edge."

"Well, I trust your instincts," Fae said. "Let's keep looking."

He knew Erin was watching the stream behind him and noticed a sudden change in her expression. "Erin?"

"Hunter, I could swear I saw movement on the far bank by those big rocks," she said, glancing at him before returning her eyes to the stream.

He resisted the urge to turn and look. "More than one?" he asked as Fae discretely leaned to look around him, peering through the now-waning fog.

"No," Erin answered confidently. "Looks like somebody's dug into the mud there just out of the water. It could be Janae."

He glanced at Fae, and she nodded, confirming she was ready to follow his lead.

"Cover us," he said.

Erin nodded.

He suddenly turned and headed back across the stream on the boulders, shifting his attention between his objective and his precarious footing until he reached the muddy embankment with Fae right behind him. Now he focused on the place Erin described and started that way. He soon realized he, too, could see the outline of someone curled up between two large rocks among the exposed roots of a tree. They were completely covered with the gray mud, concealed so well that only movement would betray their place of refuge. He knelt a few feet away to study the figure and was startled when he saw a pair of eyes peering back at him from the mud.

With a deep breath, he regained his composure. "Janae," he said softly. He slowly reached out a hand. "Janae, come to me. It's all right. . . ."

Slowly a mud-caked arm rose from the mire and reached out to him. It was unnerving, watching the featureless figure move. He had no idea of her condition, but he pondered the wracking fear that must have driven her to take such an extreme measure.

"Hunter?" she said softly as if she wasn't sure it was him.

"Yes," he replied. "It's all right; you're safe."

He moved in as she began to free herself from the muddy bank. His strong hand closed around hers, noisily squeezing

the mud from between them as she struggled to stand. He reached out and wiped some mud from her face.

"Oh Hunter, thank God you came," she said as she began to cry. "I was so scared. I didn't have my sword, and someone was chasing me, so I ran to the stream and found this place to hide. Then I heard a battle. And after that, they were looking for me. Oh, oh, and I saw him, the Shadow Knight. I knew it was him. And he saw me too. I was terrified." She was speaking faster and louder as relief overwhelmed her.

"Shhh. Calm down," he said softly. "What do you mean he saw you too?"

"After the others left, he sat on his horse up there on the bank, just looking right at me. I swear I was afraid to even blink. It was like he made me want to go to him, but I wouldn't, so he finally just went away. Oh, Hunter, what is he?" she asked through her streaming tears.

He's pure evil, he thought. "It's all right, Janae. We're here now."

Erin relaxed the grip on her bow and lowered it with a sigh of relief as Fae moved closer. "Hunter, we need to go," she said when their eyes met.

He gave her a nod.

"Janae, listen, we need to get out of here," he said. "Let's clean you up."

She calmed herself and sniffled. "Hunter, I can't go back. Celeste hates me. Please, just give me a dagger and let me go. I promise you'll never see me again," she said as her voice cracked.

"I'm not going to do that," he replied. "Janae, I had a long talk with Celeste and her father. I think you'll find them both very glad to see you again. You can't stay out here. Come with us and give them a chance, please," he added, prepared to take her by force if she refused.

"All right," she reluctantly agreed.

"Good." He smiled as he turned with her hand in his and led her into the stream. The water was comfortable with the

warmth from the nearby hot springs. Composing herself, she squatted in the crystal-clear water up to her chin and began vigorously rubbing her face and clothing. Then she took a deep breath and ducked her head under the water, continuing to scrub. While she repeated the process, he rested his sword on a nearby rock and joined her, kneeling in the water and scrubbing the mud from his clothing.

"Hunter," Erin whispered loudly. "*Hunter!*"

When he and Fae both looked at her, sensing the urgency in her voice, she pointed at the water behind Janae. The entire breadth of the stream moving away from them had turned into a massive, gray cloud.

Oh, you fool. You knew better than that, he thought as he nodded to Erin, conceding his amateurish mistake.

"Janae, come on," he said as he grabbed his sword and again took her by the hand. He hurried her across, knowing if anyone was downstream, they'd soon be onto them. Fae deftly bounded her way back across the rocks to join them, and they all set out toward camp. The fog was burning off now, and Hunter estimated he could see nearly a hundred feet. On the far bank of the stream was a thick forest that offered good cover for anyone who might give chase, so they decided to follow the road back to camp staying away from the forest. They could quickly cover the distance at a flat-out run if they were spotted, but if their pursuers were mounted, they'd have to turn and fight. Erin took point with Janae in tow and soon led them past the remains of the ransacked wagon. They walked on without speaking until Erin suddenly raised a hand as she stopped and knelt. When they joined her, they could all hear faint voices coming from the forest beyond the stream.

"Think they've been following us?" Janae whispered.

"No," Erin replied. "I'd have heard them before now."

As they huddled together, listening, Fae's intuition nagged at her. She'd been watching behind them. Her instincts told her they were being followed. After scanning through the fog

around them, she was about to dismiss her feelings when she saw movement. *There. I knew it,* she thought, looking back down the road. And she knew Hunter sensed her alarm.

"Just off the road, I saw one, maybe two, behind that fallen tree," she said softly without looking up. As they both looked that way, Hunter could barely make out the tree he knew was there and marveled at her ability to discern movement in the fog.

Erin noticed movement within the forest and knew they'd soon be cut off.

"Fae, we need to go," she whispered.

She nodded as Hunter looked into the forest, then at Janae to study her reaction. He was pleased when she glanced at him, and he saw no sign of deceit, only the same fear they all felt.

"Come on," he said, leaning close to Fae.

Just then, Erin startled them. "Bow!" she said as she stood and drew hers back.

Now they saw the silhouette of a man standing up behind the tree with his bow drawn, aiming at them. Another was just standing, and they spotted two more figures emerging from the fog, running to join them. Then the unmistakable sound of a bow's release was followed by an arrow slicing through the heavy air toward them. Erin aborted her shot as they all crouched low.

Enough! Fae thought in anger. She brought her sword up as her keen elvin vision locked onto the incoming instrument of death. Even in the fog, she moved the blade to deflect it away harmlessly.

"Run!" she yelled.

Hunter knew her intention when she pointed the tip of her sword at their pursuers. As he and Janae came to their feet, Fae unleashed the fury of her enchanted weapon. The blade briefly glowed with blinding intensity before a bolt of energy shot toward the fallen tree. It struck with ground-shaking

force, blowing it apart and sending splintered wood into the air along with the bloodied Shadow who'd sought its refuge.

They were briefly blinded by the flash. And a loud clap of thunder deafened them as she turned and shoved Janae in an attempt to get them all moving. They regained their senses while they ran in a tight group flat out toward camp.

/// \\\

Gustin managed to fulfill his duties in camp after Fae and the others left, even though his mind was on her. Hollis and Lance decided they'd use the remaining daylight to push on further south as soon as the party returned. They'd cross the Skull River and camp where the Queen's Highway split from the high road and entered the Forest of Souls.

It was now midday, and those in camp busied themselves. Horses and wagons were rechecked, loads secured, and weapons kept at the ready. Two of the wagons held stores of additional weapons, including a dozen crossbows that had been issued to those in the group most adept in their use. Normally the teamsters didn't carry the cumbersome weapons. But it was now clear they needed every defense available.

Gustin thought Fae and the others had been gone too long, and his anxiety was mounting. As he paced near the wagons, Draigistar sat on the ground with his back against a wheel, studying the Rendovan's map and documents.

"She'll be all right," he calmly said without looking up when the big man walked by.

Stoically, he turned and looked down at his friend while the others nearby held their silence. Finally, his expression softened. "You're worried too."

"Of course," the mage replied, looking up, "for both of them, but especially Fae. She's my oldest, best friend. Known her my whole life."

"Both of them? And what of Hunter?"

"Oh, he's like you. He can take care of himself," he said with a grin.

Gustin smiled and was just about to speak when a deafening clap of thunder split the eerie silence. Everyone crouched, and a driver seated on the nearby wagon recoiled so abruptly that he lost his balance and fell from the seat.

"What was that?" someone asked.

Gustin and the mage looked at each other. They knew Fae's enchanted sword was the only possible explanation. Draigistar quickly stowed the items he held and came to his feet while Gustin turned to look into the fog.

"Get your people ready!" he yelled to Lance, who'd crouched behind a large rock where he sat talking to Hollis and his daughter.

"What is it?" he asked as he stood and started his way.

"They must be in trouble," he replied. "Lance, make sure your best people are with Hollis and Celeste. I'm going out there."

"Done," he replied, knowing he wouldn't be dissuaded.

"Hey! I hear someone coming!" one of the teamsters yelled.

"I hear it too," Draigistar said. "Several, running."

"Make ready, people," Lance ordered as he and Gustin drew their swords and stood there, listening, peering into the fog. It was now obvious a group approached.

"In the camp! Hold your fire!" a feminine voice yelled out in the distance.

"It's Erin," Draigistar said with a smile of relief.

"Yes," Gustin said, still watching.

"Everyone hold your fire!" Lance yelled out. "Friends coming in!"

Then they saw four running figures appear through the fog and quickly recognized them. When they reached the safety of the wagons they slowed. Fae quickly locked eyes with Gustin and went to his waiting arms while Lance approached Hunter.

"Welcome back," he said. "Trouble?"

"A little," Hunter replied as he caught his breath.

"Were you followed?"

Hunter glanced at Fae. "She watched behind us."

"No, I don't think so, Lance," she said as she stood with her cheek pressed to Gustin's chest. "I thought I was going to have to carry you, the way you were limping," she said, teasing Hunter.

"I'm sore."

"That'll teach you to keep your butt down," she countered with a grin.

Draigistar gave Erin a hug and then looked at Janae. "You all right? You gave us a scare," he said, reaching out his open hand in a sign of friendship.

She placed her hand in his. "I gave myself a scare," she said tentatively.

Eager to show his acceptance, he stepped closer and gave her a hug that she enthusiastically returned. "Good to have you back," he said with a smile. "Were glad you're safe."

"Thank you," she replied sincerely, fighting back the tears.

When they released each other, she nervously turned to face Celeste and her father, not knowing what to say.

Hollis broke the tension. "Thank God you're safe, dear," he said with a smile.

"Oh, I'm so sorry," she said as her voice broke.

"Shhh," he whispered. "Come. Let's get you some dry clothes, and we'll talk," he added with a beckoning wave as he started to turn away.

"Celeste, can you ever forgive me?" she asked with tears now rolling down her cheeks.

Celeste smiled and reached out, embracing her as they both cried. Quietly they turned away and followed Hollis toward the kaishon.

"All right, gather round, all," Lance said. He took a moment

to lay out the plan to move on and camp after crossing the Skull River, and soon the column pulled away from the hot springs, heading back to the main road.

CHAPTER ☥ 10

Lance led the column of wagons back down to the main road, and by the time they turned south on the Queen's Highway, the fog had burned off to reveal a sunny day. The forest quickly yielded to sprawling meadows. And while it was unlikely the Shadow would try anything in open terrain, Lance kept his people vigilant. The wagons traveled closer together than in the first days of their journey, and all members of the party were now armed.

Traveling along, the four friends rode abreast near Hollis's kaishon, occasionally picking up bits of conversation.

"Think they'll work it out?" Fae asked.

"Uh huh," Erin quickly replied.

"Always the optimist," Draigistar said.

She glanced at him with a puzzled look but didn't speak.

Gustin leaned closer. "He means you always think the best will happen."

She looked at him. "Oh," she replied before looking at Draigistar. "You're right. Someone needs to."

He chuckled, keeping his eyes on the road. "That's all right. I'll stick with being the pessimist."

They rode on for a while with little conversation until Lance fell back and joined them. "The other night round the campfire, didn't I hear you say you'd explored this region when you were growing up?" he asked Draigistar.

The mage raised a brow, surprised by Lance's inquiry. Over the years, he'd grown accustomed to being ignored—even

avoided—by those who didn't know him. He was aware of the opinion most folk held of wizards. They were considered by many to be eccentric at best and, at worst, nefarious agents of darkness. He resented the stigma, but his friends didn't judge him that way. And he appreciated Lance's show of acceptance.

"Yes, that's right," he replied. "Why do you ask?"

"Well, we have just enough daylight to get across the river before making camp."

"And?" Draigistar replied.

"How much do you know about the Forest of Souls?" he asked him.

"Well, besides traveling through on the Queen's Highway, I've passed through a few other times. I explored the interior when I was young and foolish," he added with a grin. "I tried to avoid spending the night in there. It's spooky."

"Draigistar, you once told me a legend about that forest," Fae said.

"Yes, about how it got its name," he replied with a glance.

"Did you ever find a road through the forest between the main highway and the high road up in the foothills?" Lance asked him.

Draigistar locked eyes with him. "More like a trail. Surely, you're not thinking of taking these heavy wagons through there."

Lance gave a confirming nod.

"Why? What is it?" Erin asked. "What legend?"

Draigistar gave her a glance. "Well, as you all know, the road forks on the other side of the river. The high road heads straight into the forest running south along the foothills, while the main road turns east along the river before cutting in."

Then he returned his gaze to Lance. "I'm guessing you plan to camp on the main road, so they'll think we're taking the easy route. Then once we're in the forest, find the ancient road and follow it west through the forest up to the high road."

"That's right," Lance said. "It was several years ago when I went through there on horseback. I found the path purely by accident."

"Yes, *path* is a good description," Draigistar said.

Lance ignored his remark. "I spent two more days in that forest scouting it between the two roads. I believe we can get these wagons through there."

"Perhaps. As long as it hasn't rained in a while," Draigistar said. "There's a stream to cross. And the ground's thawed by now. I'm sure you know there are bogs. And if you spent days in that forest, then you spent nights in there too."

"Yes, I slept in the ruins. You're right; it was spooky."

"Why?" Erin asked.

Draigistar looked at her and the others.

"Long ago, there was an elvin village in that forest. It was called Shaelah, and its people were known as the Shaelock. They were advanced, with engineers and master carpenters. Some built great stone buildings, while others lived in elaborate wooden structures built high overhead in the huge trees. They were separatists who cherished their privacy and the surrounding forest that was the life's blood of their society.

"What I call the ancient road passes through its ruins. Legend says they were locked in a bitter feud with another people, who lived high up in the Skull Mountains. It's unknown what race they were or what they were called. In fact, very little is known about them. It's believed they, too, are now extinct. Anyway, they were more primitive and prone to violence. Each society claimed the forest, and after many years of minor disputes, a war erupted. The Shaelock were a peaceful people and no match for the ferocity of their enemy."

"What happened?" Erin asked.

"An army from the mountains invaded Shaelah. They slaughtered the Shaelock and destroyed everything. They felled the huge trees with the people still in them, destroyed their stone buildings with machines of war, and killed every Shaelock. In one day, an entire society was annihilated. . . ."

After a thoughtful pause he continued. "Now, according to legend, their souls wander the forest. It's not uncommon

for a traveler to be awakened by screams in the night, or cries of children, or other scary noises. It's even said the Shaelock can take on material form. They've been seen in other places. They can appear at will, usually at night, clothed in long, dark, hooded robes. If one comes close to you, never look directly at it. You'll see only an empty hood, but it will know you: your heart, your mind, your fears, everything about you. They carry no weapons but can kill with a thought. Good news is, they're said to be benevolent."

Erin looked at him. "Stop using big words," she said, clearly frustrated.

He smiled. "Forgive me. It means they won't harm you if you're nice. At least that's what the legend says."

"Oh," she replied. "So, have you ever seen one?"

"No. But I've heard screams at night in that forest."

As they all listened, Gustin found himself drawn to another slaughtered village on the muddy banks of a river far away. That was his nightmare. And the screams he heard in the night were his own as he fought to free himself of those horrible images that had changed him forever. Suddenly he felt a gentle touch on his arm.

"You all right?" Fae asked discretely, knowing that expression all too well.

He nodded and gave her a fleeting smile of appreciation. "I guess the question is can either of you find that passage again," he said, looking over at Lance and the mage.

"I'm confident I can," Lance replied.

"It was forty years ago for me," the mage said. "But I could find Shaelah again."

"I've forgotten it if you told me, but how long ago did Shaelah exist?" Fae asked.

Draigistar gave her a glance. "What little history is known to the outside world, records it was destroyed more than two hundred years ago."

"That's a strange story," Erin said. "Do you believe the legend?"

The mage looked at her. "Yes, Erin, I do."

"Well, it's settled then," Lance said. "We'll go through the spooky forest."

"I think we should keep this between us," Gustin said.

"Yes," Lance agreed. "I'll talk to Hollis later. And we'll tell Flynn and Hunter when they return."

"They've been gone awhile," Fae said. "Did they scout all the way to the river?"

"Well, I didn't tell them not to."

"Here they come," Erin said.

They could just make out a faint dust cloud behind the silhouettes of two riders in the distance. Lance quickened his pace, and by the time he worked his way back to the front of the column, they arrived to report the road was clear ahead. The column pushed on at a steady pace through the meadows until they reached the stone bridge that crossed the Skull River.

Lance informed Hollis when he emerged from his wagon while the four joined Hunter and Flynn.

"Think Hollis will go for it?" the mage asked while they tended to their mounts.

"Don't know," Gustin replied. "We could stay on the main road and forget about trying deception, just go as fast as we can and hope for the best. But, doing something that crazy might just give them the slip and get us there safe even though it will take longer."

"Go for what?" Hunter asked, looking over his horse at them.

"Lance wants to start down the main road and then cut through the forest up to the high road," Fae answered.

He looked at them with surprise before returning his attention to his horse. "He knows a way?"

"Yes. He and Draigistar have both traveled it before," she said.

"Can these wagons get through that forest, mage?"

"It's been years since I was last through there. But I think it's possible, if it's not too muddy. Lance is more confident than I."

Hunter finished putting his saddle back on his horse. "Well, you may be right," he said, looking at Gustin. "It's just crazy enough to work. But I think it's going to rain tomorrow, and that could change things."

"You're right, Hunter," Erin said. "Maybe not until tomorrow night, but it will rain," she added, looking up at the mountains in the west.

Just then, Lance approached with Hollis and Celeste.

"Lance tells me you can help him lead us through the forest past this place called Shaelah," Hollis said, looking at Draigistar.

"Yes. As I told him, it'll be rough with wagons, but I do know a way through."

"Thought Shaelah was a legend," Hunter said.

"Oh no, it exists," the mage replied. "Well, the ruins do."

"Have *you* been there?" Hollis asked Flynn. "Can you help lead us through?"

"No, sir. I've never gone into that forest; too many scary tales. They'll have to set the path in there."

While Hollis considered Lance's bold proposal, Hunter and Celeste gazed at each other. He sensed she was eager to talk, so they stepped away together.

"How'd it go with Janae?" he asked.

"All right . . . she's sleeping now. I think she had the scare of her life. Thanks for getting her back. And thanks for making me listen to my heart instead of my pride," she added as she leaned into him, turning a cheek to his chest. He held her tentatively, uncomfortable showing affection in front of her father.

Suddenly she leaned back and looked up at him. "She told me how she became a member of the Shadow, and how she's wanted to get out ever since we became friends. And she told me about her little encounter with you up at the springs last night."

He smiled. "So, are you jealous?"

"Uh huh," she said, continuing to gaze at him. They be-

came lost in the moment, delirious from the sensual touch of their bodies pressed together.

"All right, you two, enough of that," Hollis said in a fatherly tone.

They surrendered their embrace and turned when he approached.

"Sorry," Hunter said, embarrassed, as Hollis stepped up close.

"Hah. Nonsense. She's as irresistible as her mother was, and just as exasperating. But let us not forget you're a gentleman, and she's a lady," he said with a grin.

"Oh, Father."

Hollis chuckled. "Come, let us continue while we still have daylight," he said, heading for his horse.

"Let's get across the river and make camp," Lance said as he rode past. "Mount up! Move out!" he yelled out to the others. Hunter mounted as Celeste climbed back into her father's wagon for the final, short leg of the day's journey.

After crossing the river, they kept to the main highway where the road forked and the other route headed into the forest along the foothills. They continued on a little further before making camp a safe distance from the trees. There was another party already camped in their preferred site, a group of fellow teamsters with a rival company from the City of Queens. Lance walked over to greet them while his crew set up their camp.

"Hey, boss, looks like Lance is getting friendly with the competition," Tobias said when Hollis walked by.

"Yes, I saw that. When he returns, tell him I've docked his pay," he replied with a chuckle before continuing on.

"Where'd Hunter get off to?" Fae asked. "It's not like him to leave his horse saddled when we've stopped for the night."

"I told him I'd take care of his horse," Gustin said. "There was something he needed to do before dark."

"He's out in the meadow," Erin said, pointing between two wagons. "Looks like he's searching for something."

"I'm sure we'll find out what he's up to, eventually," Fae said as they all turned their attention back to their horses.

By the time the sun was behind the mountains, a fire roared in the center of camp with food ready to serve, and the first shift of night watch was in place. When they gathered to eat, Celeste and Janae joined them, apparently having worked things out. While the group ate, several small conversations ensued round the fire.

"You look troubled, lover," Fae said to Gustin as an invitation to share what was on his mind. "Is it Hunter?"

"Partly," he replied. "He doesn't act himself."

"And what else?" she asked with concern.

He looked at her for a moment, then leaned close and spoke softly. "That day I questioned Daemus up on the mountain, he told me they had two spies in our camp besides Janae. I directly asked him about it. Of course, I didn't use her name, but he didn't hesitate with his answer. Now I think it's safe to assume Zandor was one, but we still haven't found the other."

"I don't know what else we can do to draw him out."

"Nor do I," he replied. "I've been watching for drops along the road where messages could be left or picked up, but I've seen nothing suspicious."

She thought for a moment. "Perhaps if Lance were to gather his people and announce our plan, then we could stake out the perimeter and see who tries to slip away."

"I thought of that too. But what if they get past us, or don't even attempt to leave. Then we'll have missed a night's sleep for nothing, and we're all pretty ragged as it is. . . . Does Flynn know the truth about Janae?"

She glanced around to make sure no one else could hear. "More or less."

"What do you mean?"

"Well, I told him she'd been forced to help them, but now we're getting her out. That's all he needs to know for now. He didn't question it."

"Good."

"Listen, it's been a long day. Why don't you finish eating and we'll turn in," she said. "Erin will take first watch. And I'll go find Hunter and make sure he's not doing something foolish," she added as she stood.

He grinned at the inference that her maternal guidance was required with their new friend. "All right," he said, discretely sliding his hand up the back of her thigh. She quickly stepped away before he could reach his objective, then gave him a teasing glance over her shoulder as she walked away.

She didn't walk far until she saw Hunter in the distance. He was kneeling in front of a small fire he'd built beyond the edge of camp. She slowed her approach. He was facing the fire with his back to the camp and appeared to have his head bowed as if in prayer. His great sword stood in front of him, its tip thrust into the soft ground. She noticed a necklace with a holy symbol dangling from the hilt, its beautiful gold icon glistening in the firelight. As she neared, she could hear him. *He's praying*, she thought, feeling uncomfortable about her intrusion. Suddenly he reached out and sprinkled something into the fire and it flared up, emitting bright rainbow hues. Once it abated, he turned and looked back over his shoulder at her.

"Fae," he said, with no apparent surprise in his voice as he stood up. Clearly, he wasn't embarrassed by her witnessing his devotion.

"Hunter, I'm sorry. I, uh, I didn't mean to disturb you," she stammered.

"It's all right," he replied, taking the necklace off his sword. He placed it around his neck, slipping the icon inside his tunic until the chain went taut under its weight.

"Hunter, may I ask what you're doing?"

He briefly gazed at her, expressionless. "Preparing."

"Uh, for what?"

He reached out and rested his hand on the pommel of his

sword. "To meet an old friend. . . . We'll face each other soon," he replied with an unnerving calmness. Then suddenly, his expression changed, and he tilted his head slightly as if alerted to something.

"You'd better go back now, Fae," he said, pulling his sword from the ground and turning to face the darkness.

"What is it?" she whispered, stepping up beside him with her fingers tickling the grip of her sword. Suddenly she sensed an overwhelming presence of danger. Then she heard the faint sound of horse's hooves on the soft ground before her. Silently, Hunter took another step forward when they saw a rider emerging from the darkness. A chill coursed through her when the ominous figure slowly rode into the light. It was him, the Shadow Knight. He was clothed in black, including a long cape. Even his armor and helm were black. He rode purposefully right up to Hunter, stopping only a few feet away. For a brief moment that seemed endless to her, the two men silently gazed at each other.

"Hello, William," he said in a deep, emotionless voice. "It's been a long time."

"Too long," Hunter replied coldly.

William? Fae wondered.

"I've thought of you often, old friend," he continued.

"And I of you. . . . I should've killed you long ago, Edmond."

Suddenly the knight arched his back, tipping his head up. Fae thought he was going to laugh, but instead, he forcefully drew in a deep breath with a hideous sound like someone struggling for their dying gasp. Then he looked back down at Hunter.

"Your brother couldn't defeat me. Nor can you," he said as he slowly pulled a great sword from the scabbard tied to his mount and held it up admiringly.

"Andrew always feared you," Hunter replied. "I do not." He took another step forward, raising his sword slightly as the blade began to glow blue and pulsate eerily.

Andrew? Fae thought. *I've heard that name. And that sword, it's just like Hunter's.*

"I see you still possess some of your powers from our glory days, old friend. You can't imagine the power I possess!" the knight said with passion, forming a fist with his free hand to emphasize his words.

"We both know your power possesses you," Hunter replied coldly.

/// \\\

Just then, Krysta happened by on night watch and couldn't believe what she saw. Her heart raced as she ducked behind a wagon and watched. She couldn't hear what was being said, but seeing swords drawn, she quietly turned and raced to warn the others. While they ate their evening meal, she appeared, running straight to where Lance sat visiting with Gustin.

"Hey, he's here," she said excitedly. "The Shadow Knight's here."

"What?" Gustin asked as Lance looked at her in disbelief.

"Yes. Over there," she said, pointing behind her. "He's talking to Hunter and Fae right now."

Gustin was instantly up and running that way with Lance and the others urgently following.

/// \\\

The knight ignored Hunter's efforts to provoke him and turned his gaze upon Fae. Peering through the raised shield on his helmet, he coaxed his horse into a sidestep, moving directly in front of her. She slowly drew her sword as he sucked in another labored breath without taking his eyes from her.

"I know you, elf," he said at last.

"Yes. One dark, rainy night, I stood before you and a dozen of your henchmen. I held a crying baby, the only survivor of

your attack on her family. . . . Why? Why do you do these things?"

"Why? Because I can!" he rebutted tersely, leaning forward for emphasis. "I'd kill that girl child a thousand times over and not lose a moment's sleep," he scoffed.

Hunter was taken aback. He didn't know of their prior encounter.

"It was a mistake to let you live that night," Edmond continued. "You've grown more powerful. Yes, more dangerous," he said with a self-affirming nod.

"Yes, I have."

He suddenly took in another noisy breath and leaned forward in his saddle.

"Consider the years since then a gift!" he replied in the feeble voice of a hate-filled old woman spitting the words at her.

A chill coursed through Fae. *What is he?* she wondered, too shocked to look away.

After an uncomfortable silence, he moved back in front of Hunter.

"Enough talk, Edmond. Let us finish this here and now," Hunter said, just as he heard the sound of footfalls behind him and knew the camp had been alerted. The knight looked beyond Hunter to see his comrades approaching.

Gustin had both his swords drawn, but when he reached the gap between the wagons, something made him stop. He could see all three of them had weapons drawn, but no battle was underway. And he knew the Shadow Knight would have his minions lurking in the darkness.

"Stay here, everyone, behind cover," he said, glancing back. "Watch behind you, and be prepared to fight. Erin, watch them," he ordered, gesturing toward Hollis and Celeste, who stood with Lance. When she nodded, he slowly advanced.

Edmond watched Gustin step out from behind a freighter and approach before he looked back down at Hunter.

"No, William, not yet," he said. "You haven't suffered enough. Remember that night in Tuskin? The night *you* got us into?

The curse *you* scoffed at? I believed, and it came true for me. Andrew believed, and it came true for him. . . . I will make you suffer," he added, rearing his head back and drawing in another labored breath. When his gaze returned to Hunter he leaned forward in his saddle. "I will make *you* believe," he spat in the same raspy, old hag's voice he'd spoken to Fae in.

Again, she shuddered.

Then Edmond reined his horse around and spurred it away into the darkness.

"What was that about?" Gustin asked, joining them as the hoof beats faded.

"Just catching up with an old friend," Hunter replied.

"Hunter, my God, the spirit of another lives in him," Fae said, visibly shaken.

He looked at her. "Yes, Fae, that of an evil witch . . . a demon."

She slowly looked down, still trying to comprehend what just happened.

"So, what did he mean about the curse?" she asked, looking back up at him.

"Never mind that now," he said. "I didn't know you two had met."

She searched his expression, perplexed by his calm demeanor. "Yes. About five years ago, I was traveling from Arcana to the twin cities."

"I know that road well," he said with a distant look.

"I was riding alone in a rainstorm when I came upon an ambush. Wagons were ransacked and burned, and bodies lay everywhere. It was a party about the size of ours, only they were just peasants, unarmed. I found a baby in the wreckage. And by the time I freed her, they'd returned, so I had to face them. Hunter, they were a dozen strong. They could've killed me that night. But for some reason, he just turned and rode away, and his men followed," she said looking at him.

He could sense her need for an explanation. "I don't know

why he did that, Fae, but I'm glad he did."

Gustin gently placed a reassuring hand on the small of her back.

"Hunter, I remember something from a few days before that when I passed through the town of Forest Moon," she continued. "The locals told of two knights who fought in their streets. They said the Shadow Knight killed a paladin from the Chateau who sought his brother and then took his sword. . . . His name was Andrew."

An uncomfortable silence befell them as Hunter looked away. Fae and Gustin looked at each other until he finally turned to face them.

"Yes, Fae, he killed my brother. . . . Look, I know how close you four are, but don't share that with Hollis's people. They don't need any more distractions right now."

"Of course," she said, reaching up to place her hand on his cheek.

He took her hand in his and smiled. "Come on. The excitement's over for tonight," he said, releasing her hand and turning back toward camp.

"You all right?" Gustin asked her after Hunter walked away.

"No," she replied. "Did you hear that voice? I will never forget it."

He slid his arm around her and drew her close as they turned and headed back.

When Hunter walked back to the wagons, he was swarmed by teamsters with questions about the encounter. They were understandably curious about the knight and why they didn't duel. Questions were thrown at him faster than he could answer.

"People, please," he finally said, raising a hand to signal for silence. "Let's not worry about it now. Yes, I know the man you call the Shadow Knight. And I'll explain things in time, but right now, you should rest. For I warn you, by this time tomorrow you'll be glad you did," he said before stepping past

them. When he joined Celeste and her father, he could see the worry on her face.

"Well, that visit was unexpected, wouldn't you say?" Hollis said.

"Oh, not really."

"Don't misunderstand. It's not what I wanted, but how is it you two didn't fight?"

"Father," Celeste said with a look of surprise.

"It's all right," Hunter said with a fleeting smile. "He declined my challenge. Just came to taunt me . . . plant a seed of doubt before we face off."

Suddenly she stepped close and leaned into him. He again felt uncomfortable in her father's presence but put an arm around her when she turned a cheek to his chest.

In the dim firelight, Hollis could see tears glistening on her cheek. He smiled as he thought of the other men who'd tried to win the heart of his precious daughter. She knew so little about this quiet stranger, yet she trusted him completely. *Her wild spirit is at rest with him,* he thought, admiring the beautiful young woman she'd become. He was certain he knew her better than any man. And he knew she was in love.

"Perhaps we should go back now, child," he said, "get settled in for the night."

"All right," she replied, looking at her father with a worried smile.

"Come on," Hunter said. The three of them turned and joined some of the others straggling back after the excitement.

"Think they'll attack tonight?" Hollis asked as they walked together.

"No, sir, I don't. He wants to face me. . . . We must remain vigilant, but no, I think tomorrow night or the next when we're camped in the forest, that's when they'll attack. After that, we'll be getting too close to Bard's Landing."

"I agree," he replied as they reached the kaishons. "Well, it appears Lance has it under control. Are you having company

tonight, my sweet?"

She looked at Hunter, her mouth agape, and he grinned at her surprise.

Hollis chuckled. "Forgive me, dear, that's not what I meant. Are you and Janae all right? Is she welcome in your wagon?"

"Yes, Father, we're fine," she replied with a smile.

"Well then, I shall retire," he said, climbing into his wagon. "Do your job well, young man," he said, glancing at Hunter.

"Yes, sir. I will protect her."

Hollis paused and looked at him. "And her virtue," he said with a raised eyebrow.

"Oh, Father."

"Goodnight, precious," he said as he leaned out and gave her a peck on the forehead before pulling the flap of his wagon shut.

Hunter gently placed his hand on her back, and they walked to her wagon. When they reached it, she surprised him by rushing ahead.

"Where are you going?" he asked when she rounded the wagon, out of sight. When she didn't respond, he followed, and once they were out of the light from the campfire, she turned to face him, placing her hands on his chest. Their eyes met in the darkness as his arms slid around her waist, pulling her tightly to him. She offered no resistance when he slowly moved an open hand up the curve of her spine. Even through her clothing, the touch of his strong hands on her body electrified her senses.

Slowly their lips moved closer, and their hearts raced. She raised up on her toes as he leaned to accommodate her until, at last, their lips met. They kissed with a passion that consumed them, savoring the pleasure of their first taste. She melted in his arms as her knees went weak from the thrill of his touch. When at last their lips parted, they silently searched each other's expression.

"Hunter, I don't want to be alone tonight," she said softly.

"Nor do I, Celeste. But it cannot be, you know that," he added, gently stroking her cheek. He felt the wetness and realized she was crying. "What is it?"

She sighed. "I'm scared. I don't want you to fight him."

He smiled in the darkness. "It'll be all right. . . . I'll be all right," he said as she leaned into him, gently pressing her face against his chest. It was the first time he'd held her this close for this long, and he could tell she was trying not to cry. *She has a proud, wild spirit,* he mused. *Stubborn, outspoken, spoiled no doubt. Yeah, she's perfect.*

"Come on," he finally said. "You need to rest. And I need to know you're safely in your bed," he added, turning with an arm still around her. When they reached the back of her wagon, she turned to him again.

"Remember what you told me back in my father's warehouse? You offered to read me a bedtime story and tuck me in at night," she said with a coquettish grin.

He quietly laughed. "You remember that?"

"Uh huh. I remember everything you've ever said to me," she quietly boasted.

He tilted his head and gazed at her with an odd expression. "What?"

"Well, let's see about that," he replied. "One day early last winter, you were working in your father's mercantile. You wore brown leather pants—snuggly fitting, I might add—and a faded red shirt. You held your hair up with a braided leather tie, and you had a little smudge of dirt right about there," he said, gently touching her cheek with his fingertip. "You were showing a customer an item when you rounded the corner and bumped into a rather handsome and irresistible stranger. . . ."

He saw the look of recognition when she slowly raised her hand to her mouth.

"What did he say to you?"

"Uh, he, uh . . . I, uh, I said, excuse me. And he, uh, said

no, excuse me," she replied, reaching up and gently cupping his face in her hands. "Oh, that was you. I'm so ashamed. I'd forgotten it, but you remembered every detail," she said in disbelief.

"Uh huh."

She tried to imagine the impression she must've made on him that day.

He embraced her and kissed her on the forehead. "I'm afraid I must pass on the bedtime story tonight. But, who knows, perhaps one day."

Her heart leapt. "Hunter, what are you saying?"

He smiled. "I'm saying goodnight, Celeste."

She raised up on her toes and kissed him once more. "Goodnight." She knew she was far too excited to sleep, but she conceded and retired.

After seeing her in, he turned toward the fire.

/// \\\

The four friends talked among themselves as they walked back to center camp.

"What happened, Fae?" Erin asked. "I can't believe he just rode right into camp."

"Oh, I think he just showed up tonight in hopes of rattling Hunter," she replied.

"Did it work?" Draigistar asked.

"No. I don't know why, but he doesn't seem to fear his old friend."

"Well, I'm sure he knows something we don't," Gustin said. "And we can't spend time worrying about any one man, not even the Shadow Knight. Besides, with some luck our surprise move tomorrow will get us through the forest without another attack."

"I don't know," Erin said. "It won't be easy going. We'll have fog tonight, thick by morning unless that rain gets here."

"You're sure about the rain?" Draigistar asked, glancing at her.

"Yes."

They all looked when she pointed up into the darkness, and they could see an immense wall of clouds looming far off in the west. Lightning flashed within its dark mass that seemed to reach up to the heavens, but no thunder could be heard. They realized they'd been so focused on the Shadow Knight that they'd failed to notice the ominous sight.

"Erin that's a long ways off," Gustin said.

"Yeah, high up in the mountains right now," she replied. "If it stays up there, we'll travel in fog tomorrow. If it moves down, we'll travel in rain."

"Either way, it'll fill the streams," Fae said. "It must be dumping."

"That's not good," Draigistar said. "We'll have to cross one tomorrow."

"I remember you mentioned that," Gustin said. "No bridge?"

"No."

"Does Lance realize that?" Fae asked.

"He said he'd explored the entire length of the ancient road, and he's been to Shaelah. The crossing is at the ruins, so I'm sure he's aware of it," he said as they approached the main fire and found Hunter sitting alone, gazing into it.

"May we join you?" Fae asked.

He glanced up. "Of course."

Three hirelings huddled on the far side of the fire, quietly conversing.

"Where's everyone else?" Erin asked, sitting down next to him.

"Hollis and Celeste both retired once the excitement settled. I just passed Janae heading to Celeste's wagon. And Lance went to check on his people before turning in."

"Hunter, are you confident they won't attack tonight?" Fae asked.

He smiled fleetingly. "Well, as I told Hollis, we'd be fools to let our guard down. But I think Edmond wants to prolong it. He wants to unnerve us, study us more, see if the stress and lack of sleep are taking their toll."

"We're going to keep a night watch," Erin said. "I'm going first."

"Well, count me in," Hunter said with a nod.

"Hunter, I know you don't like it when I—"

"Fae, I don't mind your questions. I just like being evasive to make you mad," he said with a grin.

The others chuckled.

"Well, it works," she replied.

He laughed. "Fae, just give it two more days. Once we make it to Bard's Landing, we'll be too close to the City of Queens. There'll be other travelers on the road and army patrols. They won't dare attack us. Then we'll find time, and I'll tell you what you want to know."

"Everything?" she asked, gazing at him.

He smiled at her tenacity and the courage she'd shown facing Edmond. He knew he must share everything with her. He was confident. But if he was killed by his old friend, he believed she was the next best hope to defeat the Shadow Knight.

"Yes. You already know more about me than you realize," he said.

Finally, the excitement and conversation dried up and they all turned in, leaving Erin alone on watch in the center of camp while the hirelings patrolled the perimeter.

CHAPTER ✝ 11

The night passed quietly, and Lance, an early riser with the strange ability to awaken at will, woke the others to break camp well before daylight. His crews hitched wagons and saddled horses, following his mandate of absolute minimal noise. It was foggy, and he planned to take full advantage of the natural cover. They'd move slowly, keeping the wagons tightly grouped and surrounded by outriders until well away from their campsite. The sound of their movement would be covered by the steady rumble of distant thunder. The storm stayed high in the mountains overnight and was just now moving down into the valley.

Tobias had words with Lance when he learned that he'd changed their plans without telling him. Meanwhile, the four hastily saddled their mounts while Hunter's stood ready. He'd saddled his horse earlier while overhearing the tense exchange between Lance and his young apprentice. The incident troubled Hunter. He understood Tobias being upset, but something nagged at him. Finally, he dismissed it, deciding he didn't know enough history between the two men to fairly judge the encounter.

With the darkness, the fog, and the lack of sleep, progress was slow, but at last they moved out. When the road veered away from the river and into the forest, a hint of coming daylight was just beginning to illuminate the fog that settled over them in the night. It wasn't thick like the previous morning. But everyone was jumpy, with the legend of the Shaelock having been retold around the campfire last night.

By sunrise, they were several miles away from their campsite. It had started to drizzle, and the fog was waning. Lance rode point with Flynn and Erin, refusing to let anyone ride alone ahead of the column in the darkness. Finally, he signaled the lead wagon to stop, and when the rest of the column reined up, he fell back to join the mage who rode with Gustin and Fae.

"We're getting close to where we'll leave the road," he told them.

"Yes, I was just telling them that," Draigistar replied.

Lance continued as Hollis and Celeste rode up with Hunter. "The road makes a sharp curve up ahead by a clearing on the left side. On the right are two big boulders—"

"And just beyond is where we leave the road," Draigistar finished.

Lance smiled. "Yes, that's right."

"Lance, it appears we slipped away undiscovered," Hollis said. "But surely, by now, they know we're gone. We'd better get into the forest before resting the horses."

"Yes, agreed."

"Why don't I go ahead and begin scouting the route," Draigistar said.

"Not alone," Lance replied.

"No. We talked it over last night. Hunter and Erin will go with me. Gustin and Fae will stay with the group."

Lance turned in his saddle, glancing to the front of the column. Erin and Flynn sat atop their mounts facing each other, talking.

"All right," he said, turning back to them. "And take Flynn with you; doesn't look like he'll be much good to me anyway."

They smiled at his comment. A few hasty goodbyes were said, and the mage departed with his three escorts. Quickly covering the distance to the turnoff, they headed west into the forest, and soon after, Tobias turned the lead wagon off the road into the same thick growth. It was tedious, but eventually all the wagons left the road and disappeared into the Forest

of Souls. To their amazement, once the dense flora near the road was penetrated, the forest seemed to open up, and what Draigistar called the ancient road could be seen. It was as if the perimeter of this beautiful forest had grown to form a protective barrier from the outside world.

Gustin stayed behind with two of the hirelings to cover their tracks. They dragged brush along the main road in both directions from where the wagons had entered the forest before Gustin sent them on to catch up with the column. He would remain there in hiding to watch the main road for a while. He didn't want to be surprised. And he knew even a novice tracker would eventually find where they'd left the road. It was starting to rain harder now, and the distant thunder grew louder. That was good for concealing their trail. But it meant traversing the dense forest, and its bogs, in a rainstorm.

This place seemed enchanted, and he'd barely seen it from within. It appeared impervious to the chill of winter as everything flourished. The rich, black soil he raked up with his fingers explained why everything was already green. But he knew it didn't bode well for them in a torrent. He watched as the last wagon was swallowed up by the foliage, and marveled that he could no longer hear the column's movement.

A loud crack of thunder suddenly invaded the tranquility of the forest, and he looked up at the canopy as the rain began to fall heavier. *Here it comes*, he thought as big drops pelted his face. When he looked back to where he'd seen the last wagon disappear into the heavy growth, he caught a fleeting glimpse of what looked like someone stepping out of sight behind a big tree. Startled, he adjusted his kneeling position to watch it. The fog was light within the forest, and he estimated a hundred feet between him and the tree where the stranger was concealed. *Could that be the other spy?* he wondered. *Perhaps he doubled back on me.* After a while without fruition, he stood and quietly stepped over to his horse. Just as he started to untie its reins from a nearby tree, he was shaken by the

awful sound of a woman's scream in the distance. He turned his head in that direction and saw another figure duck behind a tree not more than thirty feet away. A sudden jolt of fear coursed through him as he thought of the two men he'd sent on ahead. *Both of them? No way.*

He knew if it was an ambush, he had to even the odds. Instantly he leapt over a fallen log, pulling one of his swords in stride. But when he reached the tree and looked behind it, he found nothing, not even a footprint in the damp soil. *What the?* He suddenly felt a chill and knew it wasn't from the cool rain. He scanned all around him as he walked back to his horse.

He mounted and slowly rode up to the tree where he first thought he'd seen someone. He dismounted and searched the area. But just as before, there was no sign anyone had ever been there. He felt he was being watched, but after the scare he'd just had, he didn't trust his senses. Disgusted with himself, he finally mounted and set out to catch up with the wagons.

/// \\\

When Draigistar and the others entered the forest ahead of the main group, they set about finding the best route through. He remembered more than he'd expected to when Lance first proposed the daring move. He led the way through the bogs, having to backtrack twice to find a safe route for the wagons. Then they began a slow climb as the road meandered through a series of ravines and gullies on its way up to the ruins of Shaelah. There was little sign of life save the occasional scampering critter.

"I must tell you, mage, so far, the route is easier than I expected," Hunter said.

"Well, we haven't seen how high the water is at the crossing yet. I just hope we can get the wagons through."

"How much further to the ruins?" Erin asked.

"We'll be there soon. See the stream?" he said, pointing off to their left.

They all looked over at the picturesque stream lazily cascading over the rocky terrain as it snaked its way down through the forest and on to the Skull River.

"At the top of that hill, the road levels off near a large pool," he added. "There you'll see the ruins."

They rode on, climbing through the forest until they emerged onto a large, flat clearing. A breathtaking view unfolded before them as they reined up and sat atop their mounts, gazing out over a large pool fed by a fifty-foot-high waterfall. They could barely see it through the lingering fog, but its unmistakable sound permeated the tranquil landscape. The rain had abated, but the steady rumbling thunder persisted, reminding them it was only a temporary reprieve.

"It's so beautiful," Erin said.

"I see why they wished to be left alone," Hunter said.

"I've never seen trees so big," Flynn added, pointing to the tops of massive trees looming over the ruins of the once-beautiful settlement.

"Yes, their limbs could easily accommodate the magnificent structures they once held," Draigistar said. "Shall we?"

"Yes," Erin replied with a giddy smile as she coaxed her horse forward. They rode in a close group around the edge of the pool, finding themselves on what had obviously been a road through the settlement. There'd once been at least twenty stone structures, some quite large. When they stopped and dismounted to walk through the rubble, Hunter noticed Erin seemed overly excited.

"Don't wander off," he reminded her.

"I won't," she replied with a look of offense. "Draigistar, this wasn't a village, it was a city," she said, looking around.

He glanced at Hunter with a grin. "Erin, trust me. You've not yet seen a city. A few days hence you will behold a city unlike any other."

"I know; it scares me," she replied softly.

"Where did the stone come from, mage?" Hunter asked.

"I've seen no quarry."

"I assume they brought it down from the mountains. Perhaps that was a cause of the rift between them and the society that lived up there."

"Yes, might've been," Hunter replied.

They spent time walking through the remains of the stone buildings with Draigistar explaining what he surmised each one had likely been used for. He showed them the petrified remains of the enormous trees felled so the invaders could slaughter the Shaelock.

"Even after centuries of rot, these trunks are still taller than us," Hunter marveled.

"Yes, just look at the ones that remain," the mage agreed. "Some may be two hundred feet tall."

"How do you suppose they felled such big trees?" Flynn asked.

"I don't know," he answered. "Certainly, it would've taken more than axes. Perhaps they covered the bases in pitch and burned them down."

"Or used siege machines," Hunter offered.

"Perhaps," Draigistar agreed.

While they stood together talking, Erin glanced over at a stone wall and saw a figure in an opening that was once a window. A chill raced through her when it quickly ducked from view, and she realized they weren't alone.

"Hey, I just saw someone," she said, recovering from her start.

"Where?" Hunter asked.

"In that window down there," she said with a slight nod. "Flynn?"

He looked at Hunter in surprise. "Uh, no, I didn't. But I wasn't looking that way."

Hunter exchanged a glance with Draigistar.

"Hunter, I swear I saw someone."

"It is foggy."

She rolled her eyes and sighed. "I know what I saw."

"All right, I believe you."

They formed a skirmish line and moved that way, leading their horses while they scanned the ruins for any sign of someone else. When they reached it, Hunter and Erin handed their reins off and cautiously made their way to the end of the destroyed wall. The rain had picked up again, and their footing was precarious atop the piles of rain-slicked stones that had grown over with lush vines. Hunter unsheathed his flail, and together with Erin, her scimitar in hand, they stepped around the wall. Nothing. Only a few piles of stone littered the ground. When they looked at each other it was clear she was in no mood to defend her claim. Silently, they scoured the piles to confirm there was no one hiding. Then he stowed his hand weapon and looked at her.

"I do believe you, Erin."

"Thanks, Hunter. I really did see someone. Maybe it was a Shaelock."

"Uh huh," he replied, trying to hide his skepticism.

Just as she stowed her weapon, they both felt a sudden rush of wind and heard a sound like air passing through the feathered wings of a large bird swooping overhead.

Crouching in response, she lost her balance, and when her foot slipped off the wet stone, he reached out to break her fall, inadvertently laying a hand across her bosom. She recovered, and he found himself standing before her in total embarrassment.

"I'm sorry, Erin. I did not mean to do that," he said, looking away.

"I know; it's all right," she quickly replied. "What was that?" she asked, dwelling on the strange feeling his touch had evoked.

He looked around, confident it was already long gone. "I don't know. I didn't see anything . . . well."

She looked at him. "What?"

He returned her gaze. "A small gray cloud perhaps, I don't

know. It moved so fast I'm just not sure. Come on, let's get back."

"All right."

"So, mage, where's this crossing you spoke of?" Hunter asked when they rejoined Draigistar and Flynn.

"There are two ways across the stream," he replied. "The road we came in on makes its way around the village, steadily climbing that hillside until it reaches the stream up above the waterfall," he said, pointing as he spoke. "The other way is to go around the far side of the pool and then up to meet the other road beyond the stream. The fog's still too thick to see the other side so we should probably split up. This rain is not our friend. There's still one final hill to climb after the roads rejoin, and it's steep. We need to have the best path chosen by the time the wagons arrive."

"Very well," he said considering the best way to pair up.

"Flynn and I can go up above the waterfall if you two want to scout the other crossing," Erin said.

Hunter smiled briefly and looked at Draigistar who didn't seem to object.

"All right," he conceded. "Let's do it."

They mounted up just as the rain slowed once again.

"Erin, the road overlooks the ruins," the mage said. "But for the fog, we'd be able to see each other across the pool. If you need us, yell out. We should be able to hear you."

"Well, let's go. And don't let the Shaelock get you," she said with a grin.

"Erin, please," Hunter said. "Enough superstition."

"Well, *excuse me*," she said defensively, getting surprised looks from the men.

"Oh, don't be that way," he replied. "I'm sorry, I just meant—"

"I'll see you up there," she interrupted with a narrow-eyed gaze before reining her horse around and taking off.

He knew he'd hurt her feelings. Her look made him feel like an insensitive brute. "Damn it," he said with a sigh.

215

"Women," Draigistar said, shaking his head.

"Flynn, let nothing happen to her," Hunter said as he raised a hand and pointed, indicating he was to go with.

"I won't," he replied, taking off in pursuit.

She'd bolted away, hurt by Hunter's condescending remark. She'd looked up to him since they'd met, but she didn't take to being treated like a child by anyone. She loved her friends, even when they made her mad. But recently, she'd found herself longing for independence. She found offense in things that, not long ago, were insignificant. It was great to have companions, but she yearned to experience life and learn from her own mistakes. Sometimes she felt smothered and overprotected. She knew she'd have to lean on them in the coming days when they reached the capital. She was frightened of being in such a large city. *Perhaps that's the real problem,* she thought. She just knew she was glad to be in a forest right now, even if it was haunted.

Flynn caught up, and eventually, they engaged in conversation. He was polite and respectful, and she'd learned he disliked big cities too. He was about her age and had no family ties. She was attracted to him. He made her feel good inside, confident, peaceful.

"Erin, I'm sorry Hunter made you mad," he said as they rode up the hill overlooking the ruins. "I know you respect him, a lot. So do I."

"Thanks," she replied with a glance. "You're right. I do respect him."

"I'm just glad he's on our side," he added. "In fact, I'm glad all of you are with us on this trip." They exchanged a warm smile. "I'll tell you this much," he continued. "The teamsters weren't happy about the four of you having authority to boss them around to keep Hollis and his daughter safe."

She smiled at his remark. "She has a name. Don't you like Celeste?"

"Oh, that's not it. Her father's rich, so others have made

fools of themselves for her. She'd never notice a simple man like me. Besides, I'm not in a hurry to settle down."

"So, how long have you worked for Hollis?"

"I met Lance about five years ago, not too far from here in a town called Bard's Landing. His crew was short, so he was looking to hire. I was broke and hungry. Trouble is I don't know how to drive a team of horses," he said with a grin.

"So, what happened?"

"I said I'd scout for him. Well, he hesitated, so I told him to quiz me about the road to Port Estes. Let me tell you that was a mistake. I didn't know he'd been freighting over this route for a hundred years."

Erin laughed. "A hundred years," she repeated in amusement.

"Anyway, I impressed him, so he hired me. It went well, and I've scouted a few more times for him. Each time, Hollis offers me a permanent job at a real good wage. But I don't want to be committed. I like freedom and adventure. I like to move, go where I will, when I will," he said with a self-affirming nod.

"Me too," she said with a coquettish grin.

As a brief silence befell them, she sensed he wanted to share something with her but struggled for the courage to speak it. *He's nervous because he's attracted to me*, she thought with great satisfaction. *He wants me.*

Finally, he spoke. "Erin, uh, maybe someday we could go find adventure together," he said tentatively without looking at her.

She smiled at his shy approach. "I'd like that, Flynn."

He glanced over, and they silently exchanged a smile, their gaze lingering. When they reached the top of the hill, they saw the stream that fed the waterfall. They reined left and stopped, overlooking the breathtaking sight of the bright blue pool with the ruins of Shaelah nestled on its shore. The enormous trees that surrounded them reached high into the foggy sky, their

limbs spreading out over the enchanting landscape like the arms of a mother protecting her child.

"Oh my. It's even more beautiful from up here," she said.

"Uh huh," he agreed as he stole an admiring glance her way.

"Well, we'd better scout a way across that stream," she said, backing her horse away from the edge.

Approaching the stream, they saw why there'd never been a bridge built. Where it narrowed, a wide stone pathway lay just beneath the surface of the crystal-clear water. They dismounted and began leading their horses across. Near the middle, Erin knelt and felt beneath the surface where she saw some wide cracks in the rock formation. The current's erosion had cut deeply into the monolith, and she wanted to make sure the wheels of the heavy wagons could safely span the fissures.

Just as she stood up, they were both jolted by the sound of a woman's scream. They spun to look at the bank behind them in time to see a dark figure duck behind a moss-covered tree. As her hand brushed the hilt of her scimitar, he pulled his long sword. In his haste, he lost his balance, falling back and sitting in the ankle-deep water with a splash. She raised a hand to her mouth, giggling at his mishap.

"Oh, I hate this place!" he yelled in embarrassment.

"It's all right, Flynn. I think Draigistar was right. They don't want to harm us. They're just warning us to move on."

"And I'll be glad to do just that," he replied, struggling to his feet.

They continued across and explored the other bank, seeing where the road around the pool climbed up to join theirs. Standing there looking at the steep hill they would have to negotiate to reach the high road, her heart sank.

"Flynn, how are we ever going to get those heavy wagons up there?"

"Well, it's not a long hill, just steep. The crews always carry large ropes, like on a ship. I've seen them used with a second team to pull a wagon through deep mud. Tell you what, you

take the horses back across the stream and I'll climb up there and have a look."

"I'm not sure splitting up is a good idea."

"I just want to see if there's room at the top to hitch a second team. It may be our only chance. If the stream rises after we get those wagons across and we can't make it up this hill, we could be forced to leave them."

"All right," she agreed. "But you be careful."

"And you."

They exchanged smiles, and their fingertips lingered when he handed over the reins of his mount and turned away. She watched him start up the hill, fighting the muddy soil that clung to his boots. *He's strong and fit*, she thought as she turned and headed back across the stream. Once on the other side, she tied the reins of their horses to a large sapling that had sprouted up through the rocks near the water's edge. Then she scanned the woods around her. She looked at the tree where they'd seen the figure and chuckled at the image of his startled fall into the water.

Then her mind leapt to her own mishap earlier when she'd fallen into Hunter's arms. That strange excitement was something she'd only felt once before when she'd nearly given herself to Draigistar on a moonlit night as they swam together nude. She'd wanted it to happen. But then she heard her mother's screams as she was ravished by the men who'd murdered her father. Erin shuddered and pulled herself away from that horrible memory.

She walked over to the cliff and stood by the edge near the top of the waterfall. The rain had picked up, and the fog was lifting, so she could just make out Draigistar and Hunter standing on the watershed on the far side of the pool. They were busy surveying their route, so after taking in the stunning view, she turned and headed back to her horse.

She took a few steps and then stopped, looking down at the ground. There in the mud were footprints of a child's bare

feet. A chill coursed through her. She knew they weren't there when she passed by a moment ago. She nervously scanned all around her. Nothing. *Where are you, Flynn? Hurry up*, she thought. Resting her hand on the hilt of her sword, she took a deep breath to calm herself and studied the tracks. She saw they led up to the patch of tall grass where she'd just stood on the cliff's edge, ending right behind her. Unsettled, she followed the child's footprints in the mud back to where they began. Suddenly she froze, looking at the footprints over her own. Whoever made them had followed her from her horse to the cliff, and she never knew they were there.

Her heart pounded as she looked up, hoping to see Flynn coming back down the hill. She didn't. Then she heard the cry of a baby and spun around to see a child standing only a few feet away. It appeared to be a young girl less than ten years old. She wore a dark, hooded robe and had her back to her. She was barefooted. Erin couldn't help herself; she slowly began moving toward the mysterious figure. Approaching, she could hear the cries of a baby and the soft voice of the young girl. *She's singing*, Erin realized, apparently trying to soothe the baby she held in her arms.

Erin's anxiety was unbearable as she neared what she knew must be an apparition. She moved to the side until she could clearly see the girl adjusting the baby's wrapping around its head. Erin couldn't see her face, but there were locks of brown hair dangling from the edge of her hood as she looked down at her charge. Erin swallowed hard and finally spoke.

"Hel—hello," she mustered in a shaky voice. No response. She slowly knelt and reached out to touch the child's shoulder. Then just as her fingertips drew near to the fabric of her garment, the girl suddenly transformed into a cloud of gray dust. With the same whishing noise and rush of wind she'd encountered back in the ruin, the little girl and the baby were gone.

Erin looked at her shaking hand for a moment, fighting to

regain her composure. At last, she stood and walked back into the stream to retrieve the horses. After loosening their reins from the sapling, she stood for a moment in the ankle-deep water, scanning the far side. She was getting worried about Flynn but decided to wait for Draigistar and Hunter on this side of the stream. *This side of the stream*, she suddenly thought as she looked down at her feet. *This wasn't in water before*, she realized. *Oh, you fool!* She was angry with herself for getting distracted and not noticing sooner. *The water's rising fast. I have to go tell them*, she decided as she turned to walk the horses out of the water. When she turned, she was startled by the little barefoot girl standing before her at the water's edge.

"Huh!" She gasped and stepped back. *If you come close to one, never look directly at it*, Draigistar had warned. But she couldn't help herself. She glanced down at her bare feet, confirming the tracks she'd seen were hers, then took in the sight of her flowing, dark robe. The baby she'd held in her arms before was now gone. And her head was bowed in a gesture of shyness, so Erin could only see her chin and a few locks of hair.

Her heart raced when the girl slowly looked up at her. *Oh, what a beautiful thing*, Erin thought as they studied each other. She had typical elvin features: a thin face, high cheekbones, bright green eyes, and long flowing hair. She gave Erin a slight hint of a smile. The sight of her took Erin back to another elvin village near where she'd lived as a child. She would play with the children when she went there with her father so he could trade. Briefly, she thought of her parents.

"Hello," she said with a smile as she took a step closer and knelt down, almost close enough to touch her. She didn't respond, but as Erin looked at her, she was shocked when her appearance changed. A hideous scar appeared on her face like that from a wound caused by a bladed weapon. It extended from her forehead, across the bridge of her nose, and past the corner of her mouth to her jawline. From what Draigistar had said of the Shaelock's demise, she assumed the girl had been

killed when someone struck her with a sword. Her heart ached as she envisioned the ferocity of the attack on these peaceful people.

Erin controlled her reaction to the repulsive sight. But then, the girl's features began to change yet again. Erin's smile slowly faded when she beheld something she could not at first comprehend. Her mouth fell open in disbelief. *No*, she thought, reaching out her hand toward the little girl. Her shock turned to horror, but she continued to stare. She reached up and stroked her fingertips across her own cheek as she tried to catch her breath. *No! It can't be!* Her head began to throb, and she fought to stay upright. Suddenly, intense pain coursed through her, and she raised her hands to her temples. *No!!!!* She screamed, but no sound escaped her lips as her world dimmed. She saw the water racing up to meet her, and then silent darkness prevailed. She felt the cold on her face, then nothing.

Flynn had good news to report. He thought they could get the freighters up the muddy incline. He'd scouted to the top of the hill for any signs of Shadow and found none. Now making his way back down the hill, he glanced through the trees toward the stream and stopped dead in his tracks. He could see the horses standing up on the far bank and knew the stream had widened. But his heart sank when he spotted Erin lying supine in the edge of the stream and a dark-robed figure kneeling, tugging, apparently trying to drag her away. *Oh no! Erin!* he thought in a horrible panic.

"Hey!" he suddenly yelled without thinking. The figure looked up at him, but he couldn't make out any features beneath its hood. He instantly broke into a run down the hill, praying he didn't lose his footing. Soon he was on level ground, heading toward the stream. The mysterious figure was gone, but he saw Erin floating on her back away from the bank as the current carried her toward the waterfall.

No! he thought as he reached the stream and struggled

through knee-deep water that had been only ankle-deep when they crossed over. He could see he was losing the race to catch up, so in desperation, he dove in after her. He'd never learned to swim, so he didn't know how he managed to stay afloat. He didn't care. His only concern was reaching her before she was swallowed up by the waterfall. Finally, he was close enough to grab her just in time to plant his feet on a submerged rock. Instantly he felt a crushing force against his back. It nearly ripped her limp body from his arms, but he locked them around her with all his strength.

"Erin!" he yelled in her ear, hoping for a response. He didn't know her condition, but he determined he would save her, or they would go over together. As he fought to keep both their heads above water, he realized he'd never known fear like this. Finally, he was able to gulp in a full breath, and he knew what he must do.

"Help!" he yelled as loud as he could, hoping that Hunter and Draigistar were close enough to hear him. He no longer cared if anyone else was nearby. His strength was waning against the unimaginable crushing force of the water. And if he didn't get help soon, he'd have to kick free of the rock and take his chances with the falls. Whether he lived or died, he'd do it with her in his arms.

"Help!" he repeated, fighting to keep his grip. "Help!"

/// \\\

When Flynn and Erin rode away, Draigistar could sense the storm of emotion in his moody companion. He, too, felt responsibility for his young friend. He'd seen Erin face others in combat, and she'd never failed to impress him with her courage and skill. She had more strength and agility than most men. She also had an inner driving force he assumed was rooted in her tragic childhood. Despite her naivety, he knew she could take care of herself in the forest.

"Come on, Hunter, she'll be all right," he said, coaxing his horse forward. Without a response, Hunter fell in next to him and they headed around the shoreline of the large pool. The peaceful drone of the waterfall and the low rumbles of thunder filled the enchanted setting as they silently rode up to the pool's natural spillway. It was a path nearly twenty feet wide that spanned two hundred feet of the pool's edge to the shore on the far side. Here the water lazily spilled over and began its narrowing descent through the ravines of the lower forest and bogs before reaching the river. The rocky surface was level, and the water currently ran less than ankle deep.

As they dismounted and walked across the spillway, Hunter marveled. "What do you know about this, mage? Is it natural? Or was it constructed by the Shaelock?"

"I think it's a natural granite formation that was improved and maintained by them. No matter how full the stream flows above the falls, this watershed can handle it, so the pool won't flood the village. When I was here last, it was summer, and the water barely trickled over. I could see where smaller rocks had been wedged into the cracks."

"Well, it looks solid enough for the wagons to cross."

"Agreed. My concern is the water level. There'll be runoff coming down from the mountains after that storm up there last night. We'll have to backtrack if they don't get those wagons here soon," he said as they neared the far shore.

Hunter started to speak when he realized he could hear a noise coming from the ruins. He paused and looked across the pool but saw no movement. With the low rumbling thunder and the falls, he doubted himself.

"No, it's not your imagination," Draigistar said, surprising him. "I hear it too."

"Sounds like a battle," Hunter said in disbelief. "Hey, where are you going?"

"I'm not missing this," Draigistar said, swinging himself into the saddle.

"Missing what?"

The mage looked down at him with a grin. "I don't know. That's why I'm not missing it," he said, starting back.

Hunter followed, and they soon found themselves back at the edge of the ruins.

"Come on," Draigistar said as they hurriedly dismounted and walked among the buildings. To his disappointment, the noise had mostly subsided, but they could hear faint voices shouting in an unknown tongue. There was the occasional clashing of steel mixed with the thunder of hooves and screams that unnerved them.

"Hunter, I believe we're standing in the midst of their annihilation."

"What? That's crazy. You're crazy, mage."

"Perhaps."

"How long ago did it happen?"

"More than two centuries ago. And I'll bet no one else has ever witnessed this." Standing there looking at Hunter, he suddenly spied a figure beyond him. "Ah! Look! I saw one!" he said, pointing.

Hunter spun around to see a figure in the very window where Erin had claimed to. It was fleeting. But he knew why she'd been so adamant.

"Doesn't this frighten you? My skin's crawling."

"Yeah, I'm terrified," the mage replied. "But how can you walk away from this?"

"I'm not. I'm riding away," he said as he mounted up. "And so are you. Come on."

Draigistar mounted up just as they both heard a cry for help. Their eyes instantly locked, and they froze in the saddle. "That's not part of this," he said, looking up at the waterfall. "It came from up there."

"Come on," Hunter said, yanking on his reins. Spinning his warhorse around, he spurred it toward the base of the cliff beyond the ruins. Draigistar was a good rider on a solid mount,

so he easily kept up as they blazed past the piles of broken stone.

Hunter headed toward a steep embankment, and without slowing, his horse leapt, planting its hooves into the muddy soil. Its muscles rippled as it climbed, straining to pull its mass up onto the road surface. *And he thinks I'm crazy*, the mage thought, driving his horse up behind him. It was a risky move he wouldn't have thought of trying, but his horse negotiated the ten-foot-high embankment. Racing up the road, Draigistar glanced off to his left and noticed the waterfall was now flowing bigger than before. Soon they reached the top and saw two horses standing at the edge of the stream, with no one in sight. Hunter pulled back hard on his reins and quickly scanned the forest, suspecting they'd just been lured into an ambush.

"Look!" Draigistar shouted as he reined to a stop and pointed downstream.

Hunter couldn't believe his eyes when he saw Flynn holding onto Erin, struggling against the current just above the falls. The water flowed over them in relentless surges.

"Looks like she's unconscious!" Hunter shouted. "I'm going in after them!"

"Wait! You have a rope?"

"Yes."

"Good. Give me the end. I'm a strong swimmer. I'll go; you anchor me. When I reach them, I'll tie it on so you can pull us back."

Hunter took a length of rope from his tack and handed him the end.

Draigistar threw his pack down away from the water's edge and started in as he tied a loop in the end of it. By the time it deepened, he had it securely around his wrist and dove in, racing to their aid.

"Flynn!" he yelled when he neared them.

Exhausted, the young scout glanced over his shoulder. "Hurry! I can't hold on much longer!"

226

"Hang on!" the mage yelled as he maneuvered in behind him, feeling for a footing to stay himself against the unforgiving current. Just as he grabbed Flynn's arm, he slammed into a submerged rock. The force bent him over at the waist, forcing his head underwater, so he let go to avoid taking all three of them over the fall. He struggled, holding his breath until, at last, he found a rock with his free hand and righted himself. When he emerged, he looked at Erin and saw no life in her. He was devastated, but he knew he could do her no good there.

"Flynn, I'm going to pass this rope around you so Hunter can pull you out!" he yelled to be heard over the roar of the falls.

"And Erin!"

"Yes, Erin too!" he yelled, fearing it was already too late for her. "I'm going under the water to get it around you!" He took a breath and submerged, again struggling against the incredible force of the water. He was thankful he'd kept himself fit.

Hunter watched from atop his mount and feared there was no way the mage could hold his breath that long.

Finally, Draigistar emerged and tightened the rope around them. "All right!"

"What about you?"

"Can't get enough slack! And we need to get her to shore!" he replied, signaling.

Hunter immediately reined his horse back, pulling them through the water. With the rope taut around his chest and water spilling over his shoulders, Flynn fought for his breath as he tried to keep Erin's head above the surface. Taking no chance of losing them, Hunter pulled them up onto the muddy bank before stopping. Then as he rode forward, Flynn struggled to free them both from the rope. Hunter's heart sank when he got a close look at Erin. *Oh God, please don't take her*, he thought as he ran past them, turning his attention to the mage who still fought against the crushing current.

"Hang on, mage! I'll get you!" he shouted.

Suddenly Draigistar found solid footing and turned to face him with the water spilling over his shoulders. When their eyes met, he pointed upstream, and Hunter looked to see a large log floating directly at him. Hunter knew they were out of time. When his eyes returned to Draigistar's, the mage cupped his hands around his mouth.

"Take care of her!" he yelled before reaching out to meet the log.

Hunter watched in horror as it swept over the edge of the waterfall, taking Draigistar with it, his eyes never leaving Hunter's until he was swallowed up.

"No!!!!" Hunter yelled as he leaned back with his eyes closed and raised his hands in the air, falling to his knees. At that moment, with the raindrops pelting his face and the thunder rumbling ominously overhead, he was utterly defeated. He'd never felt so helpless, convinced he'd just witnessed the death of two friends.

Then, through his grief, he thought of the mage's last words. *Take care of her*, he'd said, clearly at peace with trading his life for hers. Hunter had fought many battles and seen many unbelievable acts of courage. But he'd never witnessed such an inspiring act of selfless sacrifice. He came to his senses, stood, and headed for Erin. *Draigistar didn't fail her; neither will I.*

Flynn was kneeling over her and looked up when Hunter approached.

"Flynn, what happened?" he asked, kneeling on her other side.

"I don't know," he answered. "We split up so—"

"You did what?" He asked, looking at him with fire in his eyes.

Flynn recoiled, fearing he would strike him. "Hunter, I'm sorry. If you'll just let me explain," he added as Hunter scooped her up.

"Not now," he said, glancing at him. "Get down below and see if you can find the mage. Go!"

Flynn decided that a well-timed retreat was in order. No one could make him feel more guilt for Erin than he already did. He'd wanted her since the day they'd met. She was the most beautiful woman he'd ever seen. And the more he'd learned about her, the more he wanted to be with her. Now that was gone, and it was his fault. Without speaking, he mounted and headed down the hill.

Hunter held Erin in his arms with his cheek on her forehead as he gave into emotion. She was cold, and her lips were blue. He knew she was gone, but he refused to give up. She had no wounds, so he assumed she'd drowned. He composed himself and laid her back down on the ground.

"Erin, come on. Erin!" he said as he came to his knees and bent over her. *I'll breathe for her*, he thought, taking in a breath and placing his lips on hers. He blew into her mouth and saw her bosom rise. He repeated the act. Again, he pressed his lips to hers and breathed for her.

"Erin, don't you leave me!" he shouted before breathing into her again. He continued for what seemed like an eternity, giving her breath and speaking to her. He was so desperate. *Please, God. Please don't take her*, he prayed as he continued.

"Erin!" he yelled before placing his lips on hers. *Erin*, he thought he heard someone repeat as he gave her breath. A chill coursed through him, causing him to look up, glancing all around. But seeing nothing, he dismissed it.

"Erin!" he yelled once again, gently shaking her. *Erin*, he clearly heard again. It startled him. He was sure he wasn't alone. *That was the voice of a child*, he thought as he looked around again. Still, nothing. When he bent over her again to give her breath, he felt her convulse and saw her stomach contract. He knew what it meant, but in his exhausted state, he was slow to react. He just managed to turn his head away as her mouth opened and she vomited, covering them both.

"Oh, yes!" he exclaimed joyfully as he spat and wiped his

face with the back of his hand. She drew in a labored breath and coughed violently, then vomited again.

"Come on, you can do it!" he exclaimed. *Oh, thank you, God! Thank you!* he thought, lifting her up in one arm and wiping her face with his free hand. He watched her until she settled, remaining unconscious. He placed his hand on her to feel her chest rise and fall until she began breathing normally. She continued to sleep as he drew her to him once again, rocking back and forth on his knees with her in his arms. Finally, he placed a gentle kiss on her forehead.

"Don't you ever scare me like that again," he said, gently laying her back on the ground before standing.

He left her and stepped to the edge of the stream. Scooping up handfuls of water, he splashed it on his face as he tried not to break down from the overwhelming relief that consumed him. He took a deep breath and drank before walking over to collect the horses. He tied their reins to his saddle and picked up the mage's pack. Once he secured it, he removed a blanket from a saddle bag to cover her with. He would cradle her in his arms and ride back down to meet the others. When he turned around, he was horrified to see a short, dark-robed figure bent over Erin. He reacted without thought, his unspent emotion exploding.

"No! Get away!" he yelled, racing toward Erin, drawing his sword in stride. The figure before him transformed into a cloud of gray dust and whooshed away. Reaching Erin, he knelt and spread the blanket over her, keeping his eye on the gray cloud moving through the nearby trees.

When he stood up again, it suddenly turned on him. He had little time to react beyond raising his sword. As it charged, the sound of a young child growling like a ferocious animal grew louder. The cloud slammed into him, knocking him back violently. His feet left the ground from the impact. It felt like he'd just been kicked in the chest by a horse. He landed on

his back on the muddy ground near the horses, and his great sword flew from his grip, sliding nearly to the water's edge.

He lay there dazed, trying to comprehend what had just happened. He gasped, trying to catch his breath, but his lungs wouldn't respond. He could feel the rain on his face, and see his horse standing over him, looking down curiously. But he couldn't move. Finally, he laid his head back on the ground as darkness closed in until he could no longer feel the rain.

CHAPTER ✟ 12

Gustin caught up and escorted the wagons until Lance led them safely through the bogs. Then when they started the climb to Shaelah, he decided to fall back and continue watching for pursuers.

"Think they'll find our trail?" Fae asked him while they rode together.

"Yes, I do."

"Would they attack us in here?"

He thought briefly. "Probably not," he said, looking at her. "But that could be bad. When they discover where we've gone, they'll assume we know a way through the forest."

"And they'll be waiting on the other side."

"Yes. They should be able to beat us up to the high road by going around the forest, so I think they'll just send in a small party to follow. Perhaps if they encounter what I did, they'll decide it's not worth it."

"What?"

"Well, let's just say I plan to have a word with Draigistar about his storytelling."

"Oh, did you get scared?"

He smiled. "Tell you later. Right now, I must go hunting."

She raised a foot to her saddle and vaulted from her mount, landing in his lap as she closed an arm tightly around his neck. "You're not leaving till you give me a proper goodbye."

He grinned mischievously. "Well then, perhaps you could arrange the use of Celeste's wagon."

She feigned offense and playfully slapped his face. "That's not what I meant," she said, making him laugh until she kissed him. "Do what you must, lover. Just be careful."

He nodded. "I will. But don't worry about me; I may be gone awhile."

She gazed at him without expression. "Don't make me come find you."

"I won't," he said before giving her another kiss.

"What's this?" they heard in a fatherly tone before looking up to see Hollis sitting atop his mount beside the trail with Celeste and Janae.

"Can't decide which horse to ride?" Janae asked.

"Oh, this one's much more comfortable," she said as Gustin reined up near them.

"Hollis, I was just telling Fae it's time for me to go."

"Think we'll be followed?" the merchant asked.

"Yes. They will eventually find where we left the main road. And we need to know how many follow us in."

Hollis sighed. "Very well. Keep your wits about you and take no chances."

"Don't worry, I'm no hero."

You are to me, Fae thought as she returned to her own saddle. Their moment had passed, and she knew she must let him go.

"Well, forgive our intrusion," Hollis said, reining his horse around. "Ladies."

"Be careful, Gustin," Celeste said.

"I will," he replied as she and Janae turned to join her father.

"I'll be back before you know it," he told Fae.

She silently nodded as he eased his horse closer, leaning in the saddle so they could kiss once more. Then he reined his horse around and rode off to find his prey. She sat for a moment, watching him until he turned off the road and disappeared into the forest. She knew he'd take to the woods and

find a place to watch from, attack from perhaps. Finally, she reined her mount around and coaxed it forward to catch up with the wagons. As she rode alone, closing on the column, she pondered their relationship. They held different moral values. She loved him, more than she'd admit. But she'd been taught from childhood that you only take a life as a last resort to protect a life. Her time with Telfari had only reinforced that sense of societal obligation.

Gustin wasn't a cold-blooded killer, or she'd have nothing to do with him. He opposed taking a life as much as she did. But he considered what he was about to do a necessary measure of protection. That was something she struggled with. Perhaps it was his military training. Simply, if you were outnumbered, you took the fight to the enemy and evened the odds, a fundamental rule of survival. She knew he wouldn't do anything stupid. But if he got the chance, he'd kill as many of the Shadow as he could so they wouldn't have to face them later.

/// \\\

Gustin knew their pursuers would be focused on following the wagon tracks, so he left the trail, moving toward them in a parallel. He took to the high side of the road, where he had both a visual and tactical advantage, cutting through the forest on a hill that overlooked the ancient road. When the foliage became too thick to ride, he dismounted and led his horse until he found a place to leave it. Then moving closer to the road, he settled into some bushes on a rocky ledge.

He waited patiently, finally seeing a group of twelve riders approach. To his amazement, they stopped in the road near the ledge where he lay concealed. *Now that was foolish*, he thought. They dismounted and gathered as they pulled some dried meat from a saddle bag and sat down to eat. He watched the leader examine the wagon tracks in the road while the

others took a break. He didn't recognize any of them and could only pick up bits of conversation. But he heard the leader assign two of them to ride back and report when they moved on. *I was right*, he thought. *They're just here to follow.* He knew he must keep them from reporting. That could buy valuable time for the slow wagons.

He started to slip away and fetch his horse until he saw two of them stand up and head into the forest on a path toward his hiding place. One man stopped and turned his back while the other ventured a little further to find a suitable place to squat and answer nature's call. *Oh, now that's an opportunity I can't pass up*, Gustin thought. He carefully slipped down the incline through the wet branches until he was near the indisposed man. *You already smell dead*, he thought as he approached. He'd normally not even consider killing a man with his pants down, but their boasting of carnal intentions for the women in the wagons sealed their fate.

Gustin was in position by the time the man finished his deed. When he stood and pulled his pants up, Gustin silently emerged from the shrubs behind him. In one fluid motion, he threw his arm around the man's neck and pulled him back into him. Then, placing his hand firmly over his mouth to muffle his cry for help, he jerked his head to the side as he tightened his hold across the man's shoulders. With two muffled cracks, the man's spine yielded to Gustin's great strength. Briefly, his body stiffened and then fell limp. When he closed his eyes and gave up his last breath, Gustin relaxed his grip.

It worked. The other man, oblivious, continued his rhetoric about his unmatched skill as a fighter and a lover. Gustin quietly pulled the dead man back into the foliage and lowered him to the ground before stalking his companion. Eventually, the fool realized his friend wasn't answering. He called to him twice, each time waiting for a response. Gustin was now in position. He could take him if curiosity lured him in or make his escape if the man wisely went for help. Finally, he came

looking for his friend. When he pulled the bushes aside to reveal the man's leavings, he called to him again. Nothing but the sound of the rain.

"Come on, stop trying to scare me," he said, hesitantly taking another step. When he let go of the parted shrubs after passing through, Gustin took advantage of the rustling noise, rolling out from beneath the limbs of a pine tree into position behind him. He quickly came to his knees, and when his quarry realized he wasn't alone, he spun around. Gustin brought a fist up hard into his midsection, lifting his feet off the wet ground as the air exploded from his lungs. His eyes were wide with fear when Gustin stood and grabbed him by the neck. Then pulling him forward, he thrust his large hunting knife through his ribs and into his heart. When his knees buckled, Gustin took his weight and slid him back through the bushes. He felt a searing pain in his arm when he drove the knife home, reminding him of his own injury from the wolf attack. By the time he laid the man on the ground next to his comrade and pulled his knife free, he was dead. For both, their death had been quick, with little time to contemplate it. *More merciful than you deserved*, Gustin thought. Still, it repulsed him. He knew he lost a little more of his soul each time he took someone's life, no matter how evil they were.

He made haste back through the thick foliage, and when he reached his horse, he heard someone calling into the forest. *They've been missed.* He untied the reins and headed through the forest afoot, towing his mount parallel to the road. He covered ground as fast as he could and soon heard shouting in the distance behind him. *Found 'em.* Now he quickened his pace, unconcerned about the sound of his horse plodding through the wet forest. He doubted they'd spend time tracking him even though it would be easy. They had to keep pace with the wagons.

Running along, he suddenly got an overwhelming feeling he was being followed. *Perhaps I was wrong*, he thought. Without breaking stride, he glanced over his right shoulder, looking

behind his horse. Nothing. He quickly scanned around to the front and then glanced to his left. *There!* His step faltered in response to his scare when he saw a dark-robed figure pacing him through the woods. He suddenly stopped, only to have the figure do the same. As he stood there in the gentle rain with his chest heaving, his eyes remained fixed on the tree the figure had ducked behind. *No, I'm not playing this game again,* he thought.

He continued on, drawing closer to the road. He glanced over to his left while he ran and spotted the figure three more times, though it never moved any closer to him. It was unnerving. The hooded robe pacing him conformed to the shape of a man running, jumping over rocks and fallen trees. But there were no hands or legs visible. And when the hood turned his way, there was no face inside looking back at him. *How's a man to keep his mind on what he's doing with this?* Gustin thought, stopping at the edge of the forest to catch his breath.

While he listened for approaching horses, he made a plan. He tied his horse to a tree and removed a rope and pair of gloves from a saddlebag. The other side of the road was mostly bog with just a few trees, so he tied his rope to a large boulder and laid it out across the road. He chose a small tree he thought would have the right amount of bend and wrapped it once around the trunk at knee height before fixing a loop in it and tossing it down.

He looked up when he heard the sound of horse hooves in the distance. *Here they come.* He considered the possibility of the entire group returning after finding their dead comrades, but that seemed unlikely since returning without completing their task would no doubt earn the wrath of an unforgiving master. If they did, he'd be on the run through the forest with ten-to-one odds. *At least that'll keep them away from the others.*

He quickly kicked some mud over the rope across the road as he looked the other way to make sure no one else approached from behind him. Satisfied, he turned around in time to see

two riders come into sight. They saw him and reined their horses to a stop. They were about a hundred feet away, talking, but he couldn't hear what they said. Fortunately, neither of them carried a crossbow. He saw them looking to both sides of the road, contemplating a way around him. He was confident they wouldn't try the bogs. But he didn't want to chase them through the forest. He hoped they weren't smart enough to split up. That would force him to let one get past and then chase him down. Finally, he grew weary of their indecision.

"Shadow!" he yelled, pulling one of his swords. "Cowards! I'm alone! Dare you face me?" he challenged them, holding up his sword. He could tell they were taking his bait. *They won't split up now.* If they charged him, he'd pull his other sword and attack. If they tried to flank or run him over, he'd dive to cover and use the rope to trip their mounts. *Come on, fools, find your courage.* At last, they pulled their weapons and spurred their mounts forward. Gustin took one more look behind him when they charged, and then he stepped toward the tree. The closest one slowed and raised his sword while the other moved to the far side of the road. *They are splitting up*, he thought, diving for the rope. He grabbed the loop and pulled, raising the rope taut across the road. Just then his challenger reined up close and slashed with his sword. Gustin had no choice but to block the swinging blade with his own while he held on to the rope.

Just as the clashing of steel rang out through the forest, the other rider's horse reached the rope. Gustin leaned back when the force, lessened by the bending of the tree, pulled him off balance. His feet slipped in the mud, and a sharp pain shot through his injured arm he held the rope with. He lost his sword when he was pulled violently to the ground, but the running horse went down, unseating its rider. Recovering quickly, Gustin came to his feet, pulling his other sword as he turned his attention back to his attacker.

The mounted man pursued him, striking again with fury.

"Ahhh!" he yelled, bringing his sword down hard.

Gustin blocked and then ducked to roll under his horse. He planned to come up on the other side and thrust his sword into the man before he could reposition for another attack. Instead, the man threw his sword from one hand to the other, catching it in midair and swinging at him. *Impressive*, Gustin thought as he blocked it and came to his feet. The man swung at him again, forsaking power for a quick, second slash. But Gustin was prepared. He parried and countered with a well-placed slash across the man's thigh, laying it wide open.

"Ahhh!" he cried out in pain as he dropped the sword and grabbed his leg. Gustin followed with a thrust, but the man leaned in his saddle to avoid it. Then he spurred his horse with his good leg and bolted away.

No matter, Gustin thought. *He won't get far.* He knew the wound was serious, and it was a good distance back to the main road. The only chance of survival the man had was to dismount, lie down, and tie something around his leg to stop the bleeding. *He won't. Fear will cloud his judgment, and he'll bleed out long before he reaches help.*

He walked over to check on the other man who lay motionless after his horse went down. The mount had managed to get up and limp away. After a nudge got no response, he rolled him over and could instantly tell his neck had been broken by the impact of his less-than-graceful dismount. He moved his body and belongings to the side of the road, intentionally leaving him in sight as a warning to any other Shadow who might follow. Then he retrieved his other sword and returned them to their scabbards.

Finally, he turned his attention to the long sword that had nearly done him in. It was a beautiful weapon, well balanced, adorned with small jewels inlaid in the silver hilt. The carved teakwood handle felt good in his bare hand after removing his gloves. The blade was graced with symbols and an inscription in a foreign language. *Exquisite craftsmanship*, he thought, walking to his horse. *From the southern kingdoms, I'd say.*

When he emerged from the forest onto the road, he looked both ways before spurring his horse toward the Queen's Highway. He didn't go far before finding the blood trail. It appeared first as intermittent drops and then increased to a nearly solid line. *Yeah, he's done. Fool,* he thought as he reined up, looking down the road that meandered through the bogs. There were still eight riders closing on the column, and he knew the one who'd gotten past him wouldn't survive to reach the main road, so he reined his horse around and took off to catch up with his friends.

/// \\\

After clearing the bogs and climbing through the ravines, the column rolled up to the ruins of Shaelah. Lance was the first to crest the hill and view the pool of water with the ruins on its shore. Then one by one the wagons came to a stop in a loose line.

"What a beautiful place," Celeste said. "Amazing."

"Yes, daughter," Hollis replied as the others reined up. The fog was all but gone, and the rain was light, so they could clearly see the falls and the far side of the pool.

"This is incredible, Lance," Janae said.

Without responding, he coaxed his horse forward, scanning all around.

"Lance, what is it?" Hollis asked.

"Where's the scouting party?" he replied with a glance over his shoulder. They watched him ride into the edge of the pool and realized he was traversing a stone spillway under water a foot deep.

"Well, I'll be," Hollis said as Fae rode up to join them.

"Where is everyone?" she asked.

"There!" Janae said, pointing. They all looked to see Flynn just settling into the saddle as he spurred his mount toward them. Lance saw him and quickly made his way back to the

wagons. When he drew near, they could tell something was wrong.

"Flynn, what's going on?" Hollis demanded when his scout reined up.

"Oh, it's bad," he replied, shaking his head.

He was immediately barraged with questions from the others.

"Wait!" Lance yelled. "Let him speak!"

Everyone fell silent so he could report. "Hunter's up there with Erin," he said, pointing to the top of the falls. "She and I were trapped in the rising stream when Draigistar swam out and saved us. Hunter pulled us back with a rope, but Draigistar went over the falls and now I can't find him."

Fae was frantic. "Is Erin all right?" When he looked at her, she knew there was more. "Flynn?"

"No, Fae," he replied with a look of utter despair. "I fear she's drowned."

She yanked on her reins to spin her horse around and spurred it away. Even though she'd never been there, she knew to follow the road up the cliff beyond the ruins to the falls.

"Oh no," Janae said as Celeste spun her horse around and lit out after Fae.

"Celeste!" Hollis yelled as he followed.

"Derek, take two others and go with them! Now!" Lance ordered. "Flynn, you keep looking for the mage. Did you scout this way?" he asked him, pointing to the spillway behind him.

"No. Hunter and Draigistar did. But it's impassable up there."

"All right, go!"

Flynn turned and headed back to the base of the falls.

"I'll go help him," Janae offered.

Lance looked at her and nodded. "All right. Listen up, people!" he said as she rode off after Flynn. "We have to get these wagons across that rock formation, now. It's the only way. We'll follow the order we've been moving in. As soon as a wagon gets halfway across, another one starts. Get the remainder

of the grain out of the last two wagons and move it up."

"But, Lance, it's raining," one driver said as the others went to work.

"That's all right," he replied. "Wet grain is better than no grain. Keep it separate, and we'll feed it to the horses when we stop."

Fae raced past the piles of destroyed stone where the road began its climb up the cliff. *Oh, why did I let her go without me?* she thought, pushing her horse hard. She topped the hill to see Hunter kneeling over her.

He'd lost consciousness after the attack from the mysterious gray cloud, then awoke with sore ribs and wounded pride. He scrambled to find Erin unharmed and still sleeping, so he retrieved his sword and brought the horses closer. He was just preparing to cradle her and climb into his saddle so he could make his way down to the ruins.

"Hunter!" Fae yelled when she drew near. She yanked on the reins and leapt from her saddle while her horse slid to a stop. "Please tell me she's all right," she said, running to Erin's side.

He looked at her when she knelt down. "She was gone when we pulled her from the water. But she's breathing now."

"Hunter, what happened?" she asked, looking at him with tears flowing.

"I don't know yet. We were split up. Listen, we'll get to that later. Right now, let me get her back down the hill," he said as he looked up to see Celeste topping the hill. Before she could dismount, he scooped Erin up and climbed into his saddle.

"She's alive," Fae told her when she reined up, making eye contact with Hunter. "Thank God for that," she replied.

When Fae mounted up, Hunter handed her the reins of her friend's horses.

"I won't ask why you're alone," he said to Celeste before seeing Hollis and Derek crest the hill behind her.

She was offended that he felt she owed him an explanation, and her narrow-eyed glare showed it.

Little was said as the group made its way back down to the pool's edge. Three of the wagons were already across the spillway, with the others lined up to go. Getting across was an unnerving experience, even for Lance's seasoned drivers. The surface of the giant monolith was flat and accommodating. But moss grew in patches, making the wheels of the freighters occasionally slip as the crosscurrent pushed them dangerously close to the edge. The huge draft horses were well-trained but reacted skittishly whenever they lost their footing on the slick rocks. And Lance knew they were nearing the limits of what these magnificent animals could be pushed to do.

Hunter and the others reined up near the back of Celeste's wagon, and she and Fae immediately climbed inside. Derek joined them, and Hunter moved his mount closer to hand Erin off to him. The two women helped him place her on a pallet so she could be warmed up.

"Thanks, Derek, but it's ladies only now," Fae said.

"Understood," he said, retreating as Celeste began peeling off Erin's wet clothes.

"Fae, where's Gustin?" Hunter asked while Derek exited the kaishon.

She realized he would return not knowing about their friends. "He fell back to see if we were being followed."

"And to even the odds, no doubt."

"I'm sure," she said. "Hunter, if you see him before I do when he returns, tell him what's happened."

He understood her concern. They didn't know if Erin would recover, and Draigistar had apparently drowned. He silently nodded and pulled the cover on the wagon shut as Lance approached.

"If they're set, we need to get them across next," he said. "The water's rising fast."

Before Hunter could respond, he looked away with alarm, and Hunter turned to see one of the hirelings standing at the edge of the forest, waving his arms.

"We have company," Lance said. "Why don't you see this wagon safely across and take Hollis with you?"

Hunter wanted to stay, but his first duty was to Hollis and Celeste. "All right."

Soon the kaishon rolled onto the spillway and began crossing the edge of the pool. Hunter rode behind it with Hollis and Krysta, all in a single file. If a horse slipped and went down, they didn't want to risk taking down others. A rider or mount going over the edge of the spillway down into the rocky stream meant injuries and possibly even death. Up ahead, he could see the other wagons and teams just beginning to make their way up to the stream above the waterfall. Looking back, he saw Flynn and Janae rejoining Lance, but no sign of the mage.

He coaxed his horse closer to Hollis. "When did Janae get her weapons back?"

"Lance and I agreed we need everyone armed. I believe she's sincere."

"Well, you're about to find out."

By the time they were across, Lance had prepared a welcome for their pursuers. Fae exited the wagon and mounted her horse. "Hunter, I'm going back to help."

He worried, but he knew she needed it. Gustin was somewhere behind them, and she wasn't about to leave him, especially with what had already happened.

"How is she, Fae?" he asked as she turned her horse around.

She paused and looked at him with a painful expression. "The same; she still sleeps. Hunter, you take care of her."

Her words hit him hard, making him briefly look away.

"What is it?" she asked.

"Draigistar said the same thing to me," he said, looking at her. "Those were his last words."

She gave him a halfhearted smile. "You've always just called him *mage*. That's the first time I've heard you speak his name."

"Yeah, I guess so."

"Fae, I'm sorry about Draigistar," Hollis offered. "I'm sure I can't know how close you were."

"Thank you."

"I will look after Erin," Hunter said. "Now go, and be careful."

"I will." Coaxing her mount forward, she headed off to join the others.

"Well, son, let's make good use of our time and get these wagons up that hill," Hollis said. "From what Lance told me, quite a task awaits us."

"Yes, sir."

/// \\\

Fae crossed the spillway as fast as she could, trusting her mount's instincts. The water was rising and clouded with dirt and debris. Lance sent Flynn and Janae to hide in the trees with the two lookouts, and he and Derek had prepared a greeting by the time Fae joined them.

"Everything all right?" she asked when she dismounted.

Derek had his horse standing sideways to the road with a front hoof raised and appeared to be removing a rock. He glanced up at Fae. "Yeah, just part of our little welcome," he said. His crossbow was loaded, slung from his saddle by a leather strap within reach.

"All right, here we go," Lance said, hearing riders approach.

Fae realized she was anxious. Not normal for her, but she was not herself.

"You ready?" Lance asked her, sensing her distress.

"Yes."

He gave a fleeting smile. "Just remember, we need to question one."

"Understood."

Just then, the riders came into sight and immediately slowed up. Lance and Fae watched them as Derek continued his task.

They looked around them, first up the hillside into the trees, then toward the ruins.

"How many?" Derek asked, still scraping his horse's hoof.

"Seven," Lance replied.

Finally, they advanced in a tight skirmish line, reining up just ten feet away. All were dressed in black and were well-armed. Some wore armor, and some carried crossbows resting on their lap at the ready.

The leader looked across the pool at the wagons making their way up to the falls.

"So, the legend is true," he said, his eyes settling back on Lance. "You gave us a good chase. None of us believed there was a way through this cursed forest, or that you were foolish enough to try it. Don't you know what happens to folk who travel through here?" he asked with a smug expression. "They're never seen again."

"We're a little busy right now, and I have all the friends I need for conversation, so who are you, and what do you want?"

The man's smile faded at Lance's remark. "I represent the owner of this forest. You can't pass through without paying a toll, even if you don't follow the road," he said, causing his men to chuckle. "As for what I want, I want everything," he added, leaning forward in his saddle for emphasis. "I want the horses, the wagons, the weapons. I want the gold and the women. I'll even take the elf," he said, nodding toward Fae. "I prefer real women, but I can sell her."

His men laughed.

Fae's anger boiled inside her. *Oh, I will interrogate you,* she thought. Then she heard the release of Derek's crossbow and saw the look of fear in the leader's eyes when he glanced that way. As the bolt penetrated his leather armor into his midsection, Fae sprang into action, leaping toward the line of men. Drawing her weapon in midair, she landed in front of a horse and sliced through its reins. Then she crouched and carefully thrust her sword, just barely penetrating the horse's

chest. When it reared up to kick at her, its rider went flying.

By the time the man hit the ground, Lance's crew had opened up. As soon as Derek fired, Flynn emerged from his place of concealment, launching an arrow. His aim was true. The man on the end of the line took the arrow in his side, causing him to stiffen and fall from his saddle, dead before he hit the ground. Janae and the others fired their crossbows, but their weapons lacked accuracy at that range. She missed the man she shot at, hitting the leader in his leg instead, while the other shots flew astray.

Lance and Derek seized the moment when their opponent's attention was diverted. They slapped their horses away and charged the line with swords drawn. The rider in front of Derek raised and fired his crossbow, and Derek went down. The leader frantically backed his mount away, so Lance squared off with the next rider in line. When he tried to raise his crossbow, Lance swung his sword down hard, striking it, causing it to shoot into the ground. Then he followed with an upward thrust into the man's gut. He moaned, and when Lance pulled his blade free, he bent forward and fell to the ground dead.

Before Fae's unseated rider hit the ground, she turned her attention to the other two at her end of the line. She wanted to challenge the arrogant leader, but he'd backed away, leaving the other two nearer. And they both had crossbows. The one closest to her was raising his weapon, so she countered. To a fighter with her agility, being mounted was a disadvantage she would use against them. She dove toward the closest horse when the rider tried to get a bead on her. Rolling under the animal, she came to a knee, expecting to face the other man's crossbow, but she saw it hanging from his saddle while he tried to draw his sword. She glanced up at the other man, who was now cursing at her as he leaned to bring his weapon to bear. Time seemed to stand still when she briefly locked eyes with him. *Look into your opponent's eyes*, Telfari had told her. *It will tell you what they're feeling, and that will tell you what*

they're thinking. She held his gaze as she thrust her sword up into the back of his leg.

"Ahhh!" He yelled out, pulling the trigger on his crossbow. The distinctive sound of its firing mechanism was followed by a loud smack when the bolt struck the mount of the man next to him. The horse stumbled after being hit in the shoulder, and the rider made a frantic dismount off the other side. Fae leapt to her feet behind the stumbling horse as the rider landed and quickly turned with sword in hand. She glanced behind her to see her first victim clambering to his feet while the leader struggled to stay in his saddle. Then she saw the one she'd just stabbed leaning over in his saddle, clutching his blood-soaked leg.

"You're dead!" he yelled, looking at her.

He's busy for now. No threat, she thought, turning her attention to her new opponent. When their eyes met, she knew this man was seasoned. She let him advance. She was most comfortable fighting defensively, the very essence of the Blademaster style Telfari taught. And she'd been his star pupil. He swung at her twice in rapid succession, but she parried his first strike and sidestepped his second into a tuck-and-roll that put her where he had been. When she came up off the muddy ground, she now had her back safely to the water and all her enemies within view.

After firing their crossbows, Janae and the other two hirelings charged their mounted opponents with swords drawn. Flynn calmly approached the foray nocking another arrow. He wasn't afraid of close combat, but he was lethal with his bow and knew he'd do the most good with a wide view of the scene. Janae charged the one Fae had unseated. He was now on his feet, and he recognized her when she approached.

"You!" he exclaimed as steel clashed between them.

Before Lance could get to the man who'd shot Derek, his two hirelings were on him. The rider saw them closing and drew his sword, swinging at them wildly. As one man met the

rider's sword with his own, the other thrust his blade into his ribs, and the rider fell to the ground dead.

Now the sounds of clashing steel and moans of death unnerved Fae's opponent as he realized his back was unprotected. He lunged at her, feigning a thrust with his sword to draw her close. She anticipated the false attack but misread his true intent. When she stepped forward to parry, she put herself in reach. And with her attention on his blade, she opened herself up to a jab. He quickly lunged again, striking her with a fist. She realized her mistake and moved enough to make it a glancing blow off her cheekbone, averting a full punch to the face. But it knocked her off balance, and when she lost her footing on the muddy ground, she had to roll back into her fall. He pursued, ready to bring his sword down, but she rolled onto her back and brought her leg up, kicking him hard in the side he exposed when he raised his sword.

She heard ribs break, and his breath exploded. He recoiled, clutching his side, but managed to keep hold of his sword. Swiftly she arched her back, thrusting herself up from her supine position onto her feet again. Now injured and desperate, he lost his composure. He advanced with a wild horizontal slash, but by the time his sword sliced through the air, she was gone. She countered by crouching and spinning on one foot as she brought her sword across his stomach, eviscerating him. He went to his knees with a wide-eyed stare, coughed up blood, and then fell dead, face-down in the mud. She quickly glanced to see Janae best her opponent with a parry-and-thrust move, running him through.

Lance looked up to see the leader raising his crossbow, aiming it at him. He froze, contemplating death. Then he heard the sound of an arrow knifing through the air and a sickening thud as it slammed into the man's chest. Flynn's shot was perfect. The arrow penetrated his armor, piercing his heart. He dropped his weapon as his body stiffened. Then he fell limp from the saddle to the ground. Lance turned to see Flynn

standing thirty feet away, and they silently exchanged nods.

Fae returned her attention to the one she'd wounded. She was glad she'd spared him for interrogation. She saw he now sat up straight in his saddle, smiling at her menacingly. He'd managed to reload his crossbow.

"*You're mine*," he growled when their eyes locked.

She wasn't worried; she'd deflected arrows many times. While Flynn tried to nock another arrow, something unexpected happened. When the man leveled his crossbow on Fae, a gray cloud suddenly appeared like a whirlwind of dust blown up from the rain-soaked ground between them. It instantly formed the shape of a black, hooded robe before him. It looked as if the wearer was raising its arms, but no arms or legs were visible. A chilling scream erupted from the figure, and the man fired his weapon in sheer terror.

Fae was surprised when the bolt suddenly appeared through the cloud. And with no time to raise her sword, she barely sidestepped to avoid being struck. The man dropped his weapon and let out an ear-splitting scream when the hooded figure moved in face to face. Then he crumpled in the saddle and fell to the ground, dead. The robed figure turned back to a gray cloud and swooped away toward the ruins while Fae and the others stood there, silently looking at each other with only the sounds of the rain and the waterfall.

"What was that?" Janae asked.

"Shaelock?" Fae asked, looking at Lance.

He nodded. "Yes. I thought to never see one again, but I'm glad that one showed, even if this fool was our last chance for information," he added, looking down at him.

"I didn't do it," Fae said.

He glanced up at her with a fleeting grin, despite the grotesque sight before them.

The dead man's face was distorted in a hideous expression, covered in wrinkled skin that made him look as if he'd died as much from extreme old age as unimaginable horror.

"Looks like that thing sucked the life right out of him," Lance said.

"Lance!" Flynn yelled.

They all looked to see Flynn kneeling over Derek, who lay clutching the shaft of a bolt that protruded from his side.

"Oh, Derek," Lance said, kneeling beside him.

"Sorry, boss. I let you down."

"Nonsense, son. Let me look at that," he replied, carefully examining the wound as Derek winced in pain. "Looks like it's lodged between your ribs," he added.

"Is that good? Doesn't feel like it," he replied with a cough.

"Yes, that's good," Lance said. "If it hurts, that means you're still alive."

Derek tried to laugh but coughed again as the others smiled.

"That kept it from going in deep," Lance said. "You just relax now." He stood up and looked across the pool to see the wagons climbing up to the falls. *Good, at least that's done*, he thought while forming a plan. "All right, we need to get Derek to safety. Fae, I assume you'll want to wait here for Gustin?"

She gave a confirming nod.

"Flynn, you stay here with her. The rest of us will go on across."

"Yes, sir," Flynn answered.

Lance looked back down at Derek. "We're fresh out of wagons on this side of the stream, so you'll have to ride."

"Yes, sir," he replied. Janae knelt to help him up, and once they got him in his saddle, he and the two teamsters headed for the spillway.

"Not yet, Janae," Lance said when she started to go with them.

She reined up, looking at him.

After the others had gone, he looked at her. "Do you know that man you attacked? Or any of the others?" he asked, studying her.

She knew it was a moment of truth, with Fae and Flynn

both looking on. Lance had respectfully said nothing in front of the others, but she was certain he already knew the answer to his question.

"Yes, sir," she said. "I know the one I killed and the one who spoke to you."

"Names?" he asked without falter in his gaze.

"The one I killed is Hadrum. You turned him down when he asked you for work almost a year ago."

Lance thought back and confirmed her claim to his own chagrin. "Yes, of course. I should've remembered. And the leader?"

"His name is Barak. He runs a business in the City of Queens."

"What business?" he pressed her without expression.

"Uh, a tavern . . . and a livery. He has an animal trainer and a blacksmith who work for him. He sells wagons and horses, and. . . ." She looked away as she trailed off.

Fae's intuition told her there was more. "Janae, what is it? You can tell us."

She hesitated, but Lance was surprisingly patient. Eventually, she turned back toward them with tears streaming down her cheeks. "He sells slaves," she said softly, wiping her eyes. The implication was clear, but they didn't have time to delve. Slave trade was illegal in the Eastern Kingdom, though they all knew it happened.

"You can show me this place when we get to the capital?" Lance asked her.

She slowly nodded. "Yes, sir."

"Well, thanks for your honesty. The details are yours to share as you see fit, but I'll let Hollis know how well you conducted yourself here," he added.

"Thank you."

He gave her a fleeting smile before he reined his horse around to face Flynn and Fae. "Listen, if more Shadow show up, don't do anything foolish. And Fae, the water's still rising, so if this route is impassable when Gustin gets here, you'll have two choices. Leave the horses and cross the stream fur-

ther down the ravine on foot. Or go up to the falls and follow the stream through the forest to the high road. There you can cross on a bridge."

"Don't worry," she said. "Either way, we'll catch up."

"Fae," he said before pausing and looking away.

She wasn't sure what to make of it as he gazed off at the waterfall. She didn't take him for a sentimental man. Flynn and Janae held their silence until he finally returned his eyes to Fae.

"I know it hasn't been a good day," he finally continued. "Draigistar's gone. And God only knows where Gustin is. If he doesn't show, before you go off looking for him just remember there's someone else up there who needs you," he said with a look that betrayed his own sense of loss.

She knew he spoke of Erin. "I will do the right thing," she said, thankful for his fatherly advice.

He nodded and silently reined his horse around as Janae fell in behind him and they started across the spillway.

/// \\\

After they'd gone, Fae went to the water's edge and cleaned the mud from her clothing before walking over to the crest of the hill. She sighed as she surveyed the road that wound its way up the gently rising forest floor to where she stood. There was still no sign of Gustin. She scanned the trees on the hillside across the stream as she turned around and took in the view of the pool, the waterfall, and the ruins.

So, this is Shaelah, she thought. *What an incredibly beautiful place.* Her heart ached for the atrocities committed against the Shaelock so long ago. And her heart ached for Draigistar. They'd known each other their whole lives. She'd always known that any of the four could meet an early death. And she thought she was prepared for it. Now she knew she wasn't. She'd never realized just how much he meant to her. And she'd never felt so alone.

She watched Flynn busy himself, rummaging through the personal belongings and saddlebags of the dead men. It made sense. But she couldn't make herself care what they had in their possession. She did, however, wonder what had happened. She knew it was probably no one's fault. And it wasn't like her to lay blame, but she needed answers. She walked back over to where he was. He was kneeling, removing some coins from the pocket of one of the men. He knew she was there, and he made no apologies. And she didn't judge him for it.

She realized he was avoiding eye contact. And for the first time, she put herself in his place, considering his heartache. She knew he fancied Erin. *What man in his right mind wouldn't?* The two younglings had so much in common. *What might have been*, she thought with a heavy heart. *Now, who knows?*

She walked up behind him when he stood up next to one of the captured mounts and touched him on the shoulder. "Flynn," she said softly.

He paused. "Yes," he replied without looking at her.

"Leave this for later. Come walk with me. I need to hear what happened. And I think you need to share it. . . . Come, let us help each other."

He turned to join her, and they silently walked, leading their horses until they were at the edge of the ruins.

"The rain stopped," he said in response to a throaty rumble of thunder. "Too late."

It prompted her to turn and face him. "Flynn, tell me what happened."

He took in a deep breath and sighed as he turned to begin walking again. With her hand on his arm, they walked while he shared every detail of their time away from the column. He paused occasionally, fighting emotion, and she could sense his personal torment over the guilt. They made their way through the ruins while he talked and she listened. Fae knew they were both getting what they needed from it. He stopped and pointed to an opening in a broken-down stone wall.

"She was the first to see one of them," he said with a fleeting smile. "Over there in that window, she saw one."

Fae silently looked that way.

"Hunter didn't believe her at first. That made her mad."

Fae smiled at the image.

"You know, from the time we got here, it was like she had some kind of kinship with them," he continued. "I think that's what I saw leaning over her up there at the edge of the stream. Then, I thought it was trying to hurt her. But now I think it must have been trying to pull her from the water. And I scared it away," he said, shaking his head.

"Flynn, you don't know that," she said. "And even if it was, you had no way of knowing it at the time."

He silently nodded.

"Come on. I want to walk the edge of the pool and look once more for Draigistar." They walked right up to the base of the waterfall that now flowed with thundering force. They made their way back along the shore, but nothing was visible in the clouded water except bits of debris from upstream. Suddenly they saw Gustin ride over the crest of the hill.

"Fae, look!"

She'd already spotted her lover. "Yes, I see," she replied as she sprung into her saddle and took off to meet him. She closed the distance as he surveyed the scene of their battle. Then he leaned over when they reined up side by side with their mounts opposing.

"Looks like you've been busy," he said before their lips met and they hugged briefly. "Is everyone all right?"

"Derek's hurt, but he'll recover."

"Another good hand out of action," he said, shaking his head.

"Looks like you found some action," she said, nodding at the fancy sword tied to his saddle.

He looked down and proudly replied. "Yes, a prize, you might say. It's foreign. I thought I'd have Draigistar interpret its inscription for me," he said, looking back up at her. When

their eyes met, he knew something was wrong. "Fae, what is it?"

Tears came to her eyes. "Erin and Flynn got into trouble in the rising water. Draigistar swam out to save them, and he went over the waterfall. . . . He's gone," she said as she began to cry.

Gustin looked at her in disbelief. He was devastated, but he knew she needed him. He reached down and scooped her out of her saddle, and when he cradled her in his lap, she curled up against him and broke down. Taking up the reins of her mount, he turned and rode away. While Flynn finished searching the dead Shadow, Gustin and Fae slowly rode through the ruins. She regained her composure and told him what had happened while he patiently listened.

"How's Erin now?" he finally asked.

"I don't know," she replied with a sniffle. "She was still asleep when I left her with Hunter and Celeste. What did you run into?" she asked, looking up at him. "Where'd you get that sword?"

"These fools," he said. "There were twelve. I took down two when they stopped for a rest. Then I doubled back and got two more returning to the main road; didn't get a chance to question any of them though."

She suddenly looked up at him with alarm. "But Gustin, only seven showed up here. That still leaves one."

He smiled fleetingly. "It's all right, Fae. He and I met just down the road a ways. We settled our differences," he said, returning his eyes ahead. "He wasn't in a talking mood either."

She thought about it for a moment. "So, we can assume whoever awaits a report back on the main road still doesn't know what we're up to."

"That's right."

"Come on, we need to get across the stream while we still can." Taking her reins, she deftly slid back into her own saddle as they approached Flynn.

"You ready?" Gustin asked him.

"Yeah. It's good to see you made it all right. I'm sorry, Gustin."

"Flynn, just let me ask, did you do all you could to keep them safe?"

He thought briefly. "Yes, sir," he replied, looking up at him.

"Then don't take more than your share of the blame. It will eat you up if you let it. Trust me, I know," he said before turning toward the spillway.

Feeling little solace, Flynn mounted up and followed, towing the four uninjured horses from the fight.

CHAPTER ✝ 13

They'd left the Queen's Highway under cover of darkness and fog, moving through the dangerous bogs up to the ruins of Shaelah, a secret place of enchanting beauty and horrible tragedy. The spirits of the Shaelock who died so long ago refused to leave the wondrous realm. They made their presence, and their intentions, clearly known. It was their forest, and outsiders were not welcome.

Once all the wagons had crossed the stream, Hollis began shouting orders to his hirelings. The last obstacle to reaching the high road was the steep, muddy hill they now laid siege to. He sent a crew up the hill with spare horses and ordered the team and hitch to be uncoupled from the rear wagon. Once the team was at the top, their hitch was tied to that of the first wagon waiting to make the climb. A pair of huge, two-hundred-foot-long ropes spanned the distance between the teams of powerful animals. The team on top was out of the wagon driver's sight, so Tobias stationed himself midway to direct the operation. When everything was ready, he waved a signal flag, and the drivers of the wagon and the team on top both began driving their beasts forward. Others walked alongside, using poles to push against the wagon when its wheels slipped sideways in the mud. Occasionally a horse would lose footing, and its teammates, forced to bear the additional load, would panic instead of leaning into the pull to compensate. The more they struggled and lifted their hooves, the more momentum they lost. Handlers tried to soothe their skittish outbreaks and

coax them up the hill. They all knew a slip could mean death under the hooves of the massive animals.

When Lance rejoined them, Hollis's kaishon was just topping the hill, the fourth wagon to make the climb, with three remaining. Lance assumed his duties, and everyone pitched in, pushing wagons and pulling horses to get the heavy loads up the hill. With each pass, the muddy ruts were cut ever deeper, jeopardizing the horse's footing. It was hard work, and tempers flared at the slightest perceived sign of laziness. That was unusual for the well-disciplined group, but Hollis and Lance allowed some slack, given the stress everyone was under.

Finally, Lance ordered the second kaishon to be taken up while a hitch was carried back down the hill and mounted to the last freighter. Fae climbed into the kaishon to be with Erin, and during the bumpy ride, she watched her closely, hoping to see some sign of her waking. She fought a nagging feeling they weren't alone. Several times she turned to look behind her as the cavernous wagon rocked and pitched over the rough incline, but she saw nothing. She was glad when Celeste and Janae relieved her so she could leave the wagon to go clear her mind. Witnessing what the Shaelock had done to the man who tried to kill her had been unsettling. She kept hearing Flynn's words about Erin. *From the time we got here it was like she had some kind of kinship with them,* he'd said. *Perhaps one had contacted her,* Fae thought. She couldn't explain it, but her instincts told her Erin would be all right.

When the rigging was in place, the last wagon began its climb. Tired men drove tired horses on the pull. Taut muscles rippled in the quarters of the enormous animals as their giant hooves pounded the ground. When the wagon was about halfway up the incline, one of the lead horses lost its footing and went down. It frantically struggled as it slid under the horse behind it, tripping it up. The other two fought the load as the wagon began sliding back down the hill, pulling them with it. One of the men walking beside the wagon jammed his

pole through the spokes of a rear wheel to stop the slide, and the result was nearly disastrous. When the wheel locked up, the wagon suddenly turned sideways on the hill. With men yelling warnings and scurrying about, it came to rest listing precariously.

They all held their breath as it teetered on its right wheels, with the left wheels occasionally touching the ground. Men raced in to help the panicked horses regain their footing while the team atop the hill dug in, leaning against the increased load. The creaking sound of the giant ropes being stretched to their limits was unnerving. And the wagon's hitch twisted until the tongue split, sending huge splinters flying into the air.

"Everyone, hold!" Lance yelled over the others, restoring order to the chaotic scene. Once the urgency of the crisis passed, they quieted and calmly awaited his orders.

"All right! Let's get two more horses in here and tie them off to the front corners of the wagon. Now!"

His people responded, and soon they had two fresh horses tied into the wagon, albeit with much smaller ropes. Once those were in place, Lance ordered the two horses that had faltered to be unhitched and replaced with rested animals. While that was being accomplished, he inspected the hitch and decided they would try to complete the climb without unloading the wagon. Eventually they managed to pull the wagon back into a straight line, and Tobias flagged them to a stop.

Lance planned to wrap the wooden hitch tongue with leather straps and a tight coil of rope to keep it from failing under the strain of the pull. Everyone watched uneasily as he stepped in close to the hitch just behind the rear horses. They all knew the risk. The animals were already on edge, and if they became frightened and kicked, he could easily be killed. Just as he knelt down to go to work, he heard a loud cracking noise, and the large wooden beam exploded in front of him. The wagon instantly began rolling backward as the horses stumbled forward from the sudden release of their load.

The team atop the hill was tied into the front of the hitch with the huge pulling ropes, so like the four in front of the wagon, they were safe. But the two additional horses had been tied to the front of the wagon itself and were now being pulled back. Fortunately, men stood by at the front of the wagon with swords drawn, so when the hitch gave way, they slashed the ropes to keep the horses from being dragged down. One maintained its footing, but the other was pulled over before the rope was cut, and several men threw themselves in front of the huge horse to keep it from rolling down. Lance dove to the ground and then watched the wagon bolt down the hill with the driver jumping clear.

"Lookout below!"

Frantic warning yells resonated through the forest as the heavy birck thundered down the muddy hill. Amazingly, the front axle stayed true, keeping the freighter on a straight path to its destruction. The few hirelings still working at the bottom quickly scattered. The routes across the stream converged in a small clearing where the cliff overlooked the falls and the pool and ruins below. Now the loaded wagon rumbled down the hill toward the cliff with all eyes fixed on the unbelievable sight. When it reached the fork in the road, it continued on, crashing through the foliage and leveling small trees before going airborne. Time seemed to slow as it silently fell, turning over in midair.

Flynn sat atop his mount near the cliff, having stayed behind when Gustin and Fae went up the hill. Alone, he sat quietly overlooking the pool, replaying the day's tragic events in his mind. He'd heard the yelling when the wagon nearly turned over and had been watching with mild interest ever since. Now he had a clear view as the wagon careened down the hill. He couldn't help but smile when those in its path scattered like mice in a barn when the door was thrown open.

When the wagon went airborne, it fell from the sight of everyone save Flynn and two others who were close enough

"Sorry about the loss."

"I can afford to replace what's down there, son. Come, let's rejoin the others."

They made their way back up the hill while the stragglers collected ropes and equipment used and thrown down. Others retrieved horses tied to trees out of the way.

Eventually, everyone gathered in a clearing at the top of the hill. The rain had stopped, but thunder still rumbled in the distance, and daylight was waning.

"Lance, my thought is to camp here tonight," Hollis said as they stood together with Gustin and Fae. "Everyone's exhausted. The horses are beat up. Could we make it to the high road by dark if we press on?"

Lance thought. "Hard to say. I'm sure there'll be brush to clear."

"And what say you?" Hollis asked, looking at Gustin and Fae.

Surprised, they glanced at each other.

"Well, I'm sure they only sent in twelve riders," Gustin said. "I don't think they were supposed to make contact. But when no one reports back, they still won't know if we've found a way through the forest, so they'll have to wonder if we took out their scouts and decided to return to the main highway."

"And they'll have to keep their forces divided," Hollis said, nodding in agreement.

"I think we'll be safer in here tonight than out on the road," Fae added.

Hollis nodded. "Lance?"

"I agree," he said. "We know the Shadow's out there; we'll have to face them. And as much as I regret bringing us in here, I'd say it's best to let everyone rest up and leave in the morning. We can't outrun them. So, let's put them on edge, wondering where we are."

"Very well then. You'll inform the others?"

"Of course."

"And Lance, don't beat yourself up," he added. "It's not your

fault."

Lance simply nodded.

When they dispersed, Gustin and Fae went to tell Hunter the plan.

"Fae, I'm surprised," Gustin said as they walked. "I'd have thought you'd want to be rid of this creepy forest."

"Creepy forest," she repeated in amusement. "Men are such babies about things they don't understand."

"You try being chased through the forest by a robe with no one in it."

She chuckled. "I'd have loved to see the look on your face. No, truthfully, I guess I'm just in no hurry to leave Draigistar behind," she admitted. "Or to take Erin away from here." They stopped and held each other briefly until she looked up at him.

"Do me a favor," she said. "You go share the news with Hunter. I'm going for a walk down by the waterfall."

Gustin gave her a worried look.

"It's all right," she assured him. "I, uh . . . I just want to say goodbye," she said as her voice broke.

He knew there was nothing he could say or do to ease her pain. She just wanted to be alone. He nodded and gently kissed her forehead before releasing her. "All right."

She smiled halfheartedly and turned away.

/// \\\

He slowly ascended through a surreal world of strange sounds and sensations: *running water, crackling fire, whispering voices, darkness. Yes, it was dark, and damp.* Struggling to awaken, he tried to make sense of his surroundings. His eyes slowly opened, and the haze began to clear. He was lying supine, looking up at a rock ceiling in the dim light. *A cave?* he wondered, raising up on an elbow. A fire was burning next to him; its warmth felt good. Now he knew his senses hadn't failed him. He was in a cave. He sat up and looked around, his head

still throbbing. He reached up and gently touched his swollen forehead. And when he drew his hand away there were flakes of dried blood mixed with some fresh, shiny red.

Now his memory was returning. He recalled freeing Erin and Flynn from the waterfall before being swept over. *Oh, Erin*, he thought, remembering her cold, lifeless face. He patted his clothing. *Still damp.* He'd been here awhile—wherever here was. He remembered pushing off the log as he went over so it wouldn't crush him. But when he entered the water, he struck his head on something. He struggled in vain against the churning water, and as his world dimmed, he accepted the inevitable. Then he felt hands grab him and pull him up just before the dark silence took him.

He suddenly realized the voices he'd heard while waking were gone. He slowly stood, letting the dizziness pass, and then looked around. He took a piece of wood from the fire by its unburned end and held it up. In one direction, the surface angled downward, and he could see light and hear rushing water. *The waterfall*, he thought. In the other direction, he could see lit torches resting in sconces mounted to the rock walls. The cave floor was flat, and the walls were cut smooth. *This place was excavated*, the thought, heading down the man-made passage. He didn't know how long he'd been there, and he knew his friends would be looking for him. But he had to satisfy his curiosity.

He walked down the ten-foot-wide passage between several pairs of burning torches until he could barely hear the sound of the waterfall. He thought it odd there was little dust, no spider webs, no insects or rodents, no evidence of animals that might inhabit such a place. The passage curved and ended abruptly at a large, glistening door set in the stone wall. He held up his improvised torch and studied it. There were intricate carvings in the stone archway around a door that was graced by etchings and an inscription. He didn't know what was written, but there was a montage of scenes depicting

Shaelah before its destruction. As he brushed his hand across the surface, he moved the torch closer, and his suspicion was confirmed.

"It's made of gold," he said softly. "A history of their world. Oh, Shaelah, it was beautiful." *Oh, Shaelah*, he thought he heard a whisper from behind him. Startled, he spun around with his torch raised but saw nothing. His heart pounded. And although his head was clearing, the sudden movement caused the throbbing to return.

There were passageways leading off to the left and right, so he decided to explore them. He laid the burning remnant of firewood on the floor and concentrated.

"*Vaneeshoma-do*," he said, clapping his hands twice. Two blue orbs appeared in front of him, glowing faintly. He increased their glow and set off down the passage to the right with the lights moving ahead of him. The side passageways were narrower than the main one but also finished with smooth floors and walls. When he came to the first opening, he sent one of the orbs ahead and stepped into a large room. It appeared to be living quarters for about a dozen: several bunk beds, two large tables, and a complement of chairs. There were no remnants of blankets, garments, food scraps, or any debris scattered about. It was like this underground labyrinth was being tended to by someone even still.

Suddenly he heard faint voices out in the hallway. Unnerved but excited, he stepped to the doorway and listened. *Children's voices up ahead*, he thought, stepping into the passageway and continuing on. He inspected three more rooms just like the first before coming to an intersecting passageway.

Leading off to his right was yet another corridor, but on his left was a wide opening in the wall. He stepped through and found three wide steps leading down to the floor. It was a large room with a vaulted ceiling that contained four long wooden tables sitting parallel. Each had a dozen chairs lining both sides and one at both ends. *A dining hall*, he thought.

On each wall, two horizontal wooden poles rested on stone corbels ten feet off the floor. He'd seen similar devices and imagined tapestries once hung on them. *They could all live down here*, he thought.

He heard what sounded like a bubbling fountain at the far end of the room, so he cautiously made his way forward. Approaching the far wall, his mouth fell open in astonishment. A pair of huge tree roots protruded from the wall about waist-high. They had the girth of a man and angled downward, penetrating the floor. Cut stones had been mortared in place to form a half circle around them, jutting out from the wall to create a basin ten feet across and knee deep. Water flowed from the wall in a thin sheet, clinging to the roots. Several hollow devices had been strategically mounted to the roots, diverting water into their ladle-shaped ends. They appeared to be made of kiln-hardened clay to resist eroding as the water dribbled out of them into the shallow pool in the stone basin and on out through the floor. He was amazed at the Shaelock's ingenuity. *An underground aquifer*, he mused, *a perpetual source of fresh water*. He leaned over and reached his hand out, cupping it under one of the small streams of water, then raised it to his lips. It was cold and crystal clear, pleasant tasting. He silently smiled and shook his head before standing to resume his tour.

He left that room and continued down the passageway before turning into another. He didn't know how long he spent exploring the labyrinth. On his way back he found a large room with numerous small beds nestled in clusters around the walls. Small tables and chairs sat grouped in the middle of the room around a single large table with chairs of normal size. *A nursery*, he thought with a smile. Suddenly he heard a child's whispering voice and glanced over to see two small children dressed in dark robes standing not far away. Their hoods were down, so he could see their faces. He was in awe; they looked as real and alive as him. They were elvin, a boy and a girl, both just a few years old.

They were captivated by the blue orb he'd brought into the room with him. It silently levitated above the floor at eye level with them. Soon the little boy reached out a hand to touch it. The girl pulled his hand back, twice, but he persisted. Draigistar marveled that he could clearly see the look of worried frustration on her face as she watched her playmate. Just before the little boy touched the orb, Draigistar moved it. The boy drew back, and the children looked at each other with eyes wide before he found his courage again. Draigistar moved it again, and this time they giggled and glanced at each other, seemingly oblivious to him. He continued the game with his young visitors until he noticed other children dressed the same, appearing from out of the darkness. As they curiously walked toward the two children playing with the orb, a chill coursed through him. He realized why he hadn't seen the first pair approach. None of them cast shadows on the surrounding walls from the light of his orb.

Just then, he saw one of the newcomers glance up at the doorway with a look of surprise. Instinctively Draigistar's eyes followed hers, and he saw the figure of a robed adult standing in the opening. Their hood was up, so he couldn't see a face. But its feminine shape resembled a woman standing, resting a raised hand on the edge of the doorway. From the light of the second orb he'd left in the hallway, he could see there were no legs or arms visible, just like the one he'd seen in the ruins. He looked back at the children in time to see them all fade from sight. Then, glancing at the doorway, he saw the other figure was gone.

He stood for a moment in amazement, feeling privileged and insignificant. Finally, he left the room and returned to the main passageway. Reaching the huge door of gold, he continued on, exploring rooms down the other passage. He found what appeared to be a commissary with empty, clean shelves, and other rooms with workbenches and tools. He even found a room with large bellows over a hearth and tools for forging

metals. Finally, exhausted, he returned again to the main passage. He knew there was still much he'd not explored, but time would simply not permit.

Before seeking an exit, he examined the massive gold door one last time. As he stood there studying the scenes depicted in the beautiful etchings, a thought came to him. *Try to open it.* He reached out and took hold of the oversized handle and pulled. Nothing. He leaned back and pulled harder, and it yielded with an ominous thud. He heard some knocks and rattles from within the enormous door as it began swinging out. He leaned back for leverage to pull it open, then sent the orbs through.

When he looked inside, his mouth fell open. Entering the cavernous space, he moved the blue orbs all around. What they revealed was breathtaking. It was a huge room he estimated to be fifty feet wide and more than a hundred feet long with a vaulted ceiling thirty feet high. A dozen wide steps led down to the main floor, where stone benches sat lined up on either side of a main aisle. *It's a place of worship*, he thought, *a sanctuary.* He descended the steps and walked up the aisle to the front, stepping up on the chancel, bordered by an ornate railing. *And here's the altar*, he thought.

He methodically perused the room, taking it all in. A single large, polished column stood in each corner of the massive room extending to the ceiling. The sidewalls were lined with large decorative sconces made of copper, each fitted with a shroud of clear, faceted gems enclosing the torch inside. *Lenses for magnifying the torchlight*, he thought in amazement when he examined one. He had to see how they worked. He reached up and placed his hand near the tip of one of the torches and silently mouthed a single word as he snapped his fingers. When the torch ignited, illuminating the room, he was stunned by the beauty he beheld. He walked along both sidewalls lighting the other torches until the room was brightly lit. Looking up, he saw more of the gems hanging in clusters

from the ceiling. The light flickering off them made the walls seem to move and sway. Inspecting a sconce more closely, he concluded the gems were cut diamonds.

Like in the dining hall, there were bare poles mounted in here that had once held tapestries. On the ends of the benches were mounted plates of hammered copper inlaid with brilliant red gems glistening in the torchlight. The floor was polished, shiny and smooth as a frozen lake. Huge, gold candelabras sat near the altar, each adorned with purple silk sashes as soft and clean as the day they were fashioned. Scenes depicting life in Shaelah had been masterfully carved into the stone walls, and other religious items adorned this holy place. The wonders of artistry and craftsmanship left him awestruck as he strolled around the breathtaking room.

Standing there, trying to imagine what life must've been like, he thought he heard muffled footfalls on the steps behind him. He quickly turned but saw nothing. Now, along with the steps, he clearly heard the mischievous giggles of small children. He watched in amazement as wet footprints appeared on the bottom steps and headed toward him. The prints, like those made when someone emerges from a bath, appeared on the floor with the slapping sound of bare feet. Two sets of little wet footprints betrayed the path of unseen younglings as they ran toward him, parting to pass by on either side. He watched as the sound of their feet on the floor and their hushed laughter separated and circled the room before converging in the back and returning up the steps. As the joyous sounds of their innocence faded into silence, he couldn't help but smile.

He wondered why the Shaelock hadn't been able to seek refuge from the attack down here. *Certainly, their vanquishers never found this marvel, or it would've been plundered. Perhaps that's why they didn't try to hide down here*, he thought, *to save it from destruction.* He knew he would never know the answer. He was sure he was the only outsider who'd ever stood in this beautiful, holy place of theirs. He was honored

and humbled. Finally, he turned and ascended the steps back to the huge door. He hadn't been worried about getting sealed in. He knew they meant him no harm, or they wouldn't have pulled him from the water. He could see the torches still burning in the main passageway, so with the wave of a hand, the light from the blue orbs and the flames faded. He headed down the passageway until he heard the sound he expected. He looked back in time to see the huge door close with a thud of finality. There was no one in sight.

He suddenly realized the throbbing in his head and sore, aching muscles no longer bothered him. In fact, he felt vibrant. Without conscious thought, he reached up to touch the nasty cut he'd felt on his forehead earlier, and to his amazement, it was gone. He smiled and shook his head as he turned to leave. He walked past the place where he'd awakened and saw the fire had burned down to a pile of glowing embers. Looking back down the passageway, he watched as the torches, one pair at a time, flickered and went out. *Guess that's my invitation to leave.*

As he headed toward the growing light and the sound of rushing water, he dwelled on what he'd been graciously allowed to discover in this place. He knew he might never return. He had a responsibility to never break their trust in him and reveal its splendors. As the passageway curved, it sloped downward and narrowed, losing its manmade appearance before turning yet again. He realized where many of the stones that lay in the ruins of Shaelah must've come from. He found himself standing at the opening of the cave looking at an enormous wall of falling water. *Of course, behind the waterfall,* he thought. *Even in a dry season, there'd always be enough water running through this stream to conceal it.*

He looked to both sides to get his bearings. He knew to his left was the edge of the pool near Shaelah. He determined from the bend in the main passageway and the gentle downward slope that the labyrinth he'd just explored must be deep

under the cliff behind Shaelah. That meant there was another way in. It didn't matter; he'd never search for it. He owed them that. He owed them his life. They'd spared him and given him an exclusive glimpse of their world. As he battled the distracting roar of the waterfall, he walked along a ledge until it was swallowed up by the rush of water. *No way out here*, he thought. So, he turned around and carefully retraced his path. He passed the cave entrance and continued on.

Nearing the end, he noticed several small crevasses in the face of the cliff. He looked up, squinting through the spray. There were two big enough to climb through. He was a proficient climber, so he started up the best one. He figured he'd climbed about half the distance to reach the top near the waterfall when the opening above him suddenly squeezed into a narrow slit in the rocks. Splashing water from the swollen stream above surged down through it, drenching him.

Disheartened, he carefully climbed back down and tried the other one. He soon realized this route was far more accommodating. It was wider, and he suspected some of the convenient footholds had been crudely carved into the rock by more than nature. Again, he climbed up about thirty feet or so before the crevasse split into two routes. One continued upward but narrowed until he could barely see daylight. The other ran horizontally with a slight incline, so he climbed in and began crawling forward. He was far enough away from the waterfall that he could now look to his left and see the large pool through the spray. It was no longer tranquil. It churned with the force of the inrushing water, and debris floated on the surface. He could tell it was late in the day, and he saw no sign of his companions. Continuing on, the space tightened until he could only inch forward.

He leaned out of the opening to see if there were sufficient holds to swing out onto and continue his upward progress. Straight below him was the inaccessible edge of the pool that abutted the base of the cliff. Looking up, he could tell he was

still ten feet from the top. The space appeared to widen up ahead, so he decided to keep inching rather than risk a fall. After crawling a few more feet, he saw a ledge before him that was wide enough to climb out onto. He couldn't turn around in the crevasse, so he had to emerge head down and support himself with his hands until he could bend his legs and get his feet under him. For a brief moment, he was perched precariously fifty feet above a fatal landing if he lost his balance. Then he found himself in a standing position, looking out over the pool and the ruins beyond.

His heart sank when he focused on the far side of the pool. *Oh no!* He could see bodies lying on the ground where the road topped the hill, but they were too far away to identify. He could cast a spell to let him see clearly at that distance, but it required a material component from his pack he'd left on the bank of the stream when he swam out to save the younglings. He turned to resume his climb with a sense of urgency. When he reached the top, he cautiously peered over the cliff's edge. Not knowing what he'd find, he didn't want to rescue himself, only to emerge in the midst of the enemy. He could hear noise in the distance. *Voices*, he thought as he slowly parted the growth. There, up on the hill, he could see people moving about, leading draft horses. *Good, Hollis's people.*

He pulled himself up and stood. When he started that way, he saw the deep ruts left by the wagons as they staged to make the climb. Then he noticed the single set of tracks that ran straight down the hill to the very edge of the cliff. *Not good*, he thought, seeing the broken trees and flattened bushes. He stepped up to the edge and could see footprints of others who'd stood there looking over. *I'll bet that was a sight to behold.*

/// \\\

Fae left Gustin and walked down the hill past the teamsters gathering equipment and getting the last of the horses up to

camp. No one spoke. They could sense she wanted to be left alone. She milled around the cliff while she thought about her early life. She fondly relived moments spent with Draigistar while growing up in their small village. She smiled, thinking of mischievous pranks they'd played on each other in school, of outings with their other friends, and community gatherings under the watchful eyes of adults. She briefly allowed herself to dwell on the times they'd spent alone when approaching maturity, exploring each other intimately, satisfying their curious desires. She let herself cry freely, her heart aching for her lost friend. Finally, she sat down on a large rock near the edge of the waterfall and slowly composed herself. She wondered how his absence would affect the three who remained. She loved Gustin. And Erin was part of them both. Either of them would die for her, just as Draigistar had done. It was too soon. It just hurt too bad to think about what the future held.

At last, she stood, resigned to her emptiness. As she solemnly gazed out over the pool, she saw movement to her right. She instinctively crouched and turned that way. *More Shadow?* she wondered. Her hand gripped her sword as she quietly moved to see through the foliage.

"Huh!" she gasped. *No!* she thought in utter amazement. She couldn't believe her eyes. Draigistar stood not more than fifty feet from her, looking over the edge of the cliff. She thought of all the inexplicable things she'd seen in this forest and wondered if he'd somehow become like the Shaelock. She swallowed hard and looked all around before hesitantly starting toward him. Just then, he glanced up, and their eyes met. When he smiled, she gave into emotion, and they rushed to meet.

"Draigistar?" she asked tentatively.

Sensing her hesitation, he reassured her. "Yes, Fae, it's me," he said, holding his arms out wide. They embraced, and she cried in relief before finally looking up at him.

"What happened? Where've you been?" she asked. "You scared me to death."

He smiled and wiped her tears. "You wouldn't believe the wonders I've seen, Fae."

She gave him a quizzical look. "I—I don't understand."

"I'll tell you everything later. But when I went over the waterfall, I hit my head. I wouldn't have made it if they hadn't pulled me out."

"They? You mean, the Shaelock?"

"Yes."

"Where'd you hit your head?" she asked, glancing up.

"That's just it, Fae. I woke up in a cave behind the waterfall with a nasty gash on my forehead. Only the cave is really the entrance to an underground city, another Shaelah. It's under the stream. It goes clear back beneath the ruins and the cliff beyond. It's beautiful, Fae. I walked through it; I even went inside their holy place. And when I left, my head was healed."

She looked at him, trying to comprehend what he was saying.

"Fae, listen to me," he said, gripping her shoulders. "No one must ever learn of what I saw down there, ever. There are great riches, gold, and gems, more than I could count. But it's not ours; it's the Shaelock's."

"I understand," she said, sure at last it was really him.

"How's Erin?"

She gave a halfhearted smile. "You saved her life," she said, placing a hand on his cheek. "She's alive, but she sleeps. Hunter gave her breath until she breathed on her own, but she still hasn't awakened. We don't know what happened. There's not a mark on her. Flynn said he saw one of the Shaelock kneeling over her, but by the time he reached the stream, she was just floating away."

He thought about it as he turned, sliding an arm around her. She followed his lead, and they began walking together toward camp.

"Well, I have my strength back now. I can cast a spell on her that may let me recall her thoughts, see what she saw and did through her eyes."

"You can do that?"

He nodded, releasing her as they started up the hill. "It's not a difficult spell; I learned it when I was an apprentice. It works best on someone who's cooperative or who doesn't know the spell's being cast on them. I've used it on women I've found attractive to see if the feeling was mutual."

"Oh, you shameful letch," she said admonishingly.

He smiled. "Anyway, as my powers have developed, the spell's become more useful. The ideal subject would be unconscious."

"Hey! Look, everyone!" One of the hirelings yelled out when he saw them coming up the hill. A crowd gathered to greet them, inundating the mage with questions. He told them that after going over the waterfall, he'd climbed up on the rocks before passing out from exhaustion. No one questioned his explanation, and once the hirelings resumed their work, he and Fae joined their friends near Celeste's wagon.

"You sure gave us a scare," Gustin said. "You all right?"

Draigistar smiled. "Yeah, just took a little nap."

Hunter surprised everyone when he extended a hand to the mage.

Draigistar tentatively reached out and shook it.

"Well done, Draigistar," he said, breaking a smile. "I'm sure Fae's told you, but you saved Erin's life today. Your actions were exemplary. I know three people who are lucky to have you as a friend."

He smiled. "You mean four people who are lucky to have me as a friend."

Hunter laughed, and the others joined in. "You have me there," he replied.

"I want to see Erin," Draigistar said, looking at Fae.

"Sure, I'll take you," she replied. They headed off to the wagon just as one of the hirelings walked up with an armload of damp wood.

"Lance said to bring you some firewood," he said, dropping it in a pile.

"Help me start a fire?" Gustin asked Janae.

"Sure."

She was glad Draigistar was all right and that the attention was off of her. She'd been asked some awkward questions since running away. Celeste had forgiven her. And Hollis told her if she proved herself on the rest of the trip, all would be forgotten. He'd been impressed with her after Lance's report of their skirmish with Barak and his men. So far, only a handful of people knew the truth about her past, and they appeared not to judge her for it. She was thankful to be accepted, even though she knew when this journey ended, she'd be on her own again. And eventually, he would come for her. He'd told her if she ever ran again, he'd kill her. But even if someday she suffered a painful death at his hands, the freedom and belonging she felt now were worth it.

When Draigistar followed Fae to see Erin, Celeste went to unsaddle her horse, and Hunter followed to speak to her alone. He'd noticed her cold shoulder and knew he'd been harsh with her at the falls. He walked up behind her and could tell by the subtle tilt of her head that she knew he was there.

"Celeste, may I do that for you?"

She paused but didn't turn around. "I can manage."

He stepped up behind her, and when she lifted her saddle, he reached around and grasped it, encircling her with his arms.

"Please let me help you," he said softly. When she froze with her hands still on the saddle, he reached up and gently brushed her hair back to expose her cheek. He was about to say he was sorry when she suddenly released her grip and ducked under his arm. After she walked away, disappearing behind a nearby freighter, he hastily tended to her horse and then followed. He found her leaning against the wagon with her back to him. His attention was immediately drawn to her beautiful feminine features. Her auburn hair flowing nearly to her waist and the inviting shape of her hips in her tight leather pants took his breath away. As he slowly approached, he

pondered his growing feelings for her and how she consumed more of his thoughts with each passing day.

"Celeste, I'm sorry I hurt you. I uh . . . I was rude to you earlier and—"

"Yes, you were," she said, spinning to face him with her long hair swirling behind. She made no effort to hide the tears flowing down her cheeks.

He knew she was a headstrong, independent woman who'd never cry in front of a man if she could help it. Yet here she stood with a look on her face that tore his heart out.

"You had no right to speak to me that way," she lit into him. "How dare you presume that I shouldn't care as much about Erin as you do. She's my friend too. I know you'd been through a lot, but you talked down to me. And I will *not* be treated like a child. I told you that before we left. I *don't* answer to you," she said through gritted teeth as she planted her palms firmly on his chest, pushing him away. "If you can't speak to me in a civil tongue then don't speak at all," she added, looking away.

He held his silence, taken aback by her spirited outburst.

She wiped away her tears and sniffled before returning her gaze to him.

"I am sorry, Celeste," he said sincerely. "I never meant to hurt you."

Ignoring his apology, she continued, still upset.

"I'm going to tell my father if he insists on a bodyguard to assign someone else. This isn't working, Hunter," she said with a quiver in her voice.

He slowly reached for her, and she raised an open hand, warning him to keep his distance as she looked down. He knew he'd come to a crossroads in their budding relationship, and his next actions would set its course. He took a deep breath, choosing his words carefully.

"Celeste, I think the problem is it's working too well."

She looked up at him, her expression a mix of anger and surprise.

"And I think that scares you," he continued. "I know it scares me. . . ." He could tell by her changing expression that his admission had weakened her defenses.

"Please forgive me," he added, tentatively stepping forward. This time instead of warning him off, she crossed her arms and looked back down. He slowly closed his arms around her, pulling her in as her halfhearted resistance waned. Holding her tightly he realized how much he loved her—and how close he'd just come to losing her. She cried softly until she regained her composure and wiped her tears. Then, without looking up, she made a fist and struck his chest in feigned anger.

"Bastard," she said softly.

He smiled at her indomitable spirit before kissing her forehead through stray locks of hair. He wanted to whisper that he loved her, but he couldn't, not yet. "Come on, let's go check on Erin," he said.

She smiled and leaned into him as they turned and began walking together with his arm still around her.

/// \\\

When Fae and Draigistar reached Celeste's wagon, she stepped up on the tailgate and pulled the cover aside.

"Huh!" She jumped back to the ground as a gray cloud flew out of the opening past her with a whooshing sound. Draigistar reached out to steady her, and they watched the cloud disappear into the nearby trees.

"Shaelock."

"Yes," she agreed as they both scrambled into the wagon.

"Fae, what exactly did you see?"

She glanced up after making sure Erin was unharmed. "A small, robed figure was leaning over her right here where I am now. Its back was to me, so all I saw was an arm extended with the hand touching her on the forehead; it looked like a child's hand."

He didn't respond, just placed a hand on Erin's forehead and raised her eyelids one at a time, peering closely into her eyes. His actions made Fae uncomfortable. In elvin culture, it was believed the eyes were the window to the soul, the most revered part of the body in terms of physical attractiveness. Finally, he straightened up.

"Fae, I was this close to her only for the short time it took to tie the rope around her and Flynn, but I believe she was already gone from her body then. I'm anxious to try the spell, but first I need to hear everything Flynn told you about what happened. Take your time; give me every detail. It will help me understand what I see."

"All right." She meticulously shared everything. And just when she finished, the cover on the back of the wagon was pulled open. They looked up to see Gustin.

"Bad time? We were just coming to see how she's doing."

Fae looked at Draigistar.

"Come in," he said. "You should be here."

"Hunter and Celeste are with me."

Again, they exchanged looks. "Too distracting?" Fae asked.

"No," he replied, waving them in.

He climbed in, and they followed. "What's up?" he asked, sitting down beside her. Hunter and Celeste settled in at the foot of Erin's pallet.

"You want to tell them?" she asked the mage.

"I was just preparing to cast a spell that will let me see Erin's last moments, see her actions and know her thoughts."

"You can do that?" Gustin asked as Celeste glanced up at Hunter. She sat in front of him, leaning back against him with his arms around her.

"If I can see what happened to her, it might help us wake her," the mage said.

"He assured me there's no risk to her," Fae added.

Gustin nodded. "Well then, get to it."

They quietly watched as Draigistar placed the palm of his

hand on Erin's forehead and closed his eyes. After a meditative pause, he silently mouthed a short phrase, and then his back stiffened slightly. They nervously glanced at each other. With camp being set up, there were occasional raised voices outside, and Fae worried it might interfere. At last, her curiosity bested her patience.

"Draigistar?" she whispered.

Gustin poked her, getting a narrow-eyed glance in response.

"Shhh," the mage replied. "We're just splitting up at the ruins. She was sure mad at you, Hunter."

Celeste exchanged a grin with Fae before looking up at him. "I know the feeling," she whispered.

He looked down at her and smiled. "Shhh."

She elbowed him before returning her attention to the mage.

"They crossed the stream and then split up just as Flynn told you," the mage announced. He briefly smiled as if something amused him.

"What?" Fae asked.

"She was admiring his . . . well, she likes him," he said, drawing smiles from the others. "She went back across the stream and . . . now I can see us, Hunter. She's standing on the cliff next to the waterfall, watching us cross the spillway. . . . She turned around to go back, and now she's stopped, looking down at." He stopped speaking and leaned forward as if trying to see something. "Well, I'll be," he said softly, his eyes still closed.

"What?" Fae asked.

"A child's bare footprints over mine, uh, I mean over hers," he said. "Sorry, her thoughts." He suddenly straightened up. "It—it's a child, a little girl . . . elvin," he said with a smile. "Erin's looking at her, speaking. She's not responding. . . . What?" His expression became one of repulsion.

The others exchanged anxious glances.

"A terrible scar just appeared on her face. Looks like an old wound; it's awful," he said. "Now she's, uh. . . ." Draigistar

appeared to be struggling for the words.

"What is it?" Fae asked again, coaxing him on.

"It's—it's not the same girl. Now I'm looking at . . . she's human, about the same age, blonde hair, bright blue eyes, very pretty."

Fae grew nervous listening to him, her imagination racing ahead.

He continued with his eyes closed and his hand resting on her forehead.

"Erin's feeling disbelief, fear perhaps, I'm not sure. I don't understand; I should be able to . . . she's resisting. . . . Now there are spots of blood appearing on the little girl's cheek. I don't understand this. . . . No!" he suddenly yelled, causing everyone to jump. He made a painful expression as he reached up and touched his cheek with the fingertips of his free hand, his eyes still closed. "Erin's touching her own cheek," he continued, "trying to look away from the little girl. The blood's starting to dribble down her cheek now."

A chill coursed through them as they listened, but their eyes were on Fae. She'd covered her face with her hands, slowly shaking her head.

"Ah!" he let out a cry of pain, and his body went rigid and teetered.

Worried, Celeste glanced around at the others.

"Erin's in pain now," the mage continued. "She's scared of something that's attacking her. It's—it's in her memories. . . . No!" he yelled again and then slumped, appearing exhausted. They all looked at Fae, who held a hand over her mouth, staring at him. His eyes remained closed, and his hand still rested on Erin's forehead, but he seemed spent. They watched him regain his composure and straighten up.

"You all right?" she asked, wiping away her tears.

"Shhh," he replied, his face wrinkled as if trying to see something. "She passed out and fell into the water. . . . As I thought, she left her body while Flynn held her."

"You can see that?" Hunter asked in amazement.

"Shhh," Draigistar responded. "She watched from the bank as I tied the rope around them, and you pulled them ashore," he said, obviously addressing Hunter. His face contorted again. "She stood near Flynn as he removed the rope and held her. Then she saw you approach, after I'd gone over the falls, I guess. Now she's watching you put your lips on hers, giving her breath."

Celeste glanced up at Hunter with mixed feelings of jealousy and admiration.

He didn't notice.

"She's fighting you, Hunter," the mage continued. "She's watching you give her breath, but she doesn't want to come back. She's . . . she's at peace."

That prompted worried glances among the others.

"The little girl is standing next to her, holding her hand," he added. "She's telling her to go back. . . . Then, she came back to us. . . ." At last, he opened his eyes and looked at them, then down at Erin, gently stroking her forehead.

"That obviously had meaning to you, Fae," Gustin said, gently rubbing her back while the others looked at her curiously. "You all right?"

She looked at him and nodded before turning to Draigistar. "Are you all right?"

"Yeah, just tired," he replied. "I guess it wasn't quite what I expected. I've never seen such vivid images before, certainly not of what lies beyond death."

She looked at the curious gazes around her, then down at Erin. She thought about her duty to her young friend and knew what she must do.

"I'm risking our friendship by sharing this," she said at last. "Erin was looking at herself in your vision," she said, glancing at Draigistar. "You were right when you said they can know everything about us with a glance."

He silently nodded.

"Gustin, you know some of it," she said with a glance. "But I'll start at the beginning. . . . Erin was an only child. She grew up with her parents on a farm tucked away in the forests of the Far North Province. They kept to themselves, having little contact with others. Her parents were middle-aged and well-traveled, so when she was born, they decided to seclude themselves to raise her. They told her much about the outside world, but she'd never seen it for herself. Her father was a woodsman. He built their home, hunted for meat, grew crops, and traded in an elvin village. She adored him, followed him everywhere. He taught her to track and hunt, to shoot a bow he made for her, how to read the weather and know directions.

"Life was good until one day when she was twelve. . . . Five strangers came to their farm. Erin and her mother were inside baking and heard horses approach. They watched from the window as her father came from the barn and met them. They talked, and then a fight ensued. She remembers seeing her father run one of them through with his sword before the others piled on him. Her mother frantically hid her in the crawlspace beneath the floorboards and told her not to make a sound or come out, no matter what happened."

Fae paused and closed her eyes briefly.

Their imaginations already ran wild, and they dreaded hearing more.

Finally, she composed herself and continued. "Anyway, they beat her father senseless and dragged him into the house. Her mother fought them. But they continued to beat him while their leader raped his wife in front of him."

"Oh no," Celeste said as she leaned forward, covering her face with her hands. Tears rolled down Fae's cheeks as she continued. "When the leader finished with Erin's mother, he ran her father through with his own sword. He fell dead on the floor where Erin lay just beneath, too terrified to move. Then the others took her mother. And while Erin lay there, helpless to stop it, her father's blood dripped through the cracks in the

floorboards onto her."

Celeste turned, leaning into Hunter with her eyes closed, and he held her tightly while Fae continued.

"During the attack on her mother, Erin managed to push the dirt aside and wiggle to the back of the house. She pushed out a loose stone to make her escape, but she didn't know the leader had heard her. When she crawled out, he was waiting."

"How'd she escape?" Hunter asked as Celeste looked up, wiping away her tears.

"She grabbed a piece of firewood from the woodpile when he yanked her to her feet. Then he told her he was going to do the same thing to her that he'd done to her mother. Well, she was so scared she lost control, and when he saw she'd wet herself, he laughed and mocked her. When he raised a hand to hit her, she brought the piece of wood up across his face. He released her and stumbled away, and she ran into the forest while the others came out to the sound of his yelling. They gave chase, but the sun was going down, and she knew the forest well. They eventually gave up and left after burning the house and barn. . . . As you two know, she finished growing up alone in the forest," she said, looking at Gustin and Draigistar.

"Hunter, that's why she doesn't yet read well," she added, looking at him. "She told me you've been helping her learn."

He smiled and nodded in response as Celeste glanced up at him.

"This summer, Erin will be twenty-five," Fae continued. "So, for half her young life, she's lived with this horror. She told me the leader already had a scar on his face where she hit him, and black, lifeless eyes that she'll never forget. Make no mistake, if she finds him, she will forsake all to kill him. And I wouldn't blame her."

"Indeed," Gustin said. He'd told them about interrogating Daemus. And his description of the Shadow Knight's second fit. And when Hunter told them of his conversation with Janae at the springs, the tall, scarred man came up. Only now, they

had a name. Janae called him Hanlin. They'd agreed not to tell Erin about him until their contract with Hollis was done.

"Well, that explains some things," Draigistar said, stroking Erin's forehead.

Fae smiled at his show of affection. "She told me about that night with you."

He looked up at her. "I guess I assumed she would."

Celeste looked at Hunter with her mouth open, and he smiled back.

"I never thanked you for the way you handled your disappointment."

"Disappointed? More than you know," he said, looking back down at Erin. "But now I'm sure glad I didn't press her."

"You don't know how she admires you for that," she added.

He simply nodded, continuing to stroke Erin's forehead.

"Listen," Fae said, looking at the others. "It took many conversations over more than a year for Erin to tell me the whole story. . . . Now I'll face her when the time comes and confess to telling all of you. But no one else can ever hear of this. It's her life, her secret, her burden to bear. I told you because you're her friends. And you can help her by understanding why she's the way she is. I know she's naive and has some strange fears. But I also know why, and now so do you."

"Fae, no one here will ever betray your trust," Hunter said.

"I know. I just had to say it."

"Well, it's getting dark, and Janae built us a fire," Gustin said, standing up. "Why don't we go eat."

"You go ahead," Draigistar said. "I'm going to sit with her a while longer."

They smiled, and Fae leaned in and kissed his cheek when they got up to leave.

CHAPTER ✞ 14

As daylight came to the forest, camp was unusually quiet. Hollis and Lance had agreed to let everyone get some much-needed rest. They hoped a delay in reaching the high road and the twelve missing men sent in to follow them might cause the Shadow to doubt their strategy and keep their main force down on the Queen's Highway.

The women slept in Celeste's wagon to keep an eye on Erin. And the night passed without incident, save the occasional scream in the distance that heightened the senses of those on watch and briefly shook the light sleepers from their slumber.

Hunter stood third watch, so he was awake when the rising sun brightened the forest. The clouds had moved on during the night, revealing a sky full of brilliant stars peeking down through the canopy of huge trees. He'd just stoked up the fire and sat down when he heard a rustling of the cover on the back of Celeste's wagon. Lance and a few other early risers were stirring, so he didn't give it much thought until he saw familiar boots step to the ground behind the wagon. He knew who it was. She stood for a moment, shifting her weight in place, and Hunter noticed a teamster across camp watching intently. Finally, Erin appeared, lacing up her leather vest as she slowly walked toward him.

"Morning," she said with a smile as she sat down on a nearby log. "Hunter?"

"Uh, yes, good morning," he managed. "Anyone else awake in there?"

"No. They were beat, so I slipped out and finished dressing behind the wagon."

Now I know what had his interest, he thought. "Well, it's good to see you. We've all been worried."

She looked at him. "Hunter, it was amazing. I was, uh . . . I died. I was out of my body when you pulled me from the water. I saw what you did; you didn't give up on me," she said as tears welled up. "Thank you."

He slowly stood and moved toward her, and when she stood, he pulled her to him. "You're welcome, but there's no need to thank me. I'm just glad you came back to us," he said as she leaned into him, content to be held. Recently, she'd found herself not just comfortable with a man's touch but longing for it. She was now a grown woman and knew she had needs and desires beyond her control. It frightened her, but it made her feel good inside. And it made her feel normal.

Just then, Draigistar appeared from behind a wagon. His eyes locked with Hunter's, and he quietly started toward them. She surprised them both when she suddenly lifted her head from Hunter's chest and looked behind her. He'd not made a noise foreign to the sounds of a campsite astir, yet she knew someone approached. Hunter grinned, amazed by her keen instincts.

"Draigistar," she said as they smiled at each other. She quickly turned back to Hunter and kissed him on the cheek before heading to the mage. While Hunter watched them hug and begin talking, Lance approached.

"Someone woke up," the foreman said with a smile. "Is she herself?"

"Yes," he replied as they watched them walk away.

"Well, Hunter, I'd say today's the day."

"For an attack? Yes. Today or tonight," he agreed without a glance. "I'd say by this time tomorrow, we'll know who among

us will live to see the City of Queens."

Lance shook his head subtly. "Well, I appreciate your candor, but I don't think I'd put it quite that way around the ladies."

Hunter grinned. "Only in present company."

Lance smiled fleetingly. "It's been good having you and the four along on this one," he said. "I know you'll keep Hollis and Celeste safe."

Hunter gave him a silent nod.

"You know, you're right," he continued after a thoughtful pause. "Some of us may not live to see another sunrise. I've never been superstitious, but I've got a bad feeling this time out; can't seem to shake it. Hollis knows my last wishes, but in case something should happen to him, may I trouble you?"

Hunter raised an eyebrow and then smiled. "Nothing's going to happen to you, Lance. You're too mean to die."

He chuckled. "Yeah, that's what my wife says."

Hunter's expression turned serious. "Of course. What is it you require?"

"If I, uh . . . if I'm killed, I want to be taken home."

Hunter looked surprised. "You mean back to Port Estes?"

"That's right. Crazy, I know."

Hunter shook his head. "No, not at all."

"It's the only home I've ever had," he continued. "And I've spent too much time away over the years, missed too much. Anyway, this is to be my last trip. I've worked all these years with one goal. Hollis will always be my friend, but I look forward to retirement with my wife. . . . When he decided to move south, we knew our time had come. She has the means to sustain herself. She just needs me home."

"I admire you, Lance. Not only for staying true to your dream but for being able to leave her alone so much. I'll promise you here and now, if something happens to you and Hollis can't get you home, I will."

"Thank you," he replied. "Oh, and, uh, by the way, you can't have her," he added with a grin.

Hunter laughed robustly. "Come now, someone will. She's far too young and attractive to live out her days as a widow."

"That's not what I meant. You're an honorable man, Hunter, and I'm sure she could do worse. But in case you don't realize it, you're spoken for."

Hunter studied him.

"I've known that spirited lass her whole life," the foreman said of Celeste. "She and Jonas grew up with my children. She's been a good daughter to Hollis—stubborn and strong-willed—but I've watched her grow into a fine young woman. Oh, there've been hopeful suitors, mind you. You don't grow up in a town like Port Estes with her looks and go unnoticed. No one ever really worked out . . . until now," he said with a smile. "And any fool can see you're just as taken with her."

Hunter conceded a smile as he looked toward the wagon where she slept. Briefly, he allowed himself to fantasize about lying with her, making love to her. Feeling her warm breath on his skin and waking to see those beautiful green eyes meet his as a smile appeared on her face. "I wouldn't deny it . . . privately, that is."

"That is wise, lest I think you a liar." They both chuckled. "Hunter, you've lived life long enough to know I speak the truth when I say there could be no greater reward than to be loved by a good woman and the children she bears for you."

Hunter nodded in agreement.

"Grab hold of her, son," he continued in a fatherly tone. "Hold on for the rest of your life. She's a prize worth fighting for, to be treasured always. . . . Through the years, you'll swallow your pride, and hold your tongue, and get so mad you want to kill something. That's just what a woman does to you."

Hunter smiled in amusement.

"And someday when you're old and look back, you'll know you wouldn't have traded it for anything. . . . Well, enough talk. The rest you'll have to figure out for yourself. I have things to do before we leave."

"I'm glad we talked, Lance."

He nodded and silently turned away.

Hunter looked at the wagon when he heard voices coming from within. *They're awake,* he thought, not considering their panic when they saw Erin was gone. Fae exited, looking around, and when their eyes met, he pointed across the camp. Draigistar and Erin stood together in the distance, talking, so Fae came over to him.

"Have you talked to her?" she asked. "Is she all right?"

"Yes, we spoke. She confirmed what Draigistar told us last night."

Fae thought of the duty now set before her. She'd agreed he should cast his spell. And she'd decided to tell the others about her past. She dreaded Erin's reaction, but she knew she must confess.

"Hunter, I think I should go talk to her, tell her what happened, everything."

"Agreed," he said. "I'd think sooner is better than later."

She nodded and headed off to join them.

As the rest of the camp began to stir, Hunter stayed close to his charge. His resolve was waning, as was his focus on the Shadow Knight, he worried. He found it increasingly harder to think of anything but being with Celeste. He watched the three friends roam near camp, talking, until they headed down the hill toward the waterfall.

When Gustin emerged from his tent, ready to start the day, they began saddling their horses.

"Perhaps you should be part of that conversation," Hunter said as they worked.

"I considered that, but it seems to be going well without me."

"Coward."

They both chuckled as they continued working.

/// \\\

Draigistar told Erin about casting his spell on her and what it revealed. He also told her the others now knew about her childhood.

She was quiet for a while, taking in what he told her as they walked together.

"It's all right," she said at last. "I'm not embarrassed. You're all my friends." Then she went on to thank him for saving her life.

When Fae caught up with them, she was relieved that Draigistar had already told her and she'd taken it well.

Erin wanted a last look at Shaelah, so they walked down to the waterfall together.

"You know, we both owe them our lives," Draigistar said, looking down into the turbulent pool below the falls.

"The Shaelock? Yes, I know," Erin said, looking out at the ruins. "Seraphina saved me, told me to come back."

Fae and Draigistar exchanged a glance. "Is that the little girl you met?" Fae asked.

Erin looked at her. "Uh huh, the Shaelock. She saw her family killed, just like me. You were right, Draigistar. They know everything about you with a glance," she said, looking at the mage. "And you were also right when you said it looked in your vision like I didn't want to return. I didn't," she said as her voice cracked. She looked away, back out over the pool while she discretely wiped away tears.

The elves looked at each other, concerned for their young friend.

"I was . . . I was so at peace," she continued. "I wanted to stay in this beautiful place. But she told me it wasn't my time, and I had people who loved me and needed me. She felt bad about attacking Hunter when he was trying to protect me."

"She attacked Hunter?" Draigistar asked.

"Yeah, right after I returned to my body, she said. He yelled at her to get away and she attacked him, knocked him out."

The mage slowly smiled. "Well, now, that's good to know."

Fae reached behind Erin and poked him. "You behave."

"What?"

She smiled and shook her head. "You're shameless."

He smiled fleetingly before returning his attention to Erin, who seemed oblivious to their exchange. "Well, I'm just glad you came back to us, Erin," he said, patting her back affectionately.

"Me too," she said, leaning into him.

They stood together silently, looking out over the pool and ruins, reflecting on their experience. Then suddenly, Fae's instincts told her they weren't alone, and she turned to see a Shaelock girl standing only a few feet behind them. Startled, she gasped, and her friends spun just as the little girl began fading from sight.

"Oh, Seraphina, don't go," Erin said, quickly kneeling. "It's all right; these are my friends."

She looked up with her eyes darting back and forth between the two strangers.

"Seraphina, this is Fae, and this is Draigistar," she said as she reached out and took the little girl's hand in hers.

"Hi, Seraphina," Fae said softly as Draigistar slowly knelt by Erin.

She eyed them as Erin reached out and pulled her hood down, exposing her features. She was a beautiful elvin girl with bright green eyes and dark, flowing hair.

"Hi," she finally said with a hint of a smile.

"Seraphina's a little shy," Erin said, gently stroking her cheek. "I'm so glad I got to see you before I go. I want to give you something." She reached up and removed the necklace Hunter had given her in Port Estes and placed it around Seraphina's neck.

"This was given to me by another friend."

"The scary man?"

"Uh huh."

"He likes you."

Erin chuckled as Fae knelt down with them.

"I know. I like him too," Erin said as she fastened the necklace and gently pulled her long hair loose from beneath it, letting it settle again. "There," she said with a smile.

"It's beautiful," Fae said as the little girl looked down at it, stroking the glistening stones with her fingertips.

"You're beautiful, Seraphina," Draigistar added.

She looked up at him. "Thanks," she said shyly. As they gazed at each other, she reached up and touched his cheek, then the tip of his ear. Draigistar shuddered from the sensation evoked by her touch. He knew this beautiful little girl had died more than two centuries ago.

"Seraphina, may I give you something?" he asked.

"Uh huh," she replied nonchalantly, looking back down at her necklace.

He reached into a pocket and removed a gold coin with a jagged broken edge.

"This is from a place I searched for but never found," he said, holding it up.

She took it, and he watched her study it, turning it over to examine both sides. One side had markings—numbers or letters—he didn't know. The other side was engraved with a scene depicting a castle with a tower and spires rising behind a gated wall and mountain peaks in the background.

"Seraphina, do you know where this is from?" he asked.

She slowly looked up at him and nodded. "Lohawna."

Yes! He was elated.

"I've heard stories from the elders," she said. "They're our people. They live far away, in the mountains like the Gruebald," she added, looking down at the coin.

"The what?" Fae asked.

She looked at her. "The Gruebald," she repeated, pointing to the shrouded peaks of the Skull Mountains in the west. They could barely see them through the canopy.

"Seraphina, are they the ones who attacked Shaelah?" Erin

asked.

She looked at her as tears welled up. "Uh huh. . . . They're evil," she said, looking down. "The elders call them pagans."

Erin hugged her tightly, and she laid her head on her shoulder.

Draigistar was conflicted. His heart was breaking for Seraphina, yet it leapt with joy at her confirmation of his greatest dream. *I knew it. I knew Lohawna was real.*

"Seraphina, I have to go now," Erin said, looking down at her.

"But I want to go with you," she said with a pouting expression.

"I know," she replied. "But just like my friends need me, you have those who need you too. What about your little sister?"

Her bottom lip protruded. "Oh, all right," she said, looking down.

Erin pulled her close and hugged her again before standing up.

Seraphina looked up at her. "Promise you'll come back and see me?"

"I promise," Erin said, cupping her face in her hands and kissing her forehead.

Suddenly Seraphina turned to look as if she'd heard something. When their eyes followed hers, they saw the figure of a woman appear about forty feet away. She was a typical elvin woman: slender, with striking features, long hair, and dressed in a dark-colored robe. She reached out a hand, and Seraphina looked back up at Erin and the others.

"I have to go now," she said. They told her goodbye as she stepped forward to hug Erin one last time. "I'll miss you," she said, looking up with tears streaming down her cheeks.

"I'll miss you too," Erin replied.

Draigistar was captivated by the little girl's tears. *How can this be? She's an apparition.* He watched a teardrop fall from her cheek and was shocked when it hit the ground. A

plant suddenly sprouted up, and a bud formed, opening into a brightly colored flower. Mouth agape, he watched Seraphina walk over to the woman and take her hand before looking back and waving goodbye. Then they turned and walked away, fading from sight within a few steps.

The three friends exchanged smiles.

"I will never forget this place," Erin said. "And I will return someday."

"Come on," Fae said. "We must get back. It'll soon be time to leave."

/// \\\

After yesterday's mishap, Lance ordered a thorough inspection of the wagons, and it was discovered that another birck had a damaged hitch. Grudgingly he decided the freighters would be reloaded to distribute the heavy cargo among the others. The damaged hitch was splinted and wrapped, and that wagon was given a light load.

The unplanned activity allowed Gustin and Hunter to satisfy their curiosity about the contents of the wagons. Three bircks contained large chests, heavy, judging by the way the hirelings struggled to move them. The two big men agreed that Hollis's money must be in those chests.

By midmorning, everyone had eaten a hearty meal, and the wagons were reloaded and ready to pull out. The smell of fire and cooked food permeated the surrounding forest as the sun shone down brightly through the canopy. Even still, distant thunder rumbled, and they could see another dark wall of clouds in the west, moving down from the high country. They knew that by later in the day, they would again be traveling in rain. Finally, they pulled away from the clearing and from their last view of Shaelah. Slowly they made their way through the forest toward the high road. It soon became apparent that even winding its way through the bogs, the lower reach of

the ancient road had been better maintained than where they now traveled. They had to stop frequently to clear brush and saplings from the road that, in places, appeared to be no more than a game trail. Draigistar's prediction of slower travel above the falls had come true.

/// \\\

To learn what they would face upon emerging from the forest, a scouting party was sent ahead. Draigistar would again lay out the route from memory, escorted this time by Flynn, Gustin, and Fae, while Hunter and Erin stayed with the column. Going ahead, they moved swiftly through the forest, quietly conversing as they rode. Fae told Gustin what happened when they walked down to the falls with Erin.

"How'd she take you telling us?" he asked her as they rode behind the other two.

"Better than I expected. She understood why. I think she's more comfortable with our new friends than I realized."

Gustin looked at her. "Surely, she knows we'd never judge her. She was a child. There was nothing she could've done."

She smiled, amused by his purely male reasoning. "That's not my point, lover. It's not about harbored guilt. She's a grown woman now. She doesn't want to be pitied for her past. She's already insecure about her social skills. To make it worse, she looks up to Hunter, and he's well-educated. You know she hates being the center of attention."

"Uh huh."

"She'll be all right. We just need to let it drop."

"What about Flynn?" he asked. "Did he get a chance to talk to her?"

"They walked down to the waterfall after she got back with us," she said with a smile. "They weren't gone long, but I saw them hugging."

"Well, good for her."

Just then, Draigistar and Flynn reined up, so they cautiously joined them.

"The road's just up ahead," Draigistar said softly as they clustered. "I think we should walk from here, without talking."

They nodded and quietly dismounted. "Draigistar, we've all been on the high road before, so give us our bearings," Gustin said.

"Well, the stream that flows over the falls at Shaelah crosses under the stone bridge about a mile north of here," he said. "The next stream that crosses the high road flows under the heavy timber bridge next to that small clearing. I'd say it's about five miles to the south."

"Sounds right," Gustin agreed.

"Fae?" Flynn asked in an alarming tone. Gustin and Draigistar looked to see her just turning her attention back to them.

"What is it?" Gustin asked.

"I smell a campfire," she replied. "There's no wind, so it's hard to say where it is."

"Fresh?"

"It smolders."

"Yes, I smell it too," Draigistar said.

"Some fool kicked dirt on it and didn't get it out," Gustin said. "Let's go to work."

They formed a skirmish line and started toward the road. Soon they heard the distinct sound of horses approaching. They froze, silently waiting, watching. They could make out the silhouettes of four riders on horseback slowly making their way along the road northbound, looking into the trees as they rode. Gustin smiled when he recognized one of the riders. Even with his view obscured by the thick foliage, he couldn't mistake her. It was the Rendovan. He knew when he took her horse and left her stranded on the mountain, they would meet again. *Do not underestimate her*, he thought.

After the riders passed by, they secured their horses and emerged from the forest. Gustin and Flynn studied the tracks

on the road while Fae and Draigistar went a hundred feet in opposite directions to keep watch. The rumbling grew louder as the dark clouds rolled down the mountain, splaying over the foothills. As Fae watched through a clearing in the trees, she saw bolts of lightning streaking inside the ominous front and knew they would all soon be drenched. Suddenly she caught movement on the far side of the road and looked over to see a flash of red move swiftly through the bushes. *Oh, it's a fox*, she thought. *How cute*. Suddenly it stopped and looked at her, standing perfectly still for the longest time. As she and the animal gazed at each other, a strange feeling befell her, like she was looking into the eyes of another person. She was unsettled but found it difficult to look away. Finally, it turned and scurried off through the woods along the edge of the road.

"Strange," she whispered, resuming her watch.

At last, Gustin signaled, and they returned to their place of concealment.

"At least a dozen horses passed by heading south some time after the rain stopped late yesterday," he said when they knelt together.

"Were those four riders part of them?" Draigistar asked.

"Don't think so," he replied. "They went south this morning, then returned."

"Gustin, that was the one you told me about, wasn't it?" Fae asked.

He looked at her. "Yes, the Rendovan."

"The woman? Tall with dark skin?" Flynn said. "I've seen her before."

They looked at him, surprised.

"Where?" Gustin asked.

"In Port Estes, this winter. And I saw her last spring on the docks in the City of Queens. We didn't speak; don't know her name."

"Was she working on a ship?" Fae asked.

"No. She was talking to someone loading a ship."

"Remember the ship?" she asked.

"No, but it was Royal Navy."

"What?" Gustin asked in surprise.

"Yeah. She was talking to one of the officers while the crew loaded cargo; looked like they knew each other. I was waiting to board a ship Hollis had leased to bring supplies back to Port Estes."

"Know where the other ship was bound for?" Gustin asked.

Flynn thought briefly. "No, but she didn't go. It sailed before mine did."

A brief silence befell them.

"Well, that's another matter," Gustin finally said. "For now, let's deal with this."

"Yeah, those riders that went south may have been joining others," Flynn said.

"Possibly," Gustin said with a distant expression.

"What is it?" Fae asked, sensing he was troubled.

He looked at them. "They've been watching us for a week now. They know our strength—or at least our numbers. If they believe there's gold in the wagons, then I suppose they could just camp and wait to ambush us. But I doubt they could know for sure when an army patrol might pass by."

"What's your point?" Draigistar asked.

"I'd want to avoid any chance of outside involvement," he said. "That's what's been nagging me. Why didn't they try to take us at the springs? I don't believe that attack was just meant to wear us down. That's all they had to throw at us then. They don't have the advantage in strength that we've been assuming."

"Are you willing to risk everyone's safety on that hunch?" Draigistar asked. "And what of their strength now?"

Flynn suddenly felt uncomfortable, surprised by the mage's challenge.

The two men looked at each other while Fae kept silent.

"Think about it," Gustin said at last. "We were more iso-

lated at the springs than anywhere else on this trip until now. Everyone had just spent time relaxing in the hot water, and most were asleep. They know the entire route. There was no better time to crush us and take what they wanted."

The mage considered his reasoning.

"You asked me if I'd risk everyone's safety on that hunch," Gustin added. "Yes. I know I'm right. And as for their strength now, I'm even more convinced. One of those men I killed yesterday was former cavalry like me. I knew it when he engaged. He, and others like him, would look at this the same way I am."

"Gustin, our side trip to the springs was unplanned," Fae said.

"I know. That's why I've thought long and hard about this. I had to know I was right; too much was at stake. But yesterday convinced me. They're not sure they have the strength to take us, or there would've been fifty Shadow trailing us into the forest. . . ."

"All right, I'm convinced," Draigistar said. "So, what's next?"

"You go back and lead the others here while we go find that campfire," he quickly replied. "Yesterday, we took the fight to them. Today we do it again."

"Now you're talking," Flynn said.

Gustin glanced at Fae, and she gave him a subtle nod.

"All right. I'll be back as soon as—" Draigistar suddenly paused.

They looked at him, alarmed.

"What?" Fae quietly asked.

"Shhh," he said softly. "Don't look, but there's a fox hiding in that thicket behind you, Fae. I saw it before, near the road."

A chill coursed through her as she thought about her encounter.

"I saw it, too," she whispered. "Something was strange about it, but I thought it was just me. You don't suppose . . ." she trailed off, looking at the mage.

Flynn and Gustin realized she spoke of the Shadow's wiz-

ard. They'd all heard of shapeshifters.

"Yes," the mage answered, his eyes still fixed on the bushes behind her. "He's been spying on us. We can't let him get away."

Fae spun, and her sight quickly settled on the narrow eyes gazing back at her from the thicket just thirty feet away. While the others reacted, she pulled her sword and aimed the tip at the fox's hiding place. When she did, it turned and disappeared into the thick foliage.

Draigistar anticipated she might unleash the energy bolt from her magical weapon. In fact, he could conjure a spell to do the same thing with even more destructive power. But that wasn't an option.

"No, Fae . . . the noise."

She held her attack and remained crouched while the others stood up.

"*Bona-sheee,*" Draigistar uttered as he held out his hands splayed, fingers pointed at the thicket. Two bolts of bright green light the size of arrows flew from each hand toward the intruder, penetrating the thicket with a sound like someone crashing through it at a run. They splintered small branches and stripped away leaves, and by the time the first volley struck the target, he was prepared again.

"There!" Fae said, pointing with the tip of her sword. She held her position as Draigistar fired from behind her. The shiny red pelt of their enemy was easy to spot as the nimble creature scurried through the thicket. An arrow fired from Flynn's bow was followed by four more of Draigistar's deadly bolts racing close behind. Again, the thicket shook, and now their prey was on the run. They saw it jump to the base of a fallen tree resting on the trunk of another. It ran with incredible swiftness up the inclined trunk, weaving between the snags. Flynn fired again, but the arrow glanced off a limb as the fox ran behind it. Then Draigistar loosed another volley. Three of the bolts struck the end of the dead tree where it rested against the other, and

a shower of dead wood and bark erupted just when the fox leapt into the air. The fourth flew past harmlessly as the fox changed into a hawk in midair and began flapping its wings, ascending through the canopy.

"*Damn*," the mage quietly exclaimed as he fired two more green streaks of light at the now-winged target. One struck a damp tree limb with a thud just before intercepting the bird. The other bore down on it, briefly giving them hope, before fading from sight with a faint sizzling sound.

"It got away," Gustin said, realizing they could do no more.

They watched it clear the top of the trees and then circle, screeching as if mocking them. *Thunggg.* They heard the recoil of Flynn's bow and turned to see him eyeing his shot up through the trees. Then they heard a distant smack like the sound of a single handclap. The hawk let out a loud screech and faltered in flight as the arrow changed course and fell away. A few feathers slowly swirled downward as the bird contorted briefly, then flew away.

"That's some fine shooting," Gustin said.

"I'll say," Fae added.

Flynn smiled fleetingly. "Thanks. You know, till yesterday, I'd have said that shapeshifter was just about the strangest thing I'd ever seen."

Gustin chuckled.

Draigistar had taken a few steps away, still looking up.

"What are you doing?" Fae asked when he grabbed one of the falling feathers.

"This may be useful."

"How so?" Gustin asked.

"Well, it's literally part of him. I may learn something about him I can use to my advantage the next time we meet."

"That's disgusting," Fae said with her nose wrinkled.

"Nevertheless, true."

"He must be a powerful wizard to do what we just saw," Flynn said.

Draigistar looked at him. "Powerful? Yes. But not because he's a shapeshifter."

"Well. They'll soon know where we are," Gustin said.

"Sorry," Draigistar told Fae. "Perhaps risking the noise to kill him would've been best. I really thought we could bag him."

"It's all right; we tried."

The mage looked at Gustin. "Well, do we stick with your plan?"

"Oh, I think that decision was just made for us," he replied. "If we're lucky it'll take a while, but they will be coming. We have to go clean out that camp, now."

"Thought so," he said, heading for his horse. "I'll just be on my way."

"You be careful," Fae said.

He deftly swung himself into the saddle. "Save some fun for me."

"Godspeed," Gustin said.

He nodded as he reined his horse around and headed back to the column. He checked his mount's speed to let the damp ground muffle the sound of its hooves until he was out of earshot, then spurred it on at a fast gallop.

Once the mage had gone, they headed through the forest. Flynn was proving to be quite useful. Gustin was impressed with the quiet young man. They paralleled the road and eventually spotted a campsite in a small clearing on the other side. They carefully moved in closer and counted six men. The smoldering fire was in the middle of the clearing where they'd obviously spent the night. Bedrolls were picked up and secured to mounts that stood saddled and unrestrained. They were ready to travel. Two men sat on a log near the fire pit, quietly conversing, while one stood near his horse, rummaging through a saddle bag. Two more stood facing each other at the edge of the road, talking as they watched both directions. The last man was at the back of the clearing, kneeling near a fallen tree with his long sword laid across it, sharpening the blade.

A bow and quiver of arrows leaned against the tree within his reach. Gustin considered him the greatest threat since he was the farthest away and had a ranged weapon. He also noticed two of the horses had crossbows slung on their saddles. He carefully studied the scene with an uneasy feeling. Finally, he signaled, and they retreated to a safe place.

"What do you think?" Fae asked when they knelt together.

"Well, the one at the back of the clearing has a bow. We've got to take him out."

"I'll do it," Flynn said. They exchanged a glance and looked at him. When Flynn held Gustin's eye contact, he knew the young scout was confident in his ability. And after seeing the shot he'd made through the trees to hit the hawk in flight, he didn't doubt him.

"All right," he said with a nod before turning to Fae. "Remember what I told you about the Rendovan knowing when I was hiding up on the mountain?"

"When she could smell you?"

"Yes."

She looked perplexed until she realized his concern. "The campfire, she'd know we could smell it. Think it's a trap?"

"Don't know," he replied, glancing through the forest. "I've seen no sign of anyone else, but just the same, let's all keep watch behind us."

They both nodded.

"All right, Flynn, he's yours. When we're ready, take him out, and we'll rush the others."

"Got it."

"How about I take the two sitting on the log while you go after the two across the road?" he said, looking at Fae.

She smiled. "No offense, lover, but I can get there faster than you can. You take the two by the road."

Flynn smiled when Gustin looked at her with surprise. She was amused when he glanced at the young scout, and he looked away to hide his expression.

"All right," Gustin replied.

Soon they were in place. Flynn stood behind a large pine tree while Gustin and Fae knelt in concealment twenty feet to his flanks. After taking one last look behind them and scanning the forest on the other side of the road, Gustin closed his eyes briefly and listened for the sounds of approaching riders or anything else that seemed out of place. At last, convinced they were alone with their prey, he looked at Flynn and nodded.

The young scout already had his bow taut when he gave the signal. He tilted his head to sight down the shaft of his arrow, carefully taking aim. The man had just finished preparing his weapon and stood to admire it. A breeze was kicking up, warning of the rainstorm moving down the mountainside. Allowing for wind and drop, he slowly let out a calming breath. *Thunggg.* The familiar sound of an arrow being released was followed by a whishing noise as it knifed through the air past the two Shadow standing near the road.

Fae swiftly broke out of the bushes at a dead run when the two Shadow instinctively ducked. By the time she'd reached the middle of the road, it found its mark. It struck the man's midsection with a sickening thud, embedding itself into his stomach. The blow took his breath. He dropped his sword and grabbed himself, stumbling backward over the log behind him and falling from sight.

One down, Gustin thought as he rushed the two who now stood with their mouths agape, eyes fixed on Fae. The two who'd been seated were so startled by the arrow that one of them lost his balance and fell backward off the log. The other scrambled to his feet, pulling his sword to meet Fae as she closed on them. Gustin saw one of his two soon-to-be opponents raising his arm under his cloak as Fae ran past. When the cloak fell open, he could see a small, handheld crossbow. *The weapon of a thief,* he thought.

"Hey!" he yelled, startling both men, causing them to spin and face him. He had both his swords drawn and brought one

down across the man's forearm.

"Ahhh!" he yelled out as he dropped the crossbow and staggered back. Blood gushed from the deep wound. The other man drew his sword and stepped up to meet Gustin. He was Gustin's height but wiry, and he didn't hesitate to engage. The sound of clashing steel rang out, echoing through the forest. Both men knew Gustin had the advantage with two weapons. The man was experienced, carefully mixing offensive thrusts with quick, defensive movements to stay clear of Gustin's second blade.

Flynn now emerged from the forest, nocking another arrow. He felt bad; he knew his first arrow had struck the man below his heart, not killing him instantly.

While Gustin engaged, Fae continued on, drawing her sword in stride. Her actions would be dictated by the one who'd stepped up to meet her. He decided to use her momentum against her and crouched, thrusting forward with the tip of his blade to impale her. She expected the novice move and veered without slowing, planting a foot on a knee-high boulder. Effortlessly, she vaulted up and over the tip of his sword as he tried in vain to follow her movement. She rolled as she flew over him, swiftly bringing her sword down across his shoulder.

"Ahhh!" he cried out as he dropped his sword and clutched his wound.

She deftly landed on her feet, continuing on to charge his comrade who'd struggled to his feet and pulled a sword and a hand-axe. She glanced at the lone man standing by the horses and saw him just raising his crossbow. She didn't think about her sudden side-to-side movement when he pulled the trigger. Telfari had drilled her endlessly on the defensive maneuver. *"Again?" she'd asked him after working in the sweltering summer heat all day. "Yes! And again and again!" he'd replied. "You teach your body to react so you don't have to. It could save your life," he'd added with that annoying single hand clap to indicate the discussion was over.*

He fired at her from thirty feet away, but her evasive action made him shoot high. As the bolt sliced through the air toward her, she threw her feet out from under her and fell backward to the ground. Time seemed to slow as she watched the deadly projectile pass by a mere hand's width in front of her. She felt the wind from its flight on her face before hitting the damp ground with a jolt and rolling to come to her knees. She planted a foot, remaining crouched while she glanced at the one who'd fired, then looked at the one closing in. He swung hard in a horizontal arc with his sword, and when she ducked beneath it, he brought the axe straight down with an overhand swing. She leaned back, easily avoiding his instrument of death. *Thunk.* His eyes widened when the blade buried itself deep in the wood of the fallen log between them. He tugged on the handle as their eyes met.

"Oops," she said before leaping straight into the air, bringing her foot around across the face. He was gripping his axe so tightly that the wooden handle broke off in his hand when she kicked him. Sprawling on the ground, he dropped the useless piece of wood but managed to keep hold of his sword. She glanced over at the one who'd shot at her. He had a foot in a stirrup and was just raising a leg over his saddle, obviously forsaking his comrades to make his escape. Looking back, she saw Flynn had a bead on him. *Good. He won't get away.* Her first opponent still knelt, holding his bloody shoulder.

"Please don't kill me," he pleaded when their eyes met.

She was surprised at his youth. "Do you yield?"

"Yes. Yes, I swear."

"Then face down on the ground, and don't move if you want to live!"

He began struggling through the pain to comply.

She glanced up to see the fleeing man yanking on his reins, turning away. *Whishhh.* Flynn's incoming arrow struck him high in the back. He stiffened, then slumped, falling from the saddle to the ground in a limp, lifeless heap.

Gustin had dueled with his opponent until the injured companion found the courage to join in. Unlike the well-trained swordsman, he was no match. He tried to flank, but despite Gustin's imposing stature, he was deceptively quick. Gustin kept an eye on the wounded man, giving him the chance to strike. At last, he lunged forward to thrust, and Gustin sidestepped, spinning around. He brought a sword down to knock the man's blade away and thrust with his other one. Before he knew what happened, Gustin ran him through. With eyes wide and mouth agape, a stream of blood ran down his chin as he expelled his final breath. *Two down.* Knowing the seasoned fighter would seize the chance to strike, Gustin released the grip on his sword and shoved the dead man to the ground between them, his bloody sword still stuck in his back. By the time the lifeless body crumpled, Gustin had pulled his large hunting knife.

When the fighter stepped back, realizing he'd missed his chance, Gustin attacked. Methodically moving forward as he swung and thrust with his remaining long sword, he drove the man into a defensive posture. Just as Gustin anticipated, he lost his composure and made a predictable move. He cut through the air in crossing diagonal slashes, following up with a lunging thrust. But Gustin had carefully studied his moves and knew which way to sidestep. He moved aside and parried the man's thrust after the second downward cut, then stepped in with a horizontal slash of his big knife. The man dropped his sword and clutched his throat, silently staring with eyes wide. His hands and chest turned red as his knees buckled and he fell at Gustin's feet. *Three*, he thought, just as he heard Flynn's arrow. He looked up to see the rider take it in the back and fall to the ground. *Four.*

Now Fae looked to see the man she'd kicked was struggling to his feet.

"I'll gut you, elf," he growled, wiping blood from his face. "Ahhhhhh!" he yelled out as he raised his sword and charged her.

Now that's a mistake, Gustin thought.

He planted a foot on the log between them and leapt, intending to slash at her on his way down. But his inexperience left him open to her counter. Once he was airborne, she dropped to the ground and rolled toward him, sweeping his legs with hers. Again, he went sprawling on the ground by a woman's design. Instead of rolling into the fall, he foolishly fought the inevitable and reached out to catch himself. Landing flat, he slid on the damp ground until his hand penetrated the smoldering embers of their campfire. What had once brought him comfort now brought him excruciating pain.

"Ahhh!" he yelled out as he rolled over and drew his burned hand to his chest.

Gustin glanced over at Flynn and saw him looking away. Alarmed, he thought of his warning to keep an eye out for more Shadow. He quickly scanned around before glancing down at the man who still lay on the ground obediently.

Now Fae started toward her injured opponent. Despite her anger, compassion prevailed.

"Look around you; you're the last," she said. "Now yield!"

"To a woman, never!" he yelled with his rage out of control. He took a step toward her and swung his sword wildly. She easily avoided it and thrust hers deep into his exposed side, piercing his heart. His sword fell to the ground as his eyes rolled back and his breath escaped. She pulled her sword free, and he fell to the ground, dead.

That's five, Gustin thought. *Perfect.*

Fae's heart ached with regret. She never liked the way she felt after a battle. And she hoped she never lost that feeling.

"You all right?" Gustin asked, stepping up beside her.

She sighed. "No. You know how it is."

He smiled empathetically. He knew her anguish at the taking of life, any life. Truth was he envied her.

After she cleaned her sword and sheathed it, they turned and walked toward their prisoner.

Gustin reached down and rolled him over. "Looks like you're the last."

"Oh, please don't kill me," he pleaded in a weak voice.

"That depends on you and the answers you give me."

"I'll tell you what you want to know."

"I know you will," he said. "How long have you been here?"

"Since yesterday."

"You're lying."

"No, I swear. You're the ones with the wagons, right? We attacked you two nights ago at the hot springs. The next morning, we were sent to cover this road."

"What were your orders?" Gustin asked.

He hesitated, glancing at Fae. "The plan was . . . was to ambush the wagons, kill everyone and take the horses and gold."

"How many are you?"

"Please, can I have a drink? I'm thirsty and cold. I'm bleeding to death here."

Gustin grabbed him and yanked him to his feet. "You can have a drink when you answer me! How many?"

He looked like he was trying to muster an answer when Flynn approached with a water skin he'd retrieved from one of the mounts. "Here," he said, reaching out to hand it to Gustin.

Whishhh. The sound of an incoming arrow startled them before the full skin exploded in Flynn's hand, spraying them with water as the projectile continued on into the forest. They looked up the road to the north where it came from. Nothing. Fae dove behind the fallen tree while Gustin held the prisoner in front of him as a shield. Flynn turned and sprinted back across the road, pulling an arrow from his quiver in stride. Soon another arrow appeared, flying toward Gustin. He tried to pull the wounded man down with him as he fell, but it struck him low in the back.

"Ahhh!" he cried out as they both hit the ground on their side.

Now Flynn countered, assuming the first shot was meant

for him since he carried a bow. He stepped out and fired into a thick growth two hundred feet away on his side of the road. Before his first shot hit the bushes, he'd nocked another arrow. *Thunggg.* He released it and drew a third before pausing to listen.

Fae had scanned to make sure they weren't surrounded. Now confident the attack came from just one place, she leapt up to run into the forest on her side of the road and move north to flank their attacker. Just as she jumped up, Flynn's second shot penetrated the thicket, and she saw a figure move to reposition. *The Rendovan.* Gustin had warned them not to take her for granted. When their eyes met, Fae raised her sword, and the Rendovan brought up her bow. Fae summoned its power, and a lightning bolt streaked forth. She closed her eyes to avoid the temporary blindness but didn't have time to warn the others. The bolt struck the hilltop with explosive force, sending a shower of dirt and flora into the air, while a deafening clap of thunder buffeted them.

Both men saw the duel unfold, and while Gustin knew to close his eyes, Flynn didn't. As the chunks of wet dirt and vegetation settled, Fae and Gustin opened their eyes to see the Rendovan was gone.

"Hey! You missed!" Flynn yelled, crouching, rubbing his eyes to restore his vision. "She dove into the road and ran away!"

When Gustin shoved the now-dead prisoner away, he realized the arrow that killed him had passed through, piercing his lower abdomen. It was superficial, the pain little more than an annoyance.

"Gustin, are you all right?" Fae asked, returning to kneel beside him.

"Yeah," he replied, examining his wound. "She shot me."

"Oh lover, she nearly hit something vital," she said with a fleeting grin.

"Hope there wasn't any poison on that arrowhead," he replied, ignoring her joke.

"Let's go find out." She helped him stand up, feeling bad for having made light of his injury. They looked down the road and saw the Rendovan from the shoulders up, just beyond the crest of the hill. They could tell she'd just settled into the saddle, even though they couldn't see her mount. She looked at them from two hundred feet away. Then she tipped her head back and cackled mockingly, raising her bow overhead in a show of victory as she reined around and spurred her horse away.

Thunggg. The sound of Flynn unleashing another arrow resonated as huge raindrops suddenly began hitting the ground around them. They silently watched as the arrow raced in vain to catch up with the fleeing woman who'd disappeared over the crest of the hill. Then Flynn turned and walked toward them from the other side of the road.

"You tried," Fae said.

"I'm sure I'll get another chance," he replied.

Gustin looked at Fae. "Why don't you go through their saddlebags while we gather weapons and check their belongings? We can't stay here."

"All right," she said, and they set about their duties.

Gustin knelt over the one killed by the Rendovan. He pushed the arrow through and broke off the shaft, then carefully wrapped the head in the leather remnants of the water skin. He wanted to let Erin check it for poison.

Flynn went to the first man he'd shot and found him lying dead, face up behind the log where he'd fallen. His eyes were wide open in a typical horror-filled expression of someone who'd had time to contemplate their last breath. He quickly checked each corpse and claimed nearly fifty gold tallins from their pockets. *Well-paid scum,* he thought.

Three of the horses had bolted during the fight, but Fae inspected the saddlebags on the three that remained. She found a signet ring, a cloth pouch with two red gems in it, and a rolled-up map of the City of Queens.

It was starting to rain harder now with large drops that stung bare skin, and the scent of the coming storm permeated the air. The three met near the fire pit, where a small plume of smoke now arose with a steady sizzling noise from the raindrops hitting the bed of embers. "Well, we'll soon have company," Gustin said.

"Yeah, we'd better get back to our horses," Fae said. "We can watch the road from the forest and head out if they come in after us."

"If it's all right, I'd like to take that black," Flynn said. "My packhorse, she's a good, strong mare, but she's getting old. That black's a fine animal."

"Yeah, that's a good horse," Gustin said with a nod. "It's yours."

They waited while he quickly threw off the saddle and took the reins. Then they crossed the road and disappeared into the forest.

CHAPTER ✝ 15

They found a place in the forest to hide and watch the road from. It was now midday, and dark clouds churned overhead. The wind had picked up, and the rumble of thunder was nearly a constant noise. Large raindrops smacked the ground, and trees whipped overhead. Fingers of lightning streaked across the ominous sky, with flashes of light penetrating the canopy, casting shadows all around.

"Flynn, where'd you learn to handle your bow like that?" Gustin asked.

The young scout glanced at him. "My father taught me."

"You're good with it," Fae said. "I've seen Erin shoot like that. And she's as good as any I've seen save a handful of rangers I once saw in a tournament."

Flynn smiled. "At Simion's stronghold, I'll bet."

"Oh, you know of it?" she asked.

"Yeah, I've been to the ranger rendezvous. Competed in the tournament, got fourth place," he said proudly. "Not bad considering the company."

"That's amazing," she agreed. "Was your father a scout?"

He looked away. "No, he, uh . . . he was a criminal," he finally said, looking at them. "He ran with a band of robbers in the disputed lands. We lived in Eskondal, a little fishing town on the shore of the Frozen Sea."

"Never been there."

"I have," Gustin said.

Flynn looked at him in surprise. "You get around."

"Uh huh. That's a rough town, Flynn. You grew up there?"

"Yeah, until my father was killed trying to rob someone better with a sword than he was. You're right; it's lawless. The men kill each other in the streets and force themselves on women in dark alleys. Anyway, after my father died, my mother and I moved around. We ended up in Port Estes about ten years ago."

Fae studied him. "Flynn, may I ask your age?"

He looked at her and grinned. "Now that I've had a chance to prove myself, I don't mind answering that. I'll be twenty-five this summer," he said, looking away.

Fae and Gustin exchanged a smile.

"Does your mother still live in Port Estes?" she continued.

Again, a brief silence. "No. She moved south about a year after we settled there," he finally said. "She met someone, fell in love. At least, that's what she called it. Then one day, she came home and told me they were moving to the twin cities, and I wasn't invited. They figured I was old enough to be on my own. . . ."

Again, she glanced at Gustin, his expression affirming she should let it drop.

Just then, they heard the sound of horses on the road, approaching from the north.

"They stopped at the campsite," she said quietly.

"Uh huh," Flynn agreed while Gustin remained silent. They patiently waited for the sound to resume. Then they saw the riders pass by on the road, leading the two horses left in camp. They rode slowly, scanning the woods while the lead rider focused his attention on tracks. The trio listened until the sound faded away.

"I counted seven," Fae said.

"There'll be more," Gustin replied flatly.

"Makes no sense," Flynn said, looking at Gustin. "The woman wasn't with them."

"Yes, it does," he countered. "In her homeland, she's known

as a huntress. They're revered for their fighting skill and tactics. Rendova's a harsh place, surrounded by the disputed lands. They can journey far from home, tracking or hunting something—or someone, surviving days without food and water. Believe me it would be better to have just seen her than to not know where she is."

They exchanged worried looks before Fae spun around.

"They're coming," she said. "I hear wagons."

"Yes, there," Flynn said, pointing at two figures coming through the forest.

They saw it was Erin and Draigistar riding point just as Erin raised a hand and pointed through the trees at them.

"Well, let's get busy," Gustin said.

They stood and moved to their horses.

"I see you all survived," Draigistar said, reining up near them. "How'd it go?"

"We have six fewer Shadow to face," Gustin replied.

"Get to question any of them?"

"No. Had one, but, well, the Rendovan."

"Say no more," Draigistar said.

"She shot him," Fae said.

The mage raised an eyebrow. "The prisoner or you?"

"Both," Gustin said, removing the broken arrow from his saddlebag. When he stepped toward Erin, she saw the bloodstain on the front of his pants.

"You all right?" she asked.

"Hope so. It went through him and hit me. I kept this, hoping you could tell if it has any poison on it. I feel fine, so I doubt it."

She reached out and took it. "Just in case, I'll watch for some quillberry. It helps to chew the roots if you've been poisoned."

"Let me guess, probably tastes awful," he said sarcastically.

"Uh huh," she replied with a grin, and Fae chuckled.

They mounted up as Lance approached with the wagons

following in the distance.

"Draigistar told us what you found," he said, reining up. "What's the story?"

"We took out six, but one got away," Gustin said. "And seven more just rode past headed south."

"Any idea how many await us?" he asked.

"No way to be sure. I'd say at least twenty, probably more."

Lance shifted in his saddle, gazing off toward the road. "They'll be dug in."

"Yeah," Gustin agreed.

"Well, that'll give 'em a fighting chance," he said with a grin. "We'll give the horses a break here. Then once we're on the road, we'll push hard."

"Lance, where's Hunter?" Fae asked.

"He stayed behind."

Gustin looked up. "What?"

"Making sure we weren't being followed."

"He knew we'd meet you here," Draigistar said, "wanted us to watch Celeste."

Gustin glanced at Fae.

"I'll stay close to her," she said.

They rested the horses, and Erin and Flynn went to scout the road. While Fae talked with Celeste, she discretely watched Gustin and could tell something bothered him. *Is it the Rendovan?* she wondered. *Not knowing where she is could cost someone their life.* Others prepared for the attack they knew was imminent. They checked their weapons, and some strapped on armor for the first time since leaving home. Fae was glad to see Derek up and around. His deliberate movements indicated he was still sore, but he was probably the best shot with a crossbow in the entire group.

At last, the order was given. Several riders spread out on horseback as Tobias drove the lead freighter out of the forest onto the high road. The other wagons followed until they'd all emerged and headed south at a brisk pace. Flynn and Gustin

rode a hundred feet ahead, with the others spread throughout the column. The two kaishons followed the lead freighter, and the remainder came behind. The last wagon was nearly empty, with two well-armed teamsters inside and another pair riding close by.

/// \\\

Hunter stayed with the column until Draigistar reported, then fell back to make sure they weren't still being pursued.

"Sure that's necessary?" Lance asked him.

"I'm not taking this lightly," he told Hollis and the foreman while Celeste and the mage looked on. "I realize once we're on the road, if they attack us, it won't really matter where they come from. But I'll at least know if any more follow us through the forest. And if they find another way across the stream, I might be able to slow them down."

"All right," Hollis agreed. "But we can't wait for you. Once we reach the high road, we have to move fast. You'll be on your own."

Hunter nodded. "I know. Don't wait; I'll catch up by dark. If not, don't send anyone back for me." He noticed Celeste look down and turn away, and her reaction wasn't lost on her father.

Hollis sighed. "All right, son, go, but don't do anything foolish."

"I'll be back before you know it."

After fetching his horse, he went and found Celeste tending to her mount. She'd been crying; he knew when their eyes met.

"I'll do the right thing," she said. "I won't try to dissuade you."

He reached out and drew her close. "I will be careful, Celeste. It's no different than when Gustin fell back yesterday to do the same thing."

She feigned a smile. "Yes, Hunter, it is different, for me. I'm not—" she started to speak but paused, glancing away. Then her eyes returned to his. "I'm not in love with him," she said with her voice aquiver.

His heart leapt, hearing those words. "Have I ever told you how beautiful you are?" he asked, knowing well he'd never dared to speak such a thing.

She nodded. "Uh huh . . . every time you look at me," she said as tears rolled down her cheeks.

He pulled her to him, and they kissed. As their cheeks gently brushed together and their lips met, he could taste her briny tears. It was intoxicating. At last, he released her, and they stood face to face, gazing at each other.

"I must go, Celeste. I won't be long, I promise," he said, gently stroking her wet cheek with a fingertip.

"It would break my heart if you lied to me."

He smiled. "Then I shall not," he said before leaning in to kiss her once more. When their lips parted, he turned and placed a foot in a stirrup, swiftly settling into his saddle. Reining his warhorse around, he looked at her once more. She wiped her wet cheeks and they silently nodded to each other before he turned and rode away. A storm of emotion filled her as she watched him fade from sight. She didn't know what the future held for them or if she would ever be able to give herself to him the way she desperately wanted to. But she knew that meeting him had forever changed her life.

"It never gets any easier, child."

She smiled at the sound of her father's voice and turned to see him approaching with a smaller man's stealth.

"I wasn't spying, my sweet. I waited till I heard him leave," he reassured her as he stepped up. She leaned into his comfortable embrace and let go of her emotions. He held his daughter while she softly wept. His heart ached for her. He, too, had grown fond of the quiet stranger. When her crying subsided, he spoke again.

"Every time I rode away from your mother, from the first time to the last, it never got any easier. And it only became harder when I had to leave you and Jonas."

She sniffled and leaned back to look up at him. "I love him, Father."

"I know, child. My precious little girl has grown into a beautiful young woman who now contemplates the next stage of her life."

"Father, I'm scared. I don't know what's come over me. I've only known him a few days, yet I feel as if I've always known him."

He gave her a knowing look. "Celeste, did you ever wonder why I left you in the care of a man we've known for such a short time?"

She gazed at him briefly before looking down, and he studied her expression until she looked back up at him.

"I, uh . . . yes Father, I guess I did."

"My dear, God has blessed me greatly in this life," he said as he turned, and they began walking side by side, her arm on his. While they slowly walked through the forest, staying close to camp, he continued.

"I grew up with little means but with two loving parents who bestowed the values I've lived my life by. I've prospered in everything I've tried. I have more wealth than I can count and many friends. Mind you, some are shallow, only interested in that wealth. Others, however, are the real thing. . . . There is one such friend, a particular man I would trust my life to. And it's on his word I've placed my trust in this young man you so fancy," he said as they stopped walking.

Bewildered, she looked up at him while he gazed into the forest.

"My dear, you and Jonas are my greatest treasures," he continued. "My greatest achievements in this life—the only things I truly cherish. I came into this world with nothing, and if I am to return to dust in the same manner, then so be

it. I'm not worried," he said, looking at her. "Celeste, I would never leave you in the charge of a man I did not trust. I know much of Hunter by reputation, from a source beyond question. I know him to be a loyal, capable man of honor and integrity."

"Father, why didn't you tell me?"

"It was not my place to share his past with you, child, only to approve of him or not as your protector and, as it turns out, your suitor. . . . I approve."

She gazed at him, trying to comprehend his words.

"Celeste, when he's ready, he will share those things with you. Just be patient. Believe me when I tell you he's more afraid of you than you are of him. My dear, if I'd held any reservations about him, I would never have let him near you. Though we'd never met, I knew him by description the day he walked into the inn. And when he agreed to join us, I knew I'd found the one to watch over you. . . . Now come, let us go," he said as he turned with his arm around her. She silently pondered his revelation as they walked back to the wagons.

/// \\\

Hunter rode away with a heavy heart, allowing himself a brief dose of self-pity. Then he shook free of the thoughts of her and focused on his task, carefully making his way back to the clearing where they'd camped. When he slowly rode through their vacated campsite, he looked for signs that anyone had been there since they'd left. Finding none, he made his way back down the steep hill to the upper stream crossing. He slowly inched his horse out into the water where he knew the giant stone pathway to be, even though he couldn't see it. The swift-moving water was now murky. Soil, tree limbs, tufts of early spring grass, and other natural debris floated by in the swollen stream as he stopped his horse when the water reached its belly. *It would be insane to try to cross here*, he thought. *One slip and you'd be over the falls.*

He carefully reined his horse around and rode back out of the water. Then he proceeded to the cliff where the tracks of the lost wagon ended at the edge. He sat there for a moment, looking out over the pool at the ruins. A few broken wood planks and two barrels bobbed at the surface in the center, apparently trapped in an eddy from the falls, perpetually swirling in an endless circle above the wagon's watery grave.

He looked beyond the pool to the far side, where the lower road crested the hill and opened into the clearing. He could see the bodies of the Shadow who'd confronted Lance and the others yesterday. He knew the stream's path was much wider down there, so he turned and followed the road down to the lower crossing. He rode around to the far edge of the pool where the wagons had come ashore after crossing the spillway. He'd barely started his horse out into the water when he realized that it, too, was now impassable. *Good. I hope others come in to find their friends*, he thought, knowing they'd lose a day backtracking. Before turning around to head back to the column, he looked across the pool once again. Nothing.

Scanning the lower road back down the ravine, he bristled when he saw a group of riders. They were still half a mile away, but he knew it was more Shadow. He looked around in all directions before he cautiously dismounted, stepping into the thigh-deep water. Not wanting to be seen, he carefully led his horse back to dry land. Once out of the water, he led it into a growth of trees and tethered it there. He opened a saddlebag and retrieved a piece of thick leather with a single lace woven into each end, and a small wooden box with a latch. Returning to the end of the spillway, he knelt behind some bushes. Opening the box, he removed two clear, flat crystal pieces, one larger than the other, and carefully placed them inside the leather piece and rolled it tightly around them, creating a hollow tube with a crystal in each end. He tied the laces and held the foot-long object up to his face.

Through the lenses, he studied the intruders while they

slowly moved up the inclined road. *Too slow*, he thought. He counted six riders with ten horses, and the four in tow had saddles. He scanned the forest on the other side of the road and across the clearing beyond Shaelah. Nothing. Perplexed, he now returned his sight back to the riders. Watching them, he noticed they occasionally looked across the swollen stream to his side of the ravine. Alarmed, he quickly turned to scan below the spillway until, at last, he saw them. Four men were climbing over the rocky stream bed, making their way up toward the spillway. He knew that, eventually, they would reach their objective and emerge near where he was now concealed. Given their pace, he had plenty of time to prepare a welcome. They were muddy and looked spent.

He studied the terrain along their path and made a plan. *Yes, that'll do*, he thought, taking one last look at the riders. Rolling the device in his hand to look through a thicker part of the lens, he felt his anger begin to well up. *You*, he thought. Zandor, the other scout Hollis had hired in Port Estes, rode at the front next to another man. The other man was tall and wore black clothing and a gray cape. He knew it was the man he'd seen on horseback in the alley in Port Estes—the one Janae called Hanlin. He had to wonder if this was the man who'd murdered Erin's mother and father. Now he found himself wishing the stream wasn't impassable. *Looks like you two bastards get a reprieve*, he thought as he lowered the device and backed away from his concealment.

He returned it to his saddlebag and led his horse through the woods to a place near the edge of a small cliff a hundred feet downstream from the spillway. Again, he tied his horse and approached through the foliage, creeping up to the edge and peering over. He could see the four men approaching, climbing up the ravine on a path that would take them directly beneath him. *Perfect.*

He took the length of rope he'd brought and passed it around the trunks of two small trees growing out of the edge

of the cliff. He looped it around them twice and tied it off, being careful not to expose himself to the riders across the ravine. Then he retreated, paying out the rest of the rope on the ground before he untied his horse and moved it into place. Once the trap was set, he returned to the edge of the cliff where he watched them while examining the rocky ledge he was lying on. *Yes, this should break away nicely.*

At last, they were in position. He knew by the time he covered the distance back to his horse, they would be just beneath the cliff of shale and loose rock. He eased away from the edge until he could stand, then ran to his mount. He bent down and grabbed the end of the rope before he swung into the saddle, quickly securing it as he began coaxing his massive animal back. The rope creaked when it went taut, and he watched the trees bend. He could hear frantic voices below and knew the cliff must be starting to crumble. *Now!* When he spurred his horse and yanked back hard on the reins, the trees yielded to the force. They dislodged as his horse backed up, pulling them through the forest until he eased up.

He could hear the sound of falling rocks and imagined the devastation as they rolled and slid down the cliff onto the helpless enemy. He quickly dismounted and raced forward past the now bare-rooted trees until he neared what had become the edge. He could see that a section of the cliff face about thirty feet wide and several feet thick had crumbled away, more than enough weight to crush anyone below. He heard no voices as he carefully crept to the edge and peered over. There, below, he could see all four men. Three were partially covered, one almost completely. The fourth was floating face down in a cloud of red, being carried away by the stream. He knew they were as good as dead. Their comrades would make no effort to rescue them.

He looked across the ravine when he heard shouting and saw the other men pointing at him. He backed away from the edge and reclaimed his rope, then mounted and rode back up

to the spillway. When he emerged, he looked across to see the six remaining Shadow just cresting the hill, taking in the sight of their friends who'd fallen yesterday. They began shouting at him, and one quickly dismounted with his bow. Hunter watched him nock an arrow and take aim. He knew he was out of range, but the man pulled back and released it. Silence came over them as they watched it fly, only to fall short and splash in the water.

That's all I can do for now, Hunter thought, reining his horse around and heading up the first hill to the cliff overlooking the pool. When he reached the flat near the waterfall, he saw that two of them had started up the hill around the back side of the ruins while the others loitered among their dead comrades. He waited till the pair crested the hill. They spotted him and headed to the edge of the stream where he'd pulled Flynn and Erin ashore yesterday. Now he sat atop his mount on the opposite bank, watching Zandor and the scarred one rein up. Silently gazing at each other, Hunter kept his eyes fixed on the stranger. He didn't acknowledge Zandor, an insignificant minion. Hunter studied the expression of the scarred man. He knew his kind, a lonely, miserable wretch who despised everything and everyone, including himself. His only respite from self-loathing came from inflicting pain on others.

Suddenly all three of them were shaken by the distant sound of screams coming from the ruins below. Hunter turned in his saddle and was shocked by what he saw. The four who'd remained below were under attack by several robed figures like the one Fae had described. He glanced over to see his two opponents fixed on the horrifying sight before returning his attention to the scene. It passed quickly. The screams soon stopped, and he could see the four men lying dead on the ground with yesterday's kill. The dark figures dissipated into gray clouds, whishing away into the trees. Then there was only the sound of the waterfall.

Welcome to Shaelah, he thought. Reining his horse away from the edge, he looked at Zandor and the scarred one. They

were visibly shaken from the ghastly event they'd just wit-
nessed. When his gaze met the scarred man's, he slowly broke
a confident smile before spurring his mount away. Riding
up the steep hill, he resisted the temptation to look back. He
wanted his apparent lack of concern to unnerve them even
more. Words were futile. That was the most insulting thing he
could do. He didn't know if the Shaelock would let them live,
and he didn't have time to wait and see.

/// \\\

The rain steadily fell as they traveled on with little conversa-
tion. After resting the horses, they made good time until Lance
ordered a halt at the big wooden bridge. The stream running
under it was just starting to swell. Its source, apparently fur-
ther south, had not taken the brunt of yesterday's torrent.

"What do you think?" Lance asked while he and Hollis hud-
dled with Flynn and Erin. The two young trackers had checked
the woods on either side of the road while Gustin went to inspect
the bridge for sabotage.

"The rain took most of the tracks, but we found some over
there," Flynn said, pointing. "Six men led horses up into the
hills."

Lance and Hollis looked at each other.

"So, they're closing the trap," Hollis said.

"Probably watching us right now," Erin replied.

"This isn't good, sitting here spread out in a single line,"
Hollis added, "especially when it gets dark."

"Boss, we still have enough daylight left to reach the knoll,"
Lance said, referring to a small round hill in a clearing at the
southern edge of the Forest of Souls.

"Yes, let's do it. Keep the wagons close together and make
haste."

With the rain and lightning intensifying, they set out across
the wooden bridge. Hollis rode next to his daughter once they

were all safely across. She didn't ask about his conversation with Lance and the others, and he was glad. He dreaded what he knew was to come and wished Hunter was there. He knew the four were capable. But they didn't share his uniquely personal motivation to protect his daughter. *Where is he?* he wondered as the women riding around him quietly chatted, oblivious to the depth of his concern.

Time seemed to drag on as they continued south. Gustin now rode alone just a length ahead of the lead wagon. He figured they'd covered another five miles since their stop. The stream that passed under the wooden bridge turned and followed the road as it meandered along the edge of the forest. On the other side of the road were giant conifers blanketing the foothills. Occasionally the stream cut into the woods out of sight, only to return and parallel the road again. Finally, it veered away from the road and flowed over a series of small rapids before disappearing into the forest.

Shortly after the stream turned away, Gustin rounded a bend and saw a large pine tree lying across the road. *This is it*, he thought, reining up and signaling to stop.

When Tobias pulled back on the reins of his team, Flynn and Lance cautiously rode up to join Gustin.

"So, it's to be here," Lance said, looking down the road as he and Flynn reined to a stop on the big man's flanks. Gustin didn't respond. He was studying the situation. The other two held their peace while they all scanned the surrounding trees.

"The forest is thick here; easy for them to hide," Lance finally added.

"Yeah, but it keeps them from standing off and shooting at us," Flynn replied.

"That's right," Gustin said as Hollis approached, pulling up behind them.

"Boss, we can't protect you like this," Lance reminded him.

"We're in this together, my friend. I'll pull my weight; you know that."

"All right, listen, we don't have much time," Gustin broke

in, still looking down the road. "If I were setting up to ambush wagons here, I'd fell the tree down the road from where I planned to attack, assuming they'd stop before they reached it just like we did. So, we need two of your drafts and some heavy ropes," he said, looking over at Lance. "Give me two handlers and someone good with a crossbow, and we'll go move that tree."

"All right," he agreed with a nod as he reined his horse around. "Come on, boss. Let's you and I go see to it. I'd feel better if you'd stick close to Celeste anyway."

Hollis reined around, and they headed back.

"Flynn, can you hit a target that far away?" Gustin asked.

"Man-sized? Yeah. Difficult in this rain, but I can at least keep from hitting you."

Gustin gave a hint of a smile. "I'd appreciate that; already been shot once today."

Flynn chuckled softly.

Word spread quickly. And while the others prepared for an attack, Gustin coaxed his warhorse ahead, carrying a borrowed crossbow. Janae rode next to him. Derek had insisted he was ready, despite his injury. But Gustin had respectfully declined, choosing her instead. He wanted someone agile if they were attacked. The two handlers rode behind them, each leading a draft horse with a length of heavy rope tied to its rigging.

"Janae, I need you to keep an eye on the woods," he said when they reined up.

She nodded. "I will."

Seeing the axe marks at the base of the felled tree confirmed his suspicion. It was a trap. He decided the obstruction would have to be pulled away from them in the direction they were traveling.

"There, lead the horses 'round the tree," he said, pointing to the edge of the woods. While they complied, he dismounted and glanced back to see Janae was now kneeling in the road,

making herself a smaller target. *Smart girl.* He stepped between the limbs and over the trunk of the tree as they brought the drafts into place. A teamster unlashed the coil of heavy rope and handed Gustin the end, paying it out as he passed it twice around the trunk and tossed it back out onto the ground behind the huge horse.

He didn't like the situation. Only Janae was in sight of Flynn while he and the other men worked. And worse, he couldn't see the column. He knew that any tactician worth their salt wouldn't worry about four people when the objective was the wagons and the riches they held. Suddenly he heard a whishing noise followed by a pop. It came from the other side of the tree, barely perceptible through the sound of the falling rain.

"Gustin!" Janae yelled.

He looked at the teamster tying off the rope. "Get this road open!"

"Will do."

Gustin turned and dove over the trunk, rolling on the wet ground. He came to a knee when he cleared the limbs and saw Janae firing at one of three men rushing her from the trees. Her aim was true. The bolt hit him in the chest and his knees buckled in mid-stride. He hit the muddy ground face down.

"Ahhhh!" The next one yelled as he and Janae both threw down their spent crossbows. She reached for her sword while he ran at her with his raised.

Gustin fired his weapon from behind her, and she recoiled when it whished by. It struck the charging man in the throat, and a spray of red erupted as he fell dead. Gustin dropped his weapon and stood up as he drew his swords, turning to look behind him. Two more men approached from that side of the road. Suddenly he heard another *whish* as an arrow knifed through the rain-filled air between him and his charging opponent. *Flynn*, he thought as the other man ducked and lost his footing, going down in the mud. Gustin advanced on the

downed man, and his partner stepped up to attack. He let him swing first, then parried and thrust with his second blade, running him through.

His sacrifice had bought the other man time to scramble to his feet. Now he swung at Gustin, and he countered. Hearing the clang of steel behind him, he knew Janae had engaged. Desperate to end his match and help her, he feigned swinging his sword in a high arc. When his opponent took the bait and raised his sword to block, he swept the blade away with his second weapon and stepped in. With a crushing blow from his hand wrapped tightly around the hilt of his sword, the man fell back, losing his weapon. He landed hard in the mud, sliding to a stop where he lay motionless with blood running from his nose and mouth.

Gustin heard the teamsters coaxing the horses and saw the felled tree begin sliding away. Good, that's done, he thought, spinning around to see Janae lying on her back with a man closing in. He was too far away to help, but she raised her sword and ran him through when he leaned over to finish her with his blade. Gustin sheathed his swords and rushed over as she shoved the dead man off her and struggled to her knees.

"You all right?" he asked, seeing her face bloodied.

"Yeah," she replied while he lifted her to her feet. "Just took a fist."

"I'm sorry," he said, steadying her as she wobbled.

"It's all right. I've been hit harder than that," she said, wiping her mouth with her sleeve. "My horse is down."

He realized he could hear a commotion from the column and looked up to see they were under attack. "Janae, I have to go."

"Go on; I'll stay and help here."

He heard an axe *thunk* into the tree behind him and turned to see the teamster frantically swinging. "We'll have this gone soon as I top it."

"She's been hurt. Watch her," Gustin said, heading for his mount.

"Got it," he answered, continuing to swing.

Gustin vaulted into the saddle and spurred his mount back toward the wagons.

/// \\\

Flynn watched carefully while he and Tobias chatted. He saw Gustin dismount and step into the limbs of the felled tree while Janae took a position to cover them. Then he saw Janae's horse go down. Gustin appeared, and he and Janae dropped two men charging from the woods. When two more appeared behind Gustin, he took a shot. He knew when he fired, he'd led the man too much. Then a bolt went sailing past him.

"Attack!" Lance shouted to the back of the column as several more bolts and arrows flew at them. He heard four distinct thunks when they buried themselves in the wooden sides of the wagon. Now Shadow charged from the forest on both sides of the column.

Flynn jumped from his saddle to the seat of the wagon where Tobias sat, apparently frozen. "Shake out of it, man!" he yelled, climbing up onto the cargo for a place to use his bow.

Fae had dismounted to stand with Hollis and Celeste near the back of her wagon. "Get inside!" she yelled to Celeste when the attack began.

"Go, child!" Hollis added, drawing his sword.

She scrambled inside and grabbed the crossbow he'd given her. Against her mother's wishes, he'd taught her to shoot it when she was young.

When they stopped earlier at the bridge, Lance ordered the open wagon moved to the middle of the column. With its low, flat load of cargo and tall wooden sideboards it made the perfect platform for his people to use their crossbows from. Erin was there with Derek and Krysta. And when the Shadow attacked, they returned fire with deadly accuracy. Two drivers and an escort were hit by crossbow fire before the enemy rushed in. Erin and Flynn used their bows to drop Shadow

as they emerged from the woods. And those who made it closer faced crossbows and sword-bearing teamsters eager to engage. Lance was impressed by the ferocity of his people standing their ground.

The Shadow who led their mounts into the hills had, in fact, followed the column when it passed, and now they bore down on the last wagon. Erin saw Draigistar stand up in the seat of the fifth wagon, looking back while he raised his hands high. Then bright blue arcs jumped from his palms to meet in the middle, and a bolt of lightning streaked toward the approaching riders. With an earsplitting clap of thunder, it struck the ground, and an enormous shower of muddy soil and rocks erupted, unseating four when their horses fell.

"Get down!" Erin yelled at him. When he jumped to the ground, she saw two of the riders had managed to stay in their saddles and now continued advancing. Two of those he'd unseated were coming to their feet just as another mounted figure came into sight behind them at a swift gallop. *Hunter*, she thought with relief.

Mindful of her duty to protect Hollis and Celeste, Fae kept close to the wagon and waited for the Shadow to close. She was amazed at how many Flynn and Erin dropped in the rush, but finally, two men charged her. One carried a long sword, but the other was unique. He was slight of build for a man, very agile, and had a stone-hard expression. He carried two hand-axes, each tethered to a wrist by a foot-long lanyard. He could release the weapons and swing them fast and sure, easily recovering them without thought. She saw him kill one of the teamsters before the young man knew what happened, and she knew the hirelings were no match for this foreign-looking warrior.

She wanted to face him, but the other one was closer. When she moved far enough away from the wagon to maneuver, she heard the release of a crossbow. A bolt flew past her, striking the man just above the neckline of his chainmail vest. His

sword fell to the ground as he clutched himself and went to his knees. Then the foreigner planted a foot in his back, kicking him toward Fae. She knew the shot had come from Celeste. And Hollis was still crouched at the back of her wagon, so she didn't take her eyes off this formidable threat as she side-stepped his now-dead comrade.

Gustin broke into the melee with his horse at a full run. His well-trained mount plowed over a Shadow before the man could react. He yanked back hard on the reins and raised a leg, letting his momentum send him from the saddle when the horse slid to a stop. He landed on his feet at a run, drawing a sword while he closed on his prey.

After seeing Hunter approach, Erin fired her bow again before she caught sight of a tall, dark-skinned woman who suddenly appeared from out of the trees. *You!* Erin thought when she saw her. She knew it had to be the Rendovan. Suddenly, to Erin's horror, she raised her drawn bow and fired at Draigistar.

"No!" Erin yelled just as the woman released from a mere forty feet behind him. The arrow raced forward, instantly finding its mark. It hit the mage dead center, driving deep into his backpack, stopping with a loud cracking noise. His arms flew up from the force, and he stumbled forward, falling face down in the muddy road.

Erin was in shock. Rage consumed her as she turned her attention back to the Rendovan and saw her looking her way. Erin dropped her bow in the wagon and vaulted herself over the side, drawing her scimitar before her feet hit the ground. The Rendovan smiled and drew hers. Both women began a guttural growl as they started toward each other. Amid the chaos around them, a path seemed to open as they charged past others with their war cries building to a crescendo.

Hunter barely slowed as he swung his great sword at the fallen rider who'd just stood up. The diagonal slash cut through the man's shoulder with such force it nearly severed his arm.

Hunter ignored the others, racing on past the two rear wagons until he reined up near the empty one. He saw the Rendovan as he stopped, but he hadn't seen her shoot the mage. When he dismounted, a Shadow approached and swung at him. He raised his arm and deflected the man's blade with his buckler as he brought his own sword in from the other side. The man's thick leather vest was no match for a great sword swung by someone of Hunter's strength. It split the armor, cutting deeply into his ribcage. As he expelled his breath and fell to his knees, Hunter shoved him away. Then he looked up to see Erin engage the seasoned fighter. Like Gustin, he, too, had traveled the disputed lands and been to Rendova. There was no doubt of this woman's origin or of her fighting prowess. *She's got her hands full*, he thought of Erin.

The women passed each other in midair, swinging their blades hard. When the clang of heavy steel rang out, their vocal dueling ceased. They both quickly recovered from the momentum of their charge and turned to swing again. The Rendovan expertly utilized her skills. She matched Erin's height and reach, but was considerably lighter. While Erin clearly exceeded her in strength, she was more agile. She swung her sword with both hands, being careful to keep her balance on the slick, muddy road. Hunter anxiously glanced around, desperate to reach Celeste but reluctant to leave Erin.

Fae squared off against the foreigner with the unusual fighting style. She carefully positioned herself against his deadly blades, staying just out of reach while protecting her charge. Suddenly he advanced with a flurry from his slashing weapons. She feigned a move toward him, only to withdraw when he committed and swung at her. She countered with a vertical leap that sent her above the path of his second weapon and extended her leg with all her strength. She made contact, planting her heel firmly against his jaw. He reeled from the force of her kick, rolling backward to come to his feet again. Now his expression showed anger as he approached her. *That's it, lose*

it, she thought, smiling to inflame him more.

Gustin ran toward his opponent with a sword drawn. The man was so unnerved that he clutched his sword with both hands and swung at him. Gustin slowed and parried his attack, then grabbed him and spun him around, slamming him into the side of the wagon as he shoved his sword into his midsection. With his breath already gone, death was silent. The man's eyes rolled back, and he went limp. Gustin pulled his sword free and turned just in time to see Fae deliver a kick to her opponent, sending him rolling in the mud. With only a wagon's length between them, Gustin started her way.

Fae glanced behind her to see Hollis and Lance watching her duel. *We must be winning*, she thought, returning her eyes to her opponent. He made a lunge, swinging, and she countered. She held up her hand, palm forward, conjuring an invisible shield. When his axes met it, they bounced off, and a faint blue circle appeared in front of her before fading away. With a look of surprise, he struggled to recover. Now releasing her spell, she slashed the lanyard to one of his weapons, causing it to fall away. Enraged, he used the other to attack again.

In classic Blademaster style, she'd methodically dismantled his composure, luring him into making mistakes. Now she took a step back to bait him. He followed, intent on keeping the offensive. With his remaining weapon, he suddenly knelt and swung at her in a low horizontal arc. He'd meant to take out her legs, but his eyes had betrayed him. Even with the distractions of the battle around her, she'd read him. She leapt away, arching her back as she went over. To his dismay, by the time his blade sliced through the air where she'd been, she was gone.

Hollis and Lance watched in amazement as she executed a perfect backflip, landing on her feet just out of his reach. When she landed, she feigned a stumble, and again the angry warrior fell for her ruse and advanced. This time he swung in a high arc, and when he committed, she countered. She

slid her feet apart, hitting the ground in a split-legged maneuver as the axe passed overhead with an ominous *whoosh*. He quickly recovered and swung down on her, but she raised her sword and blocked. As the clanging of steel rang out, she rocked forward, driving her fist into his groin.

"Ohhh!" he moaned and bent over, grabbing himself as he staggered back. Effortlessly she drew her legs together, vaulting herself up onto her feet. Then shifting her weight to one foot she raised the other, landing a solid kick to his jaw. When he stiffened, she followed with another hard kick to his midsection. His breath exploded from the force, and his eyes widened. He knew he'd fallen for her deception, and it had cost him his life. Regaining her footing, she lunged forward and thrust with her sword, penetrating his ribcage and his heart. His eyes closed, and he fell to the ground as she pulled her weapon free.

"Fae!" Gustin yelled, pointing behind her.

She whirled around to see her young friend battling with an opponent she knew had the skill to best her. When the melee subsided, others had been drawn to Fae's contest, and now everyone's attention turned to Erin's duel.

Celeste had watched Fae's battle from the back of her wagon with Hollis and Lance standing guard. Now as she looked to the rear of the column, she saw Hunter standing a mere wagon's length away.

"Hunter!" she yelled.

He glanced her way and smiled before returning his attention to Erin. He'd seen her and knew she was safe with Hollis and his men around the wagon.

Erin and the Rendovan stood toe to toe, swinging their weapons at each other. Their scimitars were thick, heavy-bladed weapons made for slashing, so they didn't lend well to a thrust maneuver—unless the wielder was well-practiced. Erin would learn that lesson. When she swung down with her blade, the Rendovan raised her sword to block and lost her

footing. The slip caused her to turn sideways, and Erin seized the opening. She brought her free hand up and planted a fist hard across her cheek. The blow dazed the Rendovan and forced them apart, but she countered with a thrust when she staggered back. The tip of her sword penetrated Erin's leather vest and parted flesh to find a rib.

Erin winced as pain shot through her. She stepped back and cupped a hand over the wound, just beneath her breast. When their eyes met, the Rendovan smiled, trying to enrage her. She looked at her blood-covered hand. Though painful, she knew the wound was superficial, and she knew she had to maintain her composure. She took a deep, calming breath, ignoring her surroundings as her eyes settled back on her gloating opponent. She would avenge Draigistar or die trying.

By now, a crowd gathered. The attack had been thwarted, and dead Shadow lay sprawled throughout the macabre scene. Hunter's gaze met Fae's and Gustin's when they approached. They were all concerned about Erin.

"Krysta, give me that," Gustin said, looking up at her. She stood alone in the back of the wagon after Derek jumped out to go check on Draigistar. She handed her crossbow down to him.

Erin stepped forward, raising her sword, and the Rendovan matched her move. She lunged and brought the sword down, but the more experienced fighter anticipated her attack. She stepped toward Erin to close the distance and turned her body as she lowered her sword. She grabbed Erin's arm with her free hand and used her momentum against her. Pulling Erin in as she bent at the waist, she lifted and threw her over her shoulder. Erin hit the ground hard on her back as the Rendovan released her grip and raised her sword to strike.

Fae pointed her sword at the Rendovan, and Gustin leveled the crossbow, but before either could act, Erin brought a leg up, kicking her in the ribs with a force that took her breath away and sent her stumbling backward. Then Erin planted

her hands on the ground above her shoulders and arched her back, vaulting herself into the air and back onto her feet.

Hunter saw Celeste coming with Hollis and Lance, and pulled her to his side when she slid an arm around him.

Now the Rendovan wasn't smiling. She guarded her side, fighting to catch her breath. Erin was proving herself to be a very worthy opponent. They faced off again, and steel met, scintillating as lightning blazed in the rainy sky above them. The Rendovan tried a surprise tactic. She swung her sword low, and when Erin lowered hers to block, she stepped in and struck her on the temple with a steel gauntlet she wore. The force sent Erin reeling with a cut and blood trickling into her eyes. Dazed, she faltered just long enough for the Rendovan to spin around and bring her scimitar down hard with both hands. Erin raised hers to block, but she lost her grip, and the sword fell to the ground.

Once again, her friends deemed her to be in trouble, only to have her prove them wrong. Without hesitation, she stepped into her opponent. It was an all-or-nothing response to finding herself disarmed in a sword fight, a seasoned fighter's decision made in an instant. And there was no turning back. As she rushed in, the Rendovan raised her sword to strike. But by the time she'd begun swinging down, Erin grabbed her wrist with a crushing grip. Then she clutched the other, locking them in a face-to-face struggle.

Fear set in for the first time. The Rendovan knew she was no match for Erin's strength. Her only hope now was to force her to lose her grip. In desperation, she brought a knee up into Erin's ribs where she'd pierced her with her sword. Erin flinched as pain shot through her but refused to let go. Again, she raised her knee, driving it into Erin's midsection as hard as she could, but Erin did not relent.

Instead, standing there with their arms spread, Erin suddenly pulled her in and leaned forward. With a sickening thud, she struck the Rendovan in the face with the top of her head.

Bright red drops flew as her nose and upper lip were split by the crushing force. Her sword fell to the ground, and she fought to keep her legs under her. She was dazed and could taste her own blood as Erin now pushed her back, still holding her by the wrists. Then she raised a foot and kicked her squarely in the chest, releasing her hold.

The Rendovan's feet left the ground, and she flew back, landing hard, sliding under the edge of a thicket near the road. Briefly, she lay there feeling the rain on her face. Her head throbbed, and she struggled to breathe. In her surreal state, she knew she'd just been defeated, and her only hope of survival was to flee. Struggling to her feet, she grabbed her discarded bow and staggered into the bushes.

Erin started to pursue.

"Erin!" Fae yelled.

She stopped and turned, only then realizing everyone had been watching her fight.

"Let her go," Fae said in a calming tone.

Embarrassed by the attention and still full of rage, she picked up the Rendovan's sword and threw it through the foliage at her. No noise returned from the forest save that of the deadly spinning object breaking branches on its way to the wet ground. She stood there in the rain, chest heaving, slowly regaining her composure.

When Fae and Gustin approached, she turned and looked at them. "Draigistar," she said, trying not to break down.

"At your service, brave lady," they heard the mage say in a nonchalant voice. She looked up as Gustin and Fae turned around to see him smiling.

"What? I thought you were dead!" Erin exclaimed, rushing to him.

He held up his pack that still had the Rendovan's arrow stuck in it.

"It hit the wooden box I got from Hunter," he said. "I'm fine." He dropped it when she reached him, and they embraced.

"You all right?" the mage asked, gently touching her swollen, bloody temple.

She nodded. "Uh huh."

"Well done, Erin," Hunter said when he and Celeste stepped up.

"Indeed," Gustin said while Fae quietly admired her young friend.

"All right people, it's over!" Lance suddenly barked. "Let's account for everyone and take care of our wounded. Then start getting these injured horses unhitched. Road's open! Let's move!"

Some of the drafts had been shot, either by accident or intentionally to keep them from getting away. As the excitement of the battle subsided, they began to take stock. Janae and the two handlers returned safely after clearing the road. The teamsters set about preparing the wagons to move while the wounded were looked after. Six more of them had been injured, two seriously, and three had been killed. A dozen horses had been injured badly enough they would have to be put down.

Forty-three Shadow lost their lives in the attack. Half of those had been cut down by arrows or bolts before reaching the column to engage. The one Gustin knocked out near the felled tree had apparently woken up and escaped into the forest along with the Rendovan and several others. Of those who hadn't escaped, none survived to be questioned. Some of the teamsters had given into emotion and avenged their fallen comrades.

Hollis refused to leave until they'd buried their dead, so a detail was formed while others collected any usable weapons. The rain was now falling hard, and the thunder was a constant, deafening rumble. Lightning danced overhead as they hastily prepared to move. It was imperative they reach the knoll before dark. It was only a short distance away, and they needed to camp in a more tenable location. Finally, Lance gave

the order, and Tobias reined his team forward. One by one, the huge wagons lunged and pulled away from the site of the Shadow's latest failed attempt to take them. As each one got their last look at the carnage, they were all thankful it wasn't them lying dead by the side of the muddy road.

CHAPTER ☩ 16

Leaving the scene of the attack behind, they traveled on through the rain. There was little conversation. Most of them couldn't help but relive the harrowing battle they'd just been thrust into. For some, it was their first fight.

"What troubles you, boss?" Lance asked Hollis as they rode together.

"Oh, I knew this trip could be perilous," he answered with a sigh. "That's why I tried to keep my plans a secret. I honestly thought we had enough people, what with ours, and Hunter, and the four. I was naive in hoping it wouldn't cost anyone their lives."

"Honestly, we haven't lost as many as I'd expected to by now."

Hollis took little solace in his remark. "Guess I am just the old fool my daughter takes me for," he said. "How could I ever make it up to these young men who've paid the ultimate price to keep me from harm?"

Lance knew he was hurting. But he knew his old friend well enough to know it was time for a less-than-sympathetic approach.

"Hollis, when it comes to your daughter, don't underestimate her. Yes, she teases you about your growing years. But don't ever doubt her love for you," he said sternly.

Hollis looked at him, surprised.

"From what you've told me of Hunter, and from my own assessment, he's a fine young man. And those kids have the

sickness as bad as any I've seen," he added. "But make no mistake, if he decided to leave us right now and tried to convince her to go with him, I promise you when he rode out of sight, she'd still be right here with you."

Hollis raised an eyebrow.

"You doubt my words, but you shouldn't; I know I speak the truth. She's . . . she's my girl too," he said as his voice cracked with emotion. "I helped raise her. And I swatted her butt plenty when she did wrong as a child. I know her and love her like my own daughter. You haven't heard the way she talks about you. She's proud of you . . . damn proud." He paused to let him ponder his words before continuing.

"Now, as for those young men we left behind, you already made it up to them by paying them a wage for this trip—in advance—that they'd have to make three trips to earn working for anyone else."

Hollis looked at him again. "Surely you don't mean that as callously as it sounds."

"No, I don't," he replied. "But I can't help the way it sounds. Look, I care about every one of these thick-headed saplings that work for us. I know a lot about them, some more than others. And I don't want to see bad things happen to any of them. But that doesn't mean I'd hesitate to give them a swift kick in the backside if they don't do what I say when it's time to work. This is serious business out here. You can't be soft; you taught me that. . . . These weren't the first ones we've had to bury by the roadside over the years. And every time I do it, I feel two things: I'm sad they lost their life, and I'm thankful it's not them throwing dirt on me."

They exchanged another glance before he continued.

"Hollis, they didn't die defending you. They died defending themselves, in a situation they put themselves in when they agreed to work for you. And if they hadn't been working for you, they'd be working for someone else doing the same job

for less pay. And when their time came, they'd still be just as dead."

Hollis knew his foreman was right. "Thank you, Lance. I needed that."

"Yes, you did, boss. And you know I meant no disrespect," he said with a smile.

"Yes, I know."

By the time they reached the knoll, the rain had slowed to a sprinkle, but streaks of lightning still snaked across the churning sky above them, and the thunder persisted. They knew the storm that was slowly rolling off the mountains would catch up to them. The road had gently turned to the southeast when the forest opened up to reveal a clearing. It cut through the center, looping around the base of a lone hillock. At the west edge of the clearing was a small spring-fed pond. The forest hugged its far side, and well-worn wagon tracks led over to the water, evidence it was a popular campsite.

While Lance managed setting up camp, Hunter and Celeste rode over to Hollis.

"Father?"

"What is it, dear?"

"We were hoping since it's not dark yet that we might clean up in the pond."

Hollis raised an eyebrow at Hunter. "Bathe?"

"Oh no, sir, not me," Hunter replied. "The women."

"Ha, forgive my assumption," he replied with a smile.

"Oh, Father."

He looked at the pond, knowing a quick bath would help calm nerves. "I'd already discounted that for camp; it's too close to the forest. If they're going to do it, I want it done before dark," he told Hunter. "I presume you'll have no trouble finding volunteers to help ensure their safety," he added with a knowing smile.

Hunter smiled. "I'll personally see to it, sir. I thought perhaps we could use her wagon for some privacy," he added,

nodding toward the road.

Hollis looked across the road at the two unhitched wagons with horses tethered and several people milling round a fire at the center of their camp.

"Yes, I saw them. Looks like a family traveling through. I'm sure Lance will want to set the other wagons around the kaishons tonight. Why don't you use the empty birck for your little expedition? And Hunter, be done before dark."

"Yes, sir."

Hollis smiled, bursting with pride as he watched them ride away. She reminded him so much of her mother—the only woman he'd ever loved. He thought of her promising future and how at ease she was with Hunter.

Lance decided to set camp in the north end of the clearing, across the road from the family already camped there. He wanted their camp away from the hill so its high ground couldn't be used against them in an attack. He ordered the two covered wagons to park parallel, thirty feet apart. Then he had a freighter parked in a like manner, leaving Celeste's wagon in the center with her father's kaishon closest to the road. Then he had the two remaining freighters backed together behind them, creating two spaces, each open only at one end. Camp would be centered around the fire built between the two covered wagons, with the spare horses confined in the other space. The kaishons would remain hitched through the night in case of another attack.

After placing the open wagon near the edge of the pond, the women were eager to bathe and wash their muddy clothing. Hunter, Gustin, and Draigistar kept an eye on the surrounding forest while the women cleaned up. When the men partially disrobed to wash the mud off themselves and their clothing, whispers and giggles could be heard from the huddled women watching the show from the safety of neck-deep water.

"Feel like I'm being sold in the slave markets of Edin," Gustin said with a grin.

"Yeah, I know what you mean," Hunter agreed.

"Life could be worse," Draigistar said as he scrubbed his pants after wading in deeper and disrobing completely to clean his garments.

The two big men glanced at each other and smiled.

"You're hopeless, mage," Hunter said. "I'd think after cheating death twice in the last two days, you'd be more, oh, I don't know, introspective."

He looked up at them. "You mean too distracted to find pleasure in five beautiful, naked women bathing? Come now, let us not be hypocrites. No man's heart is that pure."

Hunter exchanged looks with Gustin.

"In fact, that's just what the experience did," Draigistar continued. "It made me rediscover the importance of relationships and appreciating the beauty of life. . . . But, enough about me, Hunter. Speaking of death and the like, I heard you got your butt kicked yesterday by a little elvin girl," he added with a grin.

"What?" Gustin asked, a smile appearing on his face.

Hunter glanced at him before looking at Draigistar. "Careful, mage, lest you attempt to cheat death a third time."

"What's he talking about?" Gustin asked.

Before he could answer, Draigistar did. "Erin's new friend Seraphina, she thought he was hurting her, so she worked him over."

"Ha ha!" Gustin laughed heartily. "That will make a good story by the campfire tonight. You must regale us."

Hunter simply shook his head in embarrassment.

With a robust chuckle of satisfaction, Draigistar waded from the water and headed around the wagon to retrieve dry clothing from his saddlebags. Gustin and Hunter looked at the women in response to the giggles they heard when the naked wizard emerged.

"Come now, ladies, let us not forget our manners," Gustin reminded.

"All right, lover, we'll behave," Fae said. "Now turn around so we can come out."

"Yes, do," he replied. "It's getting dark, and the storm approaches."

The men waded out and dutifully took their places on the other side of the wagon while the women exited the pond and dressed. They climbed in, and Krysta pulled it over next to Hollis's rig, facing the other direction. The men had cut a few small trees from the nearby forest and fashioned a crude frame of poles between the two kaishons. Then they covered the poles with spare tarpaulins to make a shelter from the looming storm. While the wagons, save the kaishons and the empty freighter, were unhitched, wood was gathered, and soon a fire roared in center camp.

Lance and Flynn ventured across the road to the other camp, and when they returned, they were accompanied by two men, brothers traveling with their families. They were from the City of Queens, headed to the Far North Province to settle and help a third brother rebuild his farm that was razed in the war. Introductions were made, and while watchfires were lit around the camp perimeter, a meal was prepared. Some avoided the guests, but Hollis and the others made them welcome.

The four friends sat with Celeste and Janae, engaging in conversation. Hunter had gone to scout the woods around the clearing. He feared the Shadow might attack again in the night. The four knew Celeste was worried about him, but all they could do was stay with her and Hollis until he returned.

By the time they finished their meal, the gentle rain had turned into a downpour, with lightning flashing all around. Their guests thanked Hollis before retreating back to their own camp, and he left orders to awaken him when Hunter returned. The main fire beneath the shelter was maintained, but the small perimeter fires were abandoned by those on night watch who now huddled under the wagons or sat at the front

edge of the shelter.

The night was turning colder, and those who remained by the fire began recounting the events of their week-long journey. Celeste took some teasing about her feelings for Hunter and laughed it off, silently worrying about him somewhere out in the darkness. Eventually, talk turned to the attack and their fight to repel the Shadow.

"Erin, where'd you learn to fight like that?" Lance asked her when someone mentioned her duel with the Rendovan.

She shrugged. "Oh, my father began teaching me when I was young. And I've watched Fae, learned from her."

"You learned well," he said.

"Yeah, you whipped her good," Flynn added.

She looked at him, and they exchanged a smile.

"Janae, do you know who she is?" Derek asked innocently, not knowing the depth of her involvement with the Shadow. The others fell silent, looking at her.

She gazed into the fire and slowly gave a confirming nod. The question obviously made her uncomfortable, and Derek regretted asking. An awkward silence lingered until she finally looked up and spoke.

"Her name is Loorkha. You already know where she's from," she said, looking back into the fire.

Gustin studied her as the others exchanged curious looks.

"Know how long she's been with the Shadow?" he asked.

She nodded without looking up. "About a year."

Fae was puzzled and concerned. "Janae, is she a friend of yours?"

She quickly looked up, surprising everyone with her response. "What? No, I hate her. I wish you'd let Erin kill her," she added with tears welling up. She looked back down, wiping her eyes while the others again exchanged glances.

"Look, I was Hanlin's woman," she continued, surprising them even more. "I knew him before he brought me into the Shadow."

"Who's Hanlin?" Erin asked, causing Fae and Gustin to exchange a look of panic.

"He leads the Shadow," Gustin quickly replied, "answers only to the knight."

"Never mind him," Fae added, steering the conversation. "How does she fit in?"

Janae looked up at Fae. "When I was," she paused and closed her eyes.

They patiently waited for her to compose herself and continue.

"When I was initiated into the Shadow, things changed between us. I soon realized I wasn't his only woman; in fact, he had many. And when I complained, he flew into a rage and beat me. Anyway, I just became another lackey to him. I was assigned duties for the Shadow, and I learned to just shut up and do what I was told. When I did good, he'd call for me. Sometimes, just being with him, pleasing him, was all I had to do. I saw him do some horrible things. And the more repulsed I was, the more he liked it. Finally, he went too far with a young slave he'd bought from Barak. That's the man we killed back at Shaelah," she said, looking at Lance.

He simply nodded.

"You see, I was . . . I was taught to give pleasure and sold as a slave when I was young," she said, looking back into the fire with tears rolling down her cheeks. "I ran away when I was fourteen and lived on the streets. I worked when I could; stole when I had to. Sold myself to survive," she added, closing her eyes.

Everyone was stunned.

Draigistar gently placed a comforting hand on her back, and she responded by leaning into him.

"Anyway, when I saw what Hanlin did to that slave girl, I helped her run away," she continued. "She escaped, but he found me," she said, wiping away tears. "He uh, beat me, but I wouldn't tell him where she was, so finally, he just gave up. He

locked me in a room with no food or water for days. I thought he'd left me there to die. But then, one night, he sent his new slave girl to clean me up and *dine* with him. That's when I met Loorkha. She was his new woman, but I didn't care. . . . Then they undressed, and he made me watch them together." she said, slowly shaking her head with her eyes closed.

"Oh, that's sick," Erin said with her nose wrinkled while the others exchanged looks of disgust.

"Celeste, that's how I met you," she continued. "After that night, he took me to Port Estes and told me I had to get close to your father. Said it was my last chance to be forgiven, and if I failed him, he'd give me to her. I've seen her torture people; she's more sadistic than he is. Oh, Celeste, I'm so sorry," she said as she started to cry.

Celeste and the other women moved in to comfort her. "It's all right," she said, holding her friend, crying with her.

Gustin stood up and placed a reassuring hand on her shoulder. "Janae, did he say why he wanted you close to Hollis?"

She looked up, wiping her eyes. "I'm not sure, but, uh, I think they planned a kidnapping. They bragged about doing it to another merchant in the twin cities."

He nodded. "Well, I'm sorry we brought it up," he said softly.

She just smiled and briefly laid her wet cheek on his hand.

When he stepped away, the other men joined him near the front of the shelter.

"Sounds like if anybody ever needed killing, it's him," Flynn said.

"Yes, I'm sure we all agree on that, son," Lance said.

"I feel bad we got that started," Gustin said, gazing out into the rainy night.

"Yeah, I didn't mean to hurt her," Derek added.

"It was fate," Lance said. "By seeking her information, you gave her something she desperately needed . . . a cleansing of her soul."

They looked at him.

"Did you notice once she began, no one needed to pry?" he continued. "It just came out on its own, because she needed it to. Think of the shame and guilt she's lived with, her innocence and dignity stolen, her body sold to the highest-bidding monster." He looked back out into the rain. "Now that she's let it out, she can begin to heal."

"Lance, did Hollis decide to move south that long ago?" Gustin asked. "Before he met Janae, I mean?"

The foreman thought. "He mentioned it that far back, but only to me, Simon, and his kids. It was really just a vague notion at first. But with workers and customers around the mercantile every day, overhearing conversations, who knows. It's hard to keep a secret. . . . You're wondering how this Hanlin could've known about it."

"Yes. And that he would take his gold with him," Gustin answered.

"Maybe he didn't know," Draigistar said, looking at Gustin. "I keep thinking back to the conversation we had in Port Estes."

"You mean when we speculated they might try to take him for ransom?"

"Yes," the mage replied with a nod. "Maybe they planned to kidnap him there."

"We must keep a close eye on him," Gustin said.

"Something I don't understand," Lance added. "If they knew that long ago, why didn't they have enough men mustered to take us outright?"

Gustin thought. "Several reasons I can think of. They've been taking what they want from travelers for so long that they overestimated their ability. Hollis didn't hire the five of us till just before the journey began. And most of all, they seriously underestimated the tenacity of your teamsters."

Lance smiled. "Indeed, they did."

They stood together awhile, silently scanning the darkness with each flash of lightning. The women quietly conversed

behind them. The crying had stopped, but they still comforted Janae. The rain had eased, but the wind was picking up, and suddenly a gust blew rain in on them.

"It's going to get worse," Draigistar said.

"Yeah, colder, too," Flynn added.

"Storm's made it down from the high country," Lance said. "I've seen it before, winter warring with spring. I wish Hunter would get back."

"He's here," Gustin replied calmly with a nod toward the darkness.

Lance looked at him, then at the two sentries standing by Hollis's wagon.

"Sir, someone's out there!" one of them said.

"In the camp! Don't shoot! Coming in!" they heard Hunter yell. They watched him emerge from the darkness, leading his mount. He stopped and tied its reins to the wheel of the wagon before stepping under the shelter to join them.

"Good to have you back," Lance said.

"Good to be back," he replied, running a hand across his wet face and over his head to wring the rain out of his short-kempt hair.

"Any luck?" Gustin asked.

Hunter nodded as he stepped past. "Bagged four. There's more out there though. Got close enough to hear them," he said as he leaned his sword against a log and moved close to the fire. He looked over at the women to see Celeste with her gaze already locked on him. It had been a miserable, lonely patrol out in the chilly downpour, and his mood reflected it. But when he saw her, a smile appeared on his face.

She smiled back and stood to greet him.

"I'm soaked," he said, hesitating to hold his arms out.

"I don't care." They came together and embraced as she laid a cheek on his cold, wet chainmail vest.

The other women stood and moved closer as the men gathered around to hear his report. He'd patrolled the edge of the

clearing, once around and halfway again. He vaguely spoke of the four he dispatched but withheld mention of any other Shadow lurking about. When they told him about Loorkha and Janae's story, he held out an arm invitingly, and she came to him.

"Hunter, thanks for helping me," she said. "I fear someday he will find me, but for now, I'm free and with my friends. That's all that matters."

"Janae, he's not going to hurt you anymore."

"All right, folks, that's enough," Lance interrupted. "It's been a long day, and we all need to get some rest. Hunter, I sent one of the cooks to fetch you something to eat. You sit down by the fire and get warm."

"Glad to," he said, releasing Janae with a gentle stroke of a fingertip down her cheek. As he removed his armor and sat down with Celeste, the others spread out, resuming quiet conversation or preparing to bed down.

Lance looked at Hunter. "Think they'll attack again tonight?"

He thought briefly, glancing at Gustin. "We dare not let our guard down. It's only a sprinkle now, but a hard rain's coming. A reasonable person would assume they won't attack in a storm. That's why it's the best time to; I would."

Lance simply nodded.

"Sir, here's some food," one of the cooks said, stepping up to hand Hunter a plate. As his empty stomach prepared to receive sustenance, a familiar, loud, sizzling sound caused them all to turn and look.

"Attack!" a night watchman yelled when a fireball emerged from the darkness. Everyone scrambled to their feet while they watched the lone object fly toward the two wagons parked on the other side of the road. It slammed into one, caroming into the other, rocking them violently. Then they heard panicked yells of alarm coming from the campsite as some of their horses broke tethers and bolted away.

"All right, people, it's started!" Lance yelled. "Everybody

up! You two go help them," he told his sentries, pointing across the road.

"Lance, wait," Hunter said. "It's a ruse. . . ."

They paused as silence settled over the clearing.

"They're just trying to keep us on edge," Hunter added.

"We still need to get those people over here with us," Lance said.

"We'll go," Fae said.

"Yes, give us three or four of your people, and we'll go get them," Gustin added.

"Done."

While the others prepared to defend the camp, Gustin and Fae led a party across the road. Shaken from their sleep, the family was uninjured. So, after escorting them to the safety of their camp, they hastily hitched up the damaged wagons and moved them in close to the bircks.

Just then, one of the teamsters approached Lance, clearly alarmed.

"What is it?" he asked, reading his expression.

"Sir, Tobias is gone."

"*What*? What happened?"

"We saw two horses near the forest while we were hitching their wagons and—"

"I saw them too," Gustin interrupted. "I told him to forget it."

"Sorry, sir, I guess he went anyway. I turned around when we got over here and he was gone."

"He knows better than that!" Lance exclaimed.

"Hey, there he is," Erin said, pointing. They saw him approaching at a run.

"What were you doing?" Lance admonished.

"Sorry, sir," he said, out of breath. "Tried to get the horses, but they bolted."

"Those horses aren't worth your life, son," Lance rebutted. "That was foolish."

"Yes, sir, you're right," he conceded. "Won't happen again."

Suddenly another fireball lit up the night. They watched it fly by harmlessly, falling to the wet road and going out.

"What was that about?" Draigistar wondered.

"He's here," Hunter said from behind them. They turned to see him standing near the fire. Earlier, he'd removed his armor in hopes of relaxation and a warm meal—neither of which he'd received. Now he wore it again. His great sword rested in its scabbard, and he was just cinching the straps on his buckler.

Celeste stood silently by his side with a look of desperation.

"There," Erin said, pointing into the darkness.

"Yes," Draigistar concurred. "Two of them—probably the wizard is with."

"No doubt," Hunter replied. "Edmond never was much for a fair fight."

An ominous feeling settled over them as they pondered the battle they were about to see. They knew Hunter sought his old friend, but they all feared him failing, feared watching him die. When he looked at Celeste, her tears began. Hollis had awakened and joined them when the commotion started, and now he stood behind his daughter with a consoling hand on her shoulder.

"Son, you don't have to do this," he told Hunter.

They exchanged a solemn look. "Yes, sir, I do." He slipped an arm around Celeste's waist and pulled her snuggly in as he looked down at her.

"I love you," she said softly, her tears now flowing freely.

"And I love you," he replied. He smiled at her as he leaned down, and their lips met for a long kiss. He was no longer embarrassed to show his affection in front of her father. He'd finally come to know someone who mattered more to him than the childhood love he'd lost so long ago. And now he must risk losing her. When their lips parted, he looked at Hollis. Both men knew too much had been left unsaid between them.

Hollis extended a hand, and Hunter eagerly shook it. "Be careful, son."

"I will, sir," he replied before releasing his grip. His eyes met Celeste's again as he raised his hand and gently stroked her wet cheek before turning toward Gustin.

"Let me join you, my friend. I'd be honored."

"The honor would be mine, Gustin. But this is something I must do. This night was foretold. And now it must be fulfilled."

Gustin and the others were puzzled by his response, but knew there was no time to pursue it.

Fae reached up and placed a hand on the back of Hunter's neck and, pulling him down to her, surprised him with a kiss. "God be with you."

He gave her a fleeting smile. "Listen to me. Watch closely. Study him. And no matter what happens, remember every detail, should this task fall to you. . . ."

She was shocked, and her expression showed it.

"I've watched you, Fae. Telfari has done well. Trust him . . . trust yourself," he added before turning away.

He must have doubts, she thought, realizing what he meant. If he failed, he gave her the best chance of defeating the Shadow Knight.

He slapped the mage on the shoulder, and they exchanged a nod before Erin stepped up and gave him a hug. She kissed him on the cheek as they parted. When he stepped out from beneath the shelter next to Janae, she looked up at him.

"Janae, no matter what happens, always know you did the right thing."

She nodded. "I will, Hunter. Good luck."

Lance and Gustin flanked him as they walked to the road. The hirelings had thrown down torches and were pouring out skins of oil to light a circle on the wet ground.

"Hope you don't mind," Lance said, gesturing toward their handiwork.

"That's fine," he replied, looking at the foreman. "You know what must be done."

"I will see Hollis and Celeste to their new home," he replied.

"And you're going to help me, once you've finished here."

Hunter smiled and glanced at Gustin. "Go, my friends. I won't be long."

"Godspeed," Lance said.

When they turned back to camp, Hunter saw the Shadow Knight coax his horse slowly forward. He wore his helm with the shield up, and his eyes bored into him.

Hunter silently mouthed the words of a prayer he'd learned as a young paladin.

Lord God Almighty, creator of all men and of all things. May Your grace and mercy abound. Give me the strength and courage to overcome this evil set before me. May Your will be done, and Your glory be magnified. And may the kind of heart and the meek of spirit be spared evil's wrath. May You empower me, Your humble servant, to smite this wicked force of darkness that I might give thankful praise to You. Amen.

Lance and Gustin set about making sure their forces were spread out through the camp in case of an attack. Little more than a mist now fell, but lightning was striking all around, with thunder constantly shaking the ground. Most of the party had left the shelter and gathered near the lead horses of the two covered wagons to watch the battle.

"You shouldn't be here, child," Hollis told his daughter.

She looked up at him, wiping away tears. "I know, Father, but I have to. I want to climb up there," she said, pointing to the back of the freighter they'd taken to the pond.

"She'll be all right; we'll stay close," Gustin told him. "But just get down if I tell you to," he warned her.

"I will," she replied, climbing up and over the tailboard. She knelt at the rear with Tobias and another teamster standing behind her.

When the knight reined up, his wizard began slowly inching his mount forward.

"You disappoint me, Edmond," Hunter said. "Do you fear me that much?"

He raised a hand, and the wizard stopped his horse forty feet behind him.

"And you disappoint me, William," he replied as he dismounted and stepped through the ring of flames. "I'd have thought by now you'd know not to involve yourself in someone else's life. Don't you know it will always end the same? You will hurt them. Or they will die."

"You've plagued society long enough, Edmond. Now come meet your due," Hunter said, slowly stepping forward.

Ignoring his challenge, the knight continued. "You know why I've let you live this long? So they could get to know you. That way, it will sting more when they watch you die. You always were the special one with the ladies. Could've had any woman you wanted, but you were too busy being in love," he said mockingly. "Made me *sick*."

"That's because your heart wasn't true. You never cared for anyone but yourself."

Ignoring him, Edmond continued. "Perhaps when I've finished with you, I'll ride to the Chateau and console dear Stephanie."

Hunter's anger now began growing, but he recognized his old friend's tactic.

The others who looked on were close enough to hear bits of their conversation, but couldn't make sense of their personal references to the past. Celeste wondered about the names she heard spoken.

"I wonder if Stephanie still mourns you, William?" he continued. "Oh well, no matter. I'm sure that little trollop you're so fond of will be devastated to watch you die. I must say she's a beauty. I watched her bathe in the pond. She'll fetch a good price in the slave markets."

"Enough," Hunter said, stepping up and swinging his sword. Those watching were in disbelief. It appeared the Shadow Knight would not defend himself, and Hunter was poised for an easy victory. Fae knew it would not be that simple. As Hunter's sword arced toward Edmond, he raised an open hand. It was

a familiar gesture to Fae. Hunter's blade struck an invisible shield and recoiled as a faint reddish disc appeared in front of Edmond. He immediately countered, thrusting a fist forward. Without making contact, Hunter suddenly flew back as if he'd been kicked squarely in the chest. He hit the ground on his back and slid through the ring of burning oil. Edmond smiled as Hunter rolled to a knee and stood up with his sword still in hand.

"Come now, old friend, is that the best you've got?" he asked, drawing his sword. Hunter silently started forward with small blue flames eerily dancing across the back of his mailed vest.

Hollis glanced up at Celeste to see her fixated on the battle.

When Hunter closed, he feigned another swing and lowered his sword when Edmond thrust his fist forward again. Hunter's sword glowed a bright blue as he thrust the tip straight at Edmond. A visible distortion appeared between them as Edmond's spell briefly dueled with the power of Hunter's magical blade. When Hunter advanced another step, Edmond acquiesced. Waving his hand to release the spell, he raised his sword and spun aside. He hoped Hunter's momentum would open him up for an attack, but he kept his balance and raised his free arm to meet Edmond's sword when he brought it down. With a loud clang, the heavy blade glanced off Hunter's buckler as he raised a leg and kicked Edmond in the gut. His breath exploded, and his feet left the ground. Now, like Hunter before, he found himself on his back in the mud.

"Come now, old friend, is that the best *you've* got?" Hunter repeated his taunting words to enrage him. Every good fighter knew that stealing their enemy's composure was as much a weapon as any blade.

"Ahhh!" he yelled out as he came to his feet. "You will pay for that," he spat at him in the ghastly voice of the hateful old hag.

"There you are, witch," Hunter calmly replied. "Come forth that I might end your reign of misery."

Suddenly Edmond's head jerked back, and his spine stiffened with arms extended.

Those watching glanced at each other in astonishment.

"Ahhh!" a horrible, earsplitting yell emitted in the feeble old feminine voice as Edmond leveled his gaze on him.

Hunter was undeterred by the demon's tactic. "That's it, come to me!" he yelled, raising his sword.

Edmond leapt toward him with amazing agility. In midair, he extended his free hand, and a bright red bolt of light the size of an arrow shot forth from his finger.

Hunter was ready. He spun his glowing sword in front of him with a bluish haze trailing off it to form a shield. The red bolt of light struck it and caromed back at Edmond, grazing his shoulder as he landed. When his momentum carried him past, Hunter deftly spun around and brought his sword down hard, intending to strike him across the back of the neck, killing him. Edmond read his move and raised his arm just in time to keep his head. Again, the clang of steel rang out as Hunter's blade met the shoulder piece of Edmond's armor. The force of his blow sent Edmond stumbling forward, sliding into the ring of burning oil. He quickly stood and, like Hunter before him, turned and resumed the melee with small flames dancing over his wet armor.

Fae studied their moves, genuinely impressed with the speed and agility of both men. Hunter was as big as Gustin, and Edmond nearly as imposing. Yet, like Gustin, their size was deceiving. They both moved like much smaller men with a flowing, refined style she'd rarely seen in human fighters.

Suddenly, a bolt of lightning struck the forest just beyond the edge of the clearing. Everyone watching the battle saw it hit with blinding light. A plume of sparks erupted when it decimated a tree, and a deafening clap of thunder buffeted them. Then a downpour began, sending some of the spectators retreating to the shelter.

Tobias couldn't believe his luck. When he'd volunteered to

go help relocate the family over to their camp, he'd hoped it would allow him to slip away. Then when he saw the horses milling in the darkness, he knew he'd found his opportunity. *Gustin had to stick his nose into it,* he thought. As soon as he got the chance, he went anyway and found two Shadow waiting in the darkness at the edge of the forest. They quickly passed along his instructions, and he returned to camp. Lance was upset, and he'd patiently listened to his self-righteous rhetoric. In the end, they all bought his story. *Fools.* Now, as he stood in the front of the nearly empty wagon, he closely watched the others. He disdained them. He knew they were busy watching Hunter's fight instead of protecting camp . . . protecting her. He'd wondered how they would get Hollis or his daughter away from the others. He couldn't believe it when she climbed into the wagon with him. *You just wait,* he thought, looking down at her kneeling just a few feet away. *Just wait.*

"Celeste, we must seek shelter," Hollis said, looking up at her.

"Father, please, I need to be here for him," she replied, squinting from the rain pelting her face.

Gustin looked up to see Tobias and the other teamster still standing behind her. The other man, armed with a crossbow, appeared to be scanning the darkness, but Tobias gave him a nod, indicating he was watching over her.

They've got a big surprise coming, Tobias thought. The Shadow had lost too many men in their futile attempts to take the gold; he knew that. And when he found the two men waiting in the forest, they told him to return and help lay their plan to kidnap Hollis or his daughter to be ransomed for the gold. He didn't care about Hollis. He wanted Celeste. He wanted more from her than her father's gold . . . much more.

"Hollis, one of us will stay with her," Gustin reassured him.

"Very well then, I too will remain," he said, turning his attention back to the fight.

When Hunter and Edmond came together this time, they

forsook magic and engaged with their great swords. They'd grown up sparring together, and now each man intended to use that life experience to their advantage. After trading a series of hard slashing blows, Hunter swung in from the side, and Edmond raised his sword to block. Anticipating the move, Hunter quickly drew his sword in close to him and swept outward in a backhanded slashing maneuver. Again, Edmond blocked, and when their swords came together, Hunter used his superior strength to push his sword away and step in close. He brought his free arm in hard, smashing his buckler into Edmonds helm with a loud clang. The force of the blow knocked Edmond off balance, and when he took a step back, Hunter pursued, swinging again. Edmond raised his sword at an angle to deflect Hunter's slash rather than block it. As expected, Hunter's momentum spun him around in the mud, opening him up to a side attack. Edmond seized the opportunity. When Hunter tried to avoid what he knew was coming, Edmond brought his arm up striking him across the temple with his steel gauntlet. It was a solid blow, and Hunter stumbled back with blood trailing down the side of his face.

Celeste's heart pounded, watching him falter. She couldn't imagine how he stayed on his feet after such a blow. Edmond persisted, swinging his sword down hard on Hunter's blade, loosening his grip.

Oh God! No! Celeste was frantic, seeing Hunter's sword fall to the mud. There was a collective gasp from his friends watching.

Hunter knew he must decide instantly. Either back away and take his chances unarmed, or step inside the range of Edmond's blade. He'd stayed alive through many battles over the years by following his well-developed instincts. He lunged forward as Edmond swung down hard, savoring the irony of killing him with Andrew's sword.

Before he could abort his attack, Hunter grabbed his arm

and twisted, lifting and throwing him over his shoulder to the ground.

"Uhhh!" Edmond moaned when he hit the muddy road flat on his back. Hunter quickly wiped the blood from his eyes and reached for his own sword, but Edmond responded. He swung his blade around at ground level, forcing Hunter to dive and roll over its arc without fruition.

They both sprang to their feet, and Edmond swung at him again. Hunter stepped in again, this time with a different tactic. When he'd dove over the path of Edmond's sword, he pulled his flail from its sheath. Now as they closed, Hunter blocked Edmonds sword with his buckler and countered with a hard swing of his own. The simple steel ball on the end of the two-foot chain now slammed into Edmond's helm with crushing force. Ears ringing, Edmond reeled from the dizzying blow. The attack surprised him. He hadn't seen Hunter pull his secondary weapon. Now Hunter pursued, striking him again from the other side with a backhanded swing. His companions hadn't seen him fight with his flail, but it quickly became obvious he was proficient. After two opposing horizontal blows, he crouched and swung the weapon into an upward arc. Pushing up with his legs, he twisted his body to follow through as he struck Edmond squarely on the chin. His feet left the ground, and his helm flew off as he was vaulted backward from the blow. He hit the ground on his back, outside the burning circle, and lost his sword.

"Yeah! Finish him, Hunter!" one excited teamster yelled.

Lance looked over at his hireling and suddenly felt uneasy. The exuberant young man wasn't standing alone before. Something nagged at Lance, so he went to check on his sentries.

Oh, thank God, Celeste thought when she saw the Shadow Knight hit the ground. She'd been terrified to watch the battle but filled with admiration for the man she loved.

Hunter sheathed his flail and stepped over to retrieve his

sword. He picked it up and turned around, intent on killing the abomination that had once been his best friend. But when his eyes settled on Edmond, he was startled to see him standing, gazing at him.

"Surely you didn't think it would be that easy, did you?" the knight said in the old hag's hideous voice.

Hunter didn't respond. He knew he wasn't really fighting his boyhood friend. The spirit of the evil witch had consumed him. That was obvious now with his helm removed. Hunter was thirty-four. And Edmond, only two years older, looked at least twenty years his senior. His face was gaunt and distorted, and his eyes were sunken. It was hard for Hunter to imagine how he mustered the ability to swing his sword with such force. He knew it had to be the demon giving him unnatural strength.

Gustin was alarmed by Lance's abrupt departure, and Fae easily read him.

"What is it, lover?"

"Don't know," he replied with a worried glance. "I'm going to go check on Lance. You watch Celeste," he added, glancing up to see Tobias with his head turned, looking beyond the covered wagons. Tobias turned, and their eyes met just as Fae looked to see what had his interest.

He knew he had to be convincing. "Where's Lance going?"

Now Hollis looked up.

"You see him?" Gustin replied.

Tobias nodded, pointing in the direction he'd just been looking.

Without a response, Gustin set off to find the foreman.

"He'll find out what's going on," Fae told Hollis. "Let's stay with Celeste."

Hunter was spent, but he stepped forward even more determined to end it. With lightning now striking the ground all around them, they again traded numerous slashes, thrusts,

and blocks. Their duel, a blend of finesse and brute force, continued till Hunter saw another opening. He struck Edmond with a fist to the jaw, and he went down again. This time when Hunter moved in for the kill, he heard a noise and looked up to see a fireball bearing down on him. He sidestepped and swung his sword, calling forth its magical power. When it met the flaming object, it cut through with ease, and the two pieces separated, one falling to the wet ground with a loud sizzling noise while the other flew past harmlessly, fading into the darkness. The knight's wizard had saved his life.

Before Hunter could recover, Edmond swung a leg around into the back of his knees. When his feet left the ground, he twisted his body to set up a counterattack. Hitting the muddy ground on his left side, he rolled toward Edmond, thrusting his right arm forward. He struck him in the face with his hand closed tightly around the hilt of his great sword. The Shadow Knight's head jerked back violently from the force with blood spraying. Dazed, he rolled over and tried to get back to his feet. *Now I have you,* Hunter thought, bringing a knee under him. He could taste victory as he stood and tightened the grip on his sword. In his haste, he failed to hear another fireball approaching from behind.

"Hunter, look out!" Fae yelled as she raised her weapon to send an energy bolt at the Shadow wizard.

Hunter had just started to bring his sword down when the fireball struck him from behind on the shoulder. It slammed into him with such force it lifted his feet from the ground and spun him violently, sending his sword flying from his hand. It turned him around before he landed face down in the muddy road, fighting to catch his breath. Pain coursed up his torqued spine from his hips to the base of his skull.

"*Veestah-shomahhh!*" Draigistar yelled out.

Startled, Fae looked over to see him standing with his hands raised over his head. A blue glow appeared in his palms, and a bright blue arc jumped from his hands, meeting in the

middle. Then a bolt of bright light shot forward. The evil wizard tried to block his attack with a shield spell but to no avail. His lightning bolt disintegrated it and struck the wizard atop his mount. His body stiffened and fell back onto the ground. His horse's legs folded, and it, too, fell dead in the muddy road.

Gustin had just stepped around the lead pair of draft horses hitched to Celeste's kaishon when he heard Fae yell a warning to Hunter. He started to turn back when a bolt of lightning lit up the night, and he saw a man standing just ten feet away. He was raising his sword over someone lying on the ground. *Lance*, he thought.

"No!" he yelled, lunging at the stranger. When the man turned to see him charging, he tried to bring his sword down, but Gustin was on him. He plowed his shoulder into his ribs, and they caromed off a draft horse, falling to the ground together.

The skittish horses were panicking all around them. *I've got to get Lance before he's trampled*, Gustin thought. He came to a knee ahead of his opponent and drew his large hunting knife. The intruder saw the glint of steel but was helpless to avoid it. Gustin thrust the blade forward, driving it into his midsection. He instinctively brought his hands together in response to the unimaginable pain, and Gustin pulled his knife free as the man fell backward to the ground, dead. Just then, lightning danced across the bottom of the clouds, and Gustin saw the dead body of one of their sentries. *Here we go again*, he thought as he turned and crawled to Lance.

Tobias spotted his comrades when they appeared from behind the freighters. They approached through the clearing to be away from the light of the campfire. The distraction had worked. The teamsters, mesmerized by the fight between the two old friends, had slowly, foolishly, dropped their guard. Two of them had already paid for that mistake with their lives.

When Lance went to check on the watch, Tobias was ready.

Then when Hunter bested the Shadow Knight, he discretely beckoned the big man waiting in the darkness. When he started for the front of the wagon, Tobias pulled his dagger and reached for the other teamster standing just in front of him. He swiftly cupped his hand over the unsuspecting victim's mouth and pulled him in as he shoved the dagger into his back. His body stiffened, causing him to pull the trigger on his crossbow. The bolt flew into the night unnoticed, thanks to a timely rumble of thunder. By the time his victim's body relaxed, the two accomplices had climbed up and over the seat. They quietly made their way past him, crawling low, concealed by the sideboards of the wagon until they were just behind Celeste.

Now it looked like Hunter might defeat their leader, but the wizard threw another fireball at him. This one hit him just as Fae yelled a warning. Celeste came to her feet so suddenly that she was nearly out of reach before the big man could react. He stood up and grabbed her from behind, cupping a hand over her mouth. He fell back with her, and when they landed on the crates, he looked up at Tobias.

"Go!"

Tobias had let the body of his victim slump in the front of the wagon and slipped into the seat, grabbing the reins. Another accomplice had removed the team's hobbles before climbing in and now threw the dead teamster over the side as Tobias slapped the horse's rumps with the reins. The wagon lunged and bolted away into the stormy night.

"Lance," Gustin said, reaching him. Just then, an agitated horse brushed against him, and he saw it step on Lance's hand. There was no response, so he grabbed him and pulled his unconscious body up. Throwing an arm around him, he leaned a shoulder into his chest and scooped him up as he stood. Startled by the sound of soggy footfalls behind him, Gustin turned to see a man charging him with his sword raised. He didn't have time to pull his own sword, and he knew he couldn't

outrun him carrying Lance, so he improvised. Standing next to a mount, he kicked it behind the ribs as he moved to keep it between him and his attacker. The horse grunted and lowered its head, kicking just as the unsuspecting man neared. The animal's hooves made contact, sending the man sprawling on the muddy ground, motionless.

"Go! Now!" Someone yelled as lightning struck, allowing Gustin to see at least two other men slinging themselves onto the backs of the horses as they began swatting them with leather straps. He could do nothing to stop them as they began driving the unrestrained horses away.

"Attack!" he yelled as chaos erupted. Bolts began flying into the camp from the darkness, and everyone dove for cover.

Fae already had her sword drawn and quickly looked to see who was missing. She heard the sound of horses being whipped behind her and turned to see the open wagon bolting away with two men kneeling in the back. It looked like Tobias was driving the team, but she couldn't see Celeste. *Oh my God,* she thought with a sick feeling.

"Celeste!" She yelled. For the first time ever, she was unable to react. She just stood there in disbelief.

"Celeste! Celeste!" Hollis yelled, turning to see the wagon disappearing into the night. "Celeste! No!" he yelled, taking off after the wagon. "No!" he yelled again as he slipped and fell in the mud.

Fae shook to her senses when she heard the sound of a bow's recoil.

Erin quickly fired two arrows at the escaping wagon before turning to take aim at the riders who were stealing their horses.

"Gustin, they've got Celeste!" Fae yelled out frantically as she ran to Hollis.

"No!" Hollis yelled as he struck the muddy ground with his fist. He was on his knees by the time she got to him. "No! God, no!" he yelled through his weeping.

Now several Shadow rushed the camp with swords, and as before, the teamsters stood their ground.

Gustin rounded the front of the covered wagon and ran to the shelter, where he laid Lance next to the fire. He didn't know his condition, but he couldn't worry about that now. He looked around to see several duels in progress but could tell they weren't outnumbered. He saw Flynn and Erin firing arrows in all directions as he ran to help Fae with Hollis. When he reached them, his eyes met Fae's, and their mutual expression betrayed the horror of what had just happened.

"Hollis, come on," Gustin said. Fae had knelt to protect him in place because he wasn't responding to her words. He just wept uncontrollably. "Hollis!" Gustin yelled, shaking him. When he looked up, Gustin pulled him to his feet. "Come on, let's get you to safety so we can go after them. Listen, we'll get her back," he said, his heart breaking at the sight of this man reduced to his current state.

Hollis regained control, and they headed for the shelter.

Hunter fought to stay conscious after being hit by the fireball. His head throbbed and his ears rang, but he managed to struggle to his hands and knees. *Where's Edmond?* he thought, knowing he was in no condition to defend himself. He turned to see if he was closing in for the kill and was shocked to see him gone. He glanced back at the wizard and saw him and his mount lying on the ground in a smoldering heap. *Draigistar*, he thought with relief. He struggled to his feet and looked up to see the open wagon gone and his party under attack. He picked up his sword and saw Gustin and Fae leading Hollis to the shelter, so he ran unsteadily to catch up.

"Fae, what's going on?" he asked when he reached them.

She turned to look at him. "Hunter, my God, they just took Celeste. She was in the back of the wagon."

He was numb, desperately trying to comprehend her words. He staggered on weak legs and thought he would retch. *Oh God, no*, he thought, looking over at Gustin.

"We'll get her back, Hunter," he said.

"Please get her back!" Hollis pleaded.

The pitiful sight of this larger-than-life man in such agonizing despair shook Hunter to his senses. *My horse!* He'd tied it to the wagon when he returned to camp, so it wasn't taken with the others.

"My horse!" he said.

"Yes, I know," Gustin replied. "I'll take it now that Hollis is safe."

"No. I'll go," Hunter replied before turning to Hollis. "I will find her, I swear to you," he said as he turned and headed past Gustin. *Oh, how could this happen?*

"Hunter, you're in no condition. Let me go!" Gustin protested.

"I will do this!"

"Then let me unhitch a draft and go with."

"Too slow," he answered as he reached his mount and untied the reins. "You take care of things here," he added, struggling into the saddle.

"Hunter, I'm so sorry," Fae said as he settled onto his mount.

He glanced away with a broken look that deepened her feelings of guilt. They both knew he was fighting the urge to blame them for what had happened. Then he looked down at them. "We'll talk about it later. Right now, we've all got work to do," he said as he leaned down and brushed a shaking hand on her cheek.

"As soon as we get things secured here, I'll be right behind you," Gustin said.

Hunter looked at him and silently nodded before spurring his horse out from between the covered wagons. He reined it hard around and started up the road in pursuit of the wagon, and the woman he loved.

"Gustin, my God, what have we done?" Fae asked him as they stood side by side watching Hunter disappear into the rainy night.

He reached out and placed a consoling hand on the small of her back. "We let him down," he replied softly. "You take care of things here. I'm going after him."

She looked at him with tears streaming. "Get her back."

CHAPTER ✞ 17

At first, Celeste didn't know what happened. She'd been kneeling in the back of the wagon, consumed by the ferocious battle. Hunter had prepared her for the time when he would face his old friend, and when the Shadow Knight called him out, he calmly prepared to go fight him. Her heart beat louder than the clashing of steel as they swung their great swords with bone-crushing force and traded kicks and blows. It was agonizing to watch, fearing he might be killed. She didn't know how long they fought, but finally, when Hunter raised his sword to end it, she heard Fae yell out and saw the fireball knock him to the ground.

"No!" She screamed. But the sound was muffled when someone clamped a hand over her face and pulled her down. Time seemed to slow with the sound of the rain all around her. Landing hard on her side in the crushing hold of a strange man, she felt the wagon jolt and take off. She heard the loud snaps of reins on the rumps of the horses as the wagon gained momentum. Now she was becoming aware of her dire situation. *My God, how did this happen? Where did they come from?* She tried reaching for her sword, but someone grabbed her hand, then leaned over her and took it.

"Oh, no, you don't," they said, just as the wagon paused for others to climb in.

"You take it," she heard a familiar voice say just before the reins popped and the wagon lunged forward again. She heard the *whish* of an arrow and the *thud* of it slamming into flesh.

"Uhhh!" One of the strangers stiffened and fell over the tailboard. The others crouched but didn't acknowledge their dead comrade.

She pulled her knee up and reached for the dagger in the top of her boot, but was again thwarted by someone's rough grasp. They grabbed her by the ankle, and she felt the small blade being pulled from its sheath. Then a hand suddenly slid all the way up between her legs.

"No!" she yelled, fighting to break free after the one who held her from behind took his hand away from her mouth.

"Another weapon," someone said.

"Check her," the strong one replied. Suddenly, hands were all over her, feeling her body from her boots up to her neck—fondling her.

"No!" she screamed as hands roughly squeezed her breasts through her clothing and felt between her legs. She fought to catch her breath as terror gripped her.

"No more weapons," the other one said as the groping finally subsided.

"Now you just lay still and enjoy the ride, pretty thing," the man holding her said with a chuckle. "It'll be a night to remember."

A paralyzing fear set in when she realized what was happening to her. She thought she would retch. *Oh God, I'm so scared*, she thought. *Come on, control your fear. Think. If you get the chance, you've got to escape. Oh Hunter—Father—somebody, help me!* She knew there were several men in the wagon with her, looking back, talking about someone not keeping up.

"Leave him!" the man who held her said as he loosened his grip and came to one knee. He rolled her on her back and placed an agonizing grip around her throat, pressing her down on the flat load of crates lining the floor of the wagon. As they pushed on through the driving rain, lightning slammed to the ground all around them. The driver pushed the huge horses at a faster pace than they could maintain.

They hadn't tied her hands or feet, so she stopped struggling. She didn't want to give them a reason to, knowing it would end any chance of escape. The big man who held her down was relaxing. She could feel his grip loosening around her neck as he kept looking behind them. She began contemplating raising a leg and kicking him in the face. When he reeled, she would roll to a knee and lunge over the side of the wagon. She'd have to clear the rear wheel and roll when she hit the muddy ground to lessen the chance of injury. Then she'd get up and run into the woods before they could stop and give chase. She knew it held great risk, but it was far better than the alternative.

All right, she thought. *The next time he looks back, go for it.*

Just then, he spoke to someone in the front of the wagon. "Hey, come spell me," he said. "My hand is tired, and I'm sure you want to say hello."

"Got that right," the familiar voice replied. He moved closer, and when the big man removed his hand, he lifted a leg and settled down astraddle of her.

She couldn't believe her eyes when a flash of lightning lit up his face. "Tobias?"

He had a crazed look on his face as he leaned forward and placed his hands on her shoulders, pinning her down. "Hello sweetheart," he said with an evil smile.

"What—what are you doing?"

"What do you mean what am I doing? I'm getting even."

A resurgence of fear coursed through her as she looked into his eyes. "For what?"

"For you thinking you're better than me, you spoiled little whore!"

Ever since he began working for her father, he'd made advances toward her, but she'd politely refused, not wanting to become intimate. She blossomed early in life, and by the time she was in her teens, it was hard for the men to focus on their work when she was around. So, she and her father had agreed

she wouldn't get involved with any of his hirelings. It was his idea, but she'd welcomed it. She wasn't looking to wed.

"Tobias, that wasn't it; I just wasn't—"

"Oh, shut up! You knew how bad I wanted to be with you. But you don't care about anybody but yourself!"

"No, that's not true," she said as her voice cracked.

Suddenly he slapped her face.

"Huh!" she gasped from surprise and the stinging pain.

"I said shut up," he replied with an eerie calmness, leaning down close. Before she knew what happened, he pulled his dagger and put it to her throat.

She froze, consumed with fear at the feel of the sharp blade against her skin.

"It didn't have to be this way, but you had to be selfish. Well, I will have you, Celeste," he said, groping her breasts through her clothing.

"Yeah, get some," one of the others encouraged.

"Oh, please don't do this!" she pleaded.

He turned his wrist, pressing the blade harder into her neck, and she stiffened. He leaned down and placed his lips hard against hers, forcing an unwanted kiss.

"Time for talk is over," he said, loosening the front of her clothes.

"Yeah, take her," another chimed in.

She started to cry, realizing he couldn't be reasoned with. *Oh God, just hang on. Don't do anything stupid*, she thought when he slid his hand inside. She could feel the excitement building in his loins as he fondled her breasts with the others goading him on. She knew this was just the beginning of the frenzy that would be unleashed on her this night. *Oh, I can't take anymore.* She clenched her fist, planning to hit him in the face as she pushed the knife away from her throat.

Then suddenly, the driver slowed. "We're here," he said, reining to a stop.

"All right, save some for later," the big man said without emotion.

Tobias forced another sloppy kiss before removing his hand and standing up.

"Looks like you're the object of everyone's desire, missy," the big man said. "Or soon will be," he added, yanking her up like a rag doll. He pushed her to the edge of the wagon and stepped in behind her. Then, reaching under her arms, he cupped his huge hands over her breasts and squeezed as he lifted her up and over the side. "Might as well get me some," he said. His painful grip nearly made her legs fail when he set her feet on the ground and let go. Then he planted an open hand between her shoulders, knocking her forward. "Move it. Can't miss the party; you're the guest of honor," he said, causing the others to laugh.

Then one of them slapped her on the butt.

She whirled to look at him with fire in her eyes.

"Ooh, got some fight in her," another one said as the laughing continued.

She would never let a man put his hands on her uninvited. But now she was outnumbered, terrified, and hoping for a chance to escape, so she swallowed her pride and let it pass.

When they headed into the forest, she heard the slap of reins again and looked back to see the driver jump from the moving wagon and stand up to follow them. She knew his attempt to send the wagon on was futile. After a short walk, they came to a steep embankment and climbed down to the edge of the stream. When they passed by here at midday, it was flowing gently. But now, the water was rushing by.

"Doesn't look good, boss," one of them said.

"Shut up and watch her," the big man replied, veering to the left and heading upstream. "Come on, keep up!" he yelled, looking back at them. The moss-covered rocks were dangerously slick, but they made their way along, and soon they reached a makeshift bridge made of cut trees lashed together. It spanned about forty feet across a narrow point in the swollen stream.

A new wave of fear suddenly gripped her. *Oh God, no. When we get across, they'll shove it in the water so no one can follow. Then I'll wish I was dead. . . .* She determined that when they made her cross the bridge, she would jump in. She knew it likely meant drowning, but that was better than being raped by this scum. If she couldn't save her life, she would at least deprive them of taking her dignity before she died.

"All right, Tobias, you first," the leader said.

"No way. I'm staying with my prize," he said. "You go," he said, pointing to the one who'd slapped her butt.

"What? The water's already splashing over it."

"I don't care! Just get across!" the big man yelled. "There's nowhere else to go!"

Reluctantly, the man complied and started crawling across. Just then another bolt of lightning struck in the forest across the stream, blinding them all.

Damn! Celeste thought. She could have bolted, but like them, she couldn't see. They all heard the man yell and then a splash, indicating he'd lost his balance and fallen in. They regained their vision in time to see him struggling in the swift-moving water as it swept him away.

One down, she thought.

"All right, Tobias, you're next," he said.

"What?"

"You go, and we'll send her next. You want to break her in, don't you? If you're too scared to cross the stream, that's fine. I'll take her first," he said, grabbing her and pulling her close to him.

Suddenly, they heard the sound of a horse up on the road. It slowed briefly and then went on.

"Everybody quiet," the leader ordered. Before she realized she had nothing left to lose by yelling out, he grabbed her from behind again with a hand over her mouth and an arm around her waist. She tried making noise, even with his hand over her mouth, until one of the others stepped up and punched her in

the stomach. She drew her knees up from the pain of having the wind knocked out of her. Then they heard the horse return and come to a stop.

"Go see who it is," he said to the one who'd driven the wagon. He nodded and quietly pulled his sword. As he climbed the slick bank and disappeared from sight, Celeste was frantic to know if it was one of the four. She knew from the sound it was a heavy horse. *It must be Hunter's warhorse,* she thought. Before long, the driver returned, carefully sliding back down the bank.

"Well?" the leader asked.

"There's a man walking through the forest, a big man. He's tracking us."

"Lord White?"

"No. It's the other big one from their group—has to be. The one who fought Lord White went out in a blaze of glory," he said, chuckling softly.

Celeste closed her eyes, racked with despair. *Oh God, no. Hunter.* She was scared and tired and chilled from the cold rain and wind. She no longer cared if she lived. She just wanted this madness to end.

Suddenly the bridge slid off the rocks, and Tobias cursed as it floated away.

Oh, thank God, she thought.

"All right, we've got to get out of here," the leader said. "You two get up the bank and start working your way around behind him. Tobias, you stay here with me and your girlfriend. Now don't try to be a hero. Just kill him."

The two men nodded and quickly scaled the muddy bank, disappearing into the darkness. The rain had let up, but lightning still lit up the night sky. Fear coursed through Celeste again when she saw the hate on Tobias's face as he stepped up in front of her.

"Too bad about your boyfriend," he taunted. "But don't worry. I'll make you forget all about him by morning," he said as he began squeezing her breasts through her wet clothing.

She wanted to resist, but she knew that would give him pleasure, so with the leader's hand cupped over her mouth, she just stared blankly.

Her lack of response angered him. "You whore; you know you like it," he said, pulling his dagger.

She recoiled into the big man who tightened his restraining hold. "Put it away," he said, aggravated. "I want some leftovers."

Not willing to let her insult him, Tobias repositioned himself on the slick rocks.

"See how you like this," he said, sliding his hand inside the front of her pants.

Unable to bear the thought of him touching her there, she leaned back into the big man and brought her leg up with all her strength. Tobias saw it coming, but couldn't react before her knee plowed into his groin.

"Ohhh!" he groaned as he pulled his hand from her pants and bent over to grab himself, then fell to his knees in blinding pain.

Without hesitation, she bit one of the big man's fingers.

"Ahhh! he yelled as he pulled his hand away from her face, but not the strong arm around her midriff. She bent her knees, forcing him to lean forward as he took her weight. Then she pushed up with her legs, arching her back and thrusting her head up, smashing it hard into his face.

"Uhhh!" He made a sickening sound as the impact broke his nose, splattering blood across his face and through her long hair.

Dazed, she staggered free when he let go of her and fell back.

Tobias was just struggling to his feet, and when their eyes met in the darkness, he knew he was at her mercy.

"You'll never touch me again, you sick bastard!" she yelled as she raised her leg, kicking him squarely in the face with the sole of her boot. His back stiffened, and his arms flailed before he lost his balance on the moss-covered rocks. Their eyes met once more when he slipped and fell into the water and was

instantly swept away. *Another one down*, she thought as he disappeared into the darkness. Now she spun around to see the big man coming to his feet, fumbling for his sword.

"You're dead!" he growled as she turned and fled, stumbling along the bank.

<div align="center">/// \\\</div>

Hunter spurred his warhorse on, riding as fast down the muddy road as he could go. The large raindrops stung his face, forcing him to squint as he raced through the darkness. Lightning bolts blazed down from the sky, striking the nearby forest, each time blinding him briefly as loud claps of thunder buffeted. He'd been riding for a while and was surprised he hadn't caught up with them yet. He knew the huge draft horses would tire when driven hard. He also knew he had to find Celeste before it was too late.

His mind drifted back to a conversation he'd had with the four while they were still in Port Estes. The possibility of the Shadow kidnapping Hollis for ransom had been discussed, but they'd not considered his children being taken. *Fool*, he thought of himself.

And how could they let her be taken? He fought the urge to blame his friends, but he knew better. They were more than competent. They were very good.

He also realized that Edmond challenging him had been a planned diversion all along. *How could they help but get caught up in the spectacle of our fight? And you, you fell for it to satisfy your need for vengeance*, he thought. *You may have gotten her killed, you damn fool.* Edmond had escaped. He was probably somewhere on the road right now, riding to meet them. *And there's nothing to stop his men from having their way with her in the meantime.* He'd never been so scared.

Each time the lightning lit up the landscape, he could see the wagon tracks on the road ahead. They weren't obscured

by the downpour now, so he knew he was getting close. He'd ridden past the sight of the earlier attack, still littered with the bodies of dead Shadow. Now, as he rounded a curve, he saw the wagon tracks veer off the right side of the road, then pull back on and continue. He slowed briefly before spurring his tired horse on. Just then a flash of lightning lit up the night sky and he could see the wagon up ahead, off to the left side of the road with the horses standing under a huge pine tree.

He pulled back hard on the reins, and his tired mount slid to a stop on the muddy road. His mind raced. He was so frantic to find her. *Think, man! Get control of yourself! You're no good to her like this!* He knew that to the left of the road was thick forest covering the foothills. And to the right were trees and a large gully where the stream meandered. Beyond that lay the southern edge of the Forest of Souls. He surmised they would want to elude followers and find a secluded place to ravish her. *Perhaps this rotten weather will keep them busy,* he hoped. Then it came to him. They'd pulled over back there and jumped off, shooing the team on. *Fools. They don't know tired draft horses won't run without being driven.*

He knew what he must do. He reined his horse around and rode back to where the tracks had left the road. He hadn't been concerned with how much noise he made; in fact, the more, the better. He wanted them to know they were being followed, no, being hunted. He hoped that would keep them too busy to turn their attention on her. Now, as he reined up and looked down, he could see several sets of footprints leading off toward the stream. He quickly dismounted. *With luck it will be impassable by now, and they'll have to turn and face me.*

He wasn't sure how many there were. He was still fighting Edmond when they took her. He quickly overtook one who rode with an arrow in him. Foolishly, he turned to fight, and now he, too, had harmed his last innocent victim. It looked like four or five sets of tracks leading into the woods. Didn't matter; when he found them, he'd kill them. He'd sworn to

protect her and failed. This would be the most important fight of his life. He would not fail her again. He tied his horse to a limb and set out through the trees, following their tracks. The rain had let up now, and he could hear the sound of rushing water. Suddenly he stopped, perfectly still, listening. He heard voices, ahead and to his left. He crept on, listening carefully. *There.* He heard it again, Celeste shouting.

Now a man's voice. "You're dead!"

Hunter's heart raced. *Oh God, she's fighting them,* he thought, breaking into a dead run. Lightning struck, revealing his path just as he reached the edge. He barely avoided going over and looked upstream to see a man chasing her toward him. He quickly made his way down to intercept.

Celeste frantically stumbled along the slick rocks, with her only sight coming from the lightning that streaked through the clouds overhead. Suddenly her foot slipped and wedged between two large rocks, causing her to lose her balance and fall. She caught herself and struggled to free her foot while her enraged pursuer closed in. Gripped with fear, she pulled her foot loose just as he reached her and raised his sword.

"No!" she screamed, diving away from his falling sword as it struck the wet rocks, scintillating in the darkness. She regained her footing and began running blindly with tears streaming down her face, then stumbled headlong into someone.

"No!" she screamed again, raising her arms in defense as she caromed off the armored chest of a big man.

"It's all right, get down," he said, pulling her around beside him.

She knew it was Hunter: the voice, the way he stood, even his scent. Overcome with relief she let go of her emotions, huddled by a large rock.

The leader approached and spoke loudly to be heard over the rushing water.

"Guess Lord White didn't finish you after all," he growled. "That's all right. I'll earn favor by taking him your head."

Hunter's sword began glowing an eerie blue. "Your master couldn't kill me. Neither can you," he replied. "Now come prove your worth."

Suddenly Celeste saw movement up on the bank when someone leapt at Hunter. "Look out!"

The man jumped with his sword raised, but Hunter was ready. He crouched and brought his sword around in a flat sweeping arc. Just as the man's feet planted in the muddy bank, Hunter slashed across his stomach, eviscerating him. He let out a moan and fell limp in the mud, losing his sword in the rushing water.

Celeste fought a wave of nausea from the stench of spilled blood and entrails as Hunter turned to engage the leader. *That's three*, she thought. She knew there was still one more lurking somewhere in the darkness. When she turned and came to her knees to look over the large rock she huddled by, something grabbed her. She screamed and spun around to see the man she thought was lying there dead, his bloody hand clamped around her ankle. Just then a bolt of lightning lit up the night, and she could see him looking up at her with a grotesque mask of impending death. The macabre scene was more than she could bear. She began screaming as she reeled back against the rock and kicked wildly at him with her free leg. The man lost his grip and silently slid off the blood-soaked rocks into the swift water, disappearing into the night.

Again, she huddled tightly against the rock, shaking from fear and cold. She looked up to see Hunter disarm his opponent before knocking him unconscious with a crushing fist. Then she was grabbed from behind and yanked to her feet.

"No!" she yelled when the man spun her around and clamped onto her throat with a death grip. "Hunter!"

While he choked her, she fought to breathe, hitting him even as her vision blurred from lack of air. She saw him raise his sword and knew it must be the end. In one final attempt to save herself, she drove her thumbs into his eyes with her waning strength.

"Ahhh!" he yelled out, releasing his grip and shoving her away.

Fighting to regain her breath, she grabbed the dagger in his belt and thrust it into his side, nearly retching from the feel of metal separating ribs.

"Uhhh!" He moaned weakly and staggered back while she fought to avoid falling into the rushing water behind her. Just then, she saw a blue streak falling down from behind him, striking him in the shoulder. In her surreal state, it didn't make sense when the man's chest exploded from the impact of Hunter's great sword.

He'd heard her scream when the man attacked her and raced over the slick rocks to her aid. They parted just as he reached them, so he swung his sword down with all his strength. The heavy blade splintered bones and cut through sinew and muscle, embedding deep in his chest. His knees folded, and he fell, dead before he hit the ground.

Now Celeste stood before him in shock, blood splattered on her face, hair, and clothing.

He glanced back at the one he'd knocked out, then looked around and saw no one else. "Celeste," he said, stepping closer, gently placing his free hand on her face.

She didn't respond, simply stared straight ahead, motionless.

He'd seen it before, in others who'd withdrawn into themselves after a traumatic event. He'd never been affected that way but often envied those who were. "Celeste!"

Startled, she looked up at him. And when lightning illuminated their faces, he saw her recognition.

"Oh, Hunter, I thought you were dead," she said, placing her hands on his face. "And—and then, they took me. Oh, I was so scared." She began to cry as she leaned into him, burying her face against his chest. He held her tightly, knowing it would take a very long time for her to put this night behind her. When she regained her composure, she looked up at him.

"Come on, let's get out of here," he said. "Do you know

how many there were?"

She shook her head. "Uh huh, there were five."

Suddenly alarmed, he glanced around. "I saw only three."

"No, it's all right," she said. "The other two are both gone, down the stream. One fell in trying to cross the bridge they had waiting. And the other one, it—it was Tobias. He—" she paused, looking down and crossing her arms in front of her.

He suddenly felt sick. *She's been violated.* His mind raced, torturing him.

"He put his hands on me," she said as she looked back up at him, trying not to break down again. "But I fought him," she added with a self-affirming nod. "I kicked him in the . . . into the stream."

"Celeste, I'm so sorry. I promise they won't hurt you anymore," he said as he turned and put an arm around her. "Come on."

She leaned into him, and they started walking toward the embankment. He was devastated that she'd been taken. But as he thought about it, Tobias being involved wasn't really a surprise. There'd been things about him; he just hadn't put it together. *And now she's paid the price for my ignorance.* It explained how the Shadow got close enough to take her. The leader was just waking, so he placed the tip of his sword on his throat.

"You tell Edmond White he crossed the line tonight. There is no place he can hide from me. He's a dead man." Then he lowered his blade, slashing him across the leg.

"Ahhh!" the man cried out in pain, grabbing his wound.

When they started past, Celeste charged him, landing a solid kick to his ribs. "Take that, you pig!" she yelled, kicking him again before Hunter wrapped an arm around her from behind and pulled her away.

"Come on, let's go."

The rain picked up as they climbed the bank and made their way back to his horse. While he untied the reins and

assessed his mount's condition, he noticed she was shivering. With the excitement of battle, he hadn't realized how cool the night was. He sheathed his sword and took a wool blanket from a saddlebag, draping it over her shoulders.

"Celeste, he's going to have to walk."

"I know; he's spent. What about the drafts? They can't have gone far."

"No, they didn't, but they're on their own for now. They'd only slow us down and make us easier to track. Listen, this storm is picking up again, and we need to get you warm and dry. I don't want to take a chance of running into more Shadow on the road, so we'll head west into the foothills. I've heard there are caves; we'll try to find one."

When she stepped up to his horse and raised a foot to a stirrup, he put his hands around her waist and lifted her into his saddle.

"Can you ride?" he asked, looking up, squinting in the heavy, cold rain.

"Uh huh."

"All right, hang on," he said before setting off at a brisk pace, leading his horse across the road into the forest on the other side.

<p style="text-align:center">/// \\\</p>

As abruptly as it began, it ended. The fight was over. And soon after, Hunter bolted away in a desperate search for Celeste. Gustin and Flynn frantically unhitched a pair of drafts and lit out after him. Now Fae stood in front of the shelter, taking stock of the carnage left in the wake of yet another attack by the Shadow. She couldn't shake the crushing burden of guilt and worry over Celeste's abduction. *How could you have let this happen?* she thought, replaying those moments in her mind. She knew she'd made an amateurish mistake getting engrossed in the battle. *I failed Hunter. I failed her father. And I failed her.*

The teamsters were helping their wounded into the shelter while the women rendered aid. Their guests had eagerly pitched in, thankful for the protection. The two wives and the grown daughter were helping Janae dress wounds while their husbands had taken up crossbows and now patrolled the camp perimeter. Krysta asked Hollis to help her tend to Lance, just to give him something to do. Lance had been struck on the head by his attacker. And now, conscious, the intense headache and throbbing hand were reflected in his mood.

Fae turned when Derek approached.

"What can I do?" he asked.

"Do we have enough people on watch?"

"Yes. I was thinking we might go see if we can find the horses," he said, glancing up the road in the direction they'd gone. "Perhaps Erin could go with?" They could both see Draigistar kneeling over the dead Shadow wizard while Erin stood watch with a torch raised high.

"Forget it," Fae said. "I'm not about to risk her for the horses. I'll walk to the City of Queens." She started toward her friends, and Derek silently fell in beside her. When they approached, Draigistar looked up, squinting in the rain.

"Shame, it would've been nice to question him," Fae said.

"Go ahead, ask him anything you like," Draigistar replied. "But I fear you'll find him most uncooperative."

Derek chuckled as the mage rummaged through the dead wizard's attire.

"You two are terrible," Erin said with a disapproving look.

Their tasteless humor was lost on Fae. "What are you doing?"

He stopped and glanced up. "What's it look like? I'm claiming his possessions. It's the code. I defeated him; his things are mine."

She looked around into the darkness. "Well, just be quick about it," she snapped, turning to head back to camp.

Derek and Erin looked at each other, surprised by her demeanor.

"Fae," Draigistar said.

Recognizing his unusual tone, she stopped as he slowly stood up behind her.

"I'm finished. Now tell me what troubles you," he said, touching her shoulder.

When she turned around to face him, he saw tears streaming down her cheeks.

"Oh, Fae, it's not your fault," he said as she leaned into his embrace. "We all share responsibility for letting them take her. But they will find her; we must believe that. The best we can do now is take care of things here and pray for her safe return."

She sniffled and nodded without lifting her head from his chest, realizing she'd forgotten how good it felt to be held by her dear friend she'd known her entire life. Supportive and nonjudgmental, he always accepted her as she was and knew her better than anyone else.

"Come on, let's go back," he said softly. They turned and walked with his arm around her as Derek and Erin silently followed.

/// \\\

Flynn and Gustin left camp just moments behind Hunter. But they quickly discovered riding bareback on rain-slicked draft horses was difficult. Not far from camp, they passed the body of a dead man lying in the road with an arrow in his back.

"Erin did it," Flynn said when they slowed briefly. "Shot him out of the wagon."

They continued on, and soon found another man lying dead in the road.

"Hunter," Flynn said. "Look at the wounds."

"Yeah, come on. He still follows the wagon."

Neither man was given to excessive talk, so they silently rode on through the raging storm, squinting to follow the

tracks of the wagon and Hunter's mount. They could read a lot from the mud-soaked tracks before them. The strides of the wagon's team were shorter, indicating they neared the end of their ability to run. To watch the magnificent animals pull heavy loads was a thing of beauty. But they were beasts of strength, not speed. They could pull all day at the right pace, but their massive bodies could not maintain a hard run.

"We're getting close!" Gustin finally yelled above the thunder.

Soon they saw the wagon tracks veer to the right side of the road, so they reined up. They glanced at each other briefly before dismounting to investigate.

"Hey, look," Flynn said, pointing to the tracks of a man leading a horse across the road into the forest. "What do you think?"

"Well, I don't see any other tracks, and the wagon pulled up here," Gustin replied just as a bolt of lightning lit up the night. He pointed at the empty wagon sitting down the road. "There it is," he added, returning his attention to the tracks. "They pulled off here, got out, and headed for the stream."

"Why?"

"Don't know; perhaps to meet others or to escape. Maybe they knew they were being followed and wanted room to spread out and fight. Let's go find out," he said, tethering the reins of his huge horse to a tree branch.

"What about Hunter? You think he's the one who led a horse into the hills?" Gustin looked at him. "Yes, I do. And that looks like smaller footprints leading up to his horse," he said, pointing.

Flynn scanned the ground. "He must have her. Think she's all right? I mean. . . ." He paused, not wanting to let his mind go there.

"I don't know, Flynn. Let's stay focused."

They set out through the forest, and soon they reached the edge of the embankment overlooking the torrent that was

once a meandering stream.

"You can bet nobody crossed that," Flynn said.

"No," Gustin said, scanning into the night, waiting for another bolt. "There!" he said before jumping off the edge, landing ten feet below at the base of the steep, muddy bank. He started across with precarious footing, trudging through the rising water with Flynn right behind. When they got close enough to see it was the body of a man, it dislodged and began floating away. They barely managed to grab on and pull it into shallow water.

"Let's see what we've got," Gustin said, rolling the body over. When the next bolt of lightning illuminated the gruesome scene, he knew it was Hunter's work.

"He's nearly cut in half," Flynn said in amazement. "What could've done that?"

"A big sword in the hands of a man desperate to save his woman," Gustin replied. "Come on, let's go. This water's rising fast."

They made their way back and struggled to climb up the slick, muddy incline, and after pulling themselves up, they stood face to face, catching their breath.

"What do you think?" Flynn asked. "There were several in that wagon when they skinned out of camp. Where'd they go?"

"I think they tried to escape across the stream, but Hunter caught up with them. He killed them and took Celeste back to his horse. He must've taken her to seek shelter and wait out the storm."

"Well, makes sense," he said just as he noticed Gustin looking intently over his shoulder. "What is it?"

"Looks like someone's lying under a tree over there."

"Alone?"

"Yeah, let's go." He started past Flynn, but the young, agile scout turned and raced ahead, both of them drawing their swords in stride.

"All right, you, get up!" Flynn ordered, sliding to a stop

with Gustin right behind.

The man moaned. "Help me, please," he said in a weak voice.

"Get out here so we can see you," Gustin said sternly.

The man rolled over and slowly came to his knees, crawling out from beneath the tree. Gustin raised a foot and shoved him over on his back as he stepped up and put the tip of his sword to his throat.

"Oh, please don't," he begged.

"You know who we are?" Gustin asked.

"You're with the wagons."

"And why are we here?"

"The daughter, you seek her, but she's already gone, with your friend."

"Where were you taking her?"

"Over there." He pointed. "Across the stream, we have a camp in the woods."

Gustin assessed the man's wounds. "Why'd he let you live?"

"So I could tell Lord White he said he's going to hunt him down and kill him."

Flynn and Gustin exchanged a glance.

"Where are the ones who helped take her?" Flynn asked.

"Dead," he replied. "Your friend killed some. The others went in the water. The woman kicked Tobias in."

"Oh?" Gustin replied. "Why?"

He hesitated. "He, uh . . . was having his way with her while I held her."

Gustin moved his sword away only to step in and kick him in the ribs.

"Uhhh!" The man's breath left him, and he tried to guard his side before Gustin landed another kick.

"You rotten bastard," he said, leaning down and punching him twice.

"Gustin!" Flynn yelled, afraid he was going to kill him.

He didn't acknowledge him. He just sheathed his sword

and drew his knife, laying the blade across the man's throat.

The dazed man stared up at him with fresh blood running from his battered face.

"You tell me what you did to her," Gustin said. "And if you lie to me, I'll make you wish you were dead."

"Please, I swear I didn't touch her. It was Tobias. He—he just put his hands inside her clothes. You know, he felt her. All I did was hold her for him, I swear."

"Where'd they go?" Flynn asked.

"I don't know. They went back to the road, but I never heard them ride away."

Gustin withdrew his knife only to punch him again, knocking him unconscious. Then he sheathed it and stood up. "Come on, let's get out of here."

They silently walked through the forest back to their horses.

"Thought you were going to kill him," Flynn said as they settled onto the drafts.

Gustin looked over at him. "I was."

Flynn studied him, concerned by his uncharacteristic behavior. "Why didn't you?"

He thought. "I don't know. Fae's influence, I guess. Sometimes I think I've just seen too many senseless acts of violence. Sorry, I wasn't myself back there."

"It's all right. What about Hunter and Celeste? Their tracks are nearly gone."

"Well, we know she's with him. She's safe," Gustin said. "He did the same thing I would have. He stayed off the road and went to find shelter, most likely a cave up in the hills. I think they need to be alone right now."

"Think we should go back? Let the storm pass? Look for them in the morning?"

"Yes."

"What'll we tell Hollis?"

Gustin sighed. "Well, Hollis is a grown man. He knows the uncertainty of life. I'll tell him what we found here and that I

believe she's safe with Hunter for the night."

"Going to tell him everything?"

He looked at him. "Flynn, we all have our secrets, our burdens to carry through life. That one's hers. Wasn't meant for us to know or tell. . . . We'll never speak of this."

Flynn nodded. "Agreed."

"Good. Now let's get that wagon and head back."

/// \\\

Some time had passed since the attack, and camp was now a quiet, solemn place. Lance told Derek to oversee things so he could rest under the shelter and nurse his injuries. While Draigistar inspected the loot he claimed off the dead wizard, Lance sat nearby with his head throbbing. His heart ached, looking across the fire pit. Janae sat with Hollis who silently stared into the fire. He was an emotional wreck, a broken, defeated man. Everyone there had seen a side of the wealthy, influential merchant they'd not thought possible.

Only Lance had ever seen him like this before. When Celeste and her brother were young, Hollis's wife suddenly took ill and died, leaving him shattered. Lance and his wife intervened, taking the siblings to stay with them and their own children who were nearly the same age. His wife had helped them through their grieving while Lance kept Hollis busy at work, remaining by his side through his suffering. Eventually Hollis recovered, with the tragic event having forever changed both men. Now their friendship transcended that of an employer and his chief hireling. Lance was not just his foreman; he was his best friend. And every decision he'd ever made about the operation of Hollis's trade empire had been with his best interests in mind.

Lance loved Hollis like a brother, and he loved his kids like they were his own. He couldn't bear the thought of what might be happening to Celeste, or of not getting her back. He knew

Hollis would not recover. He was a strong man, but Lance knew the love he had for his precious girl. And if they lost her, he would give up on everything, give up on life. Suddenly he was drawn away from his thoughts at the sound of raised voices.

"Look I don't care what you were hired for, these men need to be buried," Derek said. "They'd do the same for you."

Lance realized his two grooms were balking at Derek's order to bury their dead comrades. He would have preferred to wait until daylight to inter them, but he knew from experience not to countermand a reasonable order given by his delegate. That always led to problems . . . always.

"Why do *we* have to do it? We already pulled a watch," one said defiantly. "And our job is taking care of the horses."

Fae and Erin were quietly conversing nearby and took notice, glancing first at Hollis, then at Lance. Hollis was oblivious, continuing his expressionless gaze. He would normally not allow that kind of insubordination in his camp.

"Oh, you pulled a watch?" Derek replied, his anger surfacing. "We got attacked while you were on watch! I guess that means you're not fit for that duty! And horses? Since the only horses we have left are the ones still hitched to the wagons, you don't have anything to do. So, get busy!" he yelled as he picked up a shovel and tossed it at the one who'd spoken. The man caught it, glaring in anger.

"Enough!" Lance said sternly, causing them all to stop and look. He still sat with his head in his hands, and slowly turned to look up at them while Derek picked up the other shovel. "Don't make me get in this."

The hirelings knew the line had been drawn; the order would stand. Derek tossed the shovel on the ground in front of the other insolent man, forcing him to pick it up before they turned and walked into the night to begin their task.

"Derek, come sit," Lance said with a weary sigh. "Let's talk." His tutelage was required to take advantage of the moment.

Derek showed a lot of promise. And he apparently needed to train a new successor if what Fae had said about Tobias was true. He still couldn't believe he'd been duped by his apprentice.

Suddenly, one of the two men who'd moved their families into camp appeared from the darkness. "Hey, someone's out there in the clearing," he said.

Fae and Erin quickly stood and followed him. The rain had subsided, and the worst of the storm had passed, but lightning still danced in the clouds overhead. When they stepped out near the road, the man pointed into the darkness, and they could see a single figure slowly approaching on horseback.

"Watch our flanks!" Derek yelled to the far side of the camp. They watched the figure slowly emerge from the darkness.

"*You*," Erin said under her breath when she realized it was the Rendovan.

She tugged on her reins for a brief pause before proceeding into the road and stopping near the watch fire they had relit.

Fae discretely brushed Erin's arm. "Let's hear her out," she whispered. When she stepped forward into the road, Erin advanced with her.

"What do you want?" Fae asked.

She glared at Erin, then set her eyes on Fae. "A trade . . . the girl for the gold."

"You have my daughter?" Hollis asked, stepping forward.

Fae's heart sank. *Where's Hunter? Where's Gustin and Flynn?*

The Rendovan hesitated. "Yes. We have her."

"Is she all right?" he asked, walking closer.

She nodded while her eyes darted all around.

Fae knew she was counting, sizing them up, and assessing their strength.

"For now," she said. "But she won't be unless you agree to give us your treasure."

"Anything," Hollis replied, the desperation obvious in his voice.

"When and where?" Fae asked.

"Tomorrow, at dawn, right here. You will load the chests of gold and all other things of value—including your weapons—into a wagon. We will come inspect it, and when we're satisfied, we'll bring her here to you and leave with the wagon. We'll even return your horses tonight as a show of good faith, if you agree to this."

"You think we're that foolish?" Fae replied. "We'll not surrender our weapons."

The two women exchanged a long uncomfortable gaze.

"Very well," she said at last. "Keep your weapons. But we want the traitor," she added, pointing at Janae who stood in the back. Most of the others looked at her, wondering what the Rendovan meant.

She felt sick. *Now they will all know the truth.*

"No. You can't have her," Lance said, stepping up next to Fae.

She looked at him briefly before turning her eyes back to Janae and then settling on Hollis. "If we don't get her, you don't get your daughter. Is that what you want?" she asked, leaning forward in her saddle to emphasize the strength of her position.

He looked at her, his mind racked with anxiety and confusion. "Don't ask this," he said, looking down. "Don't make me choose."

"It's not his choice to make," Lance said, glancing over at Hollis.

When Hollis met his gaze, he wore a strange expression, leaving the others confused by their cryptic exchange.

"I'll go," Janae said, stepping into the light next to Hollis. Tears trickled down her face, and she was nauseous with fear. She looked up at him. "I owe it to you and Celeste. I am so sorry," she said before leaning in and kissing his cheek.

"Janae, you're not going anywhere," Lance said.

"It's all right, Lance." A strange peace settled over her. She

could only imagine the horrors that awaited her, but she was willing to trade her life for Celeste's.

When their eyes met, Loorkha spoke. "Come with me, Janae. You've been very bad, and he awaits you."

Now Erin stepped up. "We said she's not going. Why don't you come take her?"

Loorkha glared at her. "Oh, you think you are my equal? Next time I won't underestimate you, child," she said condescendingly.

"I'm here," Erin said, raising her arms wide to taunt her.

She tipped her head up, silently scoffing. "Our time will come again. But first I must deliver the traitor," she said, looking back at Janae. "You betrayed us, and now must be punished. I will enjoy watching you beg for mercy."

Suddenly Janae bent over and retched from the paralyzing fear that gripped her.

"Ha! You see? You are not worthy. You—" Suddenly she stopped speaking and stiffened in the saddle as she reached up, grasping her throat. Everyone stared as she began fighting for breath.

They looked at each other in amazement. Then Fae saw Draigistar approaching with his gaze set upon the Rendovan. She saw his hand formed in a shape like grasping someone around the neck. Having seen him use the spell before, she smiled. When he stepped past, he relaxed his grip and Loorkha settled back into her saddle.

"You. I thought I killed you," she said, clutching her throat and coughing.

"You can't kill me, woman," he calmly replied. "But I can easily kill you." He tightened his grip, causing her spine to stiffen as she again fought to breathe.

"You come in here demanding a ransom, telling us to disarm and turn her over. She's not going with you. She's one of us now. You can't have her." he said as she stared down at him, glassy eyed. The others exchanged looks of amazement,

witnessing his power. Draigistar relaxed his grip, allowing her to take in a labored breath.

"He won't return the daughter unless he gets her," she said, rubbing her throat.

"Then bring her in now," he replied.

She thought briefly. "No. Tomorrow."

He tightened his grip again, causing her to panic. "Then that is when we'll trade you the gold," he said. "And she'd better be unharmed. For now, you will bring us our horses. I believe you called it a show of good faith. And in return, I'll let you live, as a show of good faith," he added, relaxing his grip again.

Her chest heaved as she coughed and drew in deep breaths.

"It's no fun when you're the one in pain is it?" he asked. "Now give the signal. I know they watch. And if you lied about the horses, you're dead."

She slowly pulled a red scarf from her pocket and waved it over her head.

"How long?" he asked.

"Not long."

Soon they could hear the sound of horses approaching in the darkness.

"Everyone, get ready!" Lance yelled out.

"If it's a ruse, you'll never know if it worked," Draigistar warned her.

"It's not," she replied, glaring at him.

They watched as three men led their horses up the road, stopping near the fire.

Lance told Derek and the two grooms to inspect them while the three Shadow heeded Loorkha's gesture to leave.

"We're short two drafts and a mount, but these look all right," Derek reported.

"We couldn't find them all in the storm," she said.

"All right then," Draigistar said. "There's just one more thing before you go."

"What?" She could still feel his grip around her neck.

"Apologize to her," he said, glancing at Janae.

Janae looked at him with her mouth open while others chuckled.

The Rendovan grew enraged, not willing to swallow her damaged pride.

"Draigistar, what are you doing?" Janae said. "That'll just make it worse for me."

"I will not!" Loorkha blurted out, wanting to spur her horse away in hopes of breaking the mage's hold.

"You're thinking you can escape me," he said as he clinched his hand tighter and raised it slowly. Her body stiffened again in response to the lack of air. She began rising as if being lifted by an invisible force until she was completely out of the saddle. She frantically grasped her throat with both hands as her eyes rolled back and her world dimmed. Finally, he lowered her back into her saddle and relaxed his grip.

"Perhaps you'd care to reconsider," he said.

"All right," she conceded in a coarse whisper.

They watched her clear her throat and look at Janae. "I'm sorry," she said softly.

Janae glanced up at her before looking back down.

"Oh, come on! You can do better!" Draigistar erupted, startling everyone. "We all heard you gloating about her pain! I told you to apologize. Now speak up!"

The humiliation was crushing her pride like a stone grinding glass. She was visibly shaking with anger, but knew she dared not defy him. She composed herself and spoke again in a trembling voice. "Janae, I'm sorry. I apologize."

This time, Janae held her gaze and nodded in acknowledgment.

Satisfied, Draigistar slowly walked up in front of her mount. He gazed up at her, speaking in his normal, calm demeanor. "Remember how that felt," he said, opening his clinched hand. "Now get out of my sight before I change my mind about letting you live."

She briefly glared at him, her chest heaving as she rubbed her throat. Then she reined her horse around and spurred it into the night.

"You showed her, mage," Dahr said as he gave Janae a gentle squeeze on the shoulder in a show of support. She glanced at the normally quiet teamster, and they exchanged a brief smile.

"Well done," Erin added.

Excited talk ensued among the group about the encounter, and inevitably someone asked what Loorkha meant when she called Janae a traitor.

Lance was prepared. "All right, people, listen up!" he said abruptly. When the chatter subsided and they all looked at him, he continued. "I know you're all wondering what the Rendovan meant. We found out before leaving home that Janae knew a couple of people our new friends had identified as Shadow. One was attacked and killed by the wolves that night on the mountain. And as you know, Zandor was the other. When he left the night we were attacked at the hot springs, Janae fled, fearing they'd be after her. But we've assured her our protection."

A few glances were exchanged, but no one questioned the foreman's explanation.

"All right, get busy," he added. "We lucked out and got our horses back, so let's get them tended to. And this time make sure they don't get away!"

With a renewed sense of hope, they quickly disbursed to perform their duties.

"Quick thinking, Lance," Draigistar said softly.

"I don't like deceiving them."

"Well, you did good," the mage said, stepping toward Janae. She looked at him. "Why did you do that?"

"Because you're not going with her," he replied, gently cupping his hands around her cheeks. "Not tonight, not ever. We'll get Celeste back, but they can't have you."

"Thank you," she said with tears of relief streaming.

"Like he told her, you're one of us now," Dahr said, standing behind her. She turned to him, and he took her in his arms, holding her while she softly cried.

"Hey everyone, quiet," Erin said. "Listen."

When they quieted, they could hear a wagon approaching from the north.

"It's them," she added.

Everyone took cover and watched it roll into sight, and when Gustin reined up they all gathered round. Fae rushed to him, and they held each other, and Erin lingered in her embrace with Flynn while the group told them what had happened.

"It was the Rendovan. She rode right into camp," Gustin heard someone say.

"What? What did she want?"

"A trade," Fae replied. "They want to ransom Celeste."

He glanced away and broke a smile.

"What is it, lover?"

He raised a hand. "Quiet everyone!"

They all quieted as he searched their confused expressions before settling on the merchant. "Hollis, they don't have Celeste," he said.

He stared at Gustin with his mouth open.

"What?" Lance said.

Gustin glanced at him before addressing Hollis. "They want to get your gold together in hopes of taking it. But they don't have your daughter. She's with Hunter."

Hollis slowly looked down, trying to comprehend. "You know this?"

"Yes, I do. We found the wagon at the side of the road beyond where they attacked us. We also found two Shadow down by the stream. Hunter left one alive, and he confirmed he'd taken her away from them. We followed their tracks back to the road where she mounted his horse and he led it into the foothills seeking shelter for the night. Hollis, she's all right," he

said, grasping his shoulder for reassurance.

Hollis covered his face with his hands and softly wept. The others exchanged glances, uncomfortable with the merchant's fragile state. Janae stepped up, leaning into him, and he wrapped his arms around her. She snuggled into his comfortable embrace as he buried his face in her hair and they both gave into their emotions.

Lance squeezed his shoulder consolingly and stepped past him.

"All right, people, let's get our work done," he said. "Those of you not on first watch, get changed into some dry clothes and get some sleep."

Soon the watchfires were relit, and camp was secured for the night.

/// \\\

The two men stood together in the darkness at the far edge of the clearing, watching the camp. They hardly spoke—just watched. Finally, the tall man with the scarred face looked over at the Shadow Knight. He'd ridden hard back through the bogs to the main road and headed south, skirting the edge of the forest to rendezvous here with Edmond and the others.

Zandor hadn't made it. It had only taken a single, unexpected thrust from his dagger into Zandor's ribs to unseat him when they rode through the ruins of Shaelah. He grabbed the reins of Zandor's mount and spurred away hard while the Shaelock moved in to finish it. He resisted looking back in response to Zandor's horrified screams. In sheer terror, he'd driven his mount onward, fighting the overwhelming urge to turn and see if the Shaelock pursued him. Now, having survived the ordeal, he savored the exhilaration it had brought him. He arrived here just before the column pulled in at sundown.

Finally, he broke the long silence. "What do you think? Try

again tonight? Looks like your old friend isn't going to make it back."

"Don't count on it. Our people aren't back yet either," Edmond replied. "What was that woman of yours babbling about when she got back? Thought she was some great warrior."

Hanlin quietly chuckled. "She said their wizard used powerful magic on her. She thought he was going to kill her . . . made her apologize to Janae."

"That your runaway whore?"

"Uh huh."

The knight slowly shook his head. "Got to show a woman you mean business."

"Oh, I will. She's disobeyed me for the last time," he said with his eyes locking on her in the distance. His anger seethed, watching her sit by the campfire with her new friends.

After a long silence, Edmond spoke again. "Well, we don't have enough men left to take the gold. If they don't get back here with the daughter, there's no trade."

"You tell them not to harm her?"

"I don't give a damn what they do to her, long as there's enough left to wrap a blanket around and take back to her father. If we don't have her to trade, by this time tomorrow, they'll be at Bard's Landing. . . . Guess we'll just have to pay them a visit there," he said before he slowly turned and walked away.

Hanlin continued to watch, imagining the ways he would hurt Janae before he killed her. Then he thought about her new friends. They'd convinced her she'd be safe after betraying him. He would show her just how wrong they were.

And he would deal with *them*, but he knew he must be cautious. From everything he'd learned by watching, and from what Zandor had told him, he knew they were not to be underestimated. The big one, the former cavalry officer, clearly knew how to fight, and would kill without hesitation. And his woman, the elf, she carried herself with a confidence that only

came from knowing she was as good with a sword as any man. She fought with an unusual style that was nearly impossible to counter. She was quite possibly the most dangerous of the four. Their wizard had defeated his tonight and put a fear into Loorkha he would not have thought possible. He might just have to pay an assassin to deal with them.

Then there was the youngling, the beautiful blonde-haired woman called Erin. She stood as tall as most men and had a muscular physique that accentuated her exquisite feminine features. Large breasts hung stately between her broad shoulders and narrow waist, and she had well-defined thighs and buttocks. Her body was made for giving pleasure. She was truly unique, and he desired her. She matched Loorkha's combat prowess and was breathtaking to look upon.

When he and Edmond watched the women bathe in the pond earlier, he couldn't take his eyes off her. His loins ached with the need to take her. He would have her. She was spirited and would have to be broken; that would bring a pleasure all its own. But eventually she would submit and take her place in his stable. Finally, he shook free of his twisted fantasy and turned to follow the Shadow Knight back into the forest.

CHAPTER ✝ 18

They trudged through the forest with the rain and lightning getting worse. The hilly terrain was dotted with rock formations jutting up among the conifers. Hunter kept an eye on Celeste. He knew his horse would follow him regardless of a rider in the saddle, and she worried him. He was about to give up on finding a cave and seek shelter beneath some trees when they came to a slope covered in loose, sliding rocks. He looked up just when a streak of lightning lit up the night and could see a level outcropping about forty feet up the steep hillside. Relieved, he walked back to his horse.

"Come Celeste, I think we've found shelter," he said, reaching up.

She leaned into his arms. "Good. I'm so cold."

As he lifted her down, he assessed her condition. *Still shivering; that's good.* He'd spent most of his life in a harsh, cold climate, so he knew well the dangers of exposure. He took her by the hand and grabbed his horse's reins, and they struggled up the slick, loose rocks. When they reached the level, he saw the entrance to a mine shaft.

"Look. Isn't that a welcome sight?"

"Yes, thank God."

When they reached the entrance, he drew his sword and turned to her. "Listen, I need to have a look inside. You stay here with the horse."

"Hunter! No! Don't leave me!"

He gently touched her cheek. "I'm just going in a few steps

to make sure it's safe."

"All right."

His sword began to glow as he turned and stepped through the broken curtain of water that spilled over the large entrance. It didn't take him long to decide it was adequate, and shortly after entering, he reappeared. "It'll work."

"Good."

He held the glowing blade of his sword ahead to light her way, and when she entered, she stopped under the flowing curtain of water, letting the blanket fall to the ground. She began vigorously rubbing her hands over her face and body, running her fingers through her hair. He watched her with concern while she continued as if somehow trying to wash away the terrible images burned into her mind. He leaned his sword against the rock wall just inside the entrance, then turned and drew her to him.

"Celeste," he said softly.

She didn't answer, just lowered her head and leaned into his chest, softly crying as he held her in one arm. For a moment he gently ran his fingers through her long hair while the cold rainwater cascaded down over them. She was still shivering, and he knew he had to get her warmed up, so he turned and led her inside. She wrung the water from her hair and wiped her wet face as he pulled on the reins, coaxing his skittish horse through the curtain of water into the dark shaft. The horse's head nearly touched the rock ceiling when it entered, and Hunter picked up the discarded wet blanket and slung it over his saddle.

"Come on," he said, retrieving his sword. Extending the glowing blade in front of them, he led his horse deeper into the mine with her walking beside him. A ways in, the floor of the shaft became steeper and the ceiling lowered. His well-trained mount became more nervous when they negotiated the dimly lit incline, but soon it leveled off and opened into a dome-shaped cavern thirty feet across and twelve feet high

in the center. There were three more shafts leading off the back wall, and a smaller opening to one side. Hunter dropped the reins and slowly circled the room, passing by each of the shafts. From the light of his glowing sword, he could tell the first two had collapsed. And while the third was still intact, it obviously had not been entered for a very long time.

"This mine's been abandoned for years," he said, scanning the floor of the cavernous space. "There's not even evidence of wild animals using it."

"Good," she responded weakly.

He glanced at her, worried. He knew she was cold and exhausted and might take ill if he didn't get her warmed up. He quickly walked over to the smaller opening, and when he leaned in with his sword before him, he smiled.

"What's in there?" she asked.

He turned and reached out a hand. "Come. It's all right."

Without expression she took his hand and they stepped into the room. He noticed she barely shivered now, and her hand felt cold as ice.

"What is this place?" she asked, looking around.

"It's a respite," he answered, holding his sword up high. "This isn't natural. It was carved out by miners. Look at the fire pit in the floor and the small dome above it. And there, that carved channel funneled the smoke out into the main chamber through that opening high in the wall," he said, releasing her hand to point. "Even the sand on the floor was hauled in here. They probably lived in here for days, even weeks at a time."

"Why?"

"Oh, a lot of reasons I suppose: more convenient, more profitable, protection from the elements and robbers," he answered as he walked around the room picking up pieces of rotting wood from the degraded furnishings. He tossed the wood into the pit and headed for the doorway. "Come give me a hand."

When she walked over to the door, he handed her his sword.

She gripped it by the hilt with her shaky hands, only to struggle with the weight and drop it when he let go. He quickly bent to pick it up from the sandy floor.

"Oh Hunter, I'm sorry," she said in frustration.

"It's all right," he said softly as he reached up and stroked her cheek with his free hand. "Hang on; I'll start a fire so you can get warmed up."

She nodded without speaking. When he leaned his sword in the doorway and stepped through, she silently watched him lead his horse closer and hobble it before removing the tack. Then he carried both pairs of saddlebags in and laid them out on the floor. Removing a skin of oil, he poured it on the woodpile, then walked over and retrieved his sword.

"Come. Let's get you warm," he said, offering his hand. She placed her shaking hand in his and walked over to the pit, where she watched him place the tip of his blade into the woodpile. He closed his eyes to concentrate, and the blade began glowing brighter and changing colors. The tip changed from blue to violet, then to bright orange as the pieces of wood smoldered. Suddenly they flamed, and the lamp oil ignited with a subtle whoosh. He opened his eyes, and when he withdrew the sword, it quickly lost its glow.

"That's amazing," she said.

He smiled and laid down the sword. "No. It's magic." Picking up the skin, he poured out more oil until they had a roaring fire. "All right" he said, holding up a hand to the welcome heat. As she moved close to the fire, he took another wool blanket from a saddle bag and unrolled it.

"Celeste, I, uh, don't know how to say this, but you need to get your wet clothes off. You're dangerously cold."

She looked at him and simply nodded.

"I'll hold up the blanket so you can disrobe, then wrap yourself and sit by the fire."

"Hunter, it's all right. Forget the blanket. That's sweet of you, but I need you to help me. My hands are so cold I can't feel

them. I just want to get warm."

He looked down at her shaking hands as she held them toward the fire, and when he looked back up, she smiled.

"Really, it's all right," she whispered. "Just help me, please."

He swallowed hard, and when she turned to face him, he dropped the blanket and tentatively raised his hands. He unfastened the front of her leather vest and blouse clear down to her waist, exposing her cleavage. As he worked, he glanced up to see her eyes fixed on his. In growing discomfort, he knelt down in front of her and loosed the leather lacing on her pants. Sliding a hand down the back of her leg, she responded with a hand on his shoulder, raising first one foot and then the other so he could pull off her wet boots. He paused briefly, gazing at her bare feet in the sand, his heart pounding from arousal and embarrassment.

"Hunter, it's all right," she reassured him.

After a calming breath, he reached up and placed his hands on her waist. Then, curling his thumbs inside the top of her open pants, he struggled to slide them down over her hips and past her knees until she stepped out of them. His heart raced as he slowly revealed her private region. He looked up just as she grasped her open vest and blouse and slid them off her shoulders, letting them fall to the sandy floor. He suddenly found himself kneeling before her as she stood there nude, looking down at him with the firelight illuminating her wet, curvaceous body. Lost in the surreal moment, his head swam with desire.

"Hunter, the blanket," she said.

"Uh, sorry." Embarrassed, he shook to his senses and quickly stood up with the blanket, and when she turned away, his eyes beheld the rest of her naked flesh as he draped it over her shoulders. She took it and knelt down near the fire while he smoothed a place in the sand so he could roll out his last blanket. Then he removed four plush animal pelts and spread them out on the blanket, keeping his back to her.

Even though she was cold and exhausted beyond measure, she found herself studying him. "Hunter," she said softly, breaking the awkward silence.

There was no response.

"Hunter," she repeated. "Look at me."

He paused and took a deep breath, still looking away.

She patiently waited.

"Celeste, I apologize," he said, turning to face her. "I disrespected you, and I must beg your forgiveness. . . ."

"Come to me," she said softly.

He hesitated, then went and knelt when she reached out and took his hand.

"There's nothing to apologize for," she said, lightly touching the wound on his temple. "Hunter, I'm not embarrassed that you saw me naked."

Her words renewed the vivid images in his mind, stirring him yet again.

"Come hold me; warm me up. I'm cold and tired, and I can't . . . I can't get it out of my mind," she said as her voice cracked. "I was so scared. I'm still scared."

He gently stroked her cheek before he stood up and went over to the broken, three-legged table lying on the floor and propped it up against the wall. Then he gathered her wet clothes and laid them out on it and began removing his own. He took off his mailed vest and wet boots before peeling off his tunic and laying it on the table. Then he removed his gold chain necklace with a holy symbol medallion and laid it on the table as he turned to look at her. She'd moved to the pallet on the floor near the fire and was sitting there wrapped up, watching him intently. He picked up his weapons and slowly walked over to her where he knelt down and laid them by the pallet.

"Come lay with me," she said. "Hold me. We both need rest."

He turned away and slid out of his pants, tossing them on the sand, then looked over his shoulder to see her lying down,

holding the blanket up so he could join her beneath it. He laid down and pulled it over them as she scooted in close. Then he wrapped his arms around her, pulling her to him as they exchanged a long, passionate kiss. While they silently lay facing each other, she snuggled close, burying her face against his chest. With the heat of the fire and the blanket, and his arms wrapped tightly around her, her shivering gradually subsided. Even though she couldn't recall ever having been so exhausted, she could not find sleep. She couldn't make herself stop thinking about what would've happened if he hadn't found her. Emotions warred against her crowded, busy mind: fear, anger, humiliation. Finally, she had to speak.

"Hunter, are you awake?"

He knew talk would come before sleep. Many times, he'd crossed that deep chasm of self-reflection that follows traumatic events.

"Yes," he replied. "I'm not going to sleep until I know you're all right," he added as he reached up and brushed back her wet hair, gently kissing her forehead.

"Why did they take me? I mean, I know for Tobias it was revenge, but not for the others. Did they want ransom?"

"It would seem so. . . ."

"They were . . . they were going to kill me, weren't they? I mean, after they finished with me."

He closed his eyes, his mind torturing him with images of what they would have done to her. He knew she deserved to hear the truth; she needed to hear it.

"Yes," he said, tightening his embrace to reassure her that she was now safe. He felt her tense up as she battled a raging storm of emotion.

"They—they had no right to take me," she said in a soft, quivering voice.

"No. They didn't," he said, gently brushing his cheek against her forehead. After a long silence he could hear her sniffling, trying not to cry. He could feel her body drawing more tightly

into his, seeking greater refuge.

"Celeste, it's going to take a long time to put this night behind you," he said. "You can start by letting yourself go. Don't hold it in. Get rid of it. Free yourself. They can't hurt you anymore, my love."

He felt her let out the deep breath she'd been holding in a futile effort to force out the pain without breaking down. Then she began to cry, softly at first. It soon escalated into sobbing and clenching her fists. His heart was breaking. He knew she was reliving each humiliating act they'd done to her, and he was helpless to ease her pain. All he could do was remain silent and hold her while she endured the nightmare. She eventually cried herself out. Spent, she sniffled and rubbed her eyes without speaking. Then, at last, she fell silent, and he could tell by her breathing that she was asleep.

He continued to hold her while his mind replayed the day's events. Facing his once best friend had come with amazing ease. He'd known Edmond White for thirty years. They were inseparable as young men training together for knighthood. Now, nothing remained of his boyhood friend. He'd been consumed by evil, just as the witch had said when she cursed them so long ago. Edmond had to be killed, and he'd meant to do it. The only shred of fear in him as he faced his old friend had been the fear of dying in front of Celeste. For the first time since leaving his home years ago, he'd fought a battle caring if he lived or died. Now he realized he'd grown unaccustomed to dealing with that burden. *I've lost my edge, and Edmond knew it. That's why he taunted me. He knows I'm better with a sword than he is, but he has nothing to lose if he dies. And I do. Indeed, I do,* he thought, glancing down at her as they lay facing each other, their nude bodies snuggled tightly.

For the longest time, he watched her sleeping with her face buried against his chest. *Oh God, if I had lost you tonight,* he thought as his eyes grew wet. He gently brushed aside her hair and placed a tender kiss on her temple. She flinched and

drew in a sudden, deep breath, and he watched with a smile as she repositioned and continued to sleep. He could no longer deny his feelings. He was so madly in love with her that she consumed his every thought. He'd sworn never to love again after losing Stephanie. He'd lost *her*. But he would not lose Celeste.

She was sleeping soundly, so he bunched up one of the soft animal pelts from their bed and carefully slid it beneath her head as he pulled his arm free. Then he slipped from under the blanket they shared and stood up. He yawned and slowly stretched his sore, tired muscles before he went and gathered more broken pieces of wood from around the room and stoked the fire. Then he took a length of rope from his tack and stretched it across the room near the fire pit. After hanging their clothes to dry, he took up his sword and stepped out into the main chamber to check on his horse. Once satisfied they were alone and safe, he returned to their pallet.

For a while, he sat cross-legged on the blanket by her feet, watching her sleep, pondering his future, and revisiting his past. The warmth of the fire felt good on his naked body. And when he gazed into it, his mind drifted back to a fire pit on the sand floor of another room he once sat in twelve years ago. It was in the bustling trade city of Tuskin, far away in the kingdom of Ormond. Three young, ambitious knights sat around the fire that night: himself, his twin brother Andrew, and his best friend, Edmond White. It was the abode of a striking young woman, a chiromancer who told people their fortunes and peddled herbs and spices. The three men, on their way home from a year-long quest, were spending a few days in the alluring city. He had talked them into going with him to have their palms read. It turned out to be a horrific night ending in her death at Edmond's hand and the three of them on the run across the vast, unforgiving disputed lands.

"Hunter."

He jerked, startled, ripped from the terrible vision of his

past, and looked over at Celeste when he realized she'd spoken.

She was sitting up, wrapped in the blanket, looking at him. "Uh, I'm sorry; I didn't mean to startle you," she said with a look of concern. "Are you all right?"

He didn't speak, just nodded and looked away as he wiped sweat from his brow.

"Were you thinking about what happened tonight?"

He took in a deep, calming breath. "No. Something that happened long ago."

"It still troubles you."

Again, he nodded.

She could tell he was still not himself. "Want to talk about it?"

He took in another deep breath. "No, I'm all right . . . perhaps later."

She recalled her father's words. *When he's ready, he will share his past with you. Just be patient,* he'd told her. They silently sat, eyeing each other until, finally, her expression turned serious.

"Hunter, thank you for what you did. You saved my life— no. You saved me from a fate much worse than death, and I can never repay you."

He smiled. "You already have."

She returned the smile, recalling what he'd shared about their first meeting.

He broke their gaze when he suddenly turned and came to a knee, reaching over to toss more wood onto the fire. She was filled with desire, watching his chiseled muscles flex as he moved. When he finished, he abruptly returned to his cross-legged position and their eyes met again.

"Hey, I love sleeping on these soft pelts," she said, trying to calm herself.

He smiled mischievously. "Feel good on your bare skin, don't they?"

She chuckled at his unexpected comment. "Uh huh," she replied, holding his gaze.

Who is this man? My knight in shining armor: the battles he's fought, the enemies he's faced, the terrible things he's seen. Yet the tender, gentle way he holds me and speaks to me. . . . She loved him. She desired to know him, to give herself to him, to give him pleasure and receive his pleasure without reserve. But she still battled with the thought of what nearly happened to her just mere hours ago.

"Hunter, please come hold me again."

With their eyes locked on each other, he slowly rocked forward and began crawling on his hands and knees toward her. She came to her knees to meet him, and he closed his arms around her. Then they kissed before lying down and covering themselves again. For a long time, they lay facing each other without speaking. And while the faint sound of rumbling thunder from the storm outside echoed through the mineshaft, he held her, relishing the feel of her warm breath on his skin. Finally, she looked up at him, and he looked down at her beautiful face to see teary eyes and an expression he could not read.

"What is it, love?"

Her delayed response worried him. "I need you," she said at last.

"I'm right here, Celeste."

"No. Not like that, Hunter. . . . I need you to make love to me."

Surprised, he searched her expression. "Are you sure?"

"Yes," she replied as she started to move. When he relinquished his hold on her, she slowly came to her knees, letting the blanket slide off her shoulders. His nostrils flared, and his chest heaved with desire as he rose to his knees, facing her. She leaned into him, and their lips met with sizzling passion. They lingered, savoring the taste of each other as the tips of their tongues danced, and their heads swam. Finally, their lips parted, and she retreated slightly.

"Hunter, make love to me. Make me yours."

"Celeste, you've been through so much tonight."

"I need you to take away those memories. . . . I need to *know* I'm really all right," she said. "I love you," she added as she took his hands and placed them on her bare breasts. He began gently kneading them, and she cupped her hands over his, endorsing his affection. She arched her back and raised her head with her eyes closed, savoring the pleasure of his touch on her forbidden skin. She burned with desire as he took his time, purposefully teasing and caressing her naked body. He leaned forward and began nuzzling and kissing her breasts as he reached around and lightly brushed his fingertips down the length of her spine. She arched more still, pressing her soft flesh into his eager mouth.

Then he cupped a strong hand over her buttocks and drew her to him while his other hand stole its way between her warm, moist thighs. She tipped her head forward and looked at him with a lustful gaze while she moved her knees apart to accommodate his welcome advance. As the brunt of their passion was unleashed, they embraced, kissing while their nimble hands explored each other. Her legs trembled in weakness, and her head fell back with her softly moaning in ecstasy as he kissed her neck and cheek and nibbled her earlobes. She melted in his strong arms, unable to keep herself upright. She was completely at his mercy and never more content.

At last, he gently laid her back on their soft pallet and took her as their pent-up desire exploded. They held nothing back. They knew and pleased each other in ways not yet conceived in their fantasies. For a time, they forgot the world outside their crude sanctuary, consumed only with each other. They made love insatiably: seeing, touching, tasting, satisfying every desire. Eventually, they lay together, drenched and exhausted in their quiet haven, and fell fast asleep.

/// \\\

After a long, miserable night, dawn finally broke over the valley. The storm that raged through the evening had slowly waned, yielding to a bone-chilling cold in the predawn hours. Now an impressive blanket of fog had settled in. Everyone in camp was up. Lance had given orders for the last watch to wake the others before dawn so they could prepare to greet the Shadow, if they came for the exchange.

Fae stood at the front of the wagons, scanning into the fog. She passed on the morning meal; she had no appetite. She and Gustin had disagreed on who should go out to find Hunter and Celeste. She'd relented to keep it from turning into an argument and was still upset. She wanted to go with him, but with Hunter gone, one of them needed to stay. Erin had been eager to go, so in concession, she insisted he take her instead of Flynn. His puzzled look confirmed he was oblivious to her reasoning. That suited her. She didn't want to speak of it—or even think of it—but, truth was, her imagination had tortured her with thoughts of what might have happened to Celeste before Hunter rescued her. If she couldn't be there for her, then Erin would be. That was nonnegotiable.

"Fae?"

She managed a smile before turning to look at Hollis. "Good morning, sir."

He returned a fleeting smile. "Please don't *sir* me; makes me feel old."

She nodded before silently looking down.

"You despair," he continued, stepping closer. "Is it your disagreement with Gustin? Or perhaps you worry about my baby girl," he said in his fatherly tone.

She couldn't quell the tears as she thought of Celeste alone with her abductors. She slowly looked up at him. "Yes," she answered in a whisper. She swallowed hard to regain her voice. "Hollis, we must be prepared for the worst," she said, wiping her eyes.

He looked down and sighed. "I know, Fae. I know. . . . I will

be strong for her."

Her heart was broken, but she found the courage to continue. "Hollis, I'm uh—"

He reached out and embraced her. "Fae, it's no one's fault. I don't blame you or anyone else. Don't let it eat you up inside." She lowered her head and leaned into him, quietly crying while he held her. Her solace was cut short when Lance approached.

"Well, boss, looks like Gustin was right. It's past dawn, and there's no sign of them," he said, glancing at Fae.

"I pray that is the reason," Hollis replied, "that she is safe with Hunter."

Fae discretely turned away to compose herself.

"Oh, and our guests have agreed to go with us back to Bard's Landing," Lance added. "I told them what we've been facing, and they decided to wait for the next army patrol to escort them north."

"Good," Hollis said. "Well, I guess now it's just a waiting game."

"I'll make sure everyone stays alert."

Hollis silently nodded, and the foreman turned away.

/// \\\

Gustin and Erin had led their horses out of camp well before daylight. They waited in the forest to see if Loorkha would return with Celeste as promised or if the Shadow would attack them again and try to take Hollis's gold. They'd be in a good position to flank the Shadow forces if they tried anything.

When dawn came and went with no sign of their enemy, they moved further into the woods. Once far enough away, they mounted up and headed north through the forest into the foothills. Gustin was playing a hunch that made more sense each time he thought about it. In Hunter's position, he would've tried to find a cave in the hills and wait out the storm, then return to camp staying off the road. They moved silently

through the trees with little conversation, both lost in thought. They carefully scanned the ground for tracks and frequently stopped to just listen through the fog for sounds not of the forest. With only occasional whispering between them, they methodically worked their way north until they were beyond where they'd been attacked the previous day.

"What do you think?" she quietly asked as they sat atop their mounts. "There's been no sign of anyone."

"I still think we're doing the right thing. Tell you what, let's turn more to the west and head higher up into the hills."

"All right."

They headed northwest, searching the forested, hilly terrain until midmorning. Finally, they stopped to have a cold meal and rest their horses, and while they ate, they fell into conversation.

"You think they could've stayed closer to the road and passed by us?"

"Oh, it's possible, but I doubt it," he replied without looking up. A long silence prompted him to glance over and catch her studying him. "What?"

"Why do I get the feeling there's something you're not saying?"

"Bout what?" he replied, feigning ignorance.

"Last night," she instantly shot back.

He realized he hadn't thought fast enough to give a convincing response, but he didn't want to lie to her anyway. *Damn women's intuition.*

"What happened to Celeste?" she asked him flatly.

He held her gaze to validate his response.

"Erin, I don't *know* that anything happened, but it's possible that Tobias and the others had their way with her."

She slowly raised a hand to her gaping mouth.

"Listen, Flynn and I swore last night to never speak of it. The only reason I just broke that oath was to confirm what you already suspected. Erin, we must not do anything to make

this harder for her than it's already been. I hope I'm wrong. But if she needs to talk, she'll look to you women."

"I understand," she said with a nod. "It's safe with me."

He returned the nod as he stood and offered a hand. "Come, let's go find them."

She took his hand, pulling herself up, and they mounted to resume their search.

/// \\\

Celeste awoke with a start. She sat straight up, sweating, her eyes darting around in the dim light. The room was still comfortably warm, but the fire had burned down. Only a pile of glowing embers remained save a few tiny, orange flames jutting up with a subtle snapping sound. Her heart raced briefly when she thought she saw movement in the shadows across the room. Then as her mind cleared, she realized it was just her imagination, remnants of last night's ordeal.

She instinctively knew Hunter no longer lay next to her. As she yawned and stretched, she saw his armor still lying on the table, glinting in the firelight, and knew he hadn't gone far. His tack was laid out close to the fire, drying. It was clear he'd moved about the room with her oblivious to his activity. *I must've really been out*, she thought. She sat still for a while, quiet, naked on their soft pallet, wrapped in the blanket they'd covered themselves with after making love last night.

She wasn't a virgin. There'd been two other men in her life, the first when she was nineteen. She was young and naive and gave in too soon. It didn't work. Two years later, she met someone. She was wiser and took her time. Gradually it became serious, but he was killed in an accident. After enduring that pain, she'd lost interest in romance. Now Hunter had changed that, seemingly without even trying. Neither of them were looking for love when they met, yet here they were. She'd resisted his assigned protection duties while he patiently per-

sisted in fulfilling them. Now she thanked God he was there for her last night. She shuddered at the thought of her fate if he'd not found her. Tears began rolling down her cheeks, and she fought hard to think of something else—anything else. She'd never been so frightened in her life. Never.

At last, she managed to turn her thoughts back to him. She thought of their encounter after they found this mine, and this room, carved deep within the mountain. What had once been a place of refuge for tired miners had now become their place of refuge from a raging storm and a relentless enemy. He'd been right; they were safe. She owed him her life—a debt she could never repay. But after last night, it didn't matter. They were beyond that now. The way they made love, the way he made love to her, the way he made her feel. She knew she wanted to spend the rest of her life with him.

At last, she stood, still wrapped in her blanket. She went and checked her clothing and saw Hunter's tunic still hanging there. They were still damp, but she pulled on her pants and boots. Again, she took up the blanket, pulling it taut around her bare shoulders. She held it together with one hand as she stepped into the main chamber and saw his horse still standing there hobbled. She looked toward the entrance and listened, surmising it must be daylight outside. *The storm finally passed*, she thought, no longer hearing its throaty rumble.

She followed the growing light down the shaft, careful with her footing among the loose rocks that littered the floor of the sloping passage. She moved quietly, and when the shaft leveled off, she could see the entrance. Hunter was there, squatted down on one knee, bare above the waist, looking out into the morning. His great sword leaned against the rock wall within reach. He was scanning for any sign of danger. The rain had finally ended, but the chill of the morning had cast a thick fog over the forest. She stepped softly as she approached, admiring his physique. Looking at the well-defined muscles in his shoulders and back, she recalled their lovemaking last

night. She'd never imagined looking upon the nude body of such a man, let alone lying with him, pleasing him. She saw the slightest tilt of his head, indicating he knew she was there.

"Good morning," she said softly. She was surprised when he turned to look at her with a boyish grin. She thought how young and alive he looked with that expression she'd not seen before.

"Good morning," he replied. "Sleep well?"

She nodded. "Yeah, once I got there," she said with a teasing grin as she knelt close to him.

He held his smile briefly, then took a serious expression. "You all right?"

She glanced away, embarrassed, before realizing there was no longer any reason for her to be self-conscious around him. He hadn't asked her what happened when the Shadow took her. He'd simply let her know with his tender love and affection that he was there for her. He'd given her what she needed most, understanding and acceptance. *He always seems to know what I need.* Finally, she looked back up at him.

"Yes, Hunter, I'm all right," she said, fighting back tears. "Thanks for asking."

His compassionate, knowing look made it even harder to maintain her composure. They silently held each other's gaze until, finally, he looked away to resume his watch.

"Think they're still out there?" she asked, eager to change the subject.

"Hard to say; I doubt it," he replied, still looking away. "We've killed so many of them I've lost track. And I'm sure they know our friends are looking for us by now."

"Should we go?"

"No," he answered quickly, surprising her. "I'd chance it alone, but not with you," he said, glancing her way. "It would be too easy to stumble onto them."

Ever my protector, she thought.

"The sun's out today," he continued. "We'll give it a little

more time for this fog to burn off. Then we'll go."

"What time of day is it?" she asked, not sure how long she'd slept.

He glanced up at the obscured sky. "The sun hasn't been up long. The fog will lift enough to travel by late morning."

"Well, I, uh, guess we have some time to kill," she said, watching his reaction.

He grinned slightly, obviously trying to subdue it, but didn't speak.

His minimal response concerned her. *Perhaps it didn't mean as much to him as it did to me,* she thought with a heavy heart.

"Hunter, do you regret last night?" she asked, almost fearing his answer.

He turned to look at her, his moist eyes filled with a storm of emotion.

"No, Celeste. I've never regretted one moment I've spent with you, especially last night," he said as they gazed into each other's eyes. Only when he knew she understood the depth and sincerity of his love for her did he look away.

After an uncomfortable silence, she spoke again. "How long has it been?"

He looked at her. "Why? Was it that bad?" he asked with a smile.

She savored his playful mood. "Well . . . I'm not sure. That's why I want to have you again before I decide," she responded coquettishly.

He chuckled, and she joined in. Then after their laughter faded, he looked at her.

"It's been two years. She's a friend in the twin cities," he said, turning away again.

"Oh, then perhaps I shall get to meet her."

He quietly chuckled again. "Now, why would you want to meet her?"

"Why, to tell her you're taken, of course," she quickly replied with a smile.

He returned the smile. "So, you think I'm taken, do you?"

"Uh huh."

"You seem confident."

"Uh huh."

They continued to smile playfully. "Well, I suppose you're right. I am taken."

Her heart leapt.

"I guess I shall have to break her heart the next time I see her," he said, looking back out into the morning.

She laughed at his humor and her own joy.

"Is she the one who gave you the scarf?" she asked tentatively. She was curious and hungry to learn more about him, but her words hit him hard.

When he absently reached for his breast pocket where he always kept it, he remembered he didn't have it with him. Then he realized he hadn't thought of Stephanie once last night while they made love. Nor had he thought of her since. His thoughts this morning had been only of Celeste. He closed his eyes, thankful he'd been delivered at last from the bittersweet memory that had tormented him for so long.

She watched his distant expression. And when he closed his eyes, she thought she'd hurt him with the mention of it.

"Hunter, I'm sorry. I—I had no right asking. Please forgive me," she said as she started to stand and go back inside the mine.

He quickly reached out and took her hand.

"Celeste, wait. You misunderstood; I wasn't upset, merely lost in thought. And yes, you have every right."

She paused and looked at him, and when she settled back to her knees, he reached up and gently brushed the stray locks of hair from her forehead.

"The answer is no. The one I spoke of is truly just a friend. The one who gave me the scarf, her name is Stephanie. We were childhood sweethearts. Well, no, much more than that. We loved each other since childhood and planned to be married."

"What happened?" she asked, fearing death had taken her from him.

"Our parents had other plans," he quietly responded, looking away.

She sensed his pain and decided to leave it alone, despite her raging curiosity.

A silence befell them until he looked at her. "May I ask you a question?"

As they looked at each other, she found herself desperate to lead him back into his playful mood and back into their haven for more lovemaking. "Sure, anything."

"How old are you?"

She was dumbfounded, never considering he might ask such a thing.

"I cannot believe you just asked me that. You are a rogue. Don't you know a gentleman never asks a lady her age?"

He leaned back and laughed softly. "Oh, but you see, I'm no gentleman, so that silly rule doesn't apply."

"Oh yes, you are," she quickly rebutted. "You're the most perfect gentleman I know. Well, except for my father, of course. And by the way, I recently turned twenty-seven . . . *very* recently."

"Well, I guess I should give you a belated birthday gift," he said with a grin.

"Ha! As if I'd accept a gift from a scoundrel like you," she replied, feigning disgust. They both laughed quietly. "And now you must answer in kind," she said. "Come on, out with it."

He teased her as long as he dared. "I recently turned thirty-four . . . *very* recently."

"So, I suppose you'll be expecting a belated gift from me."

"You already gave it to me, last night," he said with a wide grin of satisfaction.

Her mouth fell open. "Oh, you are depraved." They chuckled, holding each other's gaze, each reliving every detail of last night together.

Finally, he turned to look back out into the fog. "Celeste, tell me about your father," he said after his smile faded.

"My father's a wonderful man. He's always taken good care of me and Jonas. The only time he wasn't there was when he had to be away on business."

"I assumed he must've been gone a lot, building his trade empire."

"Yes, but even then, he often took us with him, all three of us," she continued. "We traveled by ship a lot. I love to sail. I've been to the twin cities and the City of Queens many times. I've even been as far away as Port Haven in the kingdom of the Chateau Demond," she said proudly.

Hunter suddenly looked at her. "You've been to Port Haven?"

"Uh huh. When I was ten and Jonas was twelve, all four of us sailed there together. We stayed all winter—I loved it. It was so beautiful, with the mountains rising straight up into the clouds. I remember as a child, I really thought you could climb high enough in the mountains to throw a rock into the ocean," she said with a giggle as he smiled at her.

"Then I went back three years later. Father took us there after Mother died," she said, looking down. "The last time I was there was about eight years ago. I've never got to see the rest of the kingdom, though. I've heard stories of 'the city in the clouds,' the Chateau nestled high on a mountaintop. I can't imagine what that's like. I'd love to see it someday," she said, smiling.

I'd love to show it to you someday, he thought, looking at the woman he so desperately loved. "So, what takes you there?" he asked.

"My father is good friends with a master shipwright there and—"

"Drew Butkus," he softly interrupted.

She looked at him with her mouth open. "You know him?" she asked in disbelief.

He smiled and nodded. "Please, continue. Tell me more."

"I, uh, I remember Drew had the most beautiful lodge. It was right on the edge of the harbor near his shipyards. And the deck on the front, it came out to a point like—"

"Like the bow of a ship," he politely interrupted again.

As he smiled, she slowly raised her hand to her mouth. "Oh my, Hunter, are you from the Chateau?"

He looked away and slowly shook his head in confirmation. "I used to play on the bow of that pretend ship when I was a child. I'd stand behind the wheel, spinning it back and forth to advantage my ship for an attack on the enemy. And up in the very end—"

"Was a bench I would stand on to look over the rail, down into the waves below," she interrupted. They looked at each other, smiling at the irony of them having shared a common place in their childhoods. It was especially poignant, given their previous meeting last year at her father's mercantile.

"Yes, that's right," he said. "I've stood there, too, on that very spot. In fact, one time, my brother and I got caught standing up there peeing over the rail into the sea," he said with a chuckle. "Did we ever take a switching for that one?"

She laughed at his story. She could see the images of a typically mischievous boyhood flashing through his mind, and she didn't want his happiness to end. She watched him, elated as he relived memories of his homeland before finally falling silent.

"I'm surprised you shared all that with me, Hunter. I mean you haven't said much about your past."

He smiled fleetingly as he looked out into the fog. Then he turned to her with a serious expression. "Things are different now, Celeste."

She fought tears as they looked at each other. She knew what he meant. She knew he loved her as she loved him. And it scared him. If she'd ever known a man she thought was truly not afraid of anything, it was him. But for the first time, she saw fear in his eyes and realized it was her that frightened

him, or at least his love for her. Their long silence continued as they gazed at each other, speaking a thousand silent words. Finally, without breaking their eye contact, he slowly stood up. He looked down at her, his bare, muscular chest heaving from the excitement welling up inside him.

"I love you, Celeste."

Tears of joy streamed down her cheeks. After spending last night in ecstasy together, it meant so much to hear him say those words. When she stood to face him, she released her grip on the blanket, letting it slide off her shoulders. He lowered his eyes, drinking in her sensual beauty, and when their eyes met again she slowly stepped into him as his strong arms enveloped her.

"I love you too," she said softly before turning her head to press her cheek to his chest. He slid a hand up her bare back and ran his fingers through her long hair while he gently kissed her forehead. She still clutched a corner of the blanket, so he slipped it from her hand, draping it once again over her shoulders to close out the chill. She leaned back so he could pull it together in front of her, and then she reclaimed her grip while their lips met. He gently cupped his strong hands around her face and lingered, savoring the wet taste of her. Finally, their tongues and lips parted, and he reached down to pick up his sword. She watched him with great anticipation while he again scanned the terrain outside the mine entrance.

Then he turned back to her. "Like you said, we have some time to kill."

They exchanged a knowing smile as he put his arm around her, and they turned to walk back inside.

CHAPTER ☩ 19

Hunter emerged from the mine with his horse in tow. He stood for a moment, silently scanning the surrounding forest and steep hillside, using all his senses to warn him of danger. Once satisfied, he gave a subtle gesture, and Celeste stepped out to join him. They carefully made their way down the field of loose rocks, and when they reached solid ground, he mounted and leaned down with a hand extended. Grasping each other's wrists, she leapt while he straightened up, twisting in the saddle. He swung her around behind him as she spread her legs, settling across the horse's rump.

"Ready?" he asked once she was situated.

"No, wait." She placed a hand on his cheek and turned his head toward her, giving him a brief kiss. "All right," she said with a giddy smile.

He returned the smile and coaxed his mount forward.

Four hundred feet away, the parted limbs of a large pine tree slowly moved back together. She smiled and let go of them as her free hand brushed the hilt of the scimitar slung by her side. When she looked at him, he gave her a satisfied grin.

"Told you."

She headed to her mount. "Don't gloat; it's rude."

He chuckled softly as they untied their horse's reins from a nearby tree limb. "I knew when I saw it that was the perfect place," he added, settling in the saddle. They reined around and took a course that would intercept Hunter's path in a nearby clearing.

Hunter moved slowly through the trees and hadn't gone far when he suddenly reined up at the edge of a small opening in the forest. Celeste leaned to look over his shoulder, keeping her hands locked together in front of him in case they needed to bolt away. The longer he gazed into the clearing with his head atilt, the more alarmed she became. Then she heard it too. *Horses*, she thought as fear crept in.

Earlier, while they dressed to leave after making love again, vivid memories of her abduction unexpectedly flooded her mind, overwhelming her with anxiety.

He was discretely watching her, savoring her beauty, and noticed her look of distress. "Celeste, what troubles you, love?"

She looked at him, visibly shaken. "I want your dagger."

He raised an eyebrow.

"I won't let them take me again, Hunter . . . ever," she said in a quivering voice. After studying her briefly, he reached out and drew her to him. Tears silently rolled down her cheeks as she stood with her face turned against his bare chest. He knew what she meant. She would take her own life before letting them get their hands on her again. He reached down and lifted his sheathed dagger from the nearby table, placing it in her trembling hand as he gently kissed her forehead.

"I love you," he said, releasing her and turning away to dress.

She was startled back to the present when he spoke.

"Celeste, I want you to get down," he whispered, reaching a hand behind him for her to take and let herself to the ground. She didn't question, just took his hand and started to slide off.

"Wait," he said. "It's all right."

She looked across the clearing to see Gustin and Erin emerging from the trees on their mounts. She was relieved when Erin waved to them.

"Oh, thank God," she said as Hunter patted her leg and coaxed his horse forward.

"Hello," Gustin said, reining up. "Sorry I couldn't catch you

last night. You two were already gone by the time Flynn and I got there."

"That's all right," Hunter replied. "Everything worked out."

Erin eased her mount closer. "You all right, Celeste?"

"Uh huh," she replied as they leaned together and hugged. "How's my father?"

Erin's expression changed. "He took it real hard, till Gustin and Flynn got back."

"What do you mean?" Hunter asked.

"The Rendovan," Gustin broke in. "She showed up wanting to arrange a trade at dawn . . . Celeste for the gold."

"What?" Hunter asked in surprise.

"Yeah, by the time we got back, they'd already agreed to it, but I told Hollis they didn't have her. Flynn and I were sure she was with you. We knew you'd likely head into the hills to find shelter."

"Did they come for the gold?" Hunter asked.

"No. We waited in the forest, but they never showed."

"Thanks for taking care of him," Celeste said. "Hunter, I want to get back to my father."

"All right."

They set out together through the forest, now comfortable with a faster pace.

/// \\\

It was nearing midday, and the thick morning fog had burned off. The few remaining clouds were dissipating, and sunlight bathed the knoll. The wagons were hitched up with everything loaded. Despite the relative safety of daylight, Lance still required a watch. Those not assigned were struggling with boredom, and everyone eagerly anticipated the amenities of Bard's Landing.

Fae stood in the road where Hunter had fought his battle with Edmond last night. She allowed her mind to drift back

to their fight and couldn't help but consider what the Elder had told her years ago when she was training with Telfari. *Could this be my destiny? Facing the Shadow Knight?* She'd been amazed at the agility of both men when she watched them duel. And she desperately wanted to know more about their past. *Who was this witch that now lived in Edmond? And what was the curse?* It appeared that's what had put the rift between the old friends.

"May I trouble you to walk with me?"

She'd sensed Hollis approaching before he spoke, and she smiled, trying to purge her distracting thoughts. "Of course. Where are we going?"

When he feigned a smile and pointed to the knoll, she glanced up to see Flynn sitting atop his mount on the crest. She fell in beside the merchant, and they walked across the soggy ground to the base of the hill. She worried about him. The morning had seemed to drag on forever with them just waiting for their missing to return. They silently trudged on, eventually cresting the hill.

"You all right, sir?" Flynn asked when they drew near.

"Yeah, just a little winded," he replied. "The first time I walked up here and looked over this clearing was before you were born. It was easier back then."

Flynn smiled as he and Fae exchanged glances. "Well, sir, I was just heading back to camp; be glad to leave you my horse."

"No, son," he replied. "I'm up here now; I can roll back down."

Flynn just chuckled and coaxed his mount forward, leaving them alone.

After he rode away, they stood silently with her anxiety growing.

"Sir, why did we come up here?" she finally asked.

"She's not coming back to me, is she?" he replied, still looking away.

She looked at him in surprise.

"That's what's taking so long," he added, turning to face her.

"Hollis, we don't know that," she replied. "Listen, the worst thing we can do is jump to conclusions. This delay could mean anything. Please, sir, I know it's hard, but all we can do is wait and pray for her safe return."

He nodded. "Forgive me; I'm just a mess right now," he said, looking down.

"Hollis, what did Lance mean last night when he said it wasn't your decision if Janae went with them?"

He looked away again through another uncomfortable silence.

"About ten years ago, we were headed back to Port Estes from the capital with our laden wagons when some robbers attacked us," he finally began. "It wasn't the Shadow; this was before them. Anyway, my son Jonas was with us, and they captured him and one of the hired hands during the fight. They threatened to kill him, and of course, I was willing to give them anything. Fortunately, we got them back safe without giving up the freight. But after that, Lance and I agreed that if the situation ever came up again, he would make the decisions. It had to be that way, for everyone's sake. He knows I'd give all that I own for my children—either of them—but especially for my precious girl. Now, I don't love Celeste more than Jonas . . . just differently. He's a grown man. Just an overprotective father's point of view, I suppose."

She leaned into him, and he placed an arm around her.

"In case you haven't noticed, sir, she's a grown woman."

He smiled and looked down at her, just about to speak again when they heard yelling in the camp. They looked to see some were pointing down the road at the edge of the clearing. Fae's heart leapt at the sight of four riders approaching on three horses.

"Look," she said.

"Celeste," she heard him utter as he released her and started down the hill. She easily caught up and stayed beside the portly man as he ran, sliding nearly out of control, to the

bottom of the muddy knoll.

"Celeste!" he yelled when they made it to level ground.

Before Hunter reined up, Celeste's eyes were darting about camp, searching for her father. Then she heard him call out.

"Father!" she yelled, taking Hunter's hand and sliding off. He leaned over until her feet hit the ground, and she took off running. "Father!"

"Oh, Celeste!" They came together and embraced as they wept. "Oh, my precious child, you came back to me." He buried his face in her long hair and held her tightly.

Fae cried, and when Gustin approached, she went to him.

"Fae, I'm sorry I left this morning with you angry at me," he said, holding her.

"Forget it. Everything's all right now," she said before their lips met.

Once Hollis regained his composure, they walked back to camp together.

Everyone gathered to greet Celeste and ask about last night. Hunter answered their questions while she and Janae embraced and wept. She saw Lance approaching and reached for him.

"Oh, Celeste," was all he could say, holding her tightly as he fought to hold back tears.

"I'm all right, Lance," she assured him. He just smiled as she kissed him on the cheek. After a short frenzy of excited conversation, she retreated to the welcome privacy of her wagon to clean up. The women—sans Fae—joined her as Lance regained his usual gruff demeanor and started barking orders to the others. When he walked away to oversee them, Hollis approached Hunter and extended a hand.

"Hunter, I can never repay you for this. I did not know what fear was until last night, worrying about her. You've given me my life back."

"No thanks needed," he replied, shaking his hand firmly. "Just doing what I promised, sir, looking after her."

Hollis smiled. "Come now, son, it was more than just keeping your word to me."

Hunter felt a sudden discomfort, wondering if Hollis somehow knew he'd lain with his daughter. *Is he testing me? Or is his choice of words purely coincidence?* He glanced over at Gustin who stood with an arm around Fae. They both looked on as if awaiting his response.

"Well sir, it is more than that," he finally admitted. "I care deeply for Celeste."

Hollis nodded, continuing to smile. "I know, son. Perhaps when we get to the city, you and I should make the time to discuss my daughter's future, yes?"

"Yes, sir."

"Well, I think Lance is ready to go," he added, seeing him approach on his mount.

"That's right," Lance said. "If we're going to make Bard's Landing before dark, we must go now."

"All right, my impatient friend," Hollis replied.

Celeste and the other women exited her wagon to join them on horseback, and soon they pulled away from the clearing, entering the forest once again.

Derek's sister Krysta now drove the lead wagon, and she followed Lance's order to push her team hard. Just when the huge drafts were showing signs of tiring from the pace, they broke out of the forest into a vast open meadow. She slowed the column to a more reasonable pace, continuing on until they came to where the high road rejoined the main highway. Where the two roads met, there was a large open area scarred with wagon tracks, so they pulled up to rest the animals.

Two farmhouses could be seen in the distance, one near the road up ahead and the other across the meadow, nestled in the edge of a large stand of trees.

While they rested, Lance rode up. "Boss, I'm going to make a little side trip," he said, gesturing across the meadow.

"Good idea," Hollis replied. "Just take someone with you."

"I thought I'd take Flynn and—"

"Erin and I will go," Fae said. She needed to get away from camp.

"All right," Lance replied.

"So why are we going?" she asked.

He chuckled. "Hollis and I are friends with the family that lives in that big house over there. They farm and raise cattle in these fields. They keep an eye out; know when strangers come and go."

"I see," she replied. The women mounted up and the four of them set out while the others tended to their duties. Lance had made it clear that Derek was now his second in charge in his absence, answerable only to Hollis.

Hunter and Gustin worked together, tending to their horses.

"Hunter, I want you to know how sorry I am we let them take Celeste last night," Gustin said sincerely.

Hunter glanced his way and smiled.

"I must tell you, my friend, as I rode after her last night, I'd have been hard-pressed to accept anyone's apology. I was mad—scared for her—for what they might be doing to her. Thank God I reached her in time. Then later, I realized no one did anything wrong. It just happened. . . . Anyway, she's all right," he said, handing Gustin a piece of dried meat from a pouch in his saddlebag before retrieving one for himself.

Gustin took it with a nod, relieved their friendship had survived the near-tragic incident.

"Is the mage putting a move on Janae?" Hunter asked, seeing them sit together.

Gustin smiled. "Guess so. I didn't see it, but Fae said she couldn't believe the way he defended her last night. Put the Rendovan on the go—nearly choked her to death with a control spell."

Hunter glanced over at him. "I'm afraid I was distracted, but I assume he took care of Edmond's wizard for me last night."

"Yeah, fried him like a fish in a skillet."

Hunter grinned. "Well, I suppose the proper thing would be to go say thank you."

They looked at each other briefly. "Nah," they said in unison, before chuckling.

After a while, Lance and Fae returned to the wagons while Flynn and Erin stopped short and dismounted to walk along the road and examine tracks.

Lance rode up to Hollis. "They said their field hands saw eight to ten riders go past early this morning headed toward Bard's Landing at a good pace. The younglings say that matches the tracks they've been seeing all morning."

Hollis thought briefly. "So, they've gone ahead. Another ambush?" he asked, looking over at Hunter and Gustin who'd just walked up.

"Ten of them? Not a chance," Gustin said.

"No," Hunter quickly agreed. "They're not that reckless."

"Well, we can just make it by dark if we get moving," Hollis said.

"You have a place to put in?" Fae asked. "It is the last days of winter festival." Hollis smiled at Lance. "Yes, Fae, it's been taken care of."

"All right, let's move out!" Lance roared.

Everyone responded, and soon they were underway. Again, Krysta pushed the lead team at a robust pace along the muddy Queen's Highway, forcing the other teamsters to work at keeping up. The sun raced toward the mountain peaks behind them as they rolled through the sprawling meadow with its occasional stands of trees. Eventually they began passing cultivated fields being prepared for seed. This was fertile cropland, and the shacks and houses of those who owned and worked it were appearing more frequently. They exchanged pleasantries with some local travelers on the road who were returning home from a day trip into town for supplies. Workers labored in fields, some close to the road, others afar off. It was common to see them stop to wipe sweat from their brow

and wave to those in the column as it passed by.

"That's not the life for me," Draigistar said, returning a wave to some small children who played in a muddy field while their parents and older siblings labored.

"I hear that," Flynn agreed.

"Look too much like work?" Erin asked them, recalling how she'd loved to work the garden with her mother when she was a little girl.

"To rise and rest with the sun, and look at the same fields day after day? No way, not me," Draigistar replied. "Look behind us. How could you gaze upon those mountains without needing to know what lies beyond?"

"Maybe they do know," Erin countered with a wide grin.

Flynn chuckled, keeping his eyes on the road.

"Well, you have me there," the mage said, smiling at her.

"I know what you mean," Flynn said. "I could never be tied down. Seems I always have to know what's over the next hill, or beyond the next river. Just can't help myself."

Erin discretely glanced at him admiringly. She was attracted to him. He was handsome and knew how to take care of himself. He loved the wilderness and the adventures it brought. They were so alike. She felt good inside when she was near him.

Behind them, the others rode in pairs or small groups, conversing and laughing as they watched for signs of danger. Strangely, it was like they'd returned to the first day of their journey. That was the last time they were this at ease. The afternoon passed uneventfully with two more stops to rest the horses. At last, with the sun disappearing over the mountains, they gathered near the lead wagon on the hill that overlooked the bustling town of Bard's Landing. It was laid out unusually. The Skull River flowed down from the north and snaked its way around the base of some cliffs before gently turning eastward, flowing on to the Endless Ocean.

The cliffs where they now stood marked the eastern end

of a large plateau that extended out from the base of the Skull Mountains. Bard's Landing had begun as a camp along the banks of the river where travelers gathered to trade while a few resident bards entertained them. When the Queen's Highway was built through it to link the capital to the north shore region, it became a boom town. It rapidly expanded, and with the river to the east and cliffs to the west, it naturally grew along the banks. Today it was a bustling town with numerous merchants, shops, inns, pubs, and brothels. Several small warehouses crowded the banks where a few busy docks jutted into the wide river to accommodate the barges and small ships that ventured up from Eastwick and the capital. As they stood there looking down upon it, dusk was invaded by the bright lantern light coming from most of the windows in town. The light breeze rising off the riverfront carried the sounds of the laughter, music, and festivities that flourished below.

"Sounds like a big party," Erin observed.

Her friends smiled.

"You've not been here before, have you?" Hunter asked her.

"Nope," she said, shaking her head without looking up from the captivating view.

"That's pretty much what this town is," Draigistar said, grinning. "Can't wait."

"You stay away from the harlots," Fae said.

Erin giggled with a wide-eyed expression, and the others laughed.

"Boss, should we send someone ahead?" Lance asked.

"No. We're expected."

"Where are we going?" Gustin asked.

"Do you know a man named Rimick?"

Gustin thought briefly. "No. A friend?"

"Yes, for years."

Rimick. Hunter thought back to his former life with mixed emotions. *I wonder if he'll remember me?*

Celeste noticed his distant expression. "Hunter? You all

right?" she asked, prompting the others to glance his way.

"Uh, yeah, I'm fine," he replied with a feigned smile, "just lost in thought."

Their exchange wasn't lost on Hollis.

"Father, I didn't know you planned to stop there," she said. "They'll have room?"

"Yes, child. I arranged for his inn to be ours."

"Now we just need to get there before dark," Lance said impatiently.

"Indeed, let's go," Hollis said with a nod.

"Mount up!" Lance yelled as he turned away, headed for his horse.

Erin jumped, startled by his sudden outburst. "Oh, I hate it when he does that."

"Erin, I've heard that my whole life and he still makes me jump," Celeste said.

Hollis laughed heartily as he walked away.

They mounted and started down the hill toward town. Halfway down, the road forked. Going straight would lead them into town, but Lance veered right on a less-traveled road that turned south, clinging to the steep hillside beneath the cliffs overlooking town. The two families traveling with them planned to stay with a friend in town, so with parting waves they stayed on course and were soon out of sight.

The group continued on, passing some houses and a small barn. Eventually they emerged from the trees and the view opened up to reveal a beautiful lodge sitting high up near the cliffs with a dozen or so small cabins of similar design dotting the steep hillside below it. The road split again, with one leading up to the main lodge and the other leading down to barns and a few outbuildings among some corrals. Lance continued on toward the barns with Flynn and Erin by his side, and Krysta following.

"Come, join me," Hollis said, glancing at Hunter and Celeste. He reined his horse up the road toward the main lodge

as he looked over his shoulder. "You're welcome too," he said to Gustin and Fae who rode close behind. They spurred their mounts to catch up as Hollis rode up in front of the lodge. A young woman stood talking to a man, then he abruptly turned away and started down a wide path of stone steps that led past the cabins to the buildings and corrals below. When she saw them coming, she smiled and waved.

"Wynette!" Hollis said in a robust voice.

"Mr. McNeill!" she replied, heading to meet them.

"My, how you've grown, girl," he said as he dismounted and gave her a hug.

"I'm not a girl anymore," she corrected him.

"Yes, I can see that. How old are you now, young lady?"

"Just turned fifteen," she said proudly as the others dismounted. "It's so good to see you, Celeste," she said as they hugged. "I was excited when my father said you were coming to see us. How long can you stay?"

She looked at Hollis. "Well, I don't know. Father didn't tell me we were stopping."

Wynette scowled at Hollis. "Now how's a woman supposed to make plans when a man won't tell her anything?"

"Ha ha!" Hollis laughed heartily. "Young lady, you sound just like someone else I know."

Celeste reached out and playfully slapped him on the shoulder.

"Forgive my manners, dear," he said. "These are some of our friends. This is Gustin, Fae, and Hunter," he added with a gesture toward each one.

They each said hello, and she responded in kind.

"So where's that scoundrel who built this magnificent place?" he asked, glancing at the front of the lodge.

"He's down at the barns. Oh no, there he is now," she said, gesturing. They saw him walking up the stone steps, nearing the top. He was a tall, distinguished-looking man, rugged yet sophisticated.

When he saw them, he smiled. "Hello, my old friend."

"Good to see you," Hollis said, shaking his hand. "How was your return trip?"

"Fabulous sailing," he replied, searching the faces of the others. "Celeste, it's so good to see you," he said, hugging her briefly.

"And you," she replied with a smile.

He glanced over her shoulder at Hunter, and the two men held each other's gaze briefly. "William. It's been a long time," he said with a smile, offering his hand.

Hunter eagerly shook it. "Yes, it has. I wasn't sure you'd remember."

"Of course I remember you, young man. And I'm sorry about Andrew. I was saddened when I heard the news."

"Thank you."

Celeste's eyes danced between Hunter, her father, and Rimick. "Hunter, I thought I heard the Shadow Knight call you William last night," she said. "What's going on?"

"The Shadow Knight? Edmond White?" Rimick asked, surprised.

"Yes. They fought last night," Hollis said.

Rimick looked at Hollis and then at Hunter. "Kill him?"

"No. He got away."

"Oh, too bad," he replied, "the miserable wretch."

Ignoring his comment, Hunter looked down at Celeste. "Celeste, my birth name was William," he said. "You already know I'm from the Chateau. The rest is, well, complicated. Let us get settled in, and I'll explain it to you this evening."

"Uh, excuse me. Explain it to whom?" Fae asked.

He smiled and looked at Fae. "As promised, I'll explain to you too."

Rimick stepped forward and spoke. "And hello to you," he said, looking at Gustin and Fae. "My name is Rimick Bordo, and this is my daughter, Wynette."

"Hello," he replied, offering his hand. "I'm Gustin, and this is Fae."

"Forgive me, I must ask have we met?"

Suddenly it came to Gustin. *That night at the lodge.* "I, uh, I'm not—"

"Oh, of course, I remember now," Rimick interrupted. "You were the rowdy couple in the room across the hall that night in Port Estes," he said with a smile.

"That would be them," Hunter said, having no idea what he spoke of.

Fae shot him a narrow-eyed glance.

"I'm sorry, I didn't recognize you, Fae," Rimick said, gently taking her hand. "You have more clothes on than the first time we met," he added before kissing the back of it.

She silently looked down, raising her other hand to her brow.

Hollis roared in laughter, and Celeste and Wynette giggled at her embarrassment.

"You really must share this tale," Hunter said, grinning at Gustin.

When Rimick released her hand, she turned away. "You're a dead man," she told Gustin through gritted teeth, causing another brief eruption of laughter.

"Listen, you are all welcome," Rimick said. "There are plenty of rooms in the lodge, and we have a couple of empty cabins for those who, uh, require more privacy," he said, grinning at Fae.

"I'll take care of the horses while the rest of you go get settled in," Hunter said.

"No, we'll do it," Fae countered. "You stay. Sounds like you've got some catching up to do, *William.*"

He smiled at her. "All right, if you're sure."

She nodded before effortlessly vaulting into her saddle as Gustin mounted up.

Lance had led the wagons down to the complex of barns and corrals, and the teamsters now worked feverishly, un-hitching tired animals and tending to them for the night. By

the time Gustin and Fae arrived with the other mounts in tow, the doors to both barns stood wide open and crews were busy with their assigned duties.

"Lose someone?" Draigistar asked.

"No. They stayed up at the lodge," Gustin replied.

"We're invited to *dine* this evening," Fae added, feigning arrogance.

"Well, aren't you high and mighty," the mage replied with playful sarcasm.

"All of us are invited," Gustin said, smiling.

"Sounds like it shall require my best behavior."

"That's what concerns me," Fae said as they coaxed their mounts inside to where Erin had saved them adjacent stalls.

Rimick slowly walked toward the front door of his lodge with his arm around his teenage daughter. It was made of finely crafted, heavy timbers, and expertly constructed with a unique method Rimick had developed years ago. A large wooden porch ran the full length of its grandiose frontage, sporting an impressive collection of wind chimes that tinkled in the gentle breeze rising off the river. Hollis was on Wynette's other flank, and Hunter and Celeste walked behind. Rimick paused to have a brief word with his hireling who stepped off the porch and passed them on his way down to the barns.

Inside the front entrance, the lodge opened into a great room with huge, identical stone fireplaces at opposing ends of the vast expanse. On the front wall, large windows offered a clear view of the town and riverfront below, and the fertile fields of the provincial heartland beyond. A vaulted, timber ceiling rose high above them, and a second-floor balcony over-looked the opulent space. A wide wooden staircase led up to the second floor, and to one side was a large wooden counter with a man and a woman standing behind it. To the other side they could see a large, open dining area with a score of tables placed strategically throughout. A few people sat enjoying their evening meal, and the inviting smell of prepared food

invoked their appetites.

"Good evening, sir," the young lady said to Rimick.

"Gemma, our guests have arrived at last," he replied, releasing Wynette and placing his hands on the counter. "We'll need keys so they can get settled in."

"Yes, sir. And welcome everyone," she said, politely addressing the newcomers.

They nodded and returned her greeting before Rimick spoke again. "This is Gemma," he said. "She runs things around her, including me in my wife's absence."

"Oh, sir," she said, glancing away shyly.

He smiled at her. "Anything you require, just let me know," he continued with his guests. "Tad here will show you to your rooms, and he can send our people down the hill to carry up any of your personal things you may need. I'll go tell the cooks to prepare us a feast. And then I'm afraid I have a matter that requires my brief attention."

"Thanks again for your hospitality," Hollis said.

"Oh, please," he replied. "I look forward to this evening. And William, it really is good to see you," he said, looking at Hunter.

He smiled and nodded as Rimick turned and headed back to the kitchen. Tad and Wynette showed them upstairs to sleeping rooms as lavish as the rest of the lodge.

Celeste chose a large suite and sent word to Gemma that the other women in the party were welcome to share the ample space. Now she sat relaxing neck deep in a large copper bathtub in her room, her clothing thrown on the hardwood floor in a pile. The chambermaid had the tub filled with hot water, and she wasted no time disrobing to enjoy its caressing warmth. Hunter claimed the room across the hall. And then, to the maid's obvious dislike, he rejoined Celeste in her spacious suite. Now he sat in a chair on the private balcony overlooking the great room below. He stationed himself there to give her privacy while remaining close enough to protect her. She had

assured the maid it was all right for him to be present when she began doffing her clothes. He politely turned and retreated to the balcony while the maid just shook her head and left the room.

"Hunter," she now called to him invitingly.

"Yes," he replied, sitting with his back to her.

"I, uh, dropped my soap. Could you come get it for me?"

He smiled. "Liar," he said, turning his head just enough to project his voice into the room.

She smiled widely, continuing to bathe.

He closed out the distracting noises from below and listened intently to the sounds she made. Her movement in the tub as she ran her soap-slicked hands over her skin and dipped up the water to pour over her, stirred him inside. His mind took him back to last night, to the sight of her lying nude on the bed of pelts by the fire, eagerly waiting for him to make her his. The way her body felt when he made love to her, the way she reacted to his touch, and the things she did to please him. He'd never imagined he could feel the way she made him feel.

After a while, she spoke again. "Hunter, come to me. I just want to talk, really," she said, fighting to keep a straight face.

He chuckled quietly before he stood and turned to look through the doorway.

When their eyes met, she grinned coquettishly.

"Liar," he said again, causing her to giggle.

She raised a hand and curled her finger in a summons. He found her wet hair, slicked to her head and trailing down her shoulders into the water, provocative. When he started toward her, she straightened and leaned back in the tub, letting her ample breasts pierce the soapsuds. Already primed from his thoughts of last night, he felt the discomfort of his body's involuntary reaction while he savored the sight of her. She knew his dilemma and smiled in satisfaction as she leaned forward, submerging her bosom. When their eyes met again, her smile faded.

"Hunter, I love you," she said sincerely. "I want to be with you always. . . ."

He knelt next to the tub, leaning close to her.

"And I want to be with you always," he said, reaching over the edge of the tub and gently stroking a fingertip on her wet cheek. "But we must be patient. I made a promise to your father. Let us complete this journey. Then there will be time for us," he added, holding her intoxicating gaze.

"All right," she replied at last.

He leaned over the tub, and they kissed. They lingered with their eyes closed and their lips touching, savoring the sweet taste of each other as they had when they made love. At last, he withdrew, and was just about to speak when they heard footfalls in the hallway outside her door. He quickly stood as the lock rattled and the door opened. When Erin and Janae stepped in, they stared wide eyed as Erin raised a hand to her mouth.

"Well, excuse us," Janae said, smiling widely.

"Oh, shut up, you two," Celeste replied, embarrassed. "And shut the door."

"Should we come back later?" Janae asked, causing Erin to snicker.

"No, ladies. I was just watching over her until you got here," Hunter said.

"Yeah, you were watching over her all right," Janae replied teasingly.

As Erin turned away trying to subdue her laughter, he realized his poor choice of words. When Celeste covered her face with her hands and silently slid beneath the suds, he simply smiled and walked past them to the door.

When he stepped into the hallway, Janae spoke again. "Hunter, may I call for you when it's my turn to bathe?" she asked, causing Erin to burst out in laughter.

Without looking back, he shook his head in embarrassment and pulled the door shut behind him, pausing with a

smile when he heard them teasing Celeste. He walked down the hallway, carefully counting rooms and taking notice of two unmarked doors, then went downstairs to speak with Gemma about the other guests in the lodge. With the work down in the barns finished up, others in the group were being shown to their rooms as they arrived. He saw Gustin and Fae talking with Lance and Hollis and caught the end of their conversation when he approached.

"Well, all right, if you're sure," Hollis said.

"I'd feel better if I could keep an eye on things, boss," Lance replied.

"Something wrong?" Hunter asked.

"No," Gustin replied. "We were just telling Hollis we've decided to take one of the two empty cabins for the night, and Lance is staying in the other one."

"It's down at the bottom of the hill by the barns and corrals," Lance added. "I'd feel better if I could keep an eye on things."

They all exchanged a discreet, knowing smile.

"Seems these two are taking Rimick's advice about more privacy," Hollis said.

"Really," Hunter said, looking at Fae.

She playfully thrust an elbow into his ribs, causing the others to laugh.

"Staying alone?" Hunter asked Lance when the laughter subsided.

"That was my concern," Hollis interjected.

Lance smiled. "No, I recruited one of the men—one who doesn't snore."

They all laughed again.

"Listen, I think we need to have some rules," Gustin said. "For now, there seems to be enough of Rimick's people around, but I think once we've settled in for the night, no one should venture out alone."

"Yes, we know the Shadow are here in town somewhere," Hunter added.

"I agree," Hollis said.

"I'll see that our people comply," Lance said. "Some are itching to go into town and let off some steam. I'll make sure they go in groups and check in with one of us when they leave and return."

"Good," Hollis replied just as Rimick walked up.

"Gemma tells me you two decided on the privacy of a cabin," their host said.

"Yes," Gustin replied with a grin.

"Good for you," he said, glancing at Fae.

She grinned and looked away in embarrassment.

"So, is everything to satisfaction?" he continued, looking at Hollis and Lance.

"Your people were very helpful with the wagons and horses," Lance replied.

"Good. Anything else just let my people know. Besides Gemma and the inn staff, I have fifteen men working for me, all good with swords and very loyal. Four of them will watch the grounds tonight, and a patrol from the army post in town rides by at least twice each night."

"Where does the road out front go?" Gustin asked.

"It follows the cliffs past a few houses, then heads down a steep hill into the south end of town."

"Any more boarding houses on this road?" Hunter asked.

He looked at him, puzzled. "No. We're alone up here. Why? Expecting trouble?"

"Maybe."

"Rimick, the last thing we'd want to do is bring trouble here," Hollis said.

Rimick held up a hand to politely interrupt. "Old friend, you are welcome here; don't ever doubt that. And fret not over the Shadow Knight and his band of cowards. I'll make sure my people are ready."

"Thank you," Hollis said sincerely.

Rimick nodded. "Now then. More importantly, I'm told

our food is prepared, and my other guests have finished. The dining room is ours, so when your people are ready, we'll eat."

"I'll round 'em up, boss," Lance offered.

Hollis nodded in appreciation.

Soon they were gathered in the dining room, seated in groups at the various tables, conversing robustly until Rimick stood up to speak.

"All right everyone! May I have your attention, please?"

The excited chatter quickly faded as they all looked up at him.

"I'd like to welcome all of you to our inn. For those of you who don't know me, I'm Rimick Bordo, an old friend of your gracious employer, Hollis McNeill."

Several began clapping, and then others followed Rimick's lead, joining in.

"Thank you," Hollis said with a smile.

Then Rimick continued. "I'd like to introduce my lovely wife, Vanece, and our beautiful daughter, Wynette," he said with gestures toward them. They both smiled and quickly glanced around the room, nodding at those who made eye contact.

"Welcome, everyone," Vanece said.

A few politely voiced their gratitude before Hollis stood up and they all quieted.

"Rimick," he said, looking at him, then at his wife. "Vanece, on behalf of myself and my people, I sincerely thank you for your hospitality."

Rimick shook his hand to cheers from the others.

"All right, without further delay, everyone eat your fill," Rimick said, waving to summon his staff. The food was served, and a festive atmosphere soon filled the room. Excited conversations overlapped from table to table as they feasted on choices of cooked meats, fresh vegetables, and delicious desserts. Some partook of spirits after Hollis announced he'd accepted Rimick's invitation to stay a second night. Lance wasn't happy about the delay, but agreed the crew could use an extra day

to relax and experience the plethora of diverse entertainment Bard's Landing offered.

Since Rimick's people were patrolling the grounds, Hollis gave his teamsters the night off. Some passed on the meal, heading into town in search of bawdy distractions.

"So, Rimick, may I ask how you and Hollis know each other?" Gustin inquired while they sat around the main dining table.

"Oh, we actually met many years ago when I still lived in Port Haven," he replied.

"You lived in the Chateau?" Fae asked with piqued interest.

"Not the city, but in the kingdom, yes, born there."

"Rimick was the senior apprentice of Drew Butkus, a master shipwright," Hollis said. "I hired Drew to build my first ship. That was, oh, twenty-five years ago?"

"That's about right," he confirmed.

"I've heard it's beautiful there. What took you away?" Fae asked him.

"Love," he said, exchanging a smile with his wife. "Vanece is Armagocian. We met when Drew and I sailed there to build them a fleet of fishing vessels."

Vanece was tall and slender with dark olive skin and long, coal-black hair, a very attractive woman who spoke with a distinct accent.

"Um, what is Arma . . . that?" Erin asked with a confused look.

Rimick smiled at his young guest. "Why don't you explain, dear?" he said, glancing at his wife.

"Sure. Armagocia is a group of rugged, mountainous islands off the coast of the southern kingdom of Ormond," she began. "We are sovereign, but for generations, Ormond claimed our home as part of their domain. When I was young, their king declared a tax on us. Our leaders defied him, so they attacked our men when they went out to fish, and raided our coastal villages. We grew crops and livestock but were dependent on

our fishing. We needed bigger, better ships so our men could go out in large groups with weapons to defend themselves. So, some of our men sailed to the Chateau and convinced Drew to come see our home and build ships to suit our needs. When he came, Rimick was with him," she said, looking at her husband admiringly.

He smiled and placed his hand on hers.

"Rimick stayed for three years," she continued. "He managed the construction of our new ships and taught our men how to build and repair them. He even helped defend our villages when the Ormondians came. Then, at last, we were ready. We took the fight to them. We reclaimed our fishing waters and chased them from our shores," she said proudly. "I was the age Wynette is now when he came to our islands, and we slowly fell in love," she said, looking at him.

After exchanging a smile with his wife, he looked over at his daughter. "Don't get any foolish notions, young lady."

She silently looked away, rolling her eyes as laughter erupted around the table.

"So how did you end up here?" Gustin asked. "This is about as far from home as you could be."

They smiled at each other, still holding hands. Then Rimick spoke.

"It's what we wanted. . . . Turned out, no matter what I did for the Armagocians, I would never be accepted. Vanece and I loved each other, and she was of age. So, despite her parent's protests, we left Armagocia and returned to Port Haven together. We married and lived there for a while but found we didn't fit in there either. Drew is a gentleman and my friend. But there were those among Port Haven's elite who spared no effort to make us feel unwelcome, unworthy of their presence.

"So, when Drew told me he'd been offered a lucrative contract to build the largest inn in Lake City, I eagerly accepted his offer to oversee the construction. You see that's my area of expertise. His forte is shipbuilding. The Lakefront Inn was

challenging, something never done before. And Vanece and I wanted out of Port Haven. So, we packed up and moved there for two years until it was finished. After that, I struck out on my own. Drew hated to see us go, but he understood. Anyway, we ended up settling here just before Wynette was born. I built this lodge, and we own some land and livestock up on the plateau. We also have some vineyards across the river on the road to Eastwick. The wine we're drinking tonight is from our own stock. And I still build things: bridges, barges, small ships, other inns like this. We're happy here," he said, looking at Vanece and his daughter.

"I'm sorry things turned out that way," Gustin said. "But I compliment your genius, Rimick. I grew up in Lake City, and the inn that floats on the lake is considered an engineering marvel. Folks come from near and far to let there, a boon to the region for sure."

"Thank you."

A brief silence befell them while Rimick looked across the table at Hunter.

"William, I guess you must've been about the age Wynette is now when Vanece and I left Port Haven."

He looked up at him as he downed the last of his drink. "Yes, that's right. I remember when you left," he replied, setting his empty glass on the table. "I guess I was too young, or perhaps just ignorant of Port Haven society, to have known at the time why you left. But I must say, among many, you were missed . . . both of you."

"Thank you, William," Vanece said with a warm smile. "That means a lot."

"All right, I'm sorry, but I'm confused, Hunter," Celeste said. "It's time for you to explain some things."

"Isn't it," Fae added.

He smiled at Celeste, then at Fae.

"Well?" Fae added, causing the others to chuckle.

"Ladies, perhaps I can help get him started," Rimick said.

"Let me introduce you to Sir William Wyngate, holy knight, son of Lord Richard and Lady Victoria Wyngate, one of the royal families of the Chateau Demond."

Hunter scanned the eager faces around the table. He knew the four had pieced together much of his past, as had Celeste. He took notice of Hollis's lack of surprise.

"Thanks for the help," he said sarcastically, looking at Rimick.

"Don't mention it."

"We're all ears, *William*," Fae said with a smile.

He glanced at Fae, then around the table before his eyes settled on Celeste. He wasn't sure what he expected to see in her expression: disbelief, anger perhaps. Instead, he saw love and admiration, along with her inevitable surprise. He realized at that moment that even though he'd failed to kill Edmond, the time for living in the past was over. He wanted a future with her. He'd told himself that to get close to her was to put her at risk. But now he knew the best way to protect her was to be with her. He wanted to be with her. He loved her. He wanted a story like Rimick's, a story of immeasurable love overcoming all and the lovers living out their happy, content lives together despite what the cruel world threw at them. He drew in a deep breath and slowly let it out while a polite young lady refilled his glass. Then he began.

"I was born William, second to my twin brother, Andrew. I also have an older brother, an older sister, and a younger sister. Our brother Angus was trained as a paladin, and when Andrew and I were five years old, we began our training to follow in his path. And while we already knew Edmond White, that's when our destinies became entwined."

He watched the others exchange glances across the table.

"To give you some history, the Whites and Grabens are the ruling families in the kingdom of the Citadel. It came to be at the same time as the kingdom of the Chateau. You see, we descend from the same people. Three centuries ago, our ancestors lived in a place beyond the southern kingdoms known as

Belvarus. When King Zaul and his army invaded the Belvarun Highlands, the clans refused to unite against a common foe and were defeated, driven from their homes.

"Realizing their mistake, the leaders of the five biggest clans, the Whites and Grabens from the valleys, the Wyngates and Vanguards from the mountains, and the McCunes from the coastland, decided to take their people and flee together to a new home. There were also a few stragglers from the smaller clans who'd survived the purge. With Zaul's army closing in, they cast off in a fleet of nearly a hundred overloaded ships. Sailing for a month through raging winter storms, they lost many vessels. . . . Finally, after a four-day tempest that took twenty ships, the sea fell calm. Cold, exhausted, and out of food and water, they drifted for two more days in a fog so thick the remaining ships were scattered. Then, on the third day, they awoke to a beautiful coastline with snow-covered mountains rising high above the clouds. They came ashore where Port Haven sits today. That's how it got its name.

"Eventually, the Whites, the Grabens, and two smaller clans moved north, settling in the fertile valleys beyond the Mountains of Ice. They established their own kingdom and built the great walled city known today as the Citadel. . . . The rest stayed. And the Wyngates and Vanguards explored the mountains, eventually building their city of stone high on a shrouded peak. They named it Chateau Demond. In the ancient Belvarun tongue, it means 'city in the clouds.'"

"That's an amazing story," Erin said.

"Well done, William," Rimick added.

"So, how many survived the exodus?" Fae asked.

He glanced at her briefly. "Care to pick it up?" he asked, looking over at Rimick.

"Oh no, you're doing fine."

Hunter nodded with a fleeting smile.

"About five thousand people on thirty ships landed that day," he continued. "At least Fifty thousand died in the war,

and another ten thousand were lost at sea. Fortunately, all nine Belvarun clans survived. Rimick's and Drew's families descend from the clan McCune. . . . And I can't help but suspect you already knew who I was," he added, looking over at Hollis.

The merchant slowly nodded. "Yes, Hunter. Though I never knew you as William, I knew when we first spoke that day in Port Estes that you were the lost son of the house of Wyngate. Drew's told me much about you over the years. And I feel compelled to echo what you told Rimick and Vanece. Among many in your homeland, you've been missed. . . ."

Hunter looked at him briefly, expressionless, then lowered his eyes to the table as a barrage of memories invaded his thoughts. In an awkward silence, Celeste slid her hand over the back of his. He looked up and pulled her close as she leaned into him.

Hollis smiled, knowing his precious daughter was reveling in the kind of love he'd shared with her mother.

By now, the conversation at the other tables had dried up, and most of the hirelings had excused themselves. Some turned in while others ventured into town.

"Hunter, may I ask what happened between you and Edmond?" Fae asked.

He glanced at her, then at Janae who was just pulling up a nearby chair.

"Well, as I said, Andrew and I began our training at age five. Edmond was two years older, and we trained together. Our kingdoms have always been allies, and most of the clans have good relations; some have even intermarried. My family is close to Lady Fiona Graben, and Edmond is her nephew, so we spent a lot of time together growing up. Some of my earliest memories are of us playing together. . . ."

He paused briefly with a distant expression before continuing.

"The three of us were inseparable as young men. And upon completion of our training, our final task before passage

into knighthood was a year-long 'quest of enlightenment'." He shook his head. "What do twenty-year-old men know of enlightenment?"

"Certainly not the sort of thing that leads to knighthood," Rimick said with a grin. Vanece elbowed him, and the others laughed.

"Anyway, we decided to journey to the kingdom of Ormond to seek adventure," Hunter continued. "Maybe even search for Palduro."

"The lost city of gold? That's a myth," Gustin said.

"Perhaps. But it was reason enough for three young men to journey that far from home. We had a great time: saw some beautiful sights, met some wonderful people, did some treasure hunting. We managed to keep ourselves out of trouble in a foreign land, until we went through Tuskin on our way home."

"Oh, William, that's a rough city," Rimick said.

Hunter slowly nodded in agreement. "Yes, we discovered that the hard way."

"What happened?" Erin asked.

He looked at her and then back down at the table. "I, uh, got us into a nightmare."

The others at the table exchanged curious looks.

"The day we arrived in town, we rode past a place with a sign out front, the home of a fortune teller. Andrew knew I liked to get my fortune told. Now, I didn't believe in it; it was just fun to laugh at the absurd things they predicted. About the time he suggested I come back there later, an attractive young woman stepped out on the porch and smiled. She waved, so I waved back and that was the end of it, until two nights later.

"We were out walking around town, and I recognized the house, so I talked them into going with me. She was there— invited us in. We began regaling her with tales of our travels, and as we drank wine with her, the embellishments turned into outright lies."

The others smiled at their vision of typically brazen young men in the company of a beautiful woman.

"Eventually, she convinced us to drink simberi," he added. "Then it got really crazy."

"What—what berry?" Erin asked with a puzzled look.

He didn't respond; he was consumed in thought.

Gustin smiled. "It's not a berry, Erin. Simberi is a wine made from fruits and spices that only grow in the southern kingdoms. It takes away your inhibitions."

"Makes you do naughty things you wouldn't do before," Janae whispered loudly.

Erin covered her mouth and looked at her wide-eyed while the others grinned.

"Hunter, you don't have to continue," Celeste said softly.

He looked over at her. "Yes. Yes, I do," he replied. "Everyone deserves to hear it. And I need for you to know this about me."

She nodded before he turned his eyes back toward the center of the table.

Her mind raced. *Did he bed this woman?*

"Once we were drunk, she disrobed, and we all sat cross-legged round the fire pit on the sand floor," he continued. "Desire filled us while the room spun. One by one she took our hands and read our palms, first Andrew and then Edmond— they sat on either side of her. When it was my turn, she stood up and walked through the fire between us. I'll never forget it. A chill ran down my spine when she knelt and took my hand; hers was cold as ice. Let me tell you, I was sober then."

Everyone again exchanged looks across the table, and Fae noticed Vanece touch Rimick's arm. When he looked at her, she nodded toward their daughter.

"Wynette, you may leave if you wish," he told her quietly.

With an expression that betrayed her curiosity, she silently shook her head *no*. Rimick looked at his wife. "She's a young woman now," he said, obviously giving his consent for her to

remain. Vanece conceded, and Hunter resumed.

"Then, she said one of us must take her before she would tell us what she'd read in our palms," he said, shaking his head. "I didn't want anything more to do with her. I told them we should go, but then Andrew passed out, fell back like a stone statue."

Some smiled at his analogy while he continued his trance-like stare.

"Edmond got angry—said I was trying to ruin his fun. He jumped up and started tearing his clothes off. He wasn't himself. I tried to convince him there was something wrong with her. She began helping him disrobe, and when I tried to get up and stop them, he shoved me back. I hit my head on something so hard it knocked me out. When I came to, Andrew was still out. Then I saw Edmond just standing up, gathering his clothes. She was lying on the floor, smiling. . . . He'd taken her," he said with another subtle shake of his head as he relived the images in his mind.

A silence befell them again as they sat there captivated.

"Hunter, is that how he became possessed?" Fae asked.

"Only part of it," he continued. "Andrew woke up while Edmond was getting dressed. Then she sat up—still naked—and began casually telling us what she'd read. She told Andrew a full life was not to be his. She said he would betray me, and his penance would be a life of heartache and misery. Then, he would die at the hand of someone he trusted."

They all traded looks, knowing Edmond had killed Andrew.

"Then she said I was the one who longed for a simple life of companionship with my true love, but I would never have it," he added. "She said . . . she said I would lose my love, my home, and my honor, and spend the rest of my days roaming, lonely and bitter. . . . She said. . . ." He paused with a painful expression and then drew in a deep breath. "She said for me to love anyone was to bring them death."

They looked at each other, then at Celeste. She rested a

hand on his shoulder, looking at him with tears rolling down her cheeks.

He closed his eyes and slid a hand down over his face to regain his composure.

"Then it was Edmond's turn," he continued abruptly. "She told Edmond he was her chosen one. She said since he betrayed his oath of a holy knight to bed her, he would be forever cursed, slowly consumed by the evil in his impure heart. He would commit unspeakable acts until he was despised and driven from his home. He would betray and murder his family and friends. Then . . . then she said one day he and I would face each other and fight to the death. . . . She laughed and said she wouldn't tell which of us would die."

Looks of shock and disbelief were exchanged among the others.

"Now I know what you meant before you fought him, when you said that night was foretold," Gustin said.

Hunter glanced at him with a nod. "Edmond became enraged," he continued. "He called her a whore and told her to shut up. She laughed at him—at all of us—mocked us and called us hypocrites. Then she said she wanted him to see her true form." His expression changed. "Before our eyes, she transformed into an old woman with withered skin, jagged yellow teeth, and sunken eyes of pure evil. She was a witch, a demon-possessed witch. She began chanting in a tongue we didn't know. She looked at each of us and repeated it. Then she spoke in our language, saying she'd cursed us all so her prophecies would come true."

The others sat there stunned by his story as Wynette moved close to her father and he placed a reassuring arm around her.

"She began laughing at us in that feeble, old hate-filled voice he spoke to you in that night," he said, looking at Fae.

She shuddered, recalling it.

"Edmond was still standing," he continued. "And before either of us could react he lunged at her, knocking her down.

He began choking her as he pulled his dagger, but she just kept on laughing. I yelled to stop and reached for his arm just as he thrust the dagger into her stomach. . . . She screamed, writhing in pain, then grabbed him and threw him like he weighed nothing. I froze at the sight of him hitting the wall like a rag doll. Then she slapped me across the face, and I felt like I'd been kicked by a horse. I stumbled back into Andrew, and we both fell down. Then as we struggled to our feet, the screaming stopped. We saw an apparition leave the old woman's body, whishing around the room. We both dove back to the floor, and then I looked up just in time to see it enter Edmond. He was kneeling by the back wall, and when it hit him, he stiffened and fell face-first onto the sandy floor. Then there was silence. At first, I thought he was dead, but then he started moving. Andrew and I got him to his feet, and we got out of there. We ran. We were young and foolish, drunk and scared. We just ran," he said, his voice laced with guilt and remorse.

Again, the others exchanged looks, at last understanding his connection with Edmond White. When Hunter closed his eyes and lowered his head, Celeste slid her hand from his shoulder and gave a consoling pat on the back. The other guests had retired, and Rimick had dismissed the staff, so the dining room was now all theirs.

After a silence, Erin spoke. "Hunter, is that when he became the Shadow Knight?"

He looked up and slowly nodded. "That's where the change started. He convinced me and Andrew that we should flee rather than face the authorities. We were foreigners. We knew the reputation of Tuskin. We knew we'd all either be executed or thrown into prison, so we ran. For weeks we looked over our shoulders till we made it back home.

"Edmond returned to the Citadel. We went back to the Chateau, and I avoided him. I guess the terrible secret we shared had built a wall between us. We started to hear about crazy, mean things he was doing. . . . He wasn't himself, but by

then, we had our own problems."

"What do you mean?" Erin asked.

"You'll recall the witch told Andrew he would someday betray me. Of course, neither of us believed it at the time. But, he did. . . . I was in love with a young woman I'd known my whole life, Stephanie Vanguard. Her father, Lord Stephan is now the ruler of the Chateau. The throne is passed every twenty years between the three ruling families: the Wyngates, the Vanguards, and the McCunes," he said, glancing around the table.

"Stephanie and I had always planned to be married. In fact, we'd announced our intentions before I went on the quest. I didn't know it, but while I was gone, she was facing her own crisis at home. Our parents had decided that she should be wed to Andrew since he was the eldest twin."

"What? That's not fair. She was in love with you," Erin protested.

He looked at her. "That was our feeling too. However, arranged marriages are a tradition in the Chateau. . . . Stephanie's father was never my ally. He tolerated me for her sake, but he despised my independence and penchant for speaking my mind. He thought I was defiant and unruly—a bad influence on her. Anyway, we were devastated by their decision and begged them to reconsider. Finally, they laid it at Andrew's feet. He could relinquish his claim to her hand and allow us to marry. . . . That's when he told me that he, too, had always had feelings for her. . . ." He paused and looked down at his empty glass, slowly shaking his head. "He refused," he finally added in a whisper.

Celeste's heart was breaking for the man she loved. She was beginning to understand his quiet, aloof moods, and the suppressed emotional pain that had made him the way he was.

"Hunter, I'm sorry for what I said that day in Port Estes," Erin said, wiping tears as he looked up at her. "You were right. I didn't know what I was talking about."

He smiled. "Erin, you spoke the truth that day, a truth I needed to hear."

"Is that why you left?" Fae asked him.

"Yes," he quickly answered, looking at her. "It was more than a year after we'd returned home. I'd only seen Edmond a few times, but he'd changed. And I alone knew why. Andrew hadn't seen what happened to him that night, and I never told him. I knew the spirit of that evil witch lived in him. And, I could no longer deny her prophecies were coming true," he said, shaking his head.

"Stephanie and I continued to see each other covertly. And I grew more distant from my family, all except my grandmother," he added with a fleeting smile. "Then, a few days before she was to wed, we stole away together to say goodbye. I knew if she was ever to find happiness, it had to be without me. . . . I took her," he announced as his voice cracked and he paused. "We laid together, made love. . . . It was in desperate longing for the life with her I knew I could never have. But in the years since, I've come to realize it was also to spite my brother, the brother I'd loved my whole life but had grown to hate and resent. . . . Then, I rode away on a miserable, rainy day that matched my sullen mood. Haven't been back since.

"My grandmother was the only other one I said goodbye to. She understood; I could confide anything in her. When I told her of my plan, she was heartbroken. But she agreed that if either of us were to ever have a life, I had to get away from Stephanie.

"So, I left and traveled to the twin cities where I fought in the arenas of Athum for a while, hoping to meet my end. I lost myself . . . lost my soul. Driven by anger and bitterness and inconsolable pain, I did terrible things I would never have done before. I was brutal and apathetic until nothing remained of the kind, idealistic young man I was raised to be.

"I finally grew weary of the arenas but needed to support myself, so I worked as a bodyguard. I contracted to scout for

the military and eventually became a bounty hunter. I hunted criminals, and deserters if they'd committed other crimes. I bagged the ones others failed to bring in; the bounties were higher. I was good at it, earned a reputation. I could name my price to go after those who'd fled into the disputed lands. I didn't want people to know who I'd once been, so I never used my name. People called me Bounty Hunter and eventually just Hunter. So, I let them assume that was my name, seemed as good as any other. . . . Well, that's it, my life story," he said, looking at Fae.

She smiled and nodded as she wiped away tears. "Thank you."

"So, Hunter, what happened to Stephanie?" Erin asked.

He looked at her briefly. "She and Andrew wed and had three children, a son and two daughters. . . . I, uh, heard their marriage was never quite what they'd hoped for. It was in their sixth year when Edmond killed Andrew, and another two years before I heard the news. By then, she'd remarried. I know him; he's a good man. Last I knew, they'd had a son together. Over the years I've occasionally crossed paths with old friends from the Chateau. They catch me up on the gossip."

Now after hearing the whole story, something nagged at Fae.

"Hunter, when I was passing through Forest Moon several years ago, I first heard about the fight between Andrew and Edmond. The people told me he was there looking for his brother. I assume they meant you. Know why?"

He looked at her, shaking his head. "No, Fae. I went there when I heard he'd been killed. They told me the same thing. I suppose Stephanie would know what he sought me for, but I doubt I'll ever find out. . . ."

"So, uh, what do we call you?" Erin asked.

He smiled. "I don't care. Most people know me as Hunter, but you may call me William if you prefer."

"All right," she said with a grin.

After a brief but awkward silence, Rimick scooted his chair away from the table.

"Well, it's been quite an evening, and a delight to see my old friends," he said, slowly standing up. "I usually go enjoy a smoke out on the porch before I retire. If anyone would care to join me, it's a perfect evening. The breeze is just right for the chimes to play us a tune."

"Sounds splendid," Hollis said, standing up.

"Boss, I think I'll turn in," Lance said, coming to his feet.

"I think we'll do the same," Gustin said, glancing at Fae.

"Uh huh," Rimick said in a suspicious tone.

The others chuckled at his inference while Fae and Gustin grinned.

"Don't get too rambunctious. I'd hate to have to charge you for damages."

Hollis laughed heartily, and the others joined in.

"Oh, let them be, dear," Vanece admonished him with a smile.

Fae shook off her embarrassment and walked over to Hunter, where he stood with Celeste. She approached him with arms open, and he reached for her. While they embraced, she looked up at him. "I thought I'd learned a lot about you, but I never could've imagined what you told us tonight. I'm sorry for the pain in your past."

He reached up and stroked her cheek. "There's a reason for it, Fae. We all must take the bad with the good. Every day of our lives, we're just the result of what the days before conspired to make us. If I hadn't left the . . . my home, I would never have met any of you. But now I finally have a reason to live again," he said, looking over at Celeste. "Unless I've scared her away, that is."

She gave him a wide smile. "Not a chance."

"Thank you for finally telling us," Fae said before they released each other.

He smiled. "I admit I'll miss annoying you with it."

"Oh, you're a thug," she said, causing them all to chuckle.

The group slowly dispersed. Erin and Janae had taken Celeste's invitation to share her suite, so they headed upstairs to retire. The others walked through the great room on their way outside.

"Say, what's this, young lady?" Rimick asked when he saw Gemma and Tad both behind the counter.

"Oh, just catching up on the books, sir," she responded with her usual smile.

"You know I appreciate everything you do, but you're off duty," he replied. "Tad has the counter tonight."

"I don't mind, sir, really."

"I do. You need some private time to relax, just like everyone else. Lock the books up and go into town for some fun, or go take a hot bath, or read a book. I don't care what you do, as long as it's not work. Hear me?"

She looked down. "Yes, sir. It's been a busy day; I suppose I could turn in."

"Good," he said with a smile of appreciation. "There's always tomorrow."

"Yes, sir. Goodnight, everyone," she said as she picked up a ledger and headed to the back room.

They all bid her goodnight as she disappeared through an open doorway.

"Dear, I think Wynette and I shall retire as well," Vanece announced.

"Are you sure, love?" Rimick asked her.

"Yes. Everyone, it's been a wonderful evening," she said graciously, scanning the faces of her guests. They thanked her as she stepped up and gave Hollis a hug. Then as Wynette hugged Hollis and her father, Vanece stepped toward Hunter with her arms open.

"William, it's really good to see you after all these years," she said as they embraced. "Your family would be proud of the fine man you've become."

"Thank you, Vanece."

After she and her daughter headed upstairs, they walked outside onto the spacious porch. And just as Rimick had said, the numerous chimes his wife collected were tinkling in the gentle breeze that rose off the river, carrying up sounds of the town's busy nightlife.

"Well, boss, this is where we part," Lance said. "Rimick, I'd love to stay and visit, but I'm beat. I need a good night's sleep."

"Seems to think I snore," Hollis said.

Rimick chuckled. "No offense taken, Lance. You'll find a hot bath awaits you in your cabin. I told Tad to send a chambermaid to prepare it when he saw us breaking up."

"Thank you," he said, shaking his host's hand.

"You all right?" Hollis asked. "You seem distant tonight."

Lance sighed. "Oh, just worried, boss. Got a bad feeling I can't shake. Not like me; suppose I'm a little homesick."

After a brief silence, Rimick looked at Gustin and Fae. "And a bath awaits you."

"My thanks," Gustin said, shaking his hand.

Fae looked at Rimick tentatively, expecting him to embarrass her.

"Good night, Fae," he said with a sincere smile. "I thank you and the others for keeping my friends safe on their trip. By the way, where's the wizard?"

"He went into town with the teamsters," Gustin replied.

"Ahh, the lure of the nightlife," Rimick said.

"Unfortunately," Fae said with a subtle eye roll.

The men laughed at her inference.

"Well, until the morning then," Rimick said.

When the three of them stepped off the grand porch and headed down the hill, Hollis solemnly watched them walk away.

"You all right, Hollis?" Rimick asked.

He sighed. "I worry about Lance. He's not been himself since we arrived. He's never been one to get, how did he put

it, a bad feeling."

"Is it wise to let him stay down below?"

Hollis cracked a fleeting smile as he glanced at him. "It is wise not to try to dissuade him once he's made up his mind. Come, let's sit awhile."

CHAPTER ✝ 20

After leaving the lodge, they walked down the path of stone steps with little conversation. Lance seemed distant as he set the pace. When he came to the path that led to Gustin and Fae's cabin, he slowed.

"Lance, would you like us to accompany you?" Gustin asked.

"No, I'll be all right," he replied, stopping to look back. "Rimick's men are patrolling the grounds, and Dahr's rooming with me when he gets back from town. You two go on and enjoy the rest of your evening," he added with a knowing smile.

"Dahr, that's the quiet young man who drove the last wagon?" Fae asked.

He nodded. "Yeah, the one who nearly went over the cliff with his wagon," he said, turning his attention back to the steps.

"Good night, Lance," Fae said.

He just raised a hand and waved, continuing on.

"Why do you suppose he's in such a hurry?" she asked Gustin discretely. "He's seemed distracted since we got here—hardly spoke at the table."

"Oh, probably just tired," he replied. "He's been the first one up every morning. I'll bet he's just anxious to turn in after a nice hot bath."

"Sounds good," she said with a teasing grin.

He smiled and pulled her close for a kiss, and when their lips parted, he scooped her up. She surrendered in his arms with her cheek against his chest as he turned and stepped

up on the porch of their small cabin. When he opened the door and turned to squeeze through, she raised her head and looked around. Built of smoothed logs with a beautiful hardwood floor, it had an immense metal-framed bed set against one wall. On either side of the bed were tables, each with a candle burning on a small copper plate. A small writing table sat against the opposing wall with a comfortable-looking chair. In the middle of the floor stood a copper bathtub, steam rising off the surface of the water. Next to it stood a small table displaying soaps and bathing cloths by another lit candle.

"That looks so inviting," she said. "I get to go first."

"Why do you get to go first?"

She smiled widely. "Ladies first."

"I was thinking we could go at the same time."

She chuckled. "There's not enough room, silly. How bout you wash me, then I'll wash you," she said, nuzzling his neck.

"Good plan," he replied as he gently set her down and closed the door.

/// \\\

Rimick had stopped briefly to speak with four guests seated on the porch as they made their way to a cluster of comfortable wooden chairs and sat down. Now, they visited while he enjoyed a smoke. When he drew on his fancy pipe, the pleasant aroma of his tobacco permeated the evening air.

"So, Rimick, have you ever returned to the Chateau?" Hunter asked him.

He glanced at him, nodding as he inhaled. "Yes, I've been back to Port Haven several times. Drew and I have stayed in touch over the years, and he even came here to visit once when he was in the capital on business. I took Vanece and Wynette there only once, ten years ago. We sailed on to Armagocia so she could see her family again and let them meet our daughter. It, uh, didn't turn out as we'd hoped. Vanece came home

brokenhearted—swore she'd never return," he said, looking out into the night.

"I'm sorry," Hunter said.

"Oh well, you can't change people, William. You can only be yourself. And for some, that'll never be good enough. . . . But don't let my experience dissuade you from going home," he added, looking at him squarely. "I do think you'd be pleasantly surprised by your reception. And by the way, is there, uh, something you'd like to share?" he asked, glancing at Celeste.

She smiled at Rimick before looking away in embarrassment.

"Hollis, I do believe your daughter is beaming as I've never before seen her."

Hollis chuckled while Hunter and Celeste smiled at each other. "Yes, I'm afraid she's smitten," the merchant replied.

"Well, I'm happy for both of you," Rimick said. "I hope you're blessed with as much happiness as Vanece and I have found together."

"Thank you," Hunter said.

"Yes, thanks," she affirmed.

He smiled and nodded just as Derek stood up. He'd been silently enjoying a pinch of Rimick's fine, imported tobacco.

"Well, I think I'll turn in, boss," he told Hollis.

"Please forgive me, Derek. I didn't mean to exclude you," Rimick said.

"Oh no, no offense taken, sir. I just wanted to relax and have a smoke. Thanks for sharing," he said through a subdued yawn. "You were right; it is smooth. And now I'm ready for a good night's sleep."

They bid him good night, and he left.

"I'm sorry for your losses on this trip, Hollis," Rimick said after he'd gone.

Hollis sighed. "Yes, me too," he replied. "Some I knew better than others, but they were all good hands. . . . It's sobering, but I fear they'd have taken us if not for Hunter and the four.

I knew some might expect me to be traveling with gold, but I honestly thought if anyone tried to take it, we had enough help to protect ourselves. Never dreamed I had spies in my own camp or that they'd try taking Celeste."

"Well, thank God you got her back, William," Rimick said, looking over at him.

He simply nodded.

Celeste had moved when Derek left and now sat crossways on Hunter's lap with her head against his chest. He felt her curl more tightly into him when the conversation turned to her, so he laid his cheek on her forehead and rubbed her back consolingly.

Hollis sensed his daughter's discomfort and changed the subject.

"Rimick, I hadn't asked yet, but I assume the shipment arrived all right."

Finishing a draw on his pipe, he nodded. "Yes, Navarro awaits you in the capital; I just received word day before yesterday."

Celeste raised her head and looked at them. "Navarro?"

"Who's that?" Hunter asked.

"Yes, dear, we'll be sailing with him from the City of Queens on to Altus," her father replied.

"Who's he?" Hunter asked again.

Celeste looked up at him. "He's a rogue like you."

Hollis and Rimick both chuckled.

"Captain of his own ship," Rimick said. "Probably the fastest ship on the seas. I sailed back from Port Estes with him; he put me ashore in Eastwick."

"I sent a good portion of my transferable wealth ahead with him," Hollis said.

Hunter raised an eyebrow. "Hopefully, you can trust him."

Hollis and Rimick both laughed. "Oh, he's not quite as unscrupulous as my dear girl made him out to be," Hollis replied. "He's transported my goods many times over the years. And

I always try to sail with him when I need to travel by sea. His ship's not the biggest, but it's a fine vessel and very fast. He's a good friend."

"Father, is that why you didn't tell me he was in Port Estes?" Celeste asked, returning to her relaxed position on Hunter's lap.

"Yes, child. I preferred Rimick and Navarro not be seen around Port Estes. I met with them privately at the estate, and Lance oversaw the clandestine loading of the cargo onto Navarro's ship. He's the only one who knew. Even Simon didn't know until the gold was gone. And then I only told him how much I took, not how it was being moved."

Hunter began to see things more clearly as he listened. He realized some of Hollis's actions he'd considered reckless had only seemed that way because he didn't know his plan. *He's a sly old fox*, he thought.

Eventually, the talk waned, and at last, Rimick slowly stood up. "Well, friends, I hate to bring an end to such a perfect evening, but I must retire."

"Indeed, I think I'll do the same," Hollis agreed, standing up stiffly.

Celeste raised her head from Hunter's chest, and they smiled at each other. "I think that's good advice," he told her.

With a pouting expression, she lowered her bare feet to the porch and bent over to pick up her shoes. They continued to chat as they slowly walked the length of the spacious porch back to the front door of the lodge.

"William, I noticed you watching my men as we visited," Rimick said. "They're good men. They'll patrol the grounds until dawn."

"Good, I'll sleep better knowing they're out here," he replied when they stepped into the great room, now vacant, save Tad still behind the guest counter.

Rimick and Hollis said good night and went on to their rooms while Hunter and Celeste lingered for a while, taking

in the beauty of the magnificent lodge before slowly climbing the stairs together. He noticed her looking up at him as they covered the last few steps, so when they reached the top, he turned to her. She didn't look away, just silently held his gaze with a hint of a smile.

"What?"

She gave into her smile. "What a crazy night." She reached up and lightly brushed his cheek. "I really don't know what to say. I, uh—"

"Celeste, I'm not proud of many things in my past. Perhaps now you can see why I don't like to talk about it. But I needed for you to hear it, to know the truth about who I once was, and who I am now."

Her heart was breaking as she leaned in close to him. "William, look at me; look into my eyes. . . . I love you," she said as tears welled up. "Nothing you said tonight changes that. I respect and admire you even more. I want us to be together always, to grow old together, to have babies together—more than we can count."

He smiled and drew her close, and she turned her cheek to his chest. He held her so tightly it was hard for her to breathe, but she didn't mind. She melted into his strong arms and patiently waited for his storm of emotion to pass. She could sense his relief and realized just how desperately afraid of losing her he'd been. At last, he eased his grip, and she looked up at him.

"I love you, William," she whispered, "now and forever."

"I love you too. . . ." Leaning down, his lips met hers for a long kiss.

"We should sleep now," she said when their lips parted. "We're both exhausted."

"Yes," he agreed as he turned and slipped his arm around her waist. She slowly walked with him until they reached her room, then quietly unlocked her door and eased it open before turning to face him again.

"Good night, Celeste."

She raised up on her toes and kissed his cheek.

"Good night, William," she said softly before backing through the door. He raised his hand and motioned to remind her to lock her door. She nodded, holding his gaze until she closed the door between them.

Hearing the lock turn, he lowered his head and sighed, fighting to remain composed. Carrying the burden of his past had been like the weight of the world on his shoulders, and now it was gone at last. He arched his back and tipped his head up as he cupped both hands over his face, wanting to shout in elation. Finally, he took his hands away and turned to walk across the hall. He briefly listened after opening his door. All was quiet save the voices coming from her room. The others had awakened when she slipped in. *Women*, he thought, smiling as he stepped into his room and closed the door.

/// \\\

They savored their frolic in the hot bathwater before moving to the huge, soft bed where they made love. They didn't sleep after. Instead, they threw off the blankets and lay together, quietly sharing their thoughts while the gentle breeze rose off the river and spilled through the open window above them, caressing their bare skin. They reflected on their journey, the things that happened, and the new friends they made. Eventually, the talk turned to Hunter and Edmond White.

"Gustin? Fae asked as she lay with her cheek on his muscular chest and her nimble fingers lightly dancing over his bare skin.

"Yes."

"Did you hear what Hunter said to me when he was going out to fight Edmond?"

"You mean when he said, 'should this task fall to you'?"

She was surprised he'd not only heard but had clearly pondered Hunter's warning.

"Uh huh," she replied softly. "Do you remember when I told you about the Elder, the vision he had of me when I was still with Telfari?"

After an uncomfortable silence, he sighed. "Yes."

"I . . . I believe it's my destiny to face the Shadow Knight," she said, focusing every sense on reading his response. She felt him tense up, holding his breath in before letting it out slowly. Suddenly he arose and gently slipped his arm from beneath her as he turned and placed his bare feet on the floor. Without speaking, he raised his hands and slowly rubbed his temples with his fingertips.

She knew she'd hurt him with the mention of an unwelcome subject. She came to her knees behind him and began kneading the muscles in his broad shoulders. He took in a deep, relaxing breath and let it out through flared nostrils as he turned his head to the side. She felt his warm breath on her knuckles when he lowered his head and gently kissed the back of her hand. She smiled and leaned in, pressing her bare breasts to his back as she slid her hands around him, teasing his chest hair.

"We've always said we'd be honest with each other," she said softly before kissing him on the cheek.

He sighed. "I know, Fae. And you may be right. I've thought about it, too, a lot since watching them fight. They're not brawlers like me and other soldiers who learned to fight just to survive. They trained their whole lives for combat. They have a refined style that would be hard for someone like me to match."

She was uncomfortable hearing him debase his own fighting prowess. She had no doubt he could hold his own in a fight with either of them.

"I don't know how Edmond's battle magic stacks up to yours," he continued. "But one thing's for certain, he can't match your speed."

He eased forward, so she released him and watched him

stand and walk to the table by the tub. She knew he wasn't angry with her, just concerned. *Perhaps it wasn't the best time to bring it up.* He took up the largest drying linen and wrapped himself, making a loincloth. Then he quietly stepped over to the door and opened it before walking out onto the cabin's small porch. She pulled a blanket from the wadded pile on the floor and wrapped it around her shoulders before following him outside.

"I'm sorry, lover. I didn't mean to hurt you," she said, standing beside him, looking out into the night. "You're as good as they are in a fight, even if you don't think so," she added, looking up at him.

He looked at her and smiled fleetingly at her compliment. "I just worry, Fae. And that's not what I wanted to do this night."

She saw her chance to change his mood. "What did you want to do this night?"

She could see him smile in the darkness. Then he turned and reached down, closing his strong hands around her waist. Gently lifting her, he sat her on the porch rail facing him. It had worked. She was elated. She released her grip on the blanket and let it slide off her shoulders, coming to rest over the rail. Now she sat before him nude, the cool breeze titillating her bare skin. By the dim light of the torches on the nearby stone steps, she saw his smile grow wider. He reached up and began teasing her with gentle strokes of his fingertips: her back, her thighs, her stomach, her butt, and her breasts. Her body shuddered from the thrill of his sensual touch.

Finally, she reached down and pulled his loincloth loose, letting it drop. Balanced on the rail, she scooted forward, and as their lips met, she began lightly dancing her fingertips over his chest and shoulders. She knew what pleased him. His desire burned as they continued their wet kiss with tongues dueling. Finally, he bent his knees and closed an arm around her waist, sliding her off the rail. She placed her arms over

his shoulders and clamped her legs tightly around him as he turned and walked back inside. She laid her cheek on his chest with her eyes closed, eagerly anticipating what she knew was to come.

After closing the door, they lay together and she continued fondling as she slowly came to her knees, raising a leg to straddle him. While they kissed, she slid lower to press him firmly against her most private place.

"Let me take away your worries, lover," she said when their lips parted. She inched lower, kissing his neck and chest, feeling his arousal as she pushed her breasts against him. Excitement coursed through him when she paused just long enough to reach over and snuff the remaining candle on the table next to the bed.

"Where were we?" she asked as she resumed her teasing. He swallowed hard, delirious from the feel of her warm breath and wet mouth on him. Closing his eyes, he willingly surrendered to the mind-bending pleasure she dispensed.

/// \\\

Lance was exhausted. He'd been overcome with fear and worry when Celeste was taken, though he dared not let it show. He couldn't keep from thinking about his own daughter. He'd barely managed to function in his frantic state but had held on for Hollis's sake. When Hunter and Celeste rode back into camp, he'd fought the urge to break down. Relieved, he checked his emotions and led them on to the relative safety of Rimick's compound. Now it was his time. He'd enjoyed a superb meal and conversation with friends. Then he savored a nice, long soak in a steaming hot bath. As the welcome heat crept into his tired, sore muscles, he closed his eyes and let his mind drift. He thought of his beautiful wife, Mara, and how he missed her. He realized for the first time just how weary he'd grown of the endless days and nights away from home. He

eagerly anticipated his final homecoming and determined he would never again leave her side.

Dahr returned from town with the others, stopping at the cabin while they continued on up to the main lodge. Lance had just retired when he entered, so after bidding him goodnight, the foreman quickly fell asleep. What he hoped would be a long, restful night turned out to be anything but. His sleep was fitful. He tossed and turned incessantly, uncomfortable from his big meal. It was not like him to overindulge. He dreamed, repeatedly rousing from his unsettling experience, unable to shake the ominous feeling that had nagged him since arriving here. Each time, he looked over to see Dahr sleeping soundly. He would listen for noises outside the cabin to be certain nothing was amiss, then grudgingly reposition and drift off again.

Deep in the night, he suddenly awoke with a start. He sat straight up with beads of sweat clinging to his brow. He thought he'd heard a man scream out in pain. He wiped his forehead and regained control of his breathing while he listened intently. Dahr still slept. *Damn. Another dream*, he realized. *And that was me screaming.* He tried to recall more details but couldn't. Finally, overwhelmed with frustration, he turned in bed and let his bare feet to the floor and took up his pants. He quietly dressed, continuing to listen. Then once fully clothed, he walked to the door.

Dahr had locked it when he came in, so Lance carefully unlocked and opened it. He stepped through and pulled it shut, leaving it just ajar as he stood on the wooden porch. A gentle breeze still rose off the river, and he could hear a few faint sounds coming from town. Some of the clay firepots lining the stone steps up to the main lodge had burned out. He watched another one suddenly flicker and go dark, leaving only a tiny orange glow on the tip of the wick. *It's late*, he surmised, *well past midnight.* He stretched and yawned silently, admiring the starry night sky above him.

Stepping off the porch, he silently walked over to the path

of stone steps. He looked up the hill toward the main lodge. Nothing. Then he looked down at the barns and corrals not far below. Again, nothing. Something gnawed at him, causing him to shudder as he stood there in the faint moonlight, watching, listening. *Where are Rimick's men?* he wondered. He glanced both ways again before his eyes settled on the corrals. The road they'd arrived on passed by the barns and corrals, continuing on into town.

He absently gazed down the road toward the dark street at the edge of town, his mind focused mostly on sounds. Suddenly his senses piqued when he thought he detected movement in the shadows near the big barn. He carefully fixed his eyes in that direction.

There, the sound of a dry hinge on the side door of the barn. And he was sure he saw a fleeting wash of light from within cast a shadow as someone entered and closed the door. He knew it could be Rimick's men. But he should've seen one of them on patrol by now. He turned and silently made his way back to the cabin. *The second step*, he thought as he stretched to step over it onto the porch. He remembered it squeaked when he put his weight on it earlier. He stepped inside and pushed the door shut, again leaving it ajar. He approached Dahr and gently shook him by the shoulder.

"Dahr," he said softly.

"Huh? What?" he mumbled, turning and opening his eyes.

"Shhh," Lance whispered.

"Lance? What—what is it?"

"Get dressed; we're going for a walk."

"Uh, all right," he replied, sitting up in bed.

"Hurry up, and be quiet," Lance added as he stepped back over to the door and opened it slightly to look outside.

Soon Dahr was standing beside him, ready. "What's up, boss?" he whispered.

"I can't find any of Rimick's men, and someone's messing round the barns. We're going to go have a look. We'll stay off

the path, go through the corrals."

"Uh huh," he replied, wiping the sleep from his eyes.

"Hey, you with me?"

"Yes, sir, I'm awake."

"All right, let's go."

They left and cut through the trees between their cabin and the last one at the bottom of the hill. Dahr followed Lance's lead as they crept across the road, slipping between the rails of the large corral. At half his age, Dahr was impressed with Lance's agility. Weaving through the livestock, they approached the barn until Lance suddenly stopped and knelt. When he got close enough to kneel beside him, Lance pointed to the side door, and he could see a man lying motionless on the ground. They could hear muffled noises coming from inside, like a scuffle, or perhaps the wagons being ransacked. Lance signaled for him to follow, and they retreated back to the center of the large corral among the restless livestock.

"Listen to me," Lance whispered when they knelt face to face. "I want you to get back up the hill to the lodge and have the night man wake Rimick to send help. Then go wake Gustin and Fae. They're in the cabin near the top of the hill where the path makes its last turn before reaching the upper road. Move quietly and stay off the path. Cut through the trees on the back side of the cabins. We don't know how many of his men may have been taken out."

"Yes, sir," he replied with a nod. "Uh, sir, what are you going to do?"

Lance smiled fleetingly. "Don't worry, son. I'm no hero. I'll try to get close enough to help that man if I can, maybe see what's going on inside. But I'll wait for help. Now go."

Dahr silently nodded and turned away. He left the corral and quietly ran across the road, starting up the hill through the growth of pine trees that surrounded the compound. He climbed up the steep hill in the darkness past the first cabin and the one he and Lance had slept in. He paused briefly to

listen and glance back toward the barns. It was no use. Despite the moonlight, his view was now obscured by trees. For now, Lance was on his own. With a driving sense of urgency, he turned and climbed on, skirting three more cabins clustered together. Then he came to a small, level clearing with two large stumps surrounded by stacks of cut firewood. He glanced around as he walked between two waisthigh rows of wood and suddenly stopped when he thought he heard a noise coming from the cabin he'd just passed. He stood still for a moment, listening, before finally deciding it was nothing.

Just as he started to turn and continue on, he sensed a presence in his path. He quickly spun to look just as something struck him across the face with incredible force. His ears rang as he stumbled and fell back. He managed to brace himself on one knee when he slammed against a stack of wood. He was dizzy and could taste blood. He feared he might lose consciousness and knew he was in trouble.

He instinctively grabbed the hilt of his sword as he fell backward, trying to distance himself from his attacker. Now with his senses returning, he could hear his opponent pursue as he completed his backward roll up onto one knee. His head swam from the evasive maneuver when he looked up to see a man tossing a piece of wood on the ground and drawing his sword. Even in the darkness his determination was obvious, and Dahr realized he was in a fight for his life. He drew his sword and stood when the larger man closed in. He slashed downward, and Dahr parried, causing his blade to glance off and continue its downward momentum. Now the man was open to a counterattack, so he brought his fist up hard across his jaw. *Take that*, he thought, hitting him solidly. To his dismay, the blow had little effect.

The man swung his other arm backhand, hitting him in the ribs with a rock-hard fist. Dahr was an inexperienced fighter, but he saw it coming and spun away to lessen the force of the blow. Now in the brief lull, he scanned around the small clear-

ing to look for an escape route and to make sure his attacker was alone. He turned and was surprised to see the large man was already on him again. He sidestepped as the man brought his sword down with a muted clang when it struck the stack of firewood behind him. Dahr crouched, slashing with his sword across the man's midsection.

"Uhhh," the man gasped in painful surprise.

Dahr had found flesh, but it wasn't a mortal wound. When the man reeled and drew in his free arm, Dahr decided he'd just evened the odds. He would stay and finish the fight rather than turn his back to run. He lunged at the man offensively, only to be surprised by his counter. Both men had their backs to a row of cut wood, and when he advanced, the man grabbed a piece and threw it, hitting him hard in the gut.

Dahr's breath exploded, and he backed up, bending over at the waist. Now his opponent pursued him, stepping in with his sword raised. Dahr feared he'd lost the battle and became nauseous in anticipation of death. *Yell out! Wake someone!* he thought in desperation. But he was fighting to breathe, and there was no sound.

He managed to raise his sword to meet the large man as he bore down on him. He tried to move but felt a searing pain in his side when the man's blade penetrated skin and found ribs. His mind was on fire with pain as he realized his sword, too, had found its mark. The large man's momentum carried him forward, plowing into Dahr as he raised his other arm and grabbed his shoulder. Dahr saw his wide-eyed look of disbelief when they came face to face, falling over the collapsing stack of firewood behind him. Time seemed to slow as they fell together in their mutual impalement. Then he found himself lying on the ground on his side, looking at the man who lay facing him. He saw him convulse and heard him gasp and gurgle. Then his eyes closed. Dahr's mind fought the haze that closed in as he tried in vain to struggle free. *I have to warn the others. Lance is alone. Help!* he cried out in his mind. Then silent darkness invaded his world.

/// \\\

They'd fallen fast asleep after making love again. The large bed in the cabin was unbelievably comfortable. And after closing the windows and locking the door, they lay together naked in each other's embrace and drifted off in the darkness. They'd barely moved until Fae was suddenly shaken from her sleep. She jerked when she awoke, causing Gustin to react the same.

"Huh? What? What is it, Fae?" Gustin asked in a whisper, trying to focus his sleep-filled eyes.

She was slow to answer. She listened intently, lying with her head raised from his arm. Reaching up, she rubbed her nose to keep from sneezing after brushing his chest hair when she moved. "I, uh . . . I'm not sure," she finally replied. "I thought I heard something, but now I don't know."

He raised his head when she sat up next to him. "A dream, perhaps?"

"Don't think so," she said, looking into the darkness.

He didn't have to see her face. He could tell by her tone that she was concerned. He sat up and slowly ran his hand up her bare back, giving her a consoling pat.

"I'm going to go check it out."

He wasn't surprised. "Well, am I invited?"

"Oh, I guess you can tag along, if you're not afraid of the dark," she replied as she threw off the covers and spun away from him onto her stomach. She stirred through her pack on the floor next to the bed, removing some clean clothes.

He smiled at her teasing insult, savoring the moment, drinking in her sensuous curves as the moonlight shining through the window bathed her silky, naked skin. Finally, he reached over and playfully slapped her bare butt before turning away to his side of the bed. In the time they'd been together, he'd come to trust her instincts as much as he trusted his own, so he quickly stood up to get dressed.

"Hey, shhh, did you hear that?" she asked in a loud whisper.

Although he hated to admit it, he wouldn't lie to her. "I'm sorry, lover. No."

She silently emerged from her side of the bed, walking past with her sword in hand. She wore her pants, but he noticed she was still barefoot and wore only her leather vest on top, still unlaced. Despite the serious matter at hand, he briefly thought about how provocative she looked. He quickly pulled on his boots and grabbed his sword standing unsheathed next to the headboard. By the time he joined her, she'd already unbolted the door and silently pulled it open. They both stood in the half-open door for a moment, listening. Nothing. She stepped out onto the porch, and he followed where they again paused to listen. They remained silent, controlling their breathing as they freed their senses to search for any sign of danger. Finally, without speaking, Fae stepped off the porch and walked the short distance to the main path of stone steps. Gustin stood fast, continuing to listen while keeping an eye on her. He watched her scan up and down the hillside before looking back at him. Most of the clay firepots that lined the steps had burned out, but he could see her expression in the dim moonlight. She was worried. Something nagged at her. And in spite of no tangible signs of trouble, he felt it too. He slowly walked to her as she continued scanning the darkness.

"Split up?" he asked softly when they stood facing each other.

"No. Let's go check the lodge first," she whispered. "It's closer. Then we'll go down to the barns."

"Sure you don't want your boots?"

"No, I'm fine," she replied, then turned and darted up the steps. He followed, struggling to keep up. *She's amazing*, he thought of her incredible speed and stealth. She leapt over every other step without noise, like a deer evading a predator in the forest, until she stopped a few steps from the top of the hill. He joined her and quickly calmed his breathing while they observed the front of the lodge. One of Rimick's men slowly walked the length of the porch. He appeared reasonably

awake and unalarmed. They could also see Tad inside, casually dusting the furnishings in the great room.

"Looks like everything's all right here," he whispered with a glance her way, noticing she'd just finished securing the front of her vest.

"Yeah," she agreed. "But I've got a bad feeling. Let's go check down below."

"All right, let's do it."

/// \\\

After watching Dahr head off through the corral to get help, Lance quietly made his way back to the barn. He slowed his approach when he drew near the side door. It was ajar, and he could hear voices and muffled sounds of scuffling inside. And from here, he could see the man lying on the ground was beyond help. He crawled up and looked through the narrow crack of the doorway. There was enough lantern light inside for him to see half a dozen men moving around and at least one lying on the ground. He jumped when he heard a crashing noise inside.

"Damn it!" someone said in an angry voice. Then he saw a tall man walk into sight and kick the one on the ground, causing him to curl up in pain. "Where'd they put it?" he growled.

His response was weak and incoherent.

Looking for the gold, Lance thought. *And that's one of Rimick's men; he doesn't know anything.*

Suddenly the man kicked him again and pulled his sword.

No! In disbelief, Lance watched him run the helpless man through. Lance's heart raced as rage boiled up inside him.

"All right, you, stand up, slow, with your hands out."

Lance froze, realizing someone had slipped up behind him.

"Up, I said."

He spread his arms out as he stood and glanced over his shoulder to see a man standing twenty feet away with a crossbow leveled on him.

"All right, open the door and go inside, slow and quiet."

Lance knew he would be the next one interrogated unless Dahr made it back with help. And he did know where the gold was. He slowly opened the door to see several men eagerly looking his way, obviously having heard their comrade. He took a calming breath to quell his growing fear and stepped inside.

"Well, look what we have here," one of the waiting men said with a smug grin.

"Go on, keep your hands out," his captor said as he stepped through the door and closed it behind him.

Lance didn't know why, but he suddenly heard in his mind the last thing he told Dahr. *Don't worry, son. I'm no hero*, he'd said with complete conviction. Now he realized he couldn't let himself be taken without a fight. Perhaps he was just getting too old for torture. He wouldn't betray Hollis; he owed him that. Perhaps it was the pure hatred and loathing that consumed him when he searched the faces of these evildoers around him. *Damn them all*, he thought. Perhaps it was nothing more than a man's inherent need to know he'd found his measure of courage when facing the end. *Mara, sweet Mara, love of my life, mother of my children. I love you*, he thought.

He suddenly feigned a stumble and brought his hands down as if to break his fall. Then he pulled his sword and spun to face the man behind him. As those around him reacted, he reached out and sliced through the air in a horizontal sweep with his blade. It found its mark. In the dim light, the sickening sound and feel left no doubt. He'd just cut the man's throat before he saw it coming. His muscles reacted as he reached for his throat and his knees buckled. The sound of the crossbow's release filled Lance's ears when the bolt raced toward him. In the instant he realized what had happened, he felt it tear through his tunic, grazing his side. He spun around at the sound of it striking something behind him. Another Shadow— the one with the stupid grin—stood wide-eyed with his hand

raised to his chest and bright red gushing from between his fingers. The deadly projectile had struck him at the neckline of his leather vest. He, too, went down as Lance turned to face one charging him from the side. He parried the man's running thrust, letting his momentum open him to a counter. He sidestepped and planted a foot, tripping him as he brought his blade down hard across the back of his neck, killing him instantly. Elated, he started to turn and face his next opponent, but a crushing fist struck him hard across the face, sending him reeling. Dizzy, he stumbled and went to one knee, barely managing to keep hold of his sword.

"Get him!" he heard one of them yell as he sprang back to his feet. He raised his sword, but one grabbed him from behind, locking their arms under his and behind his head. Then another man stepped up and punched him in the stomach.

"Uhhh!" His breath left him, and he dropped his sword. Now someone else stepped in front, and he saw through blurry eyes that it was the Rendovan. She smiled as she brought her scimitar around at waist level, slashing across his stomach.

"Ahhh!" he cried out weakly with no air left in his lungs and his gut on fire.

"Don't kill him," he heard someone say. When the man behind him released his hold, his legs failed, and he quickly fell to his knees, guarding his stomach with his hands. He felt the warm wetness of his blood, but realized it wasn't a fatal wound.

Suddenly a hand clamped under his chin, forcefully turning his face upward. He found himself face to face with the Rendovan, and then he saw the tall, scarred man standing behind her.

"You. You are the foreman," she said through gritted teeth. "Where is the gold?" she asked, shaking him for emphasis.

Already nauseous from pain, her stank breath nearly made him retch. "You must be Hanlin," he said, ignoring the woman, looking over her shoulder at him. "You lead this pack of

cowards? Must; your stench is worse than theirs combined."

He gazed down at Lance, expressionless, then gave the Rendovan a simple nod.

Suddenly she released her vise-like grip on Lance's chin only to slap him across the face. His ears rang, and his skin stung as she smiled at him, grabbing him again like before. "Where's the gold, you swine?"

"All right—all right, I'll tell you," he said, feigning acquiescence to lure her in.

She released him and leaned in face to face, savoring his submission.

He slowly smiled, then chuckled defiantly. "It's not here, you crazy whore," he said, leaning, driving his forehead into her nose, already broken in her fight with Erin.

"Oh!" she cried out and stiffened up, staggering back with her hand to her face.

Pain shot through his head from the force of the blow, but he continued to smile, seeing the back of her hand turn red from her freely flowing blood. His elation was short-lived. One of the men struck him from behind, and he went down, his head throbbing with blinding pain.

"All right, bring him with us," he thought he heard Hanlin say.

"I'll gut you for that!" the Rendovan growled.

Barely conscious, he was powerless to block her when she kicked him in the ribs. Then she cursed him and quickly followed with a kick to his face. Then another. He felt a searing pain shoot down his spine when his head jerked back. Then his world went dark, and the pain was gone.

GLOSSARY

KINGDOMS

Andalar: a kingdom in the far west, shares a border with Myndora

Armagocia: a group of mountainous islands off the coast of Ormond

Edin: a small, wealthy island kingdom known for its illicit trade and slave markets

Myndora: a kingdom in the far west connected to the Eastern Kingdom by royal bloodline

Ormond: a faraway kingdom beyond the disputed lands

Rendova: an isolated kingdom within the disputed lands known for its ferocious fighting forces and exotic landscapes and wildlife

The Chateau Demond: a kingdom near the disputed lands, settled by the Belvarun clans, includes the Mountains of Ice, known for its premium equine stock

The Citadel: a kingdom near the disputed lands, settled by the Belvarun clans

The Eastern Kingdom: the largest kingdom in the known world, the setting of the story

PROVINCES

Central Province: smallest province, second greatest population with the twin cities - Athum and Altus (provincial capital)

Dragon Forest Province: borders the Chateau, the Citadel, and the disputed lands, contains the Dragon Forest and Enchanted Forest, provincial capital: Fort Grigg

Far North Province: northernmost province, sparsely populated, borders the Land of Simion, wealth in fur and timber trade, provincial capital: Northport

Frontier Province: expansion province, least wealth production, mostly dry grasslands and high desert, provincial capital: Fort Kotter

Lowlands Province: swamps and fertile croplands, provincial capital: Lake City, a popular destination for gambling and romantic retreats

Queen's Province: largest of the six, includes the national capital: The City of Queens, and the provincial capital: Port Estes

CITIES AND TOWNS

Altus: largest of the twin cities, provincial capital of the Central Province

Athum: one of the twin cities, the only place in the Eastern Kingdom where the sport of arena fighting is legal

Arcacia: a small town near the foothills where the Howling Mountains and the Skull Mountains converge

Arcana: a small elvin village three day's ride west of the twin cities

Bard's Landing: a rambunctious town on the Skull River north of the City of Queens

City of Queens: the capital of the Eastern Kingdom, nearly a quarter-million inhabitants

Eastwick: shipping port at the mouth of the Skull River on the Endless Ocean

Forest Moon: a small town near the Enchanted Forest

Fort Grigg: army garrison, provincial capital of the Dragon Forest Province

Fort Kotter: army garrison, provincial capital of the Frontier Province

Frontier City: a busy trade town on the far fringe of the newly formed Frontier Province

Lake City: provincial capital of the Lowlands Province, popular destination for gamblers

Lohawna: assumed to be a myth, an ancient elvin city rumored to be isolated high in the Mountains of Ice

Northport: shipping port on the Ocean of Ice, provincial capital of the Far North Province

Port Estes: shipping port on Cold Harbor, provincial capital of Queen's Province

Shaelah: ruins in the Forest of Souls, once the home of the Shaelock, the village of an elflike society destroyed two centuries ago by the Gruebald

Southport: shipping and fishing port on the southern coast of the Lowlands Province

Tuskin: a large, diverse trade city on the northern border of Ormond, a crossroads of foreign trade between the southern kingdoms and the tribes of the disputed lands, more than a quarter-million inhabitants

Twin Cities: Altus and Athum, large fortified cities on opposing banks at the mouth of the Blue River, a combined population to rival the City of Queens

PLACES

Capital Trading Company: freighting business and mercantile in the City of Queens; one of four owned by Hollis McNeill

Coastal Trading Company: freighting business and mercantile in Altus; one of four owned by Hollis McNeill

Cold Harbor Inn: a popular dining hall with rooms to let in Port Estes

Disputed Lands: a vast expanse of mostly uninhabited, inhospitable lands between the Eastern Kingdom and the kingdoms of the far west

Enchanted Forest: a dense region of forest in the Dragon Forest Province, rumored to be enchanted with benevolent magic, a popular retreat for couples seeking romance

Forest of Souls: a thick, foreboding forest in the foothills of the Skull Mountains rumored to be haunted by the souls of long-ago slaughtered Shaelock

Fort Estes: army garrison near the town of Port Estes on the shore of Cold Harbor

Frontier Trading Company: freighting business and mercantile in Frontier City; one of four owned by Hollis McNeill

Great Blue Lake: in the center of the Lowlands Province, Lake City sits on its western shores, the largest lake in the Eastern Kingdom

Hot Springs: a secluded rocky outcropping in the foothills near the Forest of Souls where hot water perpetually bubbles up into pools, a popular place for weary travelers

Howling Mountains: a rugged mountain range that rings Cold Harbor and encircles the North Shore Region, the most snow-laden mountains in the Eastern Kingdom

Howling Pass: the point where the Queen's Highway crosses over the Howling Mountains to connect the City of Queens

with the North Shore Region and the Far North Province, sometimes closed by deep snow in winter

Knawtah: a village in the disputed lands, its inhabitants massacred by Gustin's former commanding officer

Land of Dead Giants: a beautiful, uninhabited region beyond the disputed lands, heavily forested with giant trees towering hundreds of feet tall, rumored to be the place where an ancient civilized race of giants once lived

Land of Simion: an expanse of forests and meadows northwest of the Eastern Kingdom, contains isolated farms and villages protected by Simion and his followers

Mirsham Plateau: a great stone edifice with sheer, white cliffs rising several hundred feet above the surrounding grassy steppe, home to Simion and his stronghold

Mountains of Ice: the tallest known mountain range with peaks rising high into the clouds and permanently covered with snow and glaciers, found within the kingdom of the Chateau Demond

Noble Island: a large private island in the center of Queen's Bay, home to the Queen's residence and the Royal Military Academy, forbidden to unauthorized persons

North Shore Lodge: a beautiful two-story inn near the docks of Port Estes.

North Shore Region: the narrow strip of land along the shoreline of Cold Harbor, ringed by the Howling Mountains

North Shore Trading Company: freighting business and mercantile in Port Estes; one of four owned by Hollis McNeill

Palduro: assumed to be a myth, a lost city of gold in the jungles of the southern kingdom of Ormond

Skull Mountains: the longest mountain range in the Eastern Kingdom, stretches northeast from the Citadel, halfway

encircling the Frontier Province before converging with the Howling Mountains near Howling Pass

Skull River: fed by melting snow in the convergence of the Skull and the Howling Mountains, meanders past Hot Springs, the Forest of Souls, and Bard's Landing, eventually flowing into Queen's Bay

The Lakefront Inn: an enormous, multi-story inn floating on the Great Blue Lake, the crown jewel of Lake City's gambling establishments, the largest inn in the entire Eastern Kingdom with more than two hundred lavish rooms to let, designed and built by Rimick Bordo

Twin Cities Trading Company: A freighting business and mercantile in Altus owned by Rufus DeLong, a friendly competitor of Hollis McNeill's and a friend of Hunter's

MISCELLANEOUS

gold tallin: official minted coin, standard monetary unit of the Eastern Kingdom

silver rubik: official minted coin, generally considered one-tenth the value of a gold tallin

copper tung: a flat bar the thickness of a coin and half a finger's length, generally considered one-fifth the value of a silver rubik

birck: a large, heavy freight wagon with tall, rigid sides, drawn by large teams of horses

kaishon: a large wagon with solid half-sides and an upper frame covered by canvas

KSS - Kingdom Security Services: a secretive branch of the Eastern Kingdom's government comprised of loyal kingdom servants who watch for signs of unrest or disloyal movements

The Queen's Highway: a vast system of roads connecting towns in all the provinces with the capital, constructed and maintained by the Royal Army Engineers

SUPPORTING CAST

Barak: merchant and slaver from the City of Queens, Shadow member

Commander Briggs: senior officer of the garrison at Southport

Daemus: age - 17, Shadow initiate captured by Gustin

Dahr: age unknown, teamster for Hollis McNeill

Derek: age - 20s, lives in Port Estes, teamster for Hollis McNeill, brother to Krysta

Drew Butkus: (not shown), age unknown, master shipwright from Port Haven in the Chateau Demond, longtime friend to Hollis McNeill and Rimick Bordo

Dreyfus: elf, age unknown, leader of Simion's followers

Gemma (jim'mə): age - 20s, manages Rimick Bordo's lodge at Bard's Landing

General Corwin Mallory: Gustin's former commanding officer

Hadrum: Shadow member killed by Janae in Shaelah

Isaiah: (not shown), age unknown but extremely old, a blind sage who lives in Altus, friend to Simion and the Elder

Jonas McNeill: age - 29, lives in Port Estes, Hollis's son and brother to Celeste

Krysta: age - 20s, lives in Port Estes, teamster for Hollis McNeill, sister to Derek

Lady Fiona Graben: (not shown), age unknown, sister to King Lucius White of the Citadel, Edmond White's aunt, friend to the Wyngate family of the Chateau

Loorkha: age - 40s, Rendovan, Shadow member, Hanlin's lover

Mara Deiter: age - 50s, lives in Port Estes, Lance's wife

Navarro Haldaron: age - 40s, owner and captain of the *Flying Wraith*, friend to Hollis

Rimick Bordo: age - 40s, lives in Bards Landing, friend to Hollis McNeill

Rufus DeLong: (not shown), owner of the Twin Cities Trading Company in Altus, friend to Hunter

Seraphina: Shaelock, found in the ruins of Shaelah in the Forest of Souls, age unknown but appears less than 10, befriends Erin

Simion (known as Holtere in foreign lands): age unknown, elf, retired legendary ranger with scores of loyal henchmen, lives in a stronghold on the Mirsham Plateau

Simon "the Book": friend and bookkeeper to Hollis McNeill

Telfari: age unknown, elf, legendary fighter who developed the Blademaster fighting style, runs a private training compound in the swamps of the Lowlands Province

The Elder: age unknown, elf, a wizard who lives in the village of Arcana, a friend to Isaiah and Telfari

Tobias: age unknown, teamster for Hollis McNeill, Lance's apprentice, Shadow member

Vanece Bordo: age - 40s, Armagocian, Rimick's wife, lives in Bard's Landing

Wynette Bordo: age - 15, lives in Bard's Landing, daughter to Rimick and Vanece

Zandor: occasional contract scout for Hollis McNeill, Shadow member

PREVIEW

A FIGHTER'S DESTINY
COMPANIONS OF FATE: BOOK II

Hanlin stood on the foredeck of the ship as it plowed through the sea in the darkness. Occasionally the cloud cover would thin to give a hint of the bright moonlight above. Although he worried Navarro's crew might be expecting their advance and spot them, he was glad for the brief chance to scan the horizon for the silhouette of his prey. *Where is it?* He shook his head in growing frustration while the sailors around him wisely remained silent. *It doesn't make sense. Where is it?* He'd grown up a child of privilege, receiving a superb education, and he'd calculated in his mind precisely how long it should take them to close on the *Flying Wraith*. Yet it was not to be seen. Then a sobering thought occurred to him. *Yes, of course. If they were suspicious, they could've gathered way under full sail after dusk and simply outdistanced us.*

Suddenly he was shaken by a ruckus coming from the main deck behind him. He turned and saw his men scrambling, save two who just stood looking off the port side. Before he could react, he heard a noise he would later realize was the release of a ballista, followed by a whishing noise that sounded like a hundred arrows in flight. Then the two underlings were thrown back violently, sprawling on the deck as if struck by some invisible force. *No! No!* He couldn't imagine how, but

they were under attack. He looked off the port side as one of his men on the foredeck began yelling out.

"Attack! Ship ho! Attack from port side!" The man cupped his hands to his cheeks to make his alarm heard by all who'd been prepared to launch their own surprise attack off their starboard side.

Hanlin composed himself. *Ram them! Come about and ram them, you fool!* he thought of the captain at the helm. Just then he caught sight of the smaller ship slipping past them with incredible speed. Then he heard that noise again and watched in disbelief as something struck the yelling crewman. To his horror, the man's head was ripped off and his limp body thrown to the deck with arms and legs still aquiver. Hanlin flinched, feeling a spray of the young man's blood on his face. Now he heard yelling from his own crewmen as well as those on the other ship. *Damn you! You doubled back on me, you bastard!* He saw more of his men cut down as they ran from starboard to port. Then more still. Rage filled him.

"Fire your arrows! Everyone to port! Set them ablaze!" he yelled as he took a good look at the sleek vessel gliding past. He leaned to maintain his balance and realized the *Flying Wraith* was getting closer. *Good, he's turning*, he thought of his captain. *That's it. Ram them! Foul their sails! Slow them down!*

Navarro had carefully and methodically followed the larger ship, closing on them from dead astern until the last possible moment. Then as the helmsman changed course to come alongside, his ballista crews readied. There were now eight mounted on the starboard side, and he figured each crew would get at least two shots with special loads before going to standard missiles. His archers knew their orders. They were spaced down the length of the ship, kneeling inside the bulwark along the starboard rail. Once the ballista crews fired their second round, they would commence firing lit arrows into the enemy's sails. He was elated; Marin had managed the

helm flawlessly, and their attack had been a complete surprise.

Now as they raced past the enemy vessel in the darkness, his men were inflicting heavy casualties with their ballista and crossbows. He heard shouts of anger, fear, and pain, from the crew of the other ship as they began returning fire, bolts and arrows thudding all over his ship. He couldn't make out anyone specific on the other ship, but he chanced the Shadow Knight would be in the bow, so he ordered his two forward ballista crews to sweep the foredeck with their opening volleys. *"Who knows, men, maybe we'll get lucky,"* he told them. When the foredecks were abreast, he noticed the bow of the larger vessel began moving closer. *Ha. Just as I expected, trying to ram me.* He raised his hands to yell while he knelt on the steps of the foredeck.

"She's turning! Come to port! Clear the sails!"

He could only trust that Marin was attentive and responding to the enemy's tactic.

Erin stood on the quarterdeck, removing the lid from the clay pot at her feet. She wasn't concerned with concealing herself. Draigistar had cast a protection spell over them, and the enemy's missiles bounced harmlessly off the bluish, magical dome. She stuck the pitch-soaked head of her arrow into the smoldering embers and it instantly ignited. As she raised her bow and drew back, she saw other flaming arrows race into the night sky toward the enemy's sails. She followed suit and began firing her arrows in rapid succession. She was aware of the frantic yells of urgency coming from the other ship as their sails began to catch fire. She was also aware of the flaming arrows being fired back at the *Flying Wraith*, some at their sails, and some at her and the other archers.

"Beesho-nayahhh," she heard Draigistar say in a guttural tone. Then small, bright blue rods of light began shooting from his fingertips up into the night sky. They curved as if they had a mind of their own, pursuing and intercepting most of the enemy's flaming arrows before they could find their mark. Like

her arrows, his simply passed through the protective shield, causing faint blue ripples as they raced skyward. When they met the enemy's flaming arrows, the fire died and they fell from the sky. The few arrows that got past the mage's defense caused little damage to the dampened sails before crewmen could maneuver through the rigging and knock them free.

Gustin manned a crossbow, firing alongside Navarro's crewmen from a position on the main deck while Fae stood guard at the entrance to the upper passageway leading below deck, protecting Hollis and Celeste should they be boarded.

When they were out of ballista range, Draigistar released his protection spell, and the faint blue sphere covering them faded.

"*Mishta-formoshhh*," he uttered, stepping to the taffrail with hands held out to his sides. Erin and the others on the quarterdeck watched as a fist-sized flaming orb appeared in each of his cupped palms. Then he swung his arms, launching them skyward. They lobbed, unnaturally distant, growing in size as they arced high before crashing down onto the enemy ship, one on the main deck, and the other on the quarterdeck. Yelling crewmen dove for cover when the decks erupted in flames. Then it was over. With sails and decks ablaze, the larger vessel fell off as Navarro's ship raced on into the dark night.

ABOUT ATMOSPHERE PRESS

Founded in 2015, Atmosphere Press was built on the principles of Honesty, Transparency, Professionalism, Kindness, and Making Your Book Awesome. As an ethical and author-friendly hybrid press, we stay true to that founding mission today.

If you're a reader, enter our giveaway for a free book here:

SCAN TO ENTER
BOOK GIVEAWAY

If you're a writer, submit your manuscript for consideration here:

SCAN TO SUBMIT
MANUSCRIPT

And always feel free to visit Atmosphere Press and our authors online at atmospherepress.com. See you there soon!

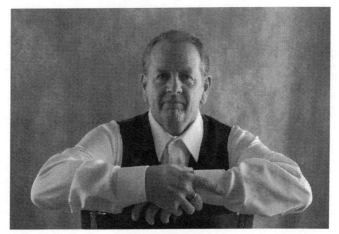

Austin C. Smith

Photo by: Sadie Sprinkle

ABOUT THE AUTHOR

**To learn more about the author,
visit his website and social media pages.**

A Perilous Road is his debut novel and
the first in his "Companions of Fate" series.

Book II - *A Fighters Destiny*,
is finished and ready to go to publication.

Book III - *A Relentless Enemy*,
is currently in progress.

SHADOWLANDS

ENTERTAINMENT

www.shadowlandsentertainment.com